Lecture Notes in Computer Science 8832

Commenced Publication in 1973
Founding and Former Series Editors:
Gerhard Goos, Juris Hartmanis, and Jan van Leeuwen

Alex Mitchell Clara Fernández-Vara
David Thue (Eds.)

Interactive Storytelling

7th International Conference
on Interactive Digital Storytelling, ICIDS 2014
Singapore, Singapore, November 3-6, 2014
Proceedings

 Springer

Volume Editors

Alex Mitchell
National University of Singapore
Department of Communications and New Media
BLK AS6, #03-22, 11 Computing Drive, Singapore 117416, Singapore
E-mail: alexm@nus.edu.sg

Clara Fernández-Vara
New York University, NYU Game Center
2 Metrotech Center, Room 854, Brooklyn, NY 11201, USA
E-mail: clara.fernandez@nyu.edu

David Thue
Reykjavik University, School of Computer Science
Menntavegur 1, Nauthólsvik, 101 Reykjavik, Iceland
E-mail: davidthue@ru.is

ISSN 0302-9743 e-ISSN 1611-3349
ISBN 978-3-319-12336-3 e-ISBN 978-3-319-12337-0
DOI 10.1007/978-3-319-12337-0
Springer Cham Heidelberg New York Dordrecht London

Library of Congress Control Number: 2014950796

LNCS Sublibrary: SL 3 – Information Systems and Application, incl. Internet/Web
and HCI

Typesetting: Camera-ready by author, data conversion by Scientific Publishing Services, Chennai, India

Printed on acid-free paper

Springer is part of Springer Science+Business Media (www.springer.com)

Preface

This volume contains the proceedings of ICIDS 2014: The 7th International Conference on Interactive Digital Storytelling. ICIDS is the premier venue for researchers, practitioners, and theorists to present recent results, share novel techniques and insights, and exchange ideas about this new storytelling medium. Interactive digital storytelling is an exciting area in which narrative, computer science, and art converge to create new expressive forms. The combination of narrative and computation has considerable untapped potential, ranging from artistic projects to interactive documentaries, from assistive technologies and intelligent agents to serious games, education, and entertainment. In 2014, ICIDS took place in Singapore at the National University of Singapore, marking the conference's first venture to Asia.

This year the review process was extremely selective and many good papers could not be accepted for the final program. Altogether, we received 67 submissions (42 full papers, 20 short papers, and five demonstrations). Out of the 42 submitted full papers, the Program Committee selected only 12 submissions for presentation and publication as full papers, which corresponds to an acceptance rate of less than 29% for full papers. In addition, we accepted eight submissions as short papers, seven submissions as posters, and five submissions as demonstrations. In total, the ICIDS 2014 program featured contributions from 26 different institutions in 18 different countries worldwide.

The conference program also highlighted three invited speakers: Bruce Nesmith, Design Director, Bethesda Game Studios, and lead designer of Skyrim; Emily Short, narrative design consultant with a special interest in interactive dialogue, and author of over a dozen works of interactive fiction, including Galatea and Alabaster; and William Uricchio, Professor of Comparative Media Studies at MIT, and Principal Investigator of MIT's Open Documentary Lab and the MIT Game Lab (formerly the Singapore-MIT GAMBIT Game Lab). The titles of their talks were:

- Bruce Nesmith:
 The Story of Radiant Story
- Emily Short:
 Narrative and Simulation in Interactive Dialogue
- William Uricchio:
 Old Dogs—New Tricks: Lessons from the Interactive Documentary

In addition to paper and poster presentations, ICIDS 2014 featured five post-conference workshops: (1) An Introduction to Game Mastering: How to Use Tabletop Role-Playing Games to Collaboratively Produce and Create Stories, (2) Managing Informational Interactive Digital Storytelling Projects,

(3) Narrative Analysis of Interactive Digital Storytelling, (4) Future Perspectives for Interactive Digital Narrative, and (5) Story Modelling and Authoring.

In conjunction with the academic conference, an art exhibition was held at ArtScience Museum at Marina Bay Sands. The art exhibition featured a selection of 10 artworks selected from 39 submissions by an international jury.

We would like to express our sincere appreciation for the time and effort invested by our authors in preparing their submissions, the diligence of our Program Committee and art exhibition jurors in performing their reviews, the insight and inspiration offered by our invited speakers, and the thought and creativity provided by the organizers of our workshops. Special thanks are also due to our sponsors and supporting organizations, and to the ICIDS Steering Committee for granting us the opportunity to host ICIDS 2014. Thank you!

November 2014 Alex Mitchell
 Clara Fernández-Vara
 David Thue

Organization

General Chair

Alex Mitchell National University of Singapore

Program Chairs

Clara Fernández-Vara New York University
David Thue Reykjavík University

Art Exhibition Chair

Jing Chiang National University of Singapore

Program Committee

Ruth Aylett	Heriot-Watt University, UK
Byung-Chull Bae	Sungkyunkwan University, South Korea
Udi Ben-Arie	Tel Aviv University, Israel
Brunhild Bushoff	Sagasnet Munich, Germany
Rogelio E. Cardona-Rivera	North Carolina State University, USA
Marc Cavazza	Teesside University, UK
Ronan Champagnat	L3i - Université de La Rochelle, France
Yun-Gyung Cheong	IT University of Copenhagen, Denmark
Sharon Lynn Chu	Texas A&M University, USA
Patrick John Coppock	University of Modena and Reggio Emilia, Italy
Chris Crawford	Storytron, USA
Gabriele Ferri	Indiana University, USA
Michael Frantzis	Goldsmiths College, UK
Pablo Gervás	Universidad Complutense de Madrid, Spain
Andrew Gordon	University of Southern California, USA
Mads Haahr	Trinity College Dublin, Ireland
Ian Horswill	Northwestern University, USA
Noam Knoller	University of Amsterdam, The Netherlands
Hartmut Koenitz	University of Georgia, USA
Petri Lankoski	Södertörn University, Sweden
Sandy Louchart	Heriot-Watt University, UK
Bradford Mott	North Carolina State University, USA
Frank Nack	University of Amsterdam, The Netherlands

Mark Nelson	Center for Computer Games Research, ITU, Denmark
Valentina Nisi	MITI, University of Madeira, Portugal
Ian Oakley	UNIST, Korea
Rafael Pérez y Pérez	Universidad Autónoma Metropolitana, Mexico
Paolo Petta	Austrian Research Institute for Artificial Intelligence, Austria
Stefan Rank	Drexel University, USA
David Roberts	North Carolina State University, USA
Remi Ronfard	Inria, France
Adam Russell	Falmouth University, UK
Marie-Laure Ryan	University of Colorado, USA
Magy Seif El-Nasr	Northeastern University, USA
Digdem Sezen	Istanbul University, Turkey
Tonguc Ibrahim Sezen	Istanbul Bilgi University, Turkey
Emily Short	Interactive Fiction Writer, USA
Mei Si	Rensselaer Polytechnic Institute, USA
Ulrike Spierling	Hochschule RheinMain, Germany
Kaoru Sumi	Future University Hakodate, Japan
Nicolas Szilas	University of Geneva, Switzerland
Mariët Theune	University Twente, The Netherlands
Emmett Tomai	University of Texas, Pan American, USA
Marian Ursu	University of York, UK
Nelson Zagalo	Universidade do Minho, Portugal
Jichen Zhu	Drexel University, USA
Alessandro Zinna	Université de Toulouse 2, France

Sponsoring Organizations

Department of Communications and New Media, National University of Singapore Keio-NUS CUTE Center, National University of Singapore

This conference was supported by the National Research Foundation, Prime Minister's Office, Singapore under its International Research Centre @ Singapore Funding Initiative and administered by the Interactive & Digital Media Programme Office.

Supported by

ArtScience Museum at Marina Bay Sands

Invited Talks

The Story of Radiant Story

Bruce Nesmith

Bethesda Game Studios
Rockville, MA, USA
bnesmith@bethsoft.com

Abstract. Early in 2009, the designers at Bethesda Game Studios were asked to create a dynamic story system. It had to withstand the rigors of an open world where the player could do just about anything–a highly ambitious goal that could make or break the project. This is the story of how Radiant Story came to be created: its pros and cons, the successes and failures of Radiant Story and how it was finally implemented in The Elder Scrolls V: Skyrim.

Biography

Bruce is the Design Director for Bethesda Game Studios where he has worked for the last 10 years. He contributed to the last three Elder Scrolls titles, Daggerfall, Oblivion, and Skyrim, as well as Fallout 3. He was the lead designer on Skyrim. Prior to joining Bethesda, Bruce worked at TSR, Inc. writing Dungeons & Dragons game books and adventures. He is particularly known for his work on the original Ravenloft boxed set and supplements.

In the course of his long career, Bruce has been a programmer, writer, designer, quality assurance technician, tech support, producer, manager, creative director and departmental director. He has created board games, card games, dice games, roleplaying games, strategy games, young adult novels, hint books, as well as video games. He's even played a few.

Narrative and Simulation in Interactive Dialogue

Emily Short

Oxford, UK
emshort@mindspring.com

Abstract. This talk draws on examples from Emily Short and Richard Evans' Versu project, including released games Blood & Laurels and House on the Hill, together with analysis of an unreleased Versu reworking of Short's classic interactive fiction Galatea and several non-Versu pieces, to discuss procedural techniques for modeling conversation flow and character behavior.

The talk looks at reviews and player feedback to consider the success of these techniques along multiple axes: as means to provide satisfying gameplay and challenge, to improve reader experience of pacing, to reduce authorial workload, or to more perfectly achieve a particular authorial vision. It further considers which of these techniques work best when the systemic aspects exposed to player attention and which are most effective when concealed.

The discussion concludes by proposing some broad questions with which to think about potential interference between interactive narrative techniques appearing in the same work.

Biography

Emily Short is a narrative design consultant with a special interest in interactive dialogue. Emily is the author of over a dozen works of interactive fiction, including Galatea and Alabaster, which focus on conversation as the main form of interaction. Most recently, she worked with Richard Evans to develop the Versu engine to create stories with AI-driven characters. She is also part of the team behind Inform 7, a natural-language programming language for creating interactive fiction.

Old Dogs - New Tricks:
Lessons from the Interactive Documentary

William Uricchio

MIT Comparative Media Studies
Cambridge, MA 02139, USA
uricchio@mit.edu

Abstract. The 'new' documentary – interactive, participatory and often referred to as Web-docs or iDocs – is deeply indebted to interactive fiction and storytelling techniques and to games. Despite its recent arrival on the interactive scene, it has found its way to new distribution platforms; new publics; and mainstream recognition in the form of Emmy, Peabody and World Press Photo awards. Can we benefit from any lessons learned?

iDocs face familiar problems – from tensions between lean-forward and sit-back experience, to the paradox that the more open the form, the shorter the user's stay. But because they are already contextualized in the real, and rely on showing as well as telling, they have some special affordances that this talk will explore. How might we rethink the role of monstration, of showing? Can we make use of rapid developments in visual recognition (LSVRC 2014), story generating algorithms (Narrative Science), and personalization algorithms (The Echo Nest) to generate personalized stories on the fly? Can interactive documentary storytelling give anything back to an area from which it has borrowed so much?

Biography

William Uricchio works with interactive documentary and games. Principal Investigator of MIT's Open Documentary Lab and the MIT Game Lab (formerly the Singapore-MIT GAMBIT Game Lab), William and his team explore new forms of non-fiction storytelling and their implications for authorship, participation and the once stable text. William is professor of Comparative Media Studies at MIT as well as at Utrecht University in the Netherlands. A specialist in old media when they were new, he is currently exploring the cultural work of algorithms. Guggenheim, Humboldt and Fulbright awards behind him, William will spend 2015 in Berlin thanks to the Berlin Prize.

Table of Contents

Theory

Retrospectives

User Experience

Posters

Demonstrations

Workshops

Storytelling with Adjustable Narrator Styles and Sentiments

Boyang Li, Mohini Thakkar, Yijie Wang, and Mark O. Riedl

School of Interactive Computing, Georgia Institute of Technology,
Atlanta, GA, USA
{boyangli,mthakkar,yijiewang,riedl}@gatech.edu

Abstract. Most storytelling systems to date rely on manually coded knowledge, the cost of which usually restricts such systems to operate within a few domains where knowledge has been engineered. *Open Story Generation* systems are capable of learning knowledge necessary for telling stories in a given domain. In this paper, we describe a technique that generates and communicates stories in language with diverse styles and sentiments based on automatically learned narrative knowledge. Diversity in storytelling style may facilitate different communicative goals and focalization in narratives. Our approach learns from large-scale data sets such as the Google N-Gram Corpus and Project Gutenberg books in addition to crowdsourced stories to instill storytelling agents with linguistic and social behavioral knowledge. A user study shows our algorithm strongly agrees with human judgment on the interestingness, conciseness, and sentiments of the generated stories and outperforms existing algorithms.

1 Introduction

Narrative Intelligence (NI), or the ability to craft, tell, understand, and respond to stories, is considered a hallmark of human intelligence and an effective communication method. It follows that Narrative Intelligence is important for Artificial Intelligence that aims to simulate human intelligence or communicate effectively with humans. In this paper, we focus on computational NI systems that can generate and tell stories.

A significant challenge in building NI systems is the knowledge intensive nature of NI. To date, most computational systems purported to demonstrate NI are reliant on substantial amount of manually coded knowledge, whose availability is limited by the time and financial cost associated with knowledge engineering. Consequently, most systems are designed to operate in only a few micro-worlds where knowledge is available. For example, an automated story generator may be told about the characters and environment of Little Red Riding Hood; that system can tell a large variety of stories about the given set of characters and topic, but no stories about other characters or topics.

Open Story Generation systems (e.g. [5, 16]) have been proposed in order to tackle the challenge of generating and telling stories in any domain. Such systems can learn the needed knowledge for story generation and storytelling without *a*

A. Mitchell et al. (Eds.): ICIDS 2014, LNCS 8832, pp. 1–12, 2014.

priori knowledge engineering about a particular domain. We previously described an open story generation system, SCHEHERAZADE [5], which uses crowdsourcing to construct a commonsense understanding about how to perform everyday activities such as going to a restaurant or going to a movie theater. Given a topic, the system learns what it needs to generate a story about the topic. However, the system does not reason about how to *tell* a story, or how to translate a sequence of abstract events into natural language.

A story may be told to achieve communicative goals, such as to entertain, to motivate, or to simply report facts. Different goals may require narrators to adopt different storytelling styles. Additionally, the narrative technique of focalization involves describing the same events from different characters' perspectives, possibly with opposing sentiments (cf. [2,18]). As a first step, we tackle the problem of creating different storytelling styles for Open Story Generation. Style parameters are learned from large data sets including the Google N-Gram corpus [8] and books from Project Gutenburg (www.gutenberg.org). We offer methods to tune the storytelling with different levels of details, fictional language, and sentiments. Our user study indicates our algorithm strongly agrees with human readers' intuition of linguistic styles and sentiments, and outperforms existing methods.

1.1 Background and Related Work

Story generation and interactive narrative have a long history. See Gervás [3] and Riedl & Bulitko [12] for overviews. Several Open Story Generation systems have been proposed before. The SayAnything system [16] generates stories from snippets of natural language mined from weblogs. McIntyre & Lapata [7] learn temporally ordered schema from fairy tales, merge schema into plot graphs, and use a genetic algorithm to maximize the coherence of generated stories. Crowdsourcing has been proposed as a means for overcoming the knowledge bottleneck. Sina *et al.* [14] use case-based reasoning to modify crowdsourced semi-structured stories to create alibi for virtual suspects in training. None of these approaches explicitly model discourse or generate different narration styles.

The work in this paper builds off our previous work on the SCHEHERAZADE system [4, 5], which learns the structure of events in a given situation from crowdsourced exemplar stories describing that situation. As opposed to other story generation systems, SCHEHERAZADE is a just-in-time learner; if the system does not know the structure of a situation when it is called for, it attempts to learn what it needs to know from a crowd of people on the Web. This results in a script-like knowledge structure, called a *plot graph*. The graph contains events that can be expected to occur, temporal ordering relations between events, and mutual exclusions between events that create branching alternatives.

The learning of the plot graph proceeds in four steps [4, 5]. After exemplar stories about a social situation are crowdsourced from Amazon Mechanical Turk (AMT), the learning starts by creating clusters of sentences of similar semantic meaning from different exemplar stories. Each cluster becomes an event in the plot graph. In order to reduce the difficulty in natural language processing,

crowd workers from AMT have been asked to use simple language, i.e., using one sentence with a single verb to describe one event, avoiding pronouns, etc. The second and third steps identify the temporal precedences and mutual exclusions between events. The final step identifies optional events. Story generation in SCHEHERAZADE is the process of selecting a linear sequence of events that do not violate any temporal or mutual exclusion relations in the script [5]. However, telling the generated story in natural language with different storytelling styles has not been previously realized.

Focalization in narration refers to telling stories from different viewpoints (e.g. of an omniscient entity or any story character; cf. [2]), potentially requiring multiple narration styles. Most computational implementations focus on plot events [11, 18] instead of linguistic variations. Curveship [10] generates focalized text based on manually coded knowledge. Our work directly addresses the problem of diverse language use by implied or explicit narrators.

Automatic generation of distinct linguistic pragmatics for narration has also been studied. The PERSONAGE system [6] maps the Big Five psychological model to a large number of linguistic parameters. Rishes *et al.* [13] used PERSONAGE to create different tellings of stories generated from a semantic representation consisting of events and character intentions. The generated linguistic styles differ mostly in aspects independent of content, such as in the use of swear words, exclamation marks and shuttering. Instead of generating from symbolic representations with precise semantic meaning, we select from existing sentences that are similar but not strictly synonymous to describe an event (i.e. sentences may differ in content). We consider parameters directly related to word choices: degree of details, fictionality, and sentiments.

2 Storytelling with Different Styles and Sentiments

This section describes the process of telling stories in natural language with a variety of personal styles. The architecture for story generation and communication is shown in Figure 1. Plot graph learning is typically an offline process that incrementally constructs a knowledge base of models of social situations, from which stories can be generated [4, 5]. A story is generated as one possible total-ordered sequence of events that respect all constraints in the plot graph. The discourse planning stage selects some interesting events from the complete sequence to be told, which is beyond the scope of this paper and not used in the evaluation. This paper focuses on the last stage of the architecture: describing the selected events with personal styles and affects, which we explain below.

Recall that each event in the learned plot graph is a cluster of natural language descriptions of similar meaning. Given a generated story (a complete, linear sequence of events), natural language text is generated by selecting the sentence from each cluster that best matches the intended narration style. We describe two criteria for selecting sentences: (1) the interestingness of the text and (2) the sentiment of the text. We aim to create a diverse set of storytelling styles that may be suitable for different occasions. For example, some narrators or story

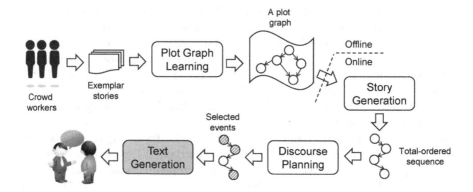

Fig. 1. The system pipeline

characters may speak very succinctly, whereas others can recall vivid details. A positive tone may be used if the narrator wants to cheer up the audience; a negative tone may be suitable for horror stories and so on. We also present a Viterbi-style algorithm that considers preferences on individual sentences and inter-sentence connections to produce coherent textual realizations.

We performed a second round of crowdsourcing to obtain a variety of event descriptions that can reflect different narration styles and sentiments. The originally crowdsourced exemplar stories were written in simple sentences that help to simplify natural language processing [4]. Thus, only simple event descriptions were available for selection. The second round of crowdsourcing asked AMT workers to provide "interesting" event descriptions. For $1, workers wrote detailed descriptions for each event in a given story; each description may contain more than one sentences. We allowed workers to interpret "interesting" however they wanted, though we suggested that they describe characters' intentions, facial expressions, and actions. Each worker saw a complete sequence of events to make sure they understand the story context. We accepted all stories that describe the events we provide, and did not perform a manual check of interestingness.

2.1 Textual Interestingness

We investigate two aspects of language that affect the interestingness of stories. The first is the amount of details provided, and the second is the degree that the story language resembles the language used in fictions. We model the amount of details with the probability of a sentence in English, since Information Theory suggests a less likely sentence contains more information (i.e. more details). We compute the probability of an English word as its frequency in the Google N-Gram corpus. Due to the large size of the corpus, these frequencies approximate word probabilities in general English. We compute the probability of a sentence

using the bag-of-word model, where the probability of sentence S containing words w_1, w_2, \ldots, w_k, each appearing x_1, x_2, \ldots, x_k times is

$$P(S) = \frac{\left(\sum_{i=1}^{k} x_i\right)!}{\prod_{i=1}^{k}(x_i!)} \prod_{i=1}^{k} P(w_i)^{x_i} \qquad (1)$$

where $P(w_i)$ is the probability of word w_i. For our purpose, the average frequency over the 10-year period of 1991 to 2000 in the "English 2012" corpus is used. Stop words are removed before computation.

We further consider the style of language as how much it resembles fictional novels. The language used in fictions has distinctive word choices as fictions tend to accurately describe actions (e.g. "snatch" instead of "take") and emotions, and make less use of formal words (e.g. "facility", "presentation"). If a word appears more frequently in fiction books than in all books, we can presume that its use creates a sense that the story is being told in a literary manner. Therefore, the *fictionality* of a word w is the ratio

$$f_w = P_{\text{fic}}(w)/P(w) \qquad (2)$$

where $P(w)$ is the probability of a word computed previously and $P_{\text{fic}}(w)$ is the probability of a word appearing in the "English Fiction 2012" corpus from the Google N-Gram corpus. The fictionality of a sentence is aggregated from fictionality values of individual words as an exponentiated average:

$$\text{fic}(S) = \frac{\sum_{w \in W} \exp(\alpha f_w)}{\text{card}(W)} \qquad (3)$$

where W is the multiset of words in sentence S, and $\text{card}(W)$ is its cardinality. α is a scaling parameter. The exponential function puts more weights on words with higher fictionality, so that a few highly fictional words are not canceled off by many words with low fictionality.

Table 1 shows some example sentences. We observe that the most probable sentence (MostProb) usually provides a good summary for the event. The most fictional (MostFic) sentence usually contains more subjective emotions and character intentions, whereas the least probable (LeastProb) sentence is usually longer and contains more objective details. We balance and combine the MostFic and the LeastProb criteria by using the harmonic mean in order to create the sentence with most interesting details (MID). Let us denote the ranks of each sentence under the LeastProb and the MostFic criteria as r_{LP} and r_{MF} respectively. For example, the least probable sentence has $r_{\text{LP}} = 1$, and the second most fictional has $r_{\text{MF}} = 2$. The harmonic mean rank r_{MID} is computed as $2 r_{\text{LP}} r_{\text{MF}}/(r_{\text{LP}} + r_{\text{MF}})$. The sentence with the lowest r_{MID} is picked as the one with the most interesting details.

2.2 Textual Sentiments

Stories may be told with positive or negative sentiment. To detect sentiments of sentences in each event cluster, we construct a sentiment dictionary called

Table 1. Example Sentences Selected with the Probability, Fictionality, and Sentiment Criteria

Example event 1: Sally puts money in bag
- MostProb: Sally put $1,000,000 in a bag.
- LeastProb: Sally put the money in the bag, and collected the money from the 2 tellers next to her.
- MostFic: Sally quickly and nervously stuffed the money into the bag.
- MID: Sally quickly and nervously stuffed the money into the bag.
- Positive: Sally continued to cooperate, putting the money into the bag as ordered.
- Negative: Sally's hands were trembling as she put the money in the bag.

Example event 2: John drives away
- MostProb: John drove away.
- LeastProb: John pulled out of the parking lot and accelerated, thinking over which route would make it easier to evade any police cars that might come along.
- MostFic: John sped away, hoping to get distance between him and the cops.
- MID: John sped away, hoping to get distance between him and the cops.
- Positive: As the stoplight turned green and the daily traffic began to move, John drove away.
- Negative: John slammed the truck door and, with tires screaming, he pulled out of the parking space and drove away.

Smooth SentiWordNet (SSWN). SSWN builds off SentiWordNet [1], which tags each synset (word sense) in WordNet [9] with three values: positivity, negativity, and objectiveness, the three summing to 1. SentiWordNet was produced by propagating known sentiments of a few seed words along connections between words in WordNet to provide good coverage, but this automatic approach can produce many erroneous values, resulting in unreliable sentiment judgments. Smooth SentiWordNet uses an unsupervised, corpus-based technique to correct errors found in the original library and expand its coverage beyond words appearing in WordNet. The intuition behind SSWN is that words that are nearby should share similar sentiments, and words closer should have a stronger influence than words farther away. We take sentiment values from SWN and "smooth" the values based on word location using Gaussian kernel functions, in order to alleviate errors and further expand the coverage.

We perform smoothing with a corpus of 9108 English books from Project Gutenberg that are labeled as fiction. These books are tagged with parts of speech (POS) with the Stanford POS Tagger [17]. Each pair of word and POS is considered a unique word. For every word we want to compute sentiment value for, we consider a neighborhood of 100 words, 50 to its left and 50 to its right. The target word is at position 0 and denoted as w_0. The words to its immediate left and right are at position -1 and 1, and so forth. The positions of these words are included in the index set N. For word w_i at position $i \in N$, its influence at position j is modeled with a Gaussian kernel function g_i: $g_i(j) = \exp\left(-(i-j)^2/d\right)$, where parameter d determines how fast the function diminishes with distance, and is empirically set to 32. Only nouns, verbs, adjectives and adverbs in complete sentences can influence the target word.

Table 2. An example partial story with most interesting details. The first 7 sentences in the story are omitted for space reasons.

(... the first 7 sentences omitted)
When it was his turn, John, wearing his Obama mask, approached the counter.
Sally saw Obama standing in front of her and she felt her whole body tense up as her worst nightmare seemed to be coming true.
Once Sally began to run, John pulled out the gun and directed it at the bank guard.
John wore a stern stare as he pointed the gun at Sally.
Sally saw the gun and instantly screamed before she could stop herself.
John told her she had one minute to get the money and shook the gun at her.
John gave Sally a bag to put the banks money in.
John struggled to stuff the money in his satchel.
Sally was quietly sobbing as John grabbed the bag full of money.
John strode quickly from the bank and got into his car tossing the money bag on the seat beside him.
John pulled out of the parking lot and accelerated, thinking over which route would make it easier to evade any police cars that might come along.

In the each neighborhood that the target word w_0 appears, its sentiment s_{w_0} is computed as a weighted average of all kernel functions at position 0:

$$s_{w_0} = \frac{\sum_{i \in N} s_{w_i}^{\text{swn}} g_i(0)}{\sum_{i \in N} g_i(0)} \qquad (4)$$

where $s_{w_i}^{swn}$ is the sentiment value from SentiWordNet, i.e. the difference between the positive and negative polarity. The SentiWordNet value for the target word w_0 has no influence on itself, i.e. $0 \notin N$. As a word can appear multiple times in different neighborhoods, the final sentiment value for w_0 is the average over all neighborhoods it appears in. We aggregate sentiments of individual words in sentence S, again using the exponential average:

$$\text{sentiment}(S) = \frac{\sum_{w \in V} \text{sign}(s_w) \exp(\beta |s_w|)}{\text{card}(V)} \qquad (5)$$

where $\text{card}(V)$ is the cardinality of the multiset V, containing only nouns, verbs, adjectives or adverbs in sentence S. β is a scaling parameter. The exponential function ensures that words expressing strong sentiments are weighted more heavily than words with weak sentiments.

We selected a subset of English words that are of interest to our task. The exemplar stories in two previously crowdsourced social situations—dating at the movie theater and bank robbery—contain 1001 unique nouns, verbs, adverbs and adjectives. We selected highly influential adjectives and adverbs from their direct neighbors, producing a total of 7559 words. We normalize the raw values produced by smoothing, so that 1 percentile and 99 percentile of the values fall

in the range of $[-1, 1]$, to account for outliers.[1] Table 1 shows some of the most positive and most negative sentences. We find the results to reflect the valences of individual words. Although this approach works most of the time, there are cases such as sarcasm where the sentiment of a sentence could be the opposite of that of individual words. SSWN is evaluated in Section 3.

2.3 Connecting Sentences

For each event, we can find individual sentences ranked highest for any criterion or combinations of criteria using the harmonic mean. However, this selection does not consider the coherence between sentences and may results in incoherent texts due to two major problems: (1) previously mentioned objects can suddenly disappear and previously unmentioned objects can appear, and (2) a sentence can repeat actions in the previous sentence. To address this problem, we propose a Viterbi-style algorithm, which considers both selection criteria for individual sentences and the connection between sentences.

In a hidden Markov model (HMM), the Viterbi algorithm finds a sequence of hidden variables that best explains a sequence of observed random variables. The algorithm relies on two things in an HMM: One, the probabilities of a hidden variable generating any observation. That is, the observation indicates preference over values of the hidden variable. Two, the probabilities of a hidden variable transiting to the next hidden variable. That is, we have preferences over pairs of values for adjacent variables.

Our problem is similar as we want to find the highest scored sentence sequence based on preferences over sentences in each event cluster, and preferences on how adjacent sentences connect. In this paper, we do not consider connection between non-adjacent sentences. Specifically, we score the connection between any two sentences s_i, s_j as $\log\left((sn(i,j) + 1)/(sv(i,j) + 1)\right)$, where $sn(i,j)$ is the number of nouns shared by the two sentences, and $sv(i,j)$ is the number of verbs shared by the two sentences. Similarly, we score individual sentences as the reciprocal of their ranks according to any selection criterion c : $\text{score}(s_i) = 1/\text{rank}_c(s_i)$.

Our algorithm is shown as Algorithm 1. The BESTSEQENDINGIN function is recursive, because in order to find the best sequence ending in a given sentence s_i^j from the j^{th} event cluster c_j, we need to consider the scores of best sequences ending in every sentence from the previous cluster c_{j-1}, in addition to the connection between every sentence from cluster c_{j-1} and s_i^j. Due to the Markov property, we do not need to consider clusters c_1, \ldots, c_{j-2}. We can then iterate over every sentence from cluster c_j to find the best sequence ending in cluster c_j. A dynamic programming approach can be used to store every sequence ending in every sentence from every cluster and their scores. For a sequence of n clusters and m sentences in each cluster, the time and space complexity are $O(m^2 n)$ and $O(mn)$. An example partial story is shown in Table 2.

[1] The list of books can be downloaded at
http://www.cc.gatech.edu/~bli46/SBG/list.txt. The resulted dictionary is at:
http://www.cc.gatech.edu/~bli46/SBG/dic.txt

Algorithm 1. Generation of Story Text

function GENERATETEXT(event sequence $\langle c_1, c_2, \ldots, c_n \rangle$)
 for each sentence $s_k \in \{s_1, s_2, \ldots, s_m\}$ in event cluster c_n **do**
 $(seq_k, \text{score}(seq_k)) \leftarrow$ BESTSEQENDINGIN(s_k, c_n)
 end for
 return the highest scored sequence from $seq_1, seq_2, \ldots, seq_m$
end function

function BESTSEQENDINGIN(s_i, c_j)
 for each sentence $s_p \in \{s_1, s_2, \ldots, s_m\}$ in event cluster c_{j-1} **do**
 $(seq_p, \text{score}(seq_p)) \leftarrow$ BESTSEQENDINGIN(s_p, c_{j-1}) ▷ stored previously
 $new_seq_p \leftarrow seq_p + s_i$
 $\text{score}(new_seq_q) \leftarrow \text{score}(seq_q) + \text{score}(s_q, s_i) + \text{score}(s_i)$
 end for
 $best_seq \leftarrow$ the highest scored sequence from $new_seq_1, \ldots, new_seq_m$
 return $(best_seq, \text{score}(best_seq))$
end function

Table 3. Statistics of crowdsourced interesting stories

	Movie Date	Bank Robbery
# Stories	20	10
# Sentences	470	210
# Words per sentence	14.53	13.7
# Verbs per sentence	2.36	2.6

3 Evaluation

We performed a user study to test if the results of our algorithm agree with human intuition. We investigated two social situations: dating at a movie theater and bank robbery. In addition to the originally crowdsourced exemplar stories, we crowdsourced interesting stories using procedures described in Section 2. Some statistics of these stories are shown in Table 3. Some of these sentences can be seen in prior examples showing least probable and most fictional sentences for particular clusters (the most probably sentence typically comes from the original, simplified language exemplars).

With the newly crowdsourced sentences added, for each situation we generate two groups of stories with the Viterbi-style algorithm with different sentence selection criteria. We do not perform discourse planning to avoid confounding factors. The first group includes stories generated from the most interesting details (MID) criterion, the most probable (MostProb) criterion, and a story where we use the MID criterion but penalize long sentences. After reading the stories, participants are asked to select the most interesting story, the most detailed story and the most concise story. Our hypothesis is that human readers will select the MID story as containing the most details and the most interesting, and the MostProb story as the most concise. We set α to 12. The second group of

Table 4. Participant agreement with our algorithm. § denotes $p < 0.0001$. * denotes $p < 0.0005$.

Test	Participant Agreement %	
	Movie Date	Bank Robbery
Most Concise Story	90.38§	75.00*
Most Detailed Story	97.92§	100.00§
Most Interesting Story	88.46§	80.77§
Positive/Negative Stories	86.54§	92.31§

stories include a story containing the sentences with the most positive sentiment from each event, and a story containing the sentences with the most negative sentiment. We set β to 16 and 2 for the movie data and bank robbery situation respectively. After reading the second group, participants are asked to select a positive and a negative story. We hypothesize human readers will agree with the algorithm's sentiment judgments.

A total of 52 undergraduate, master's, and doctoral students participated in our study. Table 4 shows the percentage of human participants that agree with the algorithm. All results are predominantly positive and consistent with our hypothesis, strongly indicating our algorithm can capture the human intuition of interestingness, conciseness, and sentiments. We use one-tailed hypothesis testing based on the multinomial/binomial distribution and find the results to be extremely statistically significantly above a random baseline.

However, it is arguably easier to detect the sentiment of an entire story than to detect the sentiment of individual sentences, because in a story, a few sentences labeled with wrong sentiments mixed with many correctly labeled sentences can be overlooked by human readers. To further evaluate our sentiment detection algorithm, we perform a sentence-level comparison. We first take out the top 3 most positive sentence and top 3 most negative sentences from 45 event clusters in both situations. One positive and one negative sentences are randomly selected from the top 3, and shown to participants, who labeled one sentence as positive and the other as negative. In total, 52 participants performed 4678 evaluations of 265 unique pairs of sentences. The results are shown in Table 5 . Overall, 70.76% of participants' decisions agree with our algorithm. The majority opinion on each pairs of sentences agrees with our algorithm for 80.75% of the time.

We further compare our algorithm with SentiWordNet. We replaced word sentiments in Equation 5 with values directly taken from SentiWordNet, and label a sentence as positive if its sentiment is higher than the median sentence in a cluster, and negative if lower. Results are matched against the participants' decisions. We tuned β to maximize performance. We also compare SSNW with the technique by Socher et al. [15] from Stanford University, which directly labels a sentence as positive, negative or neutral. The results are summarized in Table 5. SSWN outperform SWN by a margin of 11.16% to 16.22%, and outperform

Table 5. Comparing word sentiment values from SENTIWORDNET and the values computed by our smoothing technique. § denotes $p < 0.0001$.

	Participant Agreement %		
Test	Smooth SWN	SentiWordNet	Socher et al.
Sentence Sentiments	70.76	59.60[§]	35.91[§]
Sentence Sentiments by Majority Vote	80.75	64.53[§]	39.25[§]

Socher *et al.* by 34.85% to 41.5%, although Socher *et al.*'s algorithm targets movie reviews and has not been tuned on our data set. A Chi-Square test shows the difference between conditions are extremely statistically significant.

4 Discussion and Conclusions

Open Story Generation systems can learn necessary knowledge to generate stories about unknown situations. However, these systems have not considered how to tell the generated story in natural language with different styles. Such a capability is useful for achieving different communicative goals and for projecting a story to perspectives of story characters. For example, a story with mostly objective details is suitable for conveying information, whereas interesting stories tend to describe characters' subjective feelings. A positive tone may be used to cheer up the audience, or to describe things from a cheerful character's perspective. As a first step toward solving these problems, we discuss Open Storytelling with different styles, such as attention to detail, fictionality of language, and sentiments. Our technique employ the same knowledge structure learned by Open Story Generation systems and large data sets including the Google N-Gram Corpus and Project Gutenberg. We develop a method for selecting interesting event descriptions and build a sentiment dictionary called Smooth SentiWordNet by smoothing out errors in sentiment values obtained from SentiWordNet. Our user study with 52 participants reveals that corpus-based techniques can achieve recognizably different natural language styles for storytelling. Future work will investigate newer fiction corpora, such as weblogs labeled as stories, than Project Gutenberg, which may not fully reflect the language use of this day.

Our storytelling techniques help to overcome the authoring bottleneck for storytelling systems by learning from data sets consisting of crowdsourced exemplar stories, the Google N-Gram Corpus, and books from Project Gutenberg, Building off existing work [4, 5], the effort presented in this paper moves the state of the art towards the vision of computational systems capable of telling an unlimited number of stories about an unlimited number of social situations with minimum human intervention.

Acknowledgments. We gratefully acknowledge DARPA for supporting this research under Grant D11AP00270, and Stephen Lee-Urban and Rania Hodhod for valuable inputs.

References

1. Baccianella, S., Esuli, A., Sebastani, F.: SentiWordNet 3.0: An enhanced lexical resource for sentiment analysis and opinion mining. In: The 7th Conference on International Language Resources and Evaluation (2010)
2. Bae, B.C., Cheong, Y.G., Young, R.M.: Automated story generation with multiple internal focalization. In: 2011 IEEE Conference on Computational Intelligence and Games, pp. 211–218 (2011)
3. Gervás, P.: Computational approaches to storytelling and creativity. AI Magazine 30, 49–62 (2009)
4. Li, B., Lee-Urban, S., Appling, D.S., Riedl, M.O.: Crowdsourcing narrative intelligence. Advances in Cognitive Systems 2 (2012)
5. Li, B., Lee-Urban, S., Johnston, G., Riedl, M.O.: Story generation with crowdsourced plot graphs. In: The 27th AAAI Conference on Artificial Intelligence (2013)
6. Mairesse, F., Walker, M.: Towards personality-based user adaptation: Psychologically informed stylistic language generation. User Modeling and User-Adapted Interaction 20, 227–278 (2010)
7. McIntyre, N., Lapata, M.: Plot induction and evolutionary search for story generation. In: The 48th Annual Meeting of the Association for Computational Linguistics, pp. 1562–1572 (2010)
8. Michel, J.B., Shen, Y., Aiden, A., Veres, A., Gray, M., Brockman, W., The Google Books Team, Pickett, J., Hoiberg, D., Clancy, D., Norvig, P., Orwant, J., Pinker, S., Nowak, M., Aiden, E.: Quantitative analysis of culture using millions of digitized books. Science 331, 176–182 (2011)
9. Miller, G.: WordNet: A lexical database for English. Communications of the ACM 38, 39–41 (1995)
10. Montfort., N.: Generating narrative variation in interactive fiction. Ph.D. thesis, University of Pennsylvania (2007)
11. Porteous, J., Cavazza, M., Charles, F.: Narrative generation through characters point of view. In: The SIGCHI Conference on Human Factors in Computing Systems (2010)
12. Riedl, M.O., Bulitko, V.: Interactive narrative: An intelligent systems approach. AI Magazine 34, 67–77 (2013)
13. Rishes, E., Lukin, S.M., Elson, D.K., Walker, M.A.: Generating different story tellings from semantic representations of narrative. In: Koenitz, H., Sezen, T.I., Ferri, G., Haahr, M., Sezen, D., Ç atak, G. (eds.) ICIDS 2013. LNCS, vol. 8230, pp. 192–204. Springer, Heidelberg (2013)
14. Sina, S., Rosenfeld, A., Kraus, S.: Generating content for scenario-based seriousgames using crowdsourcing. In: The 28th AAAI Conference on Artificial Intelligence (2014)
15. Socher, R., Perelygin, A., Wu, J., Chuang, J., Manning, C., Ng, A., Potts, C.: Recursive deep models for semantic compositionality over a sentiment treebank. In: The Conference on Empirical Methods in Natural Language Processing (2013)
16. Swanson, R., Gordon, A.S.: Say anything: Using textual case-based reasoning to enable open-domain interactive storytelling. ACM Transactions on Interactive Intelligent Systems 2, 1–35 (2012)
17. Toutanova, K., Klein, D., Manning, C., Singer, Y.: Feature-rich part-of-speech tagging with a cyclic dependency network. In: The NAACL-HLT Conference (2003)
18. Zhu, J., Ontañón, S., Lewter, B.: Representing game characters' inner worlds through narrative perspectives. In: The 6th International Conference on Foundations of Digital Games, pp. 204–210 (2011)

Combinatorial Dialogue Authoring

James Owen Ryan[1,2], Casey Barackman[3], Nicholas Kontje[3],
Taylor Owen-Milner[4], Marilyn A. Walker[1],
Michael Mateas[2], and Noah Wardrip-Fruin[2]

[1] Natural Language and Dialogue Systems Lab
[2] Expressive Intelligence Studio
[3] Department of Linguistics
[4] Department of Computer Science
University of California, Santa Cruz, CA, USA

Abstract. We present an annotation scheme and combinatorial author-
ing procedure by which a small base of annotated human-authored di-
alogue exchanges can be exploited to automatically generate many new
exchanges. The combinatorial procedure builds recombinant exchanges
by reasoning about individual lines of dialogue in terms of their mark-up,
which is attributed during annotation and captures what a line expresses
about the story world and what it specifies about lines that may precede
or succeed it in new contexts. From a human evaluation task, we find
that while our computer-authored recombinant dialogue exchanges are
not rated as highly as human-authored ones, they still rate quite well
and show more than double the strength of the latter in expressing game
state. We envision immediate practical use of our method in a collabo-
rative authoring scheme in which, given a small database of annotated
dialogue, the computer instantly generates many full exchanges that the
human author then polishes, if necessary. We believe that combinato-
rial dialogue authoring represents an immediate and huge reduction in
authorial burden relative to current authoring practice.

Keywords: dialogue, natural language generation, authorial burden.

1 Introduction

Dialogue is a compelling storytelling mechanism and excellent way of express-
ing states that underly interactive-narrative systems, but telling a story with
dialogue entails a large authorial burden. It is infeasible to anticipate all the
potential states that a dynamic system might get into, let alone to write fully
realized dialogue for each of them. Indeed, current dialogue authoring practice
for digital storytelling systems is widely seen as inhibiting advancement of the
latter [18,9]. Even many systems that do use language to storytell or to express
underlying state have eschewed fully realized character dialogue by instead re-
lying on expressive abstractions of language, examples being *Storytron* with its
Deikto words [3] and the Simlish of *Sims 3* [4]. We envision a future in which
autonomous characters in dynamic story worlds come up with their own dialogue
from scratch by reasoning over rich representations of meaning and intent—but

A. Mitchell et al. (Eds.): ICIDS 2014, LNCS 8832, pp. 13–24, 2014.

that future is not here yet. As a step from current authoring practice toward this ideal, we present a technique in which dialogue segments carry their own specification of why and where they may be used, allowing authors to write fewer lines of dialogue that are used more often. We call this technique *combinatorial dialogue authoring*, and demonstrate it using dialogue written for a system called *Comme il Faut*, or *CiF*.

CiF is a social artificial-intelligence engine that is designed to underlie inter-active narrative experiences in which the player's primary affordances are social interactions with or between characters [11]. The system's major demonstration to date is *Prom Week*, a social-simulation videogame set in a high school in the week leading up to prom. In each level of the game, *Prom Week* players are tasked with causing certain social outcomes to be realized before the titular prom concludes the week. These outcomes may be for two characters to begin dating or to become friends, for example, and are achieved by selecting social interactions, like *flirting* or *bragging*, that are initiated by one character and directed toward another. Once a particular interaction, or *social exchange*, and initiating char-acter, or *initiator*, are selected by the player, *CiF* reasons over several thousand social considerations to decide whether the recipient of the exchange, called the *responder*, will accept or reject it. This computation is then repeated to choose an *instantiation* of that exchange to play out. An instantiation is an enactment of a social exchange through around five to ten lines of hand-authored dialogue between its participants, with *preconditions* on it specifying what must be true about the story world in order for it to be enacted.

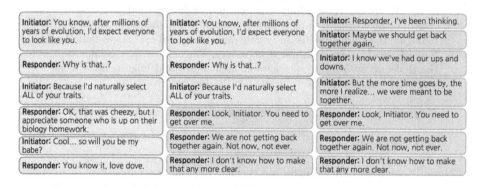

Fig. 1. A simple recombinant *Prom Week* instantiation, middle, culled from two ex-isting human-authored instantiations

Like all systems that use dialogue to storytell and express underlying state, *CiF* plays victim to the authoring bottleneck, which in this case has worked to limit the total number of instantiations hand-authored for *Prom Week*. This limitedness of the full set of instantiations in turn limits coverage, in terms of what can be expressed, of the possible social states represented in *CiF*, the multitude of which is largely the selling point of the system.

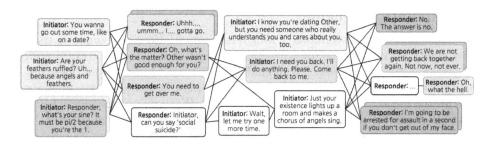

Fig. 2. A mere sixteen lines of dialogue are exploited to generate 75 unique *Prom Week* instantiations, shown here as full graph traversals. Each serves a unique purpose (represented by the set of colors passed through) not fulfilled by any existing instantiation.

So, what can be done? We present an annotation scheme and combinatorial authoring procedure by which a small base of annotated human-authored *Prom Week* instantiations is exploited to automatically generate new recombinant instantiations—like the one shown in Figure 1—that satisfy targeted constraints. Figure 1 illustrates how our method can harness a very small base of dialogue segments to generate many new exchanges. This task is not trivial, as it requires the computer to reason about how dialogue may be used to express very specific aspects of game state and how to ensure that adjacent lines of dialogue cohere. While the work we report is specifically for *Prom Week*, our method of combinatorial dialogue authoring is generalizable to any systems that use dialogue to express underlying state, particularly those whose dialogue exchanges are directed and specify a resulting state change.

Prior work has explored repurposing natural-language text for a number of applications, including story generation [17], chatbots [2], interactive tutoring [12], pedagogical simulation [7], and spoken dialogue systems [15]. While these projects involve recontextualizing language content, our approach might instead be characterized as *decontextualizing* language content, specifically dialogue, such that its usage in the very work for which it was composed becomes less constrained. Other related work has involved expressive natural language generation for digital storytelling [18,13], but by unrelated methods. The most similar work that we know of is the Versu project [6], in which techniques comparable to ours, including speech-act attribution [16], are used to compose character dialogue exchanges on the fly. Our method, while similar, is instead intended to alleviate authorial burden during the composition of dialogue *prior* to runtime, and also to be generalizable to any system. Combinatorial dialogue authoring was first proposed in [14].

In the following section, we describe our annotation scheme. Section 3 outlines our combinatorial authoring procedure, and Sections 4 and 5 show example generated recombinant instantiations and present the design and results of an evaluation procedure comparing these to human-authored instantiations.

2 Annotation Scheme

We take existing human-authored *Prom Week* instantiations and annotate their individual lines of dialogue for what they express about the story world and, because dialogue is not freely recombinable, their specifications about lines that may precede or succeed them in new contexts. More specifically, we annotate lines for the social-exchange identities (e.g., that a *Pick-up line* exchange is being enacted) or outcomes (e.g., that the responder is rejecting the core purpose of the social exchange), if any, that they communicate; instantiation preconditions (e.g., that the initiator is brainy) whose content they express; their speech acts; and any strict dependencies that they might have. Speech-act mark-up, in particular, works to specify what type of line may precede a given line (e.g., a line with the speech act *affirmative answer* should be preceded by a line with the speech act *yes-no question*) or succeed it (e.g., a *yes-no question* should be followed by an *affirmative answer* or other appropriate response) according to a policy we call *speech act concordance*, described in the next section.

Our annotation scheme includes tagsets for social-exchange identities, social-exchange outcomes, and instantiation preconditions that are coextensive, respectively, with *Prom Week*'s 39 social exchanges, 78 possible exchange–outcome combinations, and 447 unique preconditions that are used across all instantiations. Our speech-act tagset, which includes 35 acts and is available upon request, began as a combination of two existing tagsets [8,1] and was refined and expanded as needed during the early stages of annotation. Additionally, we treat core social-exchange acts, such as lines of dialogue constituting a character asking another character out, as special-case speech acts, as well as lines constituting either the responder accepting or rejecting a social exchange.

While knowing a line's speech acts is typically enough to specify which lines may precede or succeed it (assuming those lines' speech acts are also known), some lines have more nuanced dependencies that must also be captured during annotation. Most often, this occurs when a line has a speech act that allows for multiple different speech acts that a preceding line may have, but due to some nuance of the line it depends on its preceding line having one specific speech act. For these cases, our scheme allows for an annotator to specify that, in any new context, a line must be preceded by a line with a certain specified speech act. In other cases, some nuance may make it so that a line cannot reasonably be used in a new context unless it is also preceded there by a specific line from its native context. This is generally due to anaphora or wordplay, and in these cases we rely on a fallback option of annotating a line as having a strict dependence on the pertinent preceding line.

For the annotation task, we use the story-encoding tool SCHEHERAZADE [5] in a way that is suited to our purposes and is not how the tool was intended to be used.[1] The actual annotation procedure works like this: An annotator is given the dialogue of an existing human-authored *Prom Week* instantiation, as well as the name of that instantiation's social exchange, its outcome, and its n preconditions, and is tasked with annotating for which of the instantiation's line(s):

[1] For a copy of our detailed annotation guidelines, please contact the first author.

- Communicate the identity of its social exchange
- Express the content of each of its preconditions
- Communicate its outcome

Additionally, the annotator must annotate all lines for:

- Their speech acts (of which a line can have multiple)
- The speech acts they strictly depend on, if any
- The preceding lines they strictly depend on, if any

After an instantiation has been fully annotated, we use a script to process the resulting SCHEHERAZADE encoding and add each of the instantiation's lines into a database. Figure 2 shows a line of dialogue with its mark-up, which for each line also includes pointers to the lines that precede and succeed the line in its native context. This database of annotated instantiations is then queried by our combinatorial authoring procedure, which builds recombinant instantiations by reasoning about individual lines of dialogue in terms of what is specified about them by their mark-up. We describe this procedure in the following section.

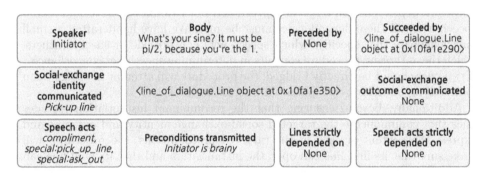

Fig. 3. A line of dialogue and its mark-up

3 Combinatorial Procedure

We generate recombinant instantiations by a combinatorial procedure that searches over the space of possible dialogue configurations, given a database of annotated lines of dialogue and a set of authoring constraints. These constraints—which comprise a targeted social exchange, exchange outcome, and set of preconditions—spell out what the recombinant exchange must *do* or *show*. Specifically, they govern the combinatorial procedure such that the recombinant instantiation must:

1. **Communicate the identity of the targeted social exchange.** Show that, e.g., a *Pick-up line* exchange is being enacted.
2. **Express the content of the targeted preconditions.** Show that, e.g., the initiator is brainy and that the responder and initiator used to date.

3. **Communicate the targeted social-exchange outcome.** Show that the responder, e.g., rejects the social exchange.

After first assembling all lines of dialogue in the database that serve to satisfy one or more of these constraints, our procedure constructs a directed search graph whose levels have nodes, respectively, for exchange-identity lines, precondition-expression lines, and exchange-outcome lines. The search then traverses this graph in a depth-first manner, incrementally building up a working instantiation as it does so. As the procedure visits a new node in the graph, it will attempt to bridge to the line of dialogue represented by that node from the final line of dialogue in the working instantiation.

For two lines to bridge, they must have *concordant* speech acts and all lines strictly depended on by the line being bridged to, if any, must already be included in the working instantiation. (Lines that are natively adjacent may be bridged together regardless of their speech acts or dependencies.) A speech act may have a backward-moving dependency, which specifies that only certain speech acts may precede it, or a forward-moving dependency, which specifies which speech acts can succeed it. Additionally, as explained above, some lines may have a strict backward dependence on a specific speech act. For two lines to have concordant speech acts, all these dependencies must be met. We have handcrafted a small knowledgebase that specifies which speech acts can precede or succeed others, which the authoring procedure consults in determining speech-act concordance.[2] If two lines cannot be directly bridged, the procedure will attempt to bridge them indirectly by searching over potential interstitial lines.

Additionally, beyond ensuring that the recombinant instantiation includes lines that communicate the targeted social-exchange identity and outcome and express the content of each of the targeted preconditions, the procedure will make sure that its first line can open the instantiation and that its final line can close it. Ideal opening and closing lines natively open and close instantiations. Otherwise, it is suitable for a line without a backward-dependent speech act to open an instantiation and for a line without a forward-dependent speech act to close one. If the working instantiation lacks these, the procedure will search for suitable opening and closing lines, as needed, and prepend or append them to the working instantiation.

We have found that with a database of at least a few dozen annotated instantiations, the combinatorial authoring procedure can be left to randomly decide its own constraints, i.e., the targeted social exchange, outcome, and preconditions for the instantiation it will author. By doing this, authorial burden is even further reduced. In the next section, we show example recombinant instantiations that were generated in this way and describe a human evaluation experiment in which we compared human-authored instantiations to recombinant instantiations generated with random constraints and also by ablating constraints.

[2] Due to length restrictions, we cannot present this knowledgebase here. Please contact the first author for its specification file.

4 Experiment

We annotated 73 instantiations that cumulatively had 428 lines of dialogue. Believing that it would facilitate recombination, we only annotated instantiations for social exchanges with a romantic bent: *Ask out*, *Pick-up line*, *Flirt*, and *Woo*. Upon proficiency, instantiations took approximately fifteen minutes to fully annotate, of which the bulk was spent assigning speech acts. Interannotator reliability was not measured, as it is not an issue in this task—an annotation of an instantiation is essentially a reading of it, and most instantiations have multiple valid readings.

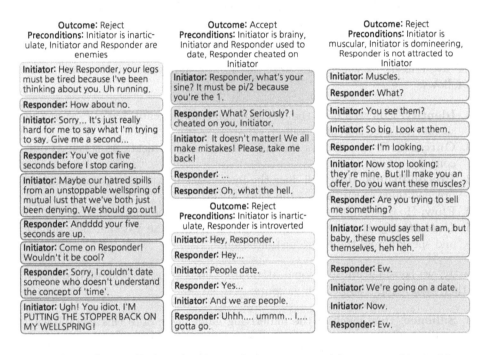

Fig. 4. Recombinant *Pick-up line* instantiations generated by our combinatorial authoring procedure. Within each instantiation, color indicates a line's native source.

Next, we wished to compare the quality of the recombinant instantiations generated by our combinatorial authoring procedure, examples of which are shown in Figure 4, to instantiations that were written by human authors. To this end, we set up a human evaluation task in which three individuals with no prior exposure to *Prom Week* were asked to rate 80 full instantiations on five criteria. The 80 instantiations were of the following types (which were not disclosed to the human raters):

– All 20 **human-authored** *Pick-up line* instantiations that currently exist in *Prom Week*.

- 20 **randomly constrained** recombinant *Pick-up line* instantiations. These were generated by allowing our combinatorial procedure to randomly select its targeted outcome and preconditions (assuming those constraints were not represented by an existing instantiation). These 20 were generated subsequently to one another without any human moderation. As such, these best represent the general performance of our method without human intervention on its input or output—i.e., with the least authorial burden.
- 20 **unconstrained** recombinant dialogue exchanges. These constituted dialogue exchanges of proper length that were generated without any specified constraints, but with speech-act concordance still enforced.
- 20 randomly **juxtaposed** dialogue exchanges. These constituted dialogue exchanges of proper length whose lines were randomly chosen without enforcing speech-act concordance.

The five criteria by which they were rated, on a four-point Likert scale[3], were as follows:

1. **Identity.** How well does the instantiation communicate that a *Pick-up line* social exchange is being enacted?
2. **Outcome.** How well does the instantiation communicate its specified outcome?
3. **Preconditions.** How well does the instantiation express what its targeted preconditions specify about the story world?
4. **Flow.** How well does the instantiation flow from line to line?
5. **Consistency.** How consistent are the characters in the way that they behave and speak across the entire instantiation?

Lastly, we consider an additional attribute whose value is computed directly, rather than being a subjective measure:

6. **Salience.** How much of the underlying game state does this instantiation express? *CiF* always enacts the most *salient* instantiation of the social exchange that the player selects. The more salient an instantiation is, the more preconditions it has. Because preconditions specify something about the story world, more salient instantiations have more specificity in terms of what they express about the state of the world. We determine salience by the number of preconditions an instantiation has.

Given these instantiation types and criteria, we make the following predictions:

- **H1.** Randomly constrained recombinant instantiations will not significantly differ from human-authored ones in their ratings for *identity*, *outcome*, and *preconditions*.

[3] 1—*Not at all well/consistent*, 2—*Not very well/consistent*, 3—*Somewhat well/consistent*, 4—*Very well/consistent*.

- **H2.** Unconstrained and juxtaposed instantiations will significantly differ in their ratings for *flow*. We predict this because only in the former is speech-act concordance enforced.
- **H3.** For *consistency*, randomly constrained recombinant instantiations will be rated significantly worse than human-authored ones and significantly better than unconstrained ones. We believe that targeted constraints work to partially enforce consistency, but that this is currently the biggest drop-off in quality from human-authored instantiations to recombinant ones.

5 Results and Discussion

Table 1 shows the results of our human evaluation task. We conducted paired *t*-tests for the comparisons in our hypotheses, and discuss these results in terms of each hypothesis.

Table 1. Mean ratings on our six criteria, as applicable, for each instantiation type

	Human-authored	Randomly constrained	Unconstrained	Juxtaposed
Identity	3.58	3.63	-	-
Outcome	3.7	3.2	-	-
Preconditions	3.55	3.2	-	-
Flow	3.77	3.05	2.03	1.65
Consistency	3.85	3.0	2.12	1.95
Salience	1.25	2.8	-	-

H1. We predicted that randomly constrained recombinant instantiations would not significantly differ from human-authored ones in their ratings for *identity*, *outcome*, and *preconditions*. This was true for *identity* ($t(59) = 0.37$, $p = 0.71$), but not for *outcome* ($t(59) = 3.09$, $p = 0.003$) or *preconditions* ($t(59) = 2.84$, $p = 0.006$). We account for the difference in *outcome* in the following way. Social-exchange-outcome lines often rely on context to effectively communicate outcome. For example, a responder line *Okay* clearly communicates an *accept* outcome if it follows an initiator line *Do you want to go out?*, but would communicate no outcome at all if elsewhere it were preceded by the line *Give me a minute*. By our current method, lines that are annotated as clearly communicating an outcome in their native contexts are considered by our combinatorial authoring procedure to inherently communicate that outcome, regardless of context. In light of this result, we intend for a future revision of our annotation scheme, likely in the guise of an authoring tool, to allow for richer specification of context dependence for exchange-outcome lines.

As for the difference in *preconditions*, the randomly constrained recombinant instantiations, compared to the human-authored instantiations, had more than twice as many preconditions on average. Intuitively, as an instantiation takes on more preconditions, the strength with which the total content of all its preconditions is expressed will decrease. The question then arises of whether this drop-off

in precondition-expression strength is worth the increase in salience. We believe that, barring an extreme drop-off, it is, because salience is tremendously important. Instantiations with greater salience better express the aspects of game state that caused the enacted social exchange to be available to the player in the first place and that determined the responder's decision of whether to accept or reject the exchange. Even if they are not expressing the total content of their preconditions quite as strongly, recombinant instantiations are doing so for *more than twice as many preconditions*, and so the strength with which they express game state is indisputably greater.

H2. Our prediction that unconstrained and juxtaposed instantiations would significantly differ in their ratings for *flow* was corroborated ($t(59) = 2.52$, $p = 0.015$). Only in the former type of instantiation was speech-act concordance enforced, and so we take this as evidence for the utility of such enforcement in maintaining line-to-line flow across lines from different native contexts that appear adjacently in recombinant dialogue exchanges.

Beyond the comparison in this hypothesis, we find that ratings for *flow* increased substantially from unconstrained to constrained recombinant instantiations, and then again between the latter and human-authored instantiations. As for the former increase, we suspect that, while speech-act concordance works as a bottom-up moderator of line flow, targeted constraints are effective as top-down flow moderators. They restrict the dialogue exchange to a purpose, prescribed by the exchange-identity line, and a trajectory, which approaches the exchange-outcome line, and these could reasonably be expected to govern line-to-line transitioning. As for the increase in *flow* from constrained recombinant instantiations to human-authored ones, it would appear that something is needed beyond speech-act concordance and targeted constraints. We have not yet given thorough investigation to this disparity.

H3. The results substantiate both of our predictions here: In terms of their ratings for *consistency*, randomly constrained recombinant instantiations are significantly worse than human-authored ones ($t(59) = 7.18$, $p < 0.0001$) and significantly better than unconstrained ones ($t(59) = 5.87$, $p < 0.0001$). As for the latter comparison, we contend that targeted constraints could reasonably be expected to maintain character consistency for the same reasons that we have given for how it could govern line flow. Again, we find that human-authored instantiations are rated much more highly on this criterion than are constrained recombinant instantiations. In this case, however, we expected as much.

While our combinatorial authoring procedure has a policy for maintaining line flow—speech-act concordance—it has no policy by which it can enforce that characters be consistent in the way they behave and speak across an instantiation. When our recombinant instantiations are authored badly, it is usually because the responder shows a volatile temperament that is not warranted by context or any specified aspect of the story world. Typically this manifests as the responder initially appearing extremely receptive, or extremely unreceptive, to an initiator's advances, before suddenly acting in the opposite way. We will address consistency maintenance in a future revision of our annotation scheme, but description of our planned policy for it is beyond the scope of this paper.

6 Conclusion

We have developed an annotation scheme and combinatorial authoring procedure by which a small base of annotated human-authored dialogue exchanges can be exploited to automatically generate manifold new recombinant exchanges. While our recombinant exchanges were generally not rated as highly as human-authored ones, they have more than double the salience, and thus better express game state. Further, we believe that the flaws that recombinant exchanges do show could easily be repaired by a human author in far less time than it would take to author an exchange from scratch. Indeed, we envision immediate practical use of combinatorial dialogue authoring in a collaborative authoring scheme in which, given a small database of annotated dialogue, the computer instantly generates full exchanges that the human author then polishes for any small nuances that are lost on the computer. This would represent an immediate and huge reduction in authorial burden relative to current authoring practice.

One criticism of our method may be that the time it takes to author and then annotate a dialogue exchange could have been spent authoring two exchanges. This is correct and would be valid except that an annotated dialogue exchange, given at least a handful of other annotated exchanges, yields many more than two recombinant instantiations (see Figure 1). We assert that authorial leverage, on a per-line-authored basis, is greatly increased by combinatorial dialogue authoring, and we plan to test this claim in subsequent work.

The method we present here has been demonstrated using dialogue that was written for a specific game built using a specific AI system, but it can be of immediate practical use to any system that uses dialogue to express underlying state. Systems for which dialogue exchanges have a directed purpose and specify a resulting change to system state, as with the social exchange and its outcome in *CiF* games, would prove especially fertile for our implementation of combinatorial dialogue authoring.

As an immediate next step in this work, we have begun to develop an authoring tool for recombinable dialogue, in which dialogue mark-up is specified *as the dialogue is written*. In this paper, we have demonstrated the promise of combinatorial dialogue authoring as a technique that alleviates authorial burden, but we have done this using dialogue that was not written with a mind toward recombinability. We look forward to investigating how authors might write dialogue differently when recombination is already intended *at the time of writing*, as this may better illuminate the true potential of combinatorial dialogue authoring.

Acknowledgments. This research was supported by NSF CreativeIT Program Grant IIS-1002921.

References

1. Artstein, R., Gandhe, S., Rushforth, M., Traum, D.R.: Viability of a Simple Dialogue Act Scheme for a Tactical Questioning Dialogue System. In: Proceedings of the 13th Workshop on the Semantics and Pragmatics of Dialogue, pp. 43–50 (2009)
2. Carpenter, R.: Cleverbot (2011), http://www.cleverbot.com/

3. Crawford, C.: Deikto: An Application of the Weak Sapir-Whorf Hypothesis. In: Proceedings of the Hypertext 2008 Workshop on Creating Out of the Machine: Hypertext, Hypermedia, and Web Artists Explore the Craft (2008)
4. Electronic Arts.: The Sims 3 (2009)
5. Elson, D.K., McKeown, K.R.: A Platform for Symbolically Encoding Human Narratives. In: Proceedings of the AAAI Fall Symposium on Intelligent Narrative Technologies (2007)
6. Evans, R., Short, E.: Versu—A Simulationist Storytelling System. IEEE Transactions on Computational Intelligence and AI in Games (2014)
7. Gaffney, C., Dagger, D., Wade, V.: Supporting Personalised Simulations: A Pedagogic Support Framework for Modelling and Composing Adaptive Dialectic Simulations. In: Proceedings of the 2007 Summer Computer Simulation Conference, pp. 1175–1182 (2007)
8. Jurafsky, D., Shriberg, E., Biasca, D.: Switchboard SWBD-DAMSL Shallow-Discourse-Function Annotation Coders Manual. In: Institute of Cognitive Science Technical Report, pp. 97–102 (1997)
9. Mateas, M.: The Authoring Bottleneck in Creating AI-Based Interactive Stories. In: Proceedings of the AAAI Fall Symposium on Intelligent Narrative Technologies (2007)
10. Mateas, M., Stern, A.: Façade: An Experiment in Building a fully-Realized Interactive Drama. In: Proceedings of the Game Developers Conference, Game Design Track (2003)
11. McCoy, J., Treanor, M., Samuel, B., Wardrip-Fruin, N., Mateas, M.: Comme il Faut: A System for Authoring Playable Social Models. In: Proceedings of the Seventh Artificial Intelligence for Interactive Digital Entertainment Conference (2011b)
12. McGreal, R.: Learning Objects: A Practical Definition. International Journal of Instructional Technology and Distance Learning (2004)
13. Rishes, E., Lukin, S.M., Elson, D.K., Walker, M.A.: Generating Different Story Tellings from Semantic Representations of Narrative. In: Koenitz, H., Sezen, T.I., Ferri, G., Haahr, M., Sezen, D., Ç atak, G. (eds.) ICIDS 2013. LNCS, vol. 8230, pp. 192–204. Springer, Heidelberg (2013)
14. Ryan, J.O., Walker, M.A., Wardrip-Fruin, N.: Toward Recombinant Dialogue in Interactive Narrative. In: Proceedings of 7th Workshop on Intelligent Narrative Technologies (2014)
15. Shibata, M., Nishiguchi, T., Tomiura, Y.: Dialog System for Open-Ended Conversation Using Web Documents. In: Informatica (2009)
16. Short, E., Evans, R.: Versu: Conversation Implementation (2013), http://emshort.wordpress.com/2013/02/26/versu-conversation-implementation/
17. Swanson, R., Gordon, A.S.: Say Anything: A Massively Collaborative Open Domain Story Writing Companion. In: Spierling, U., Szilas, N. (eds.) ICIDS 2008. LNCS, vol. 5334, pp. 32–40. Springer, Heidelberg (2008)
18. Walker, M.A., Grant, R., Sawyer, J., Lin, G.I., Wardrip-Fruin, N., Buell, M.: Perceived or Not Perceived: Film Character Models for Expressive NLG. In: André, E. (ed.) ICIDS 2011. LNCS, vol. 7069, pp. 109–121. Springer, Heidelberg (2011)
19. Wardrip-Fruin, N.: Expressive Processing: Digital Fictions, Computer Games, and Software Studies. MIT Press (2009)

Diegetization: An Approach for Narrative Scaffolding in Open-World Simulations for Training

Kevin Carpentier and Domitile Lourdeaux

Heudiasyc - UMR CNRS 7253,
Université de Technologie de Compiègne, 60200 Compiègne, France
{kevin.carpentier,domitile.lourdeaux}@hds.utc.fr
http://www.hds.utc.fr

Abstract. The use of storytelling for learning is widely approved and encouraged. Yet, in virtual environments for training, there are difficulties to build a story when there is no global control over the course of events. We present in this paper an approach called diegetization. Supported by structuralist narrative theories, this approach aims to dynamically match a sequence of events with sequence of narrative patterns. The pedagogical prescriptions are then extended to consolidate the recognized narrative sequences. The process uses semantic models to benefit from pattern matching algorithm and deep inferences. The proposition was implemented in the HUMANS platform and applied to a scenario for training in high-risk activities.

Keywords: virtual training, interactive storytelling, constraint satisfaction problem, structuralism, semiotic, semantic representation.

1 Introduction

1.1 Context

This paper describes an approach for framing a sequence of events in a virtual simulation to comply with narrative constraints. We focus our studies on virtual environments for training (VET) and especially on open-world simulations. Open-world simulations offers a high freedom of action to enable situated learning. In order to mimic real work situations, such simulations are populated with autonomous characters upon which no direct control can be enforced. Such a design permits the emergence of unexpected scenarios without authoring effort. Pedagogical control is added by taking into account expert knowledge from trainers or by joining an Intelligent Tutoring System (ITS) to the VET. Trainers and ITS can monitor the simulation by dynamically prescribing relevant learning situations. Then, a scenario manager is responsible for guiding the simulation toward the prescribed situations. This architecture enables the generation of a highly personalized pedagogical scenario which is experienced by the user in the simulation. Yet, trainers are not storytelling experts and an ITS does not

A. Mitchell et al. (Eds.): ICIDS 2014, LNCS 8832, pp. 25–36, 2014.
© Springer International Publishing Switzerland 2014

always consider narrative aspects. Without narrative control, pedagogical scenarios lack story continuity and tension management. Our purpose is to ensure that events taking place in the simulation, occurring autonomously or resulting from a prescription, tell an appealing story. A first difficulty lies in recognizing attractive plot lines in a sequence of event. Another difficulty is to add narrative aspects to trainer's prescriptions without prejudice to the pedagogical intent. In order to achieve this, we propose to consider the problem as a constraint satisfaction problem. The originality lies in the semantic representation of narrative constraints to allow easy authorship and deep reasoning.

To illustrate our work, we propose here a simple example of training of operators on hazardous-matter loading. A trainer prescribes a pedagogical situation where the learner would have to handle a hazardous-matter leak on a tank. Such an incident usually results from human neglect. Therefore, the prescription involves a responsible and a leaking valve. The prescription could be instantiated by picking any character and any tank in the virtual environment. However, by selecting these entities according to narrative rules, we can create continuity upon the sequence of events. A storyworld is gradually scaffolding each time a prescription is enriched with narrative content.

We named this approach *"diegetization"* in reference to the authoring process of building the *diegesis* [1]. The diegesis is the universe in which the story take place. In the next section of this paper, motivations for the choice of a narrative construction are presented. Then, a brief review of related works is presented. The process of diegetization and its application are described in section 3 and 4. The last section concludes this paper with discussions and perspectives.

1.2 Narrative for Learning

A first argument for the use of narrative in learning context is quite pragmatic. Indeed, as narrative is a natural expressive form [2], it can be presented through different modalities. It can be told through text or speech, shown through pictures or, as in this case, experienced through an interactive simulation. Moreover, narrative is a support for *cognitive activities*. Through narrative, learners are engaged in active thinking and are supported in their process of meaning construction [3]. This helps learners to organize knowledge and to develop cognitive abilities [4]. Narrative can also be instrumented to build *motivation*. Motivation is most significant to ease learning processes in pedagogical activities [5] in many ways. First, a storyline can arouse learners' *curiosity*. By taking into account their behaviours, an interactive narrative reinforces the learners' feeling of *control* in the simulation. Moreover, a storyworld is where *fantasy* can take place: learners can identified themselves with characters depicted through the story. Finally, narrative also provides *interpersonal motivation* through *cooperation* and *competition* between the user and the other characters depicted in the storyline. Besides, a strong motivation comes from *recognition*: it happens when the learners are rewarded for their good behaviours.

As storytelling proves to be particularly efficient for learning and training, we aim to add a narrative layer upon the pedagogical prescription over the scenario.

The definition of a *quality criteria* of a narrative is therefore fundamental to assess the quality of the content generated by the system. An engine for building narrative has to offer *variability*, thus same kind of situations can be told through different stories. It also has to be *resilient* to cope with whatever actions the autonomous characters or users may perform against the storyline. However, the production of a VET is a very time-consuming task. The addition of narrative to a VET should be easy and should require a minimal amount of authoring. The work presented in this paper try to tackle the issue of balancing *quality* and *resilience* without compromising *variability* and *minimal handmade authoring*.

2 Related Work

First attempts of story generation make the narrative emerges from the mechanical execution of world rules [6, 7, 8]. [9] argues that such systems, qualified as **world-simulation based story generation** lack the creative process of the author. She proposed an **author-intent-based** process: the author build a story around a sequence of events, therefore he/she is able to add/modify/remove characters, locations or plot points in order to create richer stories. [10] pushed this notion further and proposed an engine that simulates an author's behaviour in a two-phased generation process: an *engagment* stage to explore every possibilities and a *reflection* stage to ensure coherency. We think a similar approach can be adapted to our dynamic context to foster the story quality.

Recent works on story generation are usually pinned on a spectrum ranging from *strong story approaches* to *strong autonomy approaches* depending on the amount of global control [11]. In strong autonomy approaches [12], virtual characters act independently without any coordination. Yet, the story emerges from the individual decisions of the virtual characters. However, the lack of co-ordination between characters infringes the global quality of stories. In [13, 14], a central agent controls the simulation to ensure that the unfolding of events follows a specific path. Thanks to this control, it is possible to generate stories of high quality. Yet, as virtual characters are being supervised their behaviours might seem incoherent. To tackle this issues, some works attempt to balance global control with autonomous behaviours. In [15], the world is populated by *semi-autonomous characters*: they act freely until the *Automated Story Director* gives them an order. Even if the transition between the autonomous stage and the controlled stage is subtle, the switch in the personality might seem incoherent to the user. FACADE [16] also relies on a hybrid approach: virtual characters act autonomously to satisfy a goal proposed at a higher level by a drama manager which handle the coherency. Unfortunately, this kind of approach requires a huge amount of authoring.

Whatever approach is used, an interactive storytelling system embeds preferences about narrative aspects. Such preferences can either be *explicit* or *implicit*. Explicit preferences are specific plot points which are preferred over other because they are mandatory for the story continuity or because they induce a particular tension effect [17]. Implicit preferences allow a more subtle control

by putting constraints on properties of the scenario. For instance, in IDTENSION [18], characters' actions are selected to maximise narrative criterion such as the *cognitive load* or the level of *conflict*.

The work presented in this paper is another attempt to balance strong story approach with emergent behaviours. The simulation in which the scenario take place is executed through a character-based approach: the VET is populated by autonomous characters upon which no control is possible. However, they were designed to reproduce human behaviours, they do not comply to narrative constraints. Therefore, global supervision is necessary to manage tension, to assure narrative continuity and to provide an appealing story.

3 Approach

3.1 Narrative Theory

[19] defines a narrative as the *recounting of a sequence of events that have a continuant subject and constitute a whole*. This definition constitutes a lower bound to what has to be achieved: the events taking place in the simulation must have a continuant subject and be holistically understandable. Since classical era, the minimal steps of a story have been canonized. Grammatical views of narrative were proposed to analyse existing texts [20, 21]. They were used more recently to generate narrative [22]. A purely grammatical approach is too restrictive and would hardly fit the resilience objective. Yet, [23] suggested the concept of *grammaticality* which rests upon three principles:

1. A narrative is better than another one if it is more compliant to a grammar than the other one.
2. Narrative structures must respect grammar ordering.
3. High-level constraints are more important than low-level constraints.

These considerations focus on the sequence of a narrative but struggle to depict the structure of one element of the sequence. Building his theory upon Greimas' actancial model [24, 25] proposed a more abstract model consisting of the following elements:

- **Functions** are relevant actions in regard of the story progression- *Example: Saving the World*
- **Roles** are functions grouped together - *Example: The Savior*
- **Actants** are abstract entities entitled with one or many roles - *Example : The Protagonist*
- **Actors** are concrete instances of actants - *Example: Eric*

This structuralist approach offers a framework to describe abstract story organizations. Therefore, it can be used to model stereotypical narrative structures such as the dramatic situations listed by [26] or [27].

These thoughts from various semioticians have guided the design of the **diegetization** process. First, we design a model, inspired by Bremond's grammar,

to inform abstract narrative patterns. Graph matching algorithms recognize these narrative sequences in the unfolding of events. Then, techniques for constraint satisfaction problems are used to select and instantiate patterns fulfilling the provided pedagogical goal. A quality criteria assess the best pattern among the possibilities. This process illustrated in figure 1 is explained in following sections.

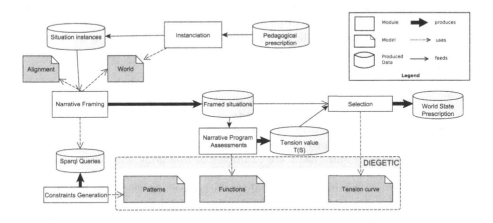

Fig. 1. Schematic view of the diegetization process

3.2 Models

The diegetization process requires to reason about two kinds of knowledge: knowledge about **the world** depicted by the simulation and knowledge about **narrative patterns**. For the sake of modularity, these two kinds of knowledge are informed in two different models. Consequently, the model of narrative patterns can be used with different models of the world which makes the approach fully domain-independent. For both models, the use of semantic representation allow for rich inferences about object capabilities and their evolution. The WORLD model and the DIEGETIC model are ontologies written in OWL/RDF language. Therefore, they benefits from OWL semantic inferences and can easily be queried using SPARQL for graph pattern matching.

WORLD Model. The WORLD model describes the world simulated by the virtual environment. It especially informs knowledge about the agents that populate the virtual world, the objects with which the user can interact and possible actions he/she can trigger. The WORLD model is written by experts of the domain of application and do not consider any narrative aspects. It is fully domain-dependent.

DIEGETIC Model. The DIEGETIC model is directly inspired by Bremond's grammar. It describes high-level entities to enable the specification of narrative structures:

- `Element` described meaningful entities within a narrative context. There are two types:
 - `Role`: a set of capabilities -*Example : `The Traitor`*
 - `Actant`: an aggregation of `Role` - *Example : `Antagonist`*

 Elements can either be impersonated by characters, concrete objects (items, locations, etc.) or abstract objects (life, love, etc.).
- `Function`: a relationship linking an `Element` to another one or to a primitive type (boolean, float, string, etc.). They can be involved in two kind of expressions:
 - `Constraints` are nomological constraints describing the state in which an `Element` should be to make a narrative structure possible - *Example: `(?x is-a :Antagonist)(?x :has-ally ?y)`*
 - `Properties` are relationships checked by a narrative structure - *Example: `(?x is-a :Treator)(?y is-a :Protagonist)(?x :harm ?y)`.*

 `:is-a`,`:has-ally` and `:harm` are examples of functions. Functions are associated with :
 - an *intrinsic-significance* (IS) value which measures the importance of the object for the subject of the relation on a zero to one scale. *Example: the `:has-ally` function has an IS 0.7. It means that the modification or the removal of the function between `?x` and `?y` is quite important for `?x`.*
 - an *extrinsic-significance* (ES) value which describes the importance of the function in a narrative structure. *Example: the `:harm` function has an ES value of 0.95. It means this function is fundamental for the pattern in which it is expressed to be meaningful.*
- `Pattern` is a specific set of `functions` between `roles`, it is also referred as *narrative structure*.
- `Path` describes the preferable transition between two `Patterns` - *Example : `Treason -> Remorse`.*

The DIEGETIC model is **fully domain-independent** and is used to describe any narrative pattern. It can be filled by storytelling experts, yet, we plan to write a canonical library of narrative patterns inspired by Polti's dramatic situations [26]. A sequence of narrative pattern written in the DIEGETIC representation is shown in figure 2.

3.3 Instantiation

Periodically, the pedagogical module produces a pedagogical prescription. It depicts a world state which should be encountered by the learner. Situations are formalized through rdf graphs consisting in fragments of a WORLD model. Such fragment generally includes both conceptual descriptions such as (`?anyvalve :has-state :leaking`) as much as instantiated descriptions such as (`:Valve01 :has-state :leaking`). Graphs including abstract concepts need to be instantiated by referring to the up-to-date world state. A graph can be instantiated in various ways (figure 3).

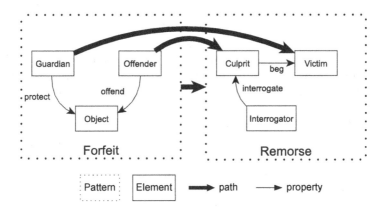

Fig. 2. A sequence of narrative patterns in the DIEGETIC model

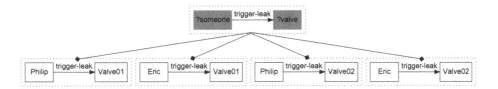

Fig. 3. Instantiation

3.4 Narrative Framing

For each instantiated situation, a *possible world* is created by assuming that the situation is true in the current world state. The narrative framing process searches *possible world* to recognize narrative patterns which are consistent with the storyline. This is a three-stage process: alignment, exploration and consistency-checking.

Alignment. The world state, which is fully domain-dependent, must be translated in terms of generic diegetical *functions* e.g. either *properties* or *constraints*. As both models are expressed through ontological representations, we use alignment rules to infer existing diegetical *functions* in the current world state. These rules are common-sense knowledge and can be written by pedagogical experts. For instance, a simple rule infers that characters involved in cooperative work (WORLD model) are mutual allies (DIEGETIC model).

Exploration. SPARQL queries are generated from the description of the *patterns* in terms of *functions*. Each possible world, describing an alternate world state, is interrogated by these queries. The results from these queries feature all possible instantiations of the pedagogical prescription fitting into a narrative structure. Queries are generated so that their results provide a mechanism

similar to **late commitment**[12]: a *pattern* frames a situation if it finds no contradictions. A framed situation involves the entities of the initial prescription. Beside, it also involves other entities needed to fill all the *elements* in the *pattern*. A framed situation is formalized through a graph S whose nodes are *elements* and whose arcs are *functions*. At this stage, each possibility is explored regardless of the coherence between the pattern and past events.

Coherency-Checking. This stage aims to assure **coherency** of the whole story taking place since the beginning of the simulation. It checks the existence of a *path* between current situations and previous ones. Inconsistent situations are dismissed. In the case where no situations survive this stage, trade-off are performed: constraints are relaxed by deleting less-valued *properties* and a new cycle of exploration/consistency-checking is performed. The coherency-checking stage ensures that the narrative elements remain consistent. For instance, an ally will remain an ally throughout the plot line unless a pattern of treason make it otherwise.

3.5 Narrative Program Assessment

[24] proposed a formal description of the evolution of the entities in a story through *narrative program*. A narrative program is the gain or the loss of a function R between a subject S_2 and an object O when it is considered by an observer S_1. In other words, a narrative program describes a shift in the relationship between S_2 and O as perceived by S_1. S_1, S_2 and O can be assimilated to diegetical *elements* (objects, characters, places, etc.).

We proposed to use narrative program to measure the evolution of dramatic tension during the sequence of events. The narrative program assessment computes the value of the tension generated between two simulation steps by using the intrinsic and extrinsic significance defined in section 3.2. An instrinsic value between S_1 and S_2, noted $I(S_1, S_2)$, is the maximum of the products of the intrinsic-significance of the function in all the possible paths between S_1 and S_2. $E(R)$ is the extrinsic-significance of the function R. $T(S_1)$ is the tension for the subject $S1$. Its value is the sum of all narrative programs (NP) in which it is involved :

$$T(S_1) = \sum_{(s,r,o) \in NP(S_1)} I(S_1, s) * (1 + I(S1, o)) * E(r) . \tag{1}$$

We propose to use the value $T(User)$ where $User$ is the entity representing the user in the knowledge base in order to monitor the dramatic tension he/she perceives.

3.6 Decision Using a Quality Criteria

Each framed situation S is evaluated according to three criterion:

- $O(\mathcal{S}) \in [0,1]$ is a measure of adequacy between opening needs and opening opportunities. The **opening** measures the number of narrative path that can follow the current step. In the beginning of the simulation, the opening needs are high to maximise the possibilities of diegetization. Such constraints can be relaxed when the session reaches its end.
- $T(\mathcal{S}) \in [0,1]$ is the ratio between the estimated tension of S and the expected value of tension according to a pre-defined curve.
- $G(\mathcal{S}) \in [0,1]$ is an evaluation of the **grammaticality** of a framed situation. It takes into account the trade-off made on the constraints during the **exploration/consistency-checking** cycle.

The narrative utility of \mathcal{S} according to the current step of simulation is $U(\mathcal{S}) = O(\mathcal{S}) + T(\mathcal{S}) + G(\mathcal{S})$. The situation \mathcal{S} with the highest $U(\mathcal{S})$ is selected to be the **world state prescription**.

4 Results

4.1 Implementation

We implemented the diegetization approach in Java using the JENA Framework [28]. It communicates as an agent in the multi-agent system of the HUMANS platform [29].

The DIRECTOR module introduced by [30] is used to lead seamlessly the simulation toward the **world state prescriptions**. At the moment, the story is only represented by mimetic means. The user experienced the story through the actions of the characters and through the different event taking place. Further research will consider possibilities to foster narrative understanding such as dialog generation and extra-diegetic indication. At the moment, a selection among the thirty-six Polti's dramatic situations [26] have been informed as *pattern* in the DIEGETIC model.

4.2 Application

The approach have been applied on a very delimited use-case: virtual training for loading hazardous-matter in oil depot. We design a WORLD model with the help of domain expert for this application. It includes four characters. Bob is the user's avatar. Philip is one of Bob's co-workers. Eric works in a different team. Paul is their supervisor. Philip, Eric and Paul are controlled by autonomous characters. Workers have to perform hazardous-matter loading on a tank through valves. Leaks can occur due to carelessness in the procedure.

For the sake of the demonstration we only present three steps in the simulation with two different tension curves (figure 4). The first condition involves a classical aristotelian tension arc, in which the climax, occurring at the second step has a medium tension value. In the second condition, the climax has a high tension value and is followed by a step with a medium tension value.

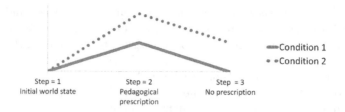

Fig. 4. Curve of tension for condition 1 and 2

In both conditions, a first diegetization procedure is run after the pedagogical module from the HUMANS platform [31] has issued a prescription : (?someone :trigger-leak ?valve). A new diegetization procedure without specific pedagogical goal is issued after the resolution of the previous situation. Partial results of the execution are presented in figure 5.

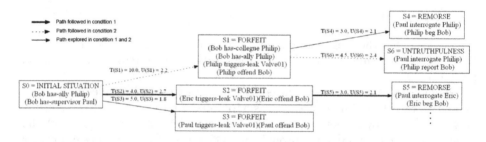

Fig. 5. Results of the diegetization process in condition 1 and 2

In the first step, the prescription issued by the pedagogical module is instantiated for each characters. In particular these situations can be framed by $S1, S2$ and $S3$ (other possibilities were not presented in the figure). In the condition 1, $S2$ is preferred to $S1$ according to the tension adequacy criteria. $S3$ is dismissed in both condition because it lacks opening opportunities.

In both $S1$ and $S2$ Bob is offended by another worker. In $S1$, Bob is offended by someone who is his ally. The intrinsec-significance of offend and has-ally are taken into account to compute $T(Bob)$ in the narrative program assessment. $S1$ is more tense than $S2$. It is explained by the fact that it is harder to be offended by someone you are supposed to rely on. Thanks to quality evaluation, $S1$ fits with the first tension curve whereas $S2$ fits with the second tension curve. $S1$ is followed by $S4$ and $S6$. The extrinsec-significance of beg is quite high. Therefore, to comply with the expected tension in condition 1, $S6$ is preferred over $S4$. In the first step, a role is given to elements of the simulation (characters in this case). It is gradually strengthened and enriched throughout the scenario to scaffold the story universe in accordance with a predefined tension curve.

5 Conclusion

Our work on pedagogical orchestration of training simulation leads us to consider using narrative as a motivational factor. Yet, the simulation taking place in an open-world, the control possibilities are quite seldom. To tackle this difficulty, we proposed the process of diegetization which relies on the recognition and on the scaffolding of narrative structure. Our propositions were implemented in the HUMANS platform and tested on a small use-case. Results are in agreement with the objectives. In the short term, we will apply the proposition to a real use-case in training for risk prevention. Experiments on the perception and the opinion of the generated storylines by the user will be conducted. Thanks to this study, we will be able to consider the best possibilities to foster story understanding without breaking the feeling of immersion of the user.

Acknowledgements. This work was made possible thanks to the funding of ANR project: NIKITA (Natural Interaction, Knowledge and Immersive systems for Training in Aeronautic).

References

1. Odin, R.: De la fiction. De Boeck Suprieur (September 2000)
2. Bruner, J.S.: Acts of meaning. Harvard University Press (1990)
3. Dettori, G., Paiva, A.: Narrative learning in technology-enhanced environments. In: Balacheff, D.N., Ludvigsen, D.S., Jong, D.T.d., Lazonder, D.A., Barnes, D.S. (eds.) Technology-Enhanced Learning, pp. 55–69. Springer Netherlands (2009)
4. Schank, R.C.: Tell me a story: Narrative and intelligence. Northwestern University Press (1995)
5. Malone, T.W., Lepper, M.R.: Making learning fun: A taxonomy of intrinsic motivations for learning. Aptitude Learning and Instruction 3(3), 223–253 (1987)
6. Klein, S., Aeschlimann, J.F., Balsiger, D.F.: Automatic novel writing: A status report. Wisconsin University (1973)
7. Meehan, J.R.: TALE-SPIN, an interactive program that writes stories. IJCAI, 91–98 (1977)
8. Bringsjord, S., Ferrucci, D.: Artificial intelligence and literary creativity: Inside the mind of brutus, a storytelling machine. Psychology Press (1999)
9. Dehn, N.: Story generation after TALE-SPIN. In: IJCAI, pp. 16–81. Citeseer (1981)
10. Prez, R.P., Sharples, M.: MEXICA: A computer model of a cognitive account of creative writing. Journal of Experimental & Theoretical Artificial Intelligence 13(2), 119–139 (2001)
11. Mateas, M., Stern, A.: Towards integrating plot and character for interactive drama. In: Working notes of the Social Intelligent Agents: The Human in the Loop Symposium, AAAI Fall Symposium Series, Menlo Park, pp. 113–118 (2000)
12. Swartjes, I., Kruizinga, E., Theune, M.: Let's pretend I had a sword. In: Spierling, U., Szilas, N. (eds.) ICIDS 2008. LNCS, vol. 5334, pp. 264–267. Springer, Heidelberg (2008)
13. Mott, B.W., Lester, J.C.: U-director: a decision-theoretic narrative planning architecture for storytelling environments. In: Proceedings of the Fifth International Joint Conference on Autonomous Agents and Multiagent Systems, AAMAS 2006, pp. 977–984. ACM, New York (2006)

14. Young, R.M., Riedl, M.O., Branly, M., Jhala, A., Martin, R.J., Saretto, C.J.: An architecture for integrating plan-based behavior generation with interactive game environments. Journal of Game Development 1(1), 51–70 (2004)
15. Riedl, M.O., Stern, A., Dini, D., Alderman, J.: Dynamic experience management in virtual worlds for entertainment, education, and training. International Transactions on Systems Science and Applications, Special Issue on Agent Based Systems for Human Learning 4(2), 23–42 (2008)
16. Mateas, M., Stern, A.: Façade: An experiment in building a fully-realized interactive drama. In: Game Developers Conference (GDC 2003) (2003)
17. Porteous, J., Cavazza, M., Charles, F.: Applying planning to interactive storytelling: Narrative control using state constraints. ACM Transactions on Intelligent Systems and Technology (TIST) 1(2), 10 (2010)
18. Szilas, N.: A computational model of an intelligent narrator for interactive narratives. Applied Artificial Intelligence 21(8), 753–801 (2007)
19. Prince, G.: A dictionary of narratology. U. of Nebraska Press (2003)
20. Propp, V.I.: Morphology of the Folktale. University of Texas Press (June 1968)
21. Todorov, T.: La grammaire du récit. Langages, 94–102 (1968)
22. Peinado, F., Gervs, P.: Evaluation of automatic generation of basic stories. New Generation Computing 24(3), 289–302 (2006)
23. Beck, U.: La linguistique historique et son ouverture vers la typologie. Editions L'Harmattan (1976)
24. Greimas, A.J.: Sémantique structurale: recherche et méthode. Larousse edn. (1966)
25. Bremond, C.: Logique du récit. ditions du Seuil (1973)
26. Polti, G.: Les 36 situations dramatiques. DV "Mercure de France" (1895)
27. Souriau, T.: Les deux cent mille Situations dramatiques. Flammarion (1950)
28. Apache Jena, https://jena.apache.org
29. Lanquepin, V., Lourdeaux, D., Barot, C., Carpentier, K., Lhommet, M., Amokrane, K.: HUMANS: a HUman models based artificial eNvironments software platform. In: Proceedings of the Virtual Reality International Conference (VRIC 2013), Laval, France (2013)
30. Barot, C., Lourdeaux, D., Lenne, D.: Dynamic scenario adaptation balancing control, coherence and emergence. In: Proceedings of ICAART 2013: International Conference on Agents and Artificial Intelligence, Barcelona, Spain, vol. 2, pp. 232–237 (2013)
31. Carpentier, K., Lourdeaux, D., Mouttapa-Thouvenin, I.: Dynamic selection of learning situations in virtual environment. In: Proceedings of ICAART 2013: International Conference on Agents and Artificial Intelligence, Barcelona, Spain, vol. 2, pp. 101–110 (2013)

Authoring Personalized Interactive Museum Stories

Maria Vayanou[1], Akrivi Katifori[1], Manos Karvounis[1], Vassilis Kourtis[1],
Marialena Kyriakidi[1], Maria Roussou[1], Manolis Tsangaris[1], Yannis Ioannidis[1],
Olivier Balet[2], Thibaut Prados[2], Jens Keil[3], Timo Engelke[3], and Laia Pujol[4]

[1] Department of Informatics and Telecommunications,
University of Athens, Athens, Greece
{vayanou,vivi,manosk,vkourtis,marilou,mroussou,
mmt,yannis}@di.uoa.gr
[2] DIGINEXT, Toulouse, France
{olivier.balet,thibaut.prados}@diginext.fr
[3] Department for Virtual and Augmented Reality, Fraunhofer, IGD, Darmstadt, Germany
{jens.keil,timo.engelke}@igd.fraunhofer.de
[4] Department of Humanities, Pompeu Fabra University, Barcelona, Spain
pujol.laia@gmail.com

Abstract. CHESS is a research prototype system aimed at enriching museum visits through personalized interactive storytelling. Aspiring to replace traditional exhibit-centric descriptions by story-centric cohesive narrations with carefully-designed references to the exhibits, CHESS follows a plot-based approach, where the story authors create stories around pre-selected museum themes. In this paper we place the CHESS system within the Interactive Digital Narrative field, describing the main objectives and requirements addressed. We present the system's architecture and outline its overall functionality. We describe the underlying storytelling model using examples from the stories authored using the CHESS Authoring Tool. Finally, we report key results focusing on the authors' perspective for the creation of personalized stories.

Keywords: Interactive digital storytelling, personalization, authoring tools

1 Introduction

The CHESS System is a research prototype that has been developed in the context of the CHESS (Cultural Heritage Experiences through Socio-personal interactions and Storytelling) project[1]. It aims to enrich museum visits through personalized interactive *storytelling,* by (re-)injecting the sense of discovery and wonder in the visitors' experience. It uses personalized information to create customized stories that guide visitors through a museum and employs mixed reality and pervasive games techniques, ranging from narrations to Augmented Reality (AR) on mobile devices [1,2].

CHESS targets two "types" of users; visitors, who "consume" CHESS stories through their devices, and story authors, who design the experiences. Aspiring to

[1] http://www.chessexperience.eu/

A. Mitchell et al. (Eds.): ICIDS 2014, LNCS 8832, pp. 37–48, 2014.

replace the traditional set of exhibit-centric descriptions by story-centric cohesive narrations with carefully-designed references to the exhibits, CHESS follows a plot-based approach, where the story authors (curators, museum staff and exhibition designers) write and produce stories around pre-selected museum themes. Two cultural institutions have participated in CHESS: the Acropolis Museum, devoted to the findings at the archaeological site of the Acropolis of Athens, Greece, and the Cité de l' Espace in Toulouse, France, a science centre about space and its conquest.

Similarly to the making of a movie, our approach to interactive story creation includes four main phases, namely scripting, staging, producing and editing. During scripting, the author chooses the main concepts and intervening elements, sketches the plot, and writes the narrative text. In staging, the author associates parts of the script with exhibits, paths and other spots in the physical museum space. Then, a set of multimedia resources is produced for the staged script, including audio-visual material, interactive images, games, quizzes, augmented reality models, and other illustrative applications. Finally, the author edits, selects, and orders the multimedia digital resources to implement the final script into a storytelling experience.

The CHESS experience is a unique non-linear combination of the story presented through the terminal on the mobile device used, the visitor's actions, the exhibits in the cultural heritage site, as well as the surrounding environment itself. When the visitor experiences the story on-site, she is subjected to five interlinked "experience modes": (a) walking from exhibit to exhibit, (b) observing an exhibit, (c) listening to narrations from the terminal, (d) interacting with the terminal to make choices, and (e) using the terminal in interactive activities such as games or AR. Obviously, the design of such experiences requires careful orchestration of different resources.

CHESS provides story authors with the CHESS Authoring Tool (CAT), a powerful authoring tool that enables the design and implementation of interactive stories for the CHESS system. CAT is based on a rich storytelling data model which uses graph-based representations to denote the story structure, along with structured meta-data to semantically describe the graph entities. During the visit, the story graphs authored are traversed by the Adaptive Storytelling Engine (ASTE), which uses visitor and contextual data to appropriately adapt the visitor's experience [3, 4].

In this paper we first place the CHESS system within the IDN field, describing the main objectives and requirements addressed. Next we provide an overview of the system architecture and workflow. We present the underlying storytelling model using examples from digital stories authored for the two cultural heritage sites using CAT, also explaining how these are utilized by the CHESS components during a visit. Finally, we report key experience and evaluation results, focusing on the authors' perspective for the creation of personalized stories.

2 Background and Related Work

To place the CHESS system within the IDN field, we first clarify its main underlying priorities and assumptions. The CHESS project integrates multidisciplinary research results and tools into a system capable of supporting cultural heritage institutions in the creation of personalized interactive digital stories for their public. Thus, simplicity and ease-of-use for non-programmers are critical priorities for CAT, the primary

environment for the crafting of stories. On the other hand, the main objective for museums is to convey accurate information about their collections to different kinds of visitors in a more accessible, meaningful and engaging way [7]. Thus, special emphasis is given to the script that communicates the cultural content and to the capacity to carefully review the knowledge conveyed through the various instantiations of the interactive digital story.

To address these needs, CHESS adopts a branching narrative structure for script modeling and representation. A similar structure is utilized to represent the editing level, where the authors specify the digital resources that will be used to manifest each part of the script. Unlike Storyspace [8], Rencontre [9] and other hyper-fiction approaches, CHESS enables story authors to define a procedural script flow and specify soft or hard constraints over the branches, depending on a variety of factors, such as visitor choices, past actions, visitor features, location, etc. Similarly to the ASAPS system [10,11] CHESS models the state of the experience through global variables, moving from simple branching systems towards a finite state machine. In CAT the script diagram is complemented with an attribute-like graphical user interface (GUI) component where authors can specify conditions over each branch, based on the values of global variables. In this way, story authors can effectively create stories based on a player visitor model and increase visitor agency by defining different story continuations based on the visitor's choices.

In addition, CHESS enables authors to account for a listener model, where the visitor has no agency in the story world. Even so, storytelling in CHESS remains a highly interactive process. A good human performer, museum guides included, continuously observes the reactions of the audience and adjusts the narration accordingly [12]. To simulate this process, the CHESS system implements generic visitor tracking and dynamic profile update techniques, and refines the visitor profile as the experience progresses. CHESS follows an implicit profiling approach, interpreting a predefined set of visitor actions as positive or negative feedback on the corresponding story graph entities. When certain conditions are met, explicit feedback menus are injected into the story to increase profiling accuracy. The visitor profile is used by the ASTE to make a personalized decision whenever a branching point is reached in the story graph [4]. From the authoring perspective, in order to leverage the dynamic profiling functionality implemented by the CHESS system, authors are required to annotate the story graph entities with a set of weighted features.

CHESS allows story authors to define and experiment with any set of visitor features, enabling them to create stories that adapt to a variety of visitor attitudes. They can do that both in the scripting and the editing level, prescribing alternative digital productions for the same script unit, to cope for example with different visitor moods [13]. Annotation based personalization has been widely explored in several personalization applications, as well as in interactive digital storytelling [12]. Aiming to be used by authors who are neither programmers nor experts in personalization issues, CHESS combines semantic annotations (using an open tag vocabulary) with a procedural branching representation of the story (presented in Section 4).

CHESS also pays special attention to the staging of the story in the physical world. Museum visitors experience a mixed reality environment made up of digital

characters and media assets that are situated in the physical space. From this perspective, the CHESS storytelling model can be related to the Mobile Urban Drama conceptual framework [14], where graph-based techniques are utilized to represent the story flow and branches may be conditioned on user actions, state, and environmental or other variables. However, in this case the graph is not complemented by annotations, thus accounting only for the users' past actions and ignoring their preferences and attitudes. Most notably, no authoring component is included in the software framework, requiring close cooperation between authors and programmers at all times. An editor environment was provided in the Mscape mobile media gaming platform developed by Hewlett Packard [15], allowing the creation of interactive stories that users can experience by following different storylines, but it targeted towards developers rather than non-programmers. Mobile based interactive storytelling has been supported by several software frameworks, in both urban [14-17] and museum environments [18, 19]. Yet most of these works focus on the visitors experience rather than on the authors, thus not addressing the authoring challenges raised.

A user friendly authoring tool is provided by ARIS[2], an open-source platform for creating and playing mobile games, tours and interactive stories. ARIS considers the user as a player and it uses a conditional quest model, unlocking quests when certain quests are accomplished. Hotspots are defined over Google maps. Unlike CAT, the platform doesn't allow using rich media (such as games, 3D or AR), nor loading or editing a customized map of a particular site.

CAT has been built upon INSCAPE[3] [21], an innovative visual authoring tool resulting from the eponym FP6 Integrated Project. The CHESS project extended and adapted this tool to support new concepts such as the mixed reality dimension of the stories and the adaptation capacities of the story to the visitor profile and context.

3 CHESS System Overview

Figure 1 depicts the high-level architecture of the CHESS system. Story authoring is accomplished with CAT. Besides editing the story graph, the tool enables authors to edit, annotate and enrich 2D and 3D maps, as well as to create narration and QR-scanning activities through activity templates. Additionally, CAT integrates an Asset Management Tool which enables authors to upload new digital assets (e.g. images, videos, audio files, etc.) with associated metadata (e.g. author, copyrights, tags, etc.). Authors can browse, search and display their project digital assets as well as to visualize the relations between them through a graphical, ontology-like diagram (the generation of which is based on the provided tags).

Authors can choose to store their story projects locally, for testing purpose, or to publish them. In the latter case, the story graphs are exported to the ASTE while the digital assets required to realize the story activities are exported to the Hub. The ASTE is responsible for traversing the story graphs while making decisions for

[2] http://arisgames.org/
[3] http://www.inscape3d.com

personalization, based on the visitors' profiles and actions. It is implemented using Enterprise Java Beans 3.0, hosted inside a JBOSS 7.0 server. The stories are internally represented in CML (CHESS Markup Language) under an XML-based format.

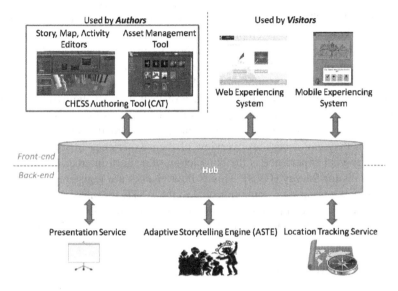

Fig. 1. Overview of the CHESS system components

The Hub lies in between the front-end and back-end components, supporting the communication among them. It is implemented as a web service (written in Python) running on the Tornado Web Server. When a story is published from CAT, the Presentation service processes the digital assets (e.g. images, audio files, etc.), creates alternate versions adapted to different network capacity and mobile device specifications, and then stores them in the Hub (using MongoDB, a "NoSQL" database that allows schema-less data storage). In this way, authors do not have to manage the specific capacity of each potential device used to experience a story; the publishing process of an interactive story has been reduced to pushing a button in the interface.

During the visit, the CHESS stories are delivered to visitors through the Mobile Experiencing System (MES), i.e. the framework running the CHESS experience on a mobile platform. It is based on InstantAR[4] App written with HTML5 and JS standards in order to support a large number of devices. The InstantAR Native App is optimized to display 3D content and embeds a state-of-the-art AR engine. In order to display the AR activities, the InstantAR App needs to be first installed in the visitor's mobile device. MES also acts as a sensing device to support adaptation: it gathers, holds and shares data about the user (position, orientation, device status, actions, etc.).

During the experience, MES continuously communicates over HTTP with the ASTE (through the Hub). The ASTE traverses the authored story graph using the visitor's profile to predict the appropriate story parts and informs MES about which

[4] http://instantar.org/

activity to fetch and display next. To do so, MES retrieves the appropriate version of the activity, depending on the current network and visitor's device conditions and characteristics. On the other hand, MES notifies the ASTE about the state of the presentation and visitor actions (e.g. completed, paused, skipped, etc.).

In places where GPS technology provides sufficiently accurate information, the Location Tracking Service is employed to create navigation activities, guiding the visitor from his current location to the next hotspot in the story. It has been tested in the environment of Cité de l' Espace, where navigation activities were instantiated upon visitor request, from the appropriate MES interface component.

Finally, CHESS also covers the pre and post visit parts of the experience, which are handled by the Web Experiencing System (WES). For instance, prior to visiting a museum, the visitors may browse information about it, play digital games, etc., while after the visit they can access an overview of their experience in situ. An important part of the pre-visit experience is the completion of a short, interactive questionnaire, the CHESS Visitor Survey (CVS). This is how visitors are registered in the CHESS system and their answers are communicated to the ASTE for initial profile elicitation. The WES uses Ajax technology to communicate with the ASTE Server through a REST protocol where messages are encoded following a specific XML specification.

4 CHESS Storytelling Model

CHESS defines a tiered storytelling data model in accordance to the authoring phases, distinguishing between scripting, staging, editing and producing the digital resources. In this section we describe the main entities under each level, showcasing how they are created by authors and then explaining how they are utilized by the CHESS components during the visit.

4.1 Scripting Level

The script is a directed graph decomposed into script units and script branching points (Figure 2). Script units contain a narrative text and have attributes, such as title, description, narrative text, purpose, etc. In general, the narrative text in each script unit should be kept brief, while at the same time as self-standing and complete as possible. The CHESS script units differ in their narrative purpose and have been defined by purposefully adapting the original "trajectories theory" for cultural experiences [20]. The main script unit categories are: *advance* or connect to main plot, *approach* (navigation hints to locate an exhibit), *engage* (confirm location), *experience* (give information related to the exhibit), *disengage* (closure of the exhibit-based information segment), and *re-connect* to main plot.

Script branching points on the other hand, are special constructs representing decision points where more than one script options are defined. Scripting is performed in the CAT Story Editor by creating script units and branching point nodes and connecting them with directed edges, denoting the script flow. Branching points are explicitly represented through dedicated nodes, since they have attributes as well. They can be i)

mandatory, in the sense that a menu should be displayed, informing the visitor about the valid alternative choices so as to choose how to proceed, ii) *automatic*, meaning that ASTE should take an automatic decision about which branch to follow, or iii) *optional*, denoting that ASTE should decide whether a menu will be displayed or an automatic decision will take place, based on its confidence for the visitor's preferences in the available choices.

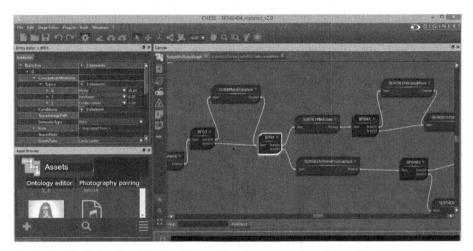

Fig. 2. Sample Script Graph in the Story Editor. The properties of the selected branching point (highlighted in white) are displayed and edited on the left panel

In the case of mandatory branching points, authors also specify the menu title as well as the template that will be employed to display the menu (image or snippet based). In the same way, authors can define conditions for each branch, which need to hold for considering it as a valid candidate continuation of the script. Conditions represent authored hard constraints and they can be based on a variety of visitor or contextual attributes. For instance, if a script unit refers to a previous piece in the experience, then authors can express this constraint on the appropriate edge, requiring that the visitor has previously successfully "consumed" the corresponding optional part.

Besides conditions, authors can also provide a set of semantic annotations for branches and script units. Several works in personalization applications focus on capturing user preferences on topics. Following this approach, authors can divide the narrative in script units based on the topics they cover and then employ (simple or complex) branching structures to link them. To enable the ASTE decide on which path matches best the visitors' preferences, authors need to assign particular topic labels to the script entities. In this way, when a visitor skips, for example, a script unit, the ASTE infers high negative feedback on those script unit topics and updates the visitor profile. Obviously, not all script units need to be annotated in this manner; for instance, those disengaging from an exhibit do not typically cover a topic.

4.2 Staging Level

Unlike a novel or film, where the user's (mental) teleportation to a different location setting may be described, implied or simply shown, in the case of museum experiences the story setting is bound to the museum physical environment. A good visualization of the museum map helps authors have a good understanding of the physical actions that the visitor will need to make during the experience. To that end, CAT enables two things: firstly, to visualize the story environment (i.e. the museum spaces) by adding a 2D or/and 3D maps to the stories project (Figure 3); secondly, to define custom hotspots over the imported maps, denoting areas of interest (areas around exhibits, windows, or any other place on the map). During staging, authors associate script pieces to specific physical locations, indicating explicitly where the user should be located in order to unfold the story.

Fig. 3. 3D representations of the Archaic Gallery (left) & Cité de l' Espace (right) with hotspots (in red)

Whenever location transitions are required to follow the staged script, the visitor needs to be somehow prompted and guided to reach the corresponding physical location. In the case of the Archaic Gallery of the AM, the accuracy of existing radiofrequency-based location tracking technologies (including GPS) was inappropriate because of the spatial proximity of the exhibits, which required a robust sub-metric location mean. In this case, the stories adopted a hints-based approach, in which the narrating character invites the visitor to find the particular physical exhibit and provides a set of clues to do so. In this way, navigation is indirectly achieved and it is integrated with the story. On the contrary, for Cité de l' Espace, the authors did not need to focus on navigation issues, since it was automatically performed by the Location Tracking Service, which computes the best path to reach the target location from the current visitor location and displays it on the site map. In both cases, to ensure that the visitor has actually reached the right place, the authors defined location confirmation branching points in the scripting level, presented through menus or QR code activities.

4.3 Producing Level

Cultural heritage sites own increasing numbers of digital resources about their collections, amongst which high-quality animations and videos, produced by external

professionals. A logic objective is to be able to reuse these rich digital resources in different projects. To address this need, and aiming to provide authors with a system that supports them throughout all the phases of the authoring endeavor, CAT enables the creation of audio narration activities. Authors can import digital assets such as images and videos and synchronize them over a timeline, either with existing audio recordings or with new ones, produced with the text-to-speech technology integrated in CAT. In addition, CAT supports the creation of QR code scanning activities, generating QR codes that are assigned to particular hotspots. Authors can print and place them in the museum environment, so that when a visitor scans a QR code, the activity running on the MES translates it into a specific hotspot and MES notifies ASTE about the visitor's location. Finally, authors can import other types of productions, such as AR applications or sophisticated games. However, in this case, a technical expert needs to shortly intervene and create the appropriate manifest files that will enable the integration of the third-party components.

4.4 Editing Level

For each script unit in the script graph, authors create a graph containing the activities (e.g. digital productions) that will be employed to realize the script unit. Similarly to their counterparts in the scripting level, the activity graphs are directed graphs that contain activity nodes and branching points, enabling the authors to use different productions for the same script unit. For instance, different images and/or audio files may be chosen depending on the visitor's age, culture or language. Even entirely different types of activities may be adopted; a script unit about the coloring of statues may be realized with an audio-visual narration, an AR production, or a painting game.

5 Experience and Evaluation Results

The CHESS system was used at the Acropolis Museum and the Cité de l' Espace to author several stories, which were subsequently tested with actual visitors during the project's formative and summative evaluation sessions. Museum personnel participated in a one-day training session and then started to use the authoring tool for several weeks to complete the creation of the stories. The authoring groups were kept small, including two to five museum representatives, as would happen in a real world scenario. The technical partners provided support and guidance when needed and monitored the use of the tools, recording usability issues as well as needs for new functionality. This longitudinal evaluation of the tool has provided valuable insight as to its strengths and weaknesses, guiding its design iterations and refinement.

One of the system main strengths is that it allows quick prototyping of the story and to simulate the designed storytelling experience, thus significantly advancing the iterative process of analyzing and refining the story in all the authoring phases. As a result, several high quality experiences have been produced at both museum sites, with limited resources and in a short time (2-3 weeks), demonstrating the effectiveness of the CHESS concept and implementation [5,6].

Focusing on the authors' perception of the CHESS authoring methodology, authors quickly familiarized themselves with the branching structure of the storytelling model. Following the training, they were able to divide the narrative into script units and they created several types of stories (e.g. linear, including minor and/or moderately complex branches, reaching different endings based on prior visitor choices, including small dialogue-like sections with the visitor, etc.). However, authors faced some difficulties in grasping the declarative part of the model, coupled with the implicit profiling techniques, asking repeatedly for examples and directions.

At the beginning of the project, authors were guided to have particular personas in mind during story creation. A set of personas was defined for each museum, capturing the main types of its visitors, while authors annotated the story pieces with regard to the personas they were suitable for. The persona-based approach was very well accepted and efficiently adopted by the authors [22].

Moving towards an individual, rather than a stereotype basis, authors were guided to create stories with several branches, coping with different visitor preferences on one or more features of the story. For example, for the purposes of the summative evaluation of the CHESS project, authors created a story containing 13 branching points (4 mandatory, 6 automatic, 3 optional). Authors chose to proceed with story creation in the following way: they first created a linear story and then revisited it to "cut and paste" parts of the story under optional branches. The script tone and style was kept uniform, so branches were defined to cover different topics.

To evaluate the ASTE's decision making performance in the story, 10 visitors experienced the story in the museum's environment and then went through a post-visit interview. During the interview, the script graph was revealed to them, focusing on the branching points. The users were presented with all the available choices in each one and were asked to evaluate the system's decision in a three-point Likert scale (right, neutral, wrong) as well as to explain the reasons.

Table 1. Users' feedback over the experienced decision points in an example story

	Right	Neutral	Wrong
ASTE in all	105	9	13
Users in menus	38	2	10
ASTE in menus	40	2	8

Aggregating over all user experiences, the ASTE took 127 decisions. In the case of menus, ASTE performance is examined based on the ranking of the available choices; if the best choice is ranked at the first place, then the system's decision is right. Table 1 summarizes the users' feedback that was collected over the 127 decision points, showing that ASTE reached approximately 89% of right decisions. An interesting observation has to do with the users' effectiveness in the decision making process. Focusing on the cases where menus were displayed and users made explicit choices, we observed that the ASTE slightly outperformed the users. This result highlights the difficulty, from the authors' perspective, to define effective narrative snippets.

Due to the small number of evaluated sessions, and especially due to the strong, inherent dependencies with the particular story's content, the reported results should not be interpreted as absolute metrics of accuracy. Nevertheless, they provide valuable insights on the ASTE's performance, indicating that the authors can effectively leverage the CHESS system in the creation of personalized, interactive stories, so as to make personalized suggestions or even make decisions on the visitor's behalf.

6 Conclusions and Future Work

In this paper we present a general overview of the CHESS prototype system and we explain how it supports story authors during the scripting, staging, production and editing phases for the creation of personalized, interactive digital stories taking place in museum environments. Authors were easily familiarized with the branching graph structures and they adopted the persona-based approach for story creation. When asked to put the personas aside and move towards individual preferences, authors decided to follow a traditional topic-based approach, requiring guidance and support in the definition of a story structure that would effectively leverage the underlying profiling mechanisms. As part of our future work we plan to supplement the CHESS framework with detailed authoring guidelines, including several "good" and "bad" example stories, to illustrate the various ways that CHESS can be used. Finally, further stories are planned to be developed, to investigate and evaluate the system's performance over different story structures, while also adapting to a variety of features.

Acknowledgements. This research has been conducted in the context of the CHESS project that has received funding from the European Union's 7th Framework Programme for research, technological development and demonstration under grant agreement no 270198.

References

1. Pujol, L., Roussou, M., Poulou, S., Balet, O., Vayanou, M., Ioannidis, Y.: Personalizing interactive digital storytelling in archaeological museums: the CHESS project. In: 40th Annual Conference of Computer Applications and Quantitative Methods in Archaeology. Amsterdam University Press (2012)
2. Keil, J., Pujol, L., Roussou, M., Engelke, T., Schmitt, M., Bockholt, U., Eleftheratou, S.: A digital look at physical museum exhibits: Designing personalized stories with handheld Augmented Reality in museums. In: Digital Heritage International Congress, vol. 2, pp. 685–688. IEEE (2013)
3. Vayanou, M., Karvounis, M., Kyriakidi, M., Katifori, A., Manola, N., Roussou, M., Ioannidis, Y.: Towards Personalized Storytelling for Museum Visits. In: 35th International Conference on Very Large Databases, Profile Management, and Context Awareness in Databases (2012)
4. Vayanou, M., Karvounis, M., Katifori, A., Kyriakidi, M., Roussou, M., Ioannidis, Y.: The CHESS Project: Adaptive Personalized Storytelling Experiences in Museums. In: 22nd Conference on User Modelling, Adaptation and Personalization, Project Synergy Workshop, vol. 1181. CEUR-WS.org (2014)

5. CHESS demo at Innovation Convention, `http://ec.europa.eu/research/innovation-union/ic2014/index_en.cfm?pg=showcase01`
6. `http://ec.europa.eu/avservices/video/player.cfm?ref=I088028, OfficialCHESSdemo`
7. Bedford, L.: Storytelling: the real work of museums. Curator: The Museum Journal 44(1), 27–34 (2004)
8. Bolter, J.D., Joyce, M.: Hypertext and creative writing. In: Proceedings of Hypertext 1987, pp. 41–50. ACM, New York (1987)
9. Bouchardon, S., Clément, J., Réty, J.-H., Szilas, N., Angé, C.: Rencontre: an Experimental Tool for Digital Literature. In: Conference Electronic Literature in Europe 13 (2008)
10. Koenitz, H.: Extensible Tools for Practical Experiments in IDN: The Advanced Stories Authoring and Presentation System. In: André, E. (ed.) ICIDS 2011. LNCS, vol. 7069, pp. 79–84. Springer, Heidelberg (2011)
11. Koenitz, H., Sezen, T.I., Sezen, D.: Breaking Points – A Continuously Developing Interactive Digital Narrative. In: International Conference on Interactive Digital Storytelling, pp. 107–113. Springer International Publishing (2013)
12. Garber-Barron, M., Si, M.: Towards Interest and Engagement: A Framework for Adaptive Storytelling. In: 5th Workshop on Intelligent Narrative Technologies, pp. 66–68. AAAI Press (2012)
13. Tanenbaum, J., Tomizu, A.: Narrative meaning creation in interactive storytelling. International Journal of Computational Science 2(1), 3–20 (2008)
14. Hansen, F.A., Kortbek, K.J., Johanne, K., Grønbæk, K.: Mobile Urban Drama - Interactive Storytelling in Real World Environments. New Review of Hypermedia and Multimedia 18(1-2), 63–89 (2012)
15. Stenton, S.P., Hull, R., Goddi, P.M., Reid, J.E., Clayton, B.J.C., Melamed, T.J., Wee, S.: Mediascapes: Context-aware multimedia experiences. IEEE MultiMedia 14(3), 98–105 (2007)
16. Paay, J., Kjeldskov, J., Christensen, A., Ibsen, A., Jensen, D., Nielsen, G., Vutborg, R.: Location based storytelling in the urban environment. In: 20th Australasian Computer-Human Interaction Conference, OZCHI 2008, vol. 287, pp. 122–129. ACM (2008)
17. Ballagas, R., Kuntze, A., Walz, S.P.: Gaming tourism: Lessons from evaluating REXplorer, a pervasive game for tourists. In: Indulska, J., Patterson, D.J., Rodden, T., Ott, M. (eds.) PERVASIVE 2008. LNCS, vol. 5013, pp. 244–261. Springer, Heidelberg (2008)
18. Damiano, R., Gena, C., Lombardo, V., Nunnari, F., Pizzo, A.: A stroll with Carletto: adaptation in drama-based tours with virtual characters. User Modeling and User-Adapted Interaction 18(5), 417–453 (2008)
19. Lombardo, V., Damiano, R.: Storytelling on mobile devices for cultural heritage. The New Review of Hypermedia and Multimedia 18(1-2), 11–35 (2012)
20. Fosh, L., Benford, S., Reeves, S., Koleva, B., Brundell, P.: See Me, Feel Me, Touch Me, Hear Me: Trajectories and Interpretation in a Sculpture Garden. In: Computer-Human Interaction Conference, pp. 149–158. ACM, New York (2013)
21. Balet, O.: INSCAPE an authoring platform for interactive storytelling. In: Cavazza, M., Donikian, S. (eds.) ICVS-VirtStory 2007. LNCS, vol. 4871, pp. 176–177. Springer, Heidelberg (2007)
22. Roussou, M., Katifori, A., Pujol, L., Vayanou, M., Rennick-Egglestone, S.J.: A Life of Their Own: Museum Visitor Personas Penetrating the Design Lifecycle of a Mobile Experience. In: Computer-Human Interaction Conference Extended Abstracts on Human Factors in Comp. Systems, pp. 547–552. ACM, New York (2013)

An Authoring Tool for Movies
in the Style of Heider and Simmel

Andrew S. Gordon and Melissa Roemmele

Institute for Creative Technologies
University of Southern California
Los Angeles, CA USA
{gordon,roemmele}@ict.usc.edu

Abstract. Seventy years ago, psychologists Fritz Heider and Marianne
Simmel described an influential study of the perception of intention,
where a simple movie of animated geometric shapes evoked in their sub-
jects rich narrative interpretations involving their psychology and social
relationships. In this paper, we describe the Heider-Simmel Interactive
Theater, a web application that allows authors to create their own movies
in the style of Heider and Simmel's original film, and associate with them
a textual description of their narrative intentions. We describe an eval-
uation of our authoring tool in a classroom of 10th grade students, and
an analysis of the movies and textual narratives that they created. Our
results provide strong evidence that the authors of these films, as well as
Heider and Simmel by extension, intended to convey narratives that are
rich with social, cognitive, and emotional concerns.

1 Introduction

Heider and Simmel [9] describe a fascinating study that continues to capture our
imagination today. In this work, Fritz Heider and Marianne Simmel prepared a
short, 90 second animated film depicting the movements of two triangles and a
circle around a rectangle with a section that opened and closed as if it was a door.
114 undergraduate subjects were divided into three groups. The first group was
shown the film, and then asked simply to "write down what happened in the
picture." The second group was instructed to interpret the movements of the
figures as actions of persons, and then answer 10 questions concerning the be-
havior of the triangles and circle. The third group watched the film in reverse,
and then asked to answer a subset of the behavioral questions.

Nearly every subject in the first group described the events in anthropomor-
phic terms, typically involving a fight between two men (the triangles) over a
woman (the circle). The narratives of these subjects employ mentalistic phrases:
the girl hesitates, she doesn't want to be with the first man, the girl gets wor-
ried, is still weak from his efforts to open the door, they finally elude him and
get away, he is blinded by range and frustration. The second group of subjects
further explained these anthropomorphic interpretations: the larger triangle is
an aggressive bully, the smaller triangle is heroic, the circle is helpless, and the

A. Mitchell et al. (Eds.): ICIDS 2014, LNCS 8832, pp. 49–60, 2014.

actions of the smaller triangle and circle lead to their successful escape from the larger triangle, sending him into a rage for being thus thwarted. The third group of subjects, seeing the film in reverse, also interpreted the movements as human actions. Here the variations in narrative were much greater: a man resolved to his fate is disrupted by a woman accompanied by evil incarnate, a prisoner thwarts a murder attempt and then escapes, and a mother chastises a father over the behavior of their child.

What were these subjects thinking? Why did they attribute mentalistic causes to the observable behavior? What cognitive mechanism accounts for these interpretations? Fritz Heider's own explorations of these questions culminated in the writing of his influential book, *The Psychology of Interpersonal Relations* [8]. Here, Heider motivates the role of commonsense psychology in behavior explanation, where perception of action is integrally tied to a conceptual network of beliefs, desires, sentiments, and personality traits that serve as the invariant dispositional properties that underlie social phenomena. In Heider's view, subjects ascribed mental states to the moving shapes in his film in the same way that they naturally do in everyday human-to-human interactions.

In his autobiography, Heider describes the process of crafting the film with Marianne Simmel by manipulating wooden cutouts on a backlit screen, and his pleasure with the final product:

> It took us about six hours, working in this exposure-by-exposure fashion, to make a film that gives a perception of lively movement and takes about three minutes to project. I still remember how pleased I was at my first showing of the film. And it has been impressive the way almost everybody who has watched it has perceived the picture in terms of human action and human feelings. [7]

Heider's writings provide us with no information about the narrative that he intended to convey through this animation, or even that such an intention was present. Still, it must be remembered that the conventions of animated storytelling [15] were already well established in the popular films of the 1940s, which saw the release of Disney's *Pinocchio* (1940), *Fantasia* (1940), *Dumbo* (1941), and *Bambi* (1942) in the years before Heider and Simmel crafted their anachronistic film. For Heider's subjects, the question of "what happened in the picture" would have been naturally understood as "what story have the animators intended?" From this perspective, however, the experiment of Heider and Simmel leaves many questions unanswered. What sorts of narratives can be successfully conveyed given the limits of the medium? What are the factors that govern the degree of variance in interpretations? How much can successful storytelling be attributed to the the talents of Heider and Simmel, specifically, as animators? Answering these questions requires that we enlist the talents of a larger pool of animators, whose explicit authorial intentions can be compared to audience interpretations.

This paper describes a software solution for creating and narrating movies in the style of Heider and Simmel's film. The *Heider-Simmel Interactive Theater*

allows authors to record their own movies by dragging shapes around a two dimensional plane using a mouse or multitouch interface, and then associate with them a written description of their narrative intentions. Built as a web application, users' movies are viewed by other users, who can share their own written interpretations. After presenting the software and its capabilities, we describe an evaluation of this authoring tool by students in a 10th grade public school classroom in Los Angeles, using school-issued tablet computers as a hardware platform. We then provide an analysis of these students' animations and written narratives, to better understand the conceptual scope of the narratives that these films were meant to convey.

2 The Heider-Simmel Interactive Theater

The *Heider-Simmel Interactive Theater*[1] is a web-based authoring tool designed to allow users to author their own movies in the style of Heider and Simmel's film, and to author textual narratives of their own films and those of other users. Unlike professional animation or movie-editing software that strive for realism and high production quality, the design goal for this application was to enable novice users to quickly make short (90 second) movies without the need for instruction of any sort. We achieved this goal through a combination of intuitive user interface design and by limiting the movies' characters and props to exactly those seen in Heider and Simmel's original film: one large triangle, one smaller triangle, one circle, and one box with a movable door. Each of these elements appear in every movie, which can be fully encoded as a time-indexed array of position and rotation parameters for the three characters and the door. Figure 1 shows a user creating a movie using this software on a tablet computer.

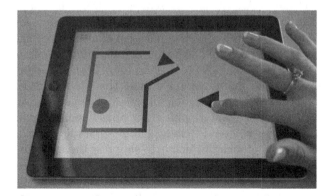

Fig. 1. The Heider-Simmel Interactive Theater

Architecturally, this web application consists of client-side hypertext markup and scripts, making heavy use of Scalable Vector Graphics, and a server-side

[1] Accessible online at http://hsit.ict.usc.edu

application interface and database to store user login accounts and movie data. The client-side application allows users to manipulate characters using either a mouse or touch interface, enabled by handling web browser-based touch events. This architectural design simplifies the deployment of the application; users access the application using the web browser on their desktop or tablet computers. As all movies and textual narratives are stored centrally on our servers, this provides us with an ever-increasing amount of data to be analyzed in our research on visual storytelling.

2.1 Object Manipulation

The main authoring screen of this application is realized as a full-screen Scalable Vector Graphics (SVG) object in the Document Object Model of a web page. The white stage and black shapes from Heider and Simmel's original film are represented as elements of this SVG object, with object properties that specify their rotation and translation transformations. Compared to Heider and Simmel's original, these elements are scaled slightly larger, making it easier for a user to place their finger directly on top of an object when using a tablet computer, given contemporary screen sizes. Even with this concession, we found it to be ergonomically difficult for a user to place two fingers on a single shape, which is required when using a common interface convention for simultaneous rotation and translation of two dimensional objects. Accordingly, it was necessary to develop a capability for expressively dragging a character across the stage using only a single finger, or via a traditional mouse interface.

Our custom 1-pointer solution for simultaneous rotation and translation consists of two parts, the "sticky finger" and the "slippery center." Dragging is initiated on mouse-down or touch-start browser event handlers attached to each draggable SVG element. As the user subsequently drags their mouse or finger, the position of the SVG object is updated such that the pointer's location on the object is the same as when the drag was initiated (the "sticky finger"), and the new center point of the object lies on the line segment between its previous location and the new location of the pointer, as in Figure 2(a). By updating the SVG position at the rate of incoming pointer events, this approach yields fluid and intuitive manipulation of each draggable object in most cases. However, if the dragging is initiated near the center point of the object, small and uncontrollable movements of the pointer will tend to induce large, sporadic rotations. We found a simple solution to this problem, which is to suppress the initiation of dragging until the pointer has been dragged sufficiently far away from the center point of an object (the "slippery center"), as in Figure 2(b). The latency in an object's movement is largely imperceptible, and the effect is that every attempt to drag an object affords a degree of expressive control.

We crafted a specialized dragging routine for the door of the box to allow it to be rotated nearly 180 degrees in either the open or closed direction. We made no efforts to detect or react to object collisions, or to model inertia or other physical properties of moving masses. Unfortunately, these choices prohibit users

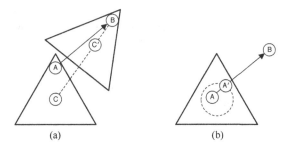

(a) (b)

Fig. 2. Dragging gestures \overrightarrow{AB}, showing (a) positioning of new center point C' on \overline{CB}, and (b) suppression of dragging from center region, yielding drag gesture $\overrightarrow{A'B}$

from recreating the climactic ending of Hieder and Simmel's original film, where the larger triangle busts through the walls of the box from the inside. We intend to support this option in future versions of the authoring tool.

2.2 Recording and Editing Movies

Much of the complexity of conventional video production software relates to the recording and editing process. For the *Heider-Simmel Interactive Theater*, our design goal was to provide users with some editing abilities, but to do so with an intuitive user interface that required no instruction.

When creating movies, users are first see the stage with characters in fixed starting positions. Recording begins as soon as a user starts to drag a character, using their mouse pointer or a finger. From this moment, a timer display in the corner of the screen becomes active, displaying both the elapsed time and available time remaining for the performance, limited to 90 seconds. In the simplest case, a user simply moves the various characters to record their movie until 90 seconds have elapsed.

If the user clicks on the timer display, or when the timer reaches 90 seconds, a movie editing toolbar is displayed (Figure 3). Similar to conventional playback controls for digital video, this editing toolbar has a slider that moves from left to right to indicate the current time point in the movie. To the left of this slider is a (green) recording trail, indicating the portion of the duration that contains recorded data. Dragging the slider left or right along this toolbar allows the user to scrub through their recording, causing the characters to move back to their positions as recorded at each time point. Clicking the slider starts playback from the selected time point.

Fig. 3. Movie editing toolbar

If the user initiates dragging during playback, the recording begins again from that moment forward. This action erases all subsequent recorded data, which is reflected in the recording trail. This interface behavior affords a simple form of incremental, linear editing of a recorded performance. To make a change, the user moves the slider to the time point in their recording that they would like to edit, and then creates a revised movie from that point onward. Although limited, this approach eliminates the complex interface controls necessary in nonlinear video editing, e.g. to support splices and joins.

Two additional controls, represented as (white) polygons on either end of the editing toolbar, allow users to trim off durations from the beginning and ending of their recording. These "trim blocks" can be dragged left and right, up until the current position of the slider, to specify new start and end times for a recorded performance. The start time trim block is particularly useful for creating movies where the characters begin in novel positions. To do so, the user takes a few seconds at the beginning of their recording to position their characters as desired, then trims this duration off during editing.

2.3 Narrating Movies

The *Heider-Simmel Interactive Theater* allows users to associate their own textual narration with their movies, and to offer textual interpretations of the movies of other users. When watching another user's movie, we first ask the viewer to give the film a "star rating" from one to five, and then describe their interpretation of the events in the movie. When finished, the viewer is shown the author's own textual narration, for comparison. Each viewer's interpretation also becomes visible to the author to review on subsequent visits to this web application.

3 Evaluation

To assess the usability of our authoring tool design, we conducted a user evaluation with 10th grade students from Alliance Health Services Academy, a charter high school providing public education to students in a South Los Angeles neighborhood. We conducted this evaluation with 23 students during a two-hour classroom period intended specifically to prepare students for the California High School Exit Exam. Our exercise with this classroom was scheduled at the end of the academic year, after state-mandated achievement tests, so as not to conflict with their normal educational curriculum. The majority of these 23 students were 15 or 16 years old, and included all of the 10th grade students in the school receiving special education as part of an Individualized Education Program (IEP). Each student in this classroom uses an Apple iPad through an initiative of the Los Angeles Unified School District that began in 2013 aimed at providing tablet computers to every student. These iPads are distributed to students each morning, and later returned to school administrators to be recharged overnight.

Three members of our research team conducted this evaluation, with the assistance of this classroom's teacher. On this teacher's advice, we offered no background information about Heider and Simmel's original film, and nearly no instruction on how to use our software. After brief introductions to our team, we handed out index cards with pre-established usernames and passwords for each student, along with the URL of the *Heider-Simmel Interactive Theater* to enter into their iPad's web browser. Students were then asked to perform three tasks, and given roughly 15 minutes for each. First, we asked to create their own creative movies, depicting any storyline of their choosing, using the authoring interface described in the previous section. Students completed this task easily, and many used the allotted time to create additional movies. During this time, our research team answered students' questions and monitored the classroom for problems, which were minimal. Second, we asked students to write a textual narrative that described the events depicted in their movies, using the touchscreen keyboard that appears on the iPad's browser screen. Third, we asked students to write their interpretations of movies created by other users of our application, selected randomly from all previous recordings. Of the three tasks, this one was the least successful, as students were largely only interested in seeing the films created by their fellow classmates. As a consequence, they spent an inordinate amount of time clicking through random movies until they found one associated with a username assigned to their peers.

After these tasks were completed, the teacher of this classroom directed a classroom exercise for the remainder of the period. Here, students were selected to present their movies to the whole class, by connecting their iPads to a classroom video projector, and tell the class the narrative they intended. Our research team was struck by the high degree of creativity exhibited by this group. To better understand the ways that our tool was used by these students, we subsequently conducted analyses of both the recorded movie data and the students' textual narratives, described below.

3.1 Analysis of Movie Recordings

We analyzed the usage of two user interface features intended to aid the authoring and editing of movies. First, we analyzed usage of the multitouch interface, which enabled authors to simultaneously animate two or more shapes. We examined each of the 43 movies authored by students in our evaluation, specifically looking for evidence of multitouch animations. Our encoding of the movie data made it simple to detect when shapes were moving simultaneously. By iterating through each time point in the recording, we detected multitouch activity when more than one shape changes position between consecutive time points. We found that 16 of 23 students (70%) used the multi-touch authoring capability, and these students authored 23 multi-touch movies. Since students largely authored animations independently, we interpret this result as evidence of an intuitive design for character manipulation.

Second, we analyzed the usage of functionality in the movie edit bar, shown in Figure 3. We had provided students almost no instruction on the use of the

edit bar, so we were particularly interested in seeing evidence of successful movie editing. However, our incremental linear editing approach, where edits are made by recording over trailing portions of the user's movie, leaves no evidence of edits in the movie data. However, we could detect the use of the "trim blocks" that enable authors to delete portions from the beginning and ending of movies, shown as white polygons in Figure 3. Use of the beginning trim block can accurately be detected by examining the position of characters in the first frame of users' movies. Cases where characters are not in their default positions indicates that the author had used the trim block to adjust the start frame of the movie. We found that 4 of 23 authors (17%) did this type of editing, and they contributed 5 movies with an edited start time. We interpret this result as weak evidence for an intuitive design for movie editing, particularly given that this feature was not explicitly communicated to students.

3.2 Analysis of Textual Narratives

Thirty-four of the 43 movies created by students in our experiment were narrated by their authors, who typed these short, paragraph-sized texts directly into our user interface using their iPads. A wide range of topics and descriptive elements appeared in these narratives, as seen in the following three examples:

> *The triangles are the brother and the circle is the sister. The sister was annoyed by her brothers so she went to her room since she didn't want to be bothered. So her brothers went after her bugging her even more. Once they got out of her room, she went to go apologize.*

> *The three musketeers must fight the evil box. While Mr. Circle goes to fight the evil box, the evil box eats Mr. Circle. Mr. Small triangle then tries to help his friend, but gets eaten in the processes as well. It's all up to Mr. Big triangle to save the day. Mr. Big triangle fights the evil box. He then kills the evil box and saves both his friends, and they lived happily ever after.*

> *A girlfriend is upset at her boyfriend for ignoring her. He is always talking to his bestfriend and pays her no mind until it's too late. Once he notices her she already has a really big attitude, so he gives up on trying to make up with her. But she forgives him and they make up anyway.*

To better understand the diversity of the narrative elements used by these students, we conducted a series of lexical analyses to identify patterns in the types of characters, setting, and actions that were described.

First, we analyzed references to characters in these narratives. The *Heider-Simmel Interactive Theater* has four objects that can be animated: three shapes (circle, little triangle, and big triangle), and the door of the box. We began by identifying and counting distinct characters mentioned in each narrative, finding either four (3 narratives), three (20 narratives), two (10 narratives), or one character (1 narrative) referenced in the text. When four characters were

mentioned, the authors either referred to characters not explicitly shown in the animation or treated the box as a character (the *evil box*, in the second example above). Of the 93 characters referenced in these narratives, most (58) were referred to by their respective shape names (e.g. "circle" or "triangle"), and the two triangles were distinguished by their relative size, i.e. calling one the "big" or "large" triangle and the other the "small" or "little" triangle. We discerned gender assignments for 35 characters, either by personal pronouns or gender-specific roles (e.g. "boyfriend", "sister"), and found male characters more frequent (27) than female characters (8). The most commonly expressed relationship between characters was friendship, as indicated by the keywords "friend" or "best friend", which occurred in 13 narratives. Three narratives described a dating relationship ("boyfriend", "girlfriend"), 3 narratives described a sibling relationship ("brother", "sister"), and 2 narratives described a "teacher" and "student" relationship. Interestingly, the author appeared as a character in 4 narratives, identified through the use of first-person personal pronouns.

Second, we analyzed references to the locations and props in these narratives. The majority of narratives (20) explicitly mentioned locations or props, some of which refer to on-stage objects. We were particularly interested in how authors referred to the box on the stage, given its ambiguity. Authors made frequent use of terms indicating a walled structure with a door, including "house," "home," "door," "room," "building," "entrance," and "exit." Two narratives interpreted the animated circle as a "ball" rather than a character. Further creativity is evidenced by a wide variety of other locations and props included in these narratives, including "roof," "pool," "safe," "hallway," "money," "corner," "lock," and "cave." These locations and props evoke a variety of intended activity contexts and situations, which are only sometimes explicated in the text. For example, one author writes: "First, their is two triangles and a circle going over to a house which a friend is throwing a party. "

Third, we analyzed references to actions performed by characters in these narratives. The subjects in Heider and Simmel's [9] original experiment reportedly viewed the shapes as human characters that physically manipulated their environment, engaged in social interaction with other characters, and experienced psychological states involving thought and emotion. In analyzing the range of actions and experiences in our students' narratives, we aim to characterize the degree to which these elements also exist in the narratives intended by the authors of these animations, and by Heider and Simmel as well by extension. For this analysis, we catalogued each narrative according to its predicates, i.e. phrases indicating an action or experience on the part of the character typically verbs (e.g. "chase", "talk") or adjectives ("happy", "in love"). With each narrative containing a mean of 52 words, there were 236 total predicates across all narratives, or 6.9 predicates per narrative on average. We classified these predicates into five different high-level categories. First, we defined "physical predicates" as actions involving physical interaction between a single character and its environment (e.g. "walk", "enter"). Second, "physical-social predicates" are actions involving physical interaction between at least two characters (e.g. "fight", "fol-

low"). Third, "psychological-social predicates" are also actions involving social interaction between at least two characters, but these actions rely strongly on human-like psychological capacities (e.g. "talk", "convince"). Fourth, "perceptual predicates" involve a character experiencing human-like sensory abilities and cognition (e.g. "see", "think"). Finally, "emotional predicates" involve a character experiencing human-like emotions, desires, and intentions by a character ("want", "get angry"). In general, these predicate categories are listed in the order of increasing psychological attribution on the part of the author. The former categories reflect behavior more directly observed from the movements in the animations. In contrast, the latter categories reflect experiences not easily observed in the animations, but elaborated by the author based on insight into the characters' psychology.

Table 1. Predicates used in textual narratives

category	predicates	count	narratives
physical	come/go, jump, trapped, open/close, lock/unlock, wait, take, turn, transform, relax, throw, fall, hit, escape, shake, sit/stand, knock	75 (32%)	21 (62%)
physical-social	fight, capture/restrain, join/approach, evade, rescue, play, kill, chase, hide, hit, help, block, lead/follow, interfere	47 (20%)	22 (65%)
psycho-social	talk, socialize, bother, befriend/de-friend, convince, intimidate, agree/refuse, invite, mock, argue, deceive, scream, cry, defend, laugh	45 (19%)	18 (53%)
perceptual	see, think, ignore, hear, lost, count	31 (13%)	15 (44%)
emotional	angry, desire, anxious, sad, annoyed, happy, tired/alert, love, dislike, serious, react, confused, relieved, give up, injured	38 (16%)	22 (65%)

Table 1 presents statistics for each high-level category, and lists each of the predicates apparent in the text, ordered by frequency from high to low. Of the 236 predicates contained in these narratives, the most frequent predicate, by far, was the *come/go* predicate in the physical category, which occurred 43 times across 18 narratives. The second most frequent predicate overall was the *see* predicate in the perceptual category, evident 18 times in 11 narratives. Also frequent was the *talk* predicate in the psychological-social category, evident 13 times in 8 narratives. Collectively, the diversity of predicates used across these narratives provides strong evidence that authors of movies in the style of Heider and Simmel intend rich narratives that pass well beyond the realm of observable physical actions, and into a wide range of social, psychological, and emotional concerns.

4 Discussion

Our evaluation in a classroom of high-school students provided us with convincing evidence that we had achieved our design objective: The *Heider-Simmel Interactive Theater* allows novice users to easily author movies intended to convey rich narratives that involve various physical, social, and psychological concerns. By broadening the pool of authors, we can now begin to explore many of the research questions that follow from Heider and Simmel's [9] thought-provoking experiment. What sorts of narratives can be successfully conveyed given the limits of the medium? What are the factors that govern the degree of variance in interpretations? How much can successful storytelling be attributed to the the talents of Heider and Simmel, specifically, as animators? We hope that the ever-growing number of movies and narratives collected through this application will support these analyses in the future. Additionally, it provides a new tool that researchers can use to craft visual stimuli for controlled experiments, particularly for those perception psychologists who use abstract shapes in their studies [1,5,6,16].

Similar experimental stimuli has also been popular among developmental psychologists, both for studying developmental changes in the perception of causality [4,11,14] and in understanding the developmental impairments of autism [2,10,13]. This tool may be useful in psychiatric clinical settings, particularly for children who are predisposed to interact with technology. The *Heider-Simmel Interactive Theater* may compliment other projective personality measures used in psychoanalysis, such as Rorschach inkblot tests or the Thematic Apperception Test, by allowing patients a means of interacting with ambiguous and unstructured stimuli.

Our experience with 10th grade students also encourages us to explore the educational potential of our application. We expect that the *Heider-Simmel Interactive Theater* would be useful in language arts curriculum, particularly as a tool for developing creative writing and storytelling skills. In school systems that are embracing tablet computers as educational tools, our application could potentially be used in lesson plans that include a presentation of Heider and Simmel's original research, and the influence of Heider's work on contemporary social psychology.

Our own research interests are toward the use of this application as a data-collection platform for research in artificial intelligence. As in previous research [3,12], we aim to develop algorithms that can automatically interpret and narrate observed behavior, in much the same fashion as the subjects in Heider and Simmel's original study. This authoring tool allows us to collect hundreds or thousands of movie and narration pairs from volunteers, which can be used both to evaluate the performance of our algorithms and to model the relationships between observed action, intentions, and the language used to narrate interpretations.

Last, but not least, our application affords a new form of creative expression for web users of all sorts, enabling interactive digital storytelling through the playful manipulation of geometric shapes.

Acknowledgments. We thank Ms. Maribel Gonzalez and her 10th grade students at Alliance Health Services Academy in Los Angeles for their participation in this research. This research was supported by ONR grant N00014-13-1-0286.

References

1. Barrett, H., Todd, P., Miller, G., Blythe, P.: Accurate judgments of intention from motion cues alone: A cross-cultural study. Evolution and Human Behavior 26, 313–331 (2005)
2. Bowler, D., Thommen, E.: Attribution of mechanical and social causality to animated displays by children with autism. Autism 4(2), 147–171
3. Crick, C., Scassellati, B.: Inferring Narrative and Intention from Playground Games. In: Proceedings of the 7th IEEE International Conference on Development and Learning (ICDL 2008), Monterrey, California (August 2008)
4. Dasser, V., Ulbaek, I., Premack, D.: The perception of intention. Science 253, 365–367 (1989)
5. Gao, T., McCarthy, G., Scholl, B.: The Wolfpack Effect: perception of animacy irresistibly influences interactive behavior. Psychological Science 21(12), 1845–1853 (2010)
6. Gao, T., Newman, G., Scholl, B.: The psychophysics of chasing. A case study in the perception of animacy. Cognitive Psychology 59, 154–179 (2009)
7. Heider, F.: The life of a psychologist: An autobiography. Lawrence, KS: University of Kansas Press
8. Heider, F.: The psychology of interpersonal relations. Lawrence Erlbaum Associates, Hillsdale (1958)
9. Heider, F., Simmel, M.: An experimental study of apparent behavior. American Journal of Psychology 13 (1944)
10. Klin, A.: Attributing social meaning to ambiguous visual stimuli in higher-functioning autism and asperger syndrome: The social attribution task. Journal of Child Psychology and Psychiatry 41(7), 831–846
11. Leslie, A., Keeble, S.: Do six-month-old infants perceive causality? Cognition 25, 265–288 (1987)
12. Pautler, D., Koenig, B., Quek, B.K., Ortony, A.: Using modified incremental chart parsing to ascribe intentions to animated geometric figures. Behavior Research Methods 43(3), 643–665 (2011)
13. Salter, G., Seigal, A., Claxton, M., Lawrence, K., Skuse, D.: Can autistic children read the mind of an animated triangle? Autism 12(4), 349–371
14. Schlottmann, A., Surian, L.: Do 9-month-olds perceive causation-at-a-distance? Perception 28, 1105–1113 (1999)
15. Thomas, F., Johnston, O.: The Illusion of Life: Disney Animation. Hyperion, New York (1995)
16. Tremoulet, P., Feldman, J.: Perception of animacy from the motion of a single object. Perception 29, 943–951 (2000)

Exploring Performative Authoring
as a Story Creation Approach for Children

Sharon Lynn Chu, Francis Quek, and Kumar Sridharamurthy

TAMU Embodied Interaction Lab, Department of Visualization, Texas A&M University
College Station, TX, USA
{sharilyn,quek,kumarsmurthy}@tamu.edu

Abstract. We propose performative authoring, an approach for children to author digital animated stories using pretend play or story enactment. Using a systematic methodology, we designed and developed DiME, a prototype system to explore how children may make use of performative authoring to create stories. Findings showed that children greatly enjoyed the authoring approach, and that DiME supported the child's imagination of characters, objects and environments during enactment. However, enactment for authoring lacked narrative structuring and the affordance for rapid iterative editing that is critical to creativity. We conclude that performative authoring has great potential to facilitate and even improve children's storytelling.

Keywords: Storytelling, Authoring, Children, Creativity, Enactment, Pretend play.

1 Introduction

Story authoring interfaces for children remain tied to the traditional GUI-based paradigm of the mouse and keyboard, even as other types of interactive systems, such as games, are moving towards the emerging paradigm characterized by broader use of embodiment for interaction, i.e., using broader sets of body motion or embodiment as the user interface. Unlike interfaces for consuming pre-defined content where users' actions are mostly predetermined (e.g., platform games, interactive books, etc.), or at least bounded by rules (e.g., role-playing games, sandbox games, etc.), story authoring interfaces are, by definition, engaged in the production of novel and creative output. As such, story authoring interfaces provide greater design challenges.

In the consumer arena, recent developments in story authoring interfaces for children include touch-based 'apps' such as *ToonTastic* [1], which allows a child to record an animated story by moving 'sticker-like' cartoon characters around on the tablet screen. We are not aware of any commercially available story authoring interfaces that have attempted to go beyond the display-centric interaction of the computer or of the tablet. The closest interaction approach that uses body movements for 'authoring' is the use of full-blown motion capture in the entertainment industry to enable actors to create content for animation. In the research community, a few projects have proposed prototype systems that make use of embodied motion for story authoring. We shall provide an overview of those later.

A. Mitchell et al. (Eds.): ICIDS 2014, LNCS 8832, pp. 61–72, 2014.
© Springer International Publishing Switzerland 2014

This paper explores *performative authoring*, an enactive approach that allows children to create animated cartoon stories using embodied enactment. The approach to storytelling for children is motivated by the numerous benefits of children's pretend play. Pretend play has been advocated as a basis for imaginative thinking, creativity, and combinational flexibility, as well as for other skills such as reductions in egocentricity, improvements in perspective-taking, and cooperative social problem-solving (see [2] for a review). To situate performative authoring in the space of existing designs, we first present a review of story authoring systems within a framework of embodiment. We then describe the design and development of an exemplar performative authoring system: the DiME (*Digital Micro-Enactment*) system. Finally, we describe an exploratory study of how DiME was used by children, aged 8 to 10. Findings inform further development of our prototype system, and contribute to the understanding of how embodied enactment may be used to allow children to author stories.

2 Embodied Story Authoring Systems

Figure 1 classifies representative embodied story authoring systems into three types: (i) *Direct manipulation* – the child manipulates story elements onscreen through the mouse pointer or finger touch interaction; *(ii) Puppeteering* – the child controls story characters through manipulation of external physical objects; *(iii) Enactive* – the child performs the role of story characters. Each of these approaches possesses different characteristics by which the child expresses her imagination. Figure 2 illustrates the problem of digital story authoring. Essentially, storytelling is an idea-driven process founded on creativity that may be defined as a process of recombination of bits drawn from real-life experiences [3, 4]. Say, the child wants the hero of her story to wave goodbye, and walks away from his village, sad that he is leaving his parents. She now needs to translate this into actions by a *graphical representation* of the hero character. Figure 2 summarizes distinctions of how the child may realize this in the three types of authoring interfaces. For both the *direct manipulation* and *puppeteering* interfaces, the child will have to know that waving can be decomposed into a series of repeated movements of an upraised arm tracing an arc, and that 'walking sadly' may translate to 'walking slowly with hunched shoulders and dipped head'. For a *direct manipulation* interface, the child will further need to know the appropriate

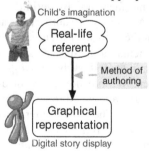

Interface Type	Tool	Focus	Perspective
Direct manipulation	Mouse cursor	Graphical object	Allocentric
	Finger	Graphical object	Allocentric
Puppeteering	Puppet	External proxy	Allocentric
Enactive	Self	Idea	Egocentric

Fig. 1. Story authoring interfaces **Fig. 2.** Story authoring

actions to realize these movements in the graphical avatar using the mouse and key-board. With *puppeteering* interfaces, the child may be aided by the affordances of an appropriately-designed puppet to, for example, execute the waving motion by moving the puppet's upraised arm back and forth using the natural joint constraints.

In the *Enactive* interface, the child neither engages in motoric decomposition nor in the mechanics of a particular tool use. The instrument is the child's own body, an instrument with which she already has experience 'in her body' (from an egocentric point-of-view). Her focus is on the story idea itself, making storytelling the idea-driven process it is meant to be. This is in distinction to the requirements of both *direct manipulation* and *puppeteering* to construct the necessary decomposition from an allocentric perspective before overcoming the operational burden of executing the constituent actions. Thus, authoring through the *enactive* is perhaps the most intuitive and seamless for the child. Quoting Pederson et al. [5], the child's imagination (in storytelling) is effectively supported when she can move "from action in response to objects present in the perceptual field (e.g., the graphical object, the external proxy) to action generated and controlled by ideas".

Wayang authoring [6, 7] is a *direct manipulation* interface that enables children to author stories in the form of shadow puppetry, a traditional Indonesian storytelling art. The child composes a story using a web-based graphical user interface by clicking and dragging objects on a 'stage'. The system records the direction and speed of the dragging movement as 'the story being told'. The authors reported that "the visual appearance and the implemented work flow were first uncommon but easy to handle for most of the children". However, only informal testing of the system was reported.

Video puppetry [8] allows children to tell stories through *puppeteering* with cut-out-style animations. After drawing and cutting out the story elements using paper and scissors, the user moves the paper-based elements in front of a camera. The software processes the input frames from the camera by detecting the 'object' drawn and tracking it as the user moves the cut-out element around, and removes the user's hands from the video. Although the system was not specifically designed for children, it was showcased at several public events where it was used by children. The authors reported that "the system is easy to learn and use. All users were able to control the onscreen puppets with minimal instruction because the interface is so transparent."

We did not find any *enactive* interfaces that were designed specifically for children to author stories. *Handimation* [9] maps the movement of a 3D virtual character to a user's movements by requiring the user to use three wiimotes (one in each hand, and one attached on the top of the head), but the interface follows a music sequencer metaphor and is rather complex to use. The system was developed for animators. The approach of performative authoring that we present in this paper is an 'enactive' method that simulates children's role-playing or pretend play to enable children to author digital stories. The following sections describe the theoretical foundation of the approach, and the principled design of a system based on the approach.

3 Performative Authoring: Pretend Play for Digital Storytelling

We focus on children between the ages of 8 to 10 as they undergo significant socio-cognitive developmental changes. Changes include the emergence of strong social

awareness [10], the beginning of the development of logical and hypothetical thinking [11], and the need for competence and the formation of one's self-concept [10]. The child in this phase thus is in critical need of support and scaffolding. Pretend play (sometimes also called make-believe, imaginative play, or story enactment) has been shown to be beneficial not only more generally as a 'zone of proximal development' [12] for the development of cognitive skills such as problem-solving, but also more specifically for the budding literacy and storytelling skills. Comparing the recall of narrative structures after 4- and 5-year-old children engaged in conditions where they either pretend play enacted stories or only listened to stories, Kim [13] found that over short time periods, pretend play can facilitate narrative recall and expression. Chu et al. [14] also described a study that showed that the story quality in terms of richness and coherence was significantly better when children enacted story scenes with physical objects than when they simply viewed a narrated video of the story, especially when the enactment of the children involved imagination beyond a certain threshold.

According to Lillard [15], the necessary and sufficient components for pretend play to take place include: *1) A pretender* (i.e., the child) ; *2) A reality* – the real world in which we are constantly immersed (i.e., the bounded space within which the pretend play takes place); *3) A mental representation that is different from reality* (i.e., the idea of a story character, or of a non-visually present story object); *4) A layering of the representation over the reality, such that they exist within the same space and time* (i.e., the child imagining herself as the story character, the child projecting on a visually-present object); *5) Awareness of the pretender of components 2, 3, 4.*

These components are integrated for use in pretend play across three subparts:

Character Play: The child takes on the role of someone who she is not. Pretend play by children is a key contributor to the development of what cognitive psychologists call the 'theory of mind', the human ability to "explain people's behavior in terms of their thoughts, feelings, beliefs, and desires" [16]. Being able to associate and interpret observed behavior with underlying mental states is essential for character playing. Theory of mind has also been related to perspective-taking.

Object Substitution: The child imagines an object to be something else (E.g., a stick becomes a horse). Much imaginary object substitution involves 'projection', defined by Kirsh [17] as "augmenting the observed thing, of projecting onto it".

Fantasy Worlds: The child imagines a surrounding environment that is not present. The creation of mental imagery that specifies an ambient 'world' has been called the ability for 'broader imagination by Chu et al. [18].

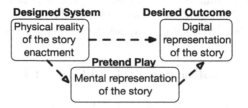

Fig. 3. Performative authoring

Within each of these subparts, the child has to simultaneously engage with the *physical reality* in which she is acting, and her own *mental representation*. However to make use of pretend play to author <u>digital</u> stories, an additional layer of representations is required: the *digital representation* of the story being created. The layering of these elements is at the core of our proposed approach of performative authoring. Fig. 3 illustrates it conceptually. The end goal of performative authoring is to produce stories in a digital form, which can be text-, graphics-based, animation, or multimodal in nature. The environmental structures extant during performative authoring are critical, as it shapes the reality of the child while she engages in the creation of stories. Within this setup, performative authoring asks the child to overtly enact her imagination of character roles and to imagine object props and surrounding worlds.

Practically therefore, a system based on performative authoring needs to consist at the minimum of: **i.** A setup that enables a child to create a digital story through pretend play/enactment; **ii.** Structures that support a child's imagination or mental representations as she enacts; **iii.** A way for the child to view and edit her digital story.

A performative authoring system embodying these specifications can be designed in a myriad of ways. In the next section, we lay out the design pathways and rationale for the prototype system that we developed to explore the authoring approach.

4 Designing *DiME*: A <u>D</u>igital <u>M</u>icro-<u>E</u>nactment System

Design Methodology: In order to avoid losing the wood for the trees, we followed the *Finding-NEVO* 'design-oriented research' methodology proposed by Chu et al. [19] to design DiME to exemplify performative authoring. The approach "articulates a methodology to select design ideas that yield prototypes that are faithful to a conceptual rationale and seed idea". As such, it ensures the validity of both a research prototype and the scientific process that employs the prototype for testing and inquiry.

Finding-NEVO specifies that a set of 'idea-defining characteristics' should be produced arising from the seed idea for the system (in our case, using pretend play for story authoring). We used the 3 core requirements (i) - (iii) listed in Section 3 as our guiding list of idea-defining characteristics. In a 'gatekeeping process' that precedes each system development cycle, every prospective design feature is evaluated against

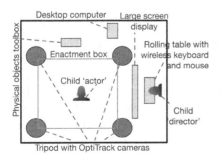

Fig. 4. DiME setup

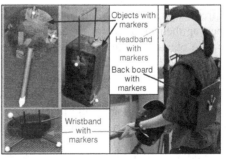

Fig. 5. Reflective markers

the idea-defining characteristics list. The rationale for key design decisions included consideration for the abilities of children in our target age range, technical possibility and feasibility, time constraints, study findings from prior literature, etc.

System Description: DiME captures the movements of a child using a physical object, and mirrors the actions in real-time through an animated cartoon character with a graphical prop. To capture children's enactments, we used the OptiTrack [20] motion-capture suite to track body and physical object movements, and an external microphone to capture sound effects or any narration that the child may make while enacting. Figure 4 shows the setup of DiME. Reflective markers are embedded in props for acting and in wristbands, headbands, etc. worn by the child (Figure 5).

The main interface consists of a series of frames set in a filmstrip-like visual metaphor (see Figure 6). The child creates a story scene in each frame using either text or enactment. Figure 6A shows the text editor interface. If the child chooses to enact a story scene/frame, she is first asked to choose a 2D cartoon character. She can then choose to act with a prop from a library (Figure 6B), or without one. After the child selects the graphical prop, the system directs her to pick up a corresponding physical object to use in her enactment. DiME maps the available 3D graphical props to 'generic' physical objects according to 'affordances'. The mapping is one to many where each physical object is mapped to several graphical props with similar interaction affordances. For example, the racket-like physical object in Figure 5 can be a graphical tennis racket, guitar, frying pan, fan or stop-sign prop.

During enactment, the cartoon character and the graphical prop (if selected) are shown against a white background. As the child 'actor' moves around in the tracked space with the physical object, the cartoon character follows her movements in real-time. When the 'actor' is ready to start the enactment, the child 'director' starts the recording of the cartoon animation by pressing the spacebar on a wireless keyboard.

DiME was pilot tested for usability with two children (one girl and one boy aged 8 and 10 respectively) in a laboratory setting. The updated version of the system after bug fixing was used in the exploratory study.

5 Exploratory Study with DiME

Study Description: We ran a study to investigate the use of DiME by children at a local 'Boys and Girls Clubs of America' afterschool program. The participants were 7 children (4 girls, 3 boys), all aged between 8 and 10 years old. Parents voluntarily signed up their children for the study, and completed a consent form. Verbal assent was also obtained from each child for her willingness to participate. The study ran over a period of two weeks. The children used the system in pairs on certain weekdays from 4 to 6 pm. Study activities included a i) familiarization session consisting of an ice-breaking game with the researchers, the researchers explaining to the children how to use the system, and practicing creating stories with DiME; ii) story creation session based on a given theme, and iii) post-study interview. The story theme given to the children for the story creation session was 'An adventure in the jungle'. The children were told that their story had to contain *at least* two enactment frames and two text frames. Figure 7 and Figure 8 show the use of DiME during the study.

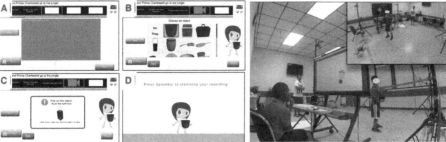

Fig. 6. DiME user interface Fig. 7. Children using DiME

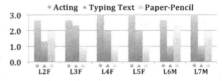

Fig. 8. Enactment Mapping Fig. 9. Fun Sorter *(Y-axis: coded ranking)*

In the post-study interview, a questionnaire was administered to the child to assess her experience of storytelling via enactment, via text, and via the approach of paper-and-pencil typically used at school. We used survey methods from the Fun Toolkit [21] developed specifically for use with children. These include the smileyometer (5-point Likert scales from 'Awful' to 'Brilliant'), the Fun Sorter (ranking of storytelling methods on 'I like', 'Is fun', 'Makes me happy'), and the Again-Again table (choice of 'yes', 'maybe', 'no' for motivation to do it again).

The amount of time allocated to each activity of the study was not restricted since we were interested in exploring system use and study protocol with the children. Table 1 summarizes the pair groupings of the children (M: Male, F: Female) and the full stories produced. All sessions were audio and video recorded.

Data Analysis. Answers to each question in the post-study questionnaires were numerically coded and entered in a spreadsheet for statistical analysis. We used both the animated cartoons created, as well as the actual video of the children's enactments for story enactment analysis. Children's narrations in the enactment videos were transcribed with speaker labels (actor, director), and a text summary of each story scene was produced to facilitate analyses.

Findings: Children's System Evaluation. The results of the children's assessment from the post-study questionnaires were overall very positive. Mean ratings on the 5-point Likert-scale smileyometer were: Acting ($\mu = 4.3$); Paper-pencil ($\mu = 3.7$); Typing ($\mu = 3.2$). However, examination of the individual scores showed that some children gave the same ratings for at least two of the methods. Results from the Fun Sorter, which required children to rank order the methods, were more conclusive.

Table 1. Children pairs in our study

Children IDs	Story IDs
1M, 3F	A
3F, 5F	B
2F, 4F	C
6M, 7M	D

Table 2. 'Again-Again' results

	Acting	Typing	Paper-Pencil
Yes	6	1	2
Maybe	0	5	2
No	0	0	1

The method ranked 'Best' was given a score of 3, and the one ranked 'Worst' was scored 1. Combined mean scores for the three dimensions of the Fun Sorter are shown in Figure 9. Similarly, results from the 'Again-Again' question, in Table 2, showed that children were overwhelmingly motivated to continue using DiME.

Findings: Children's System Use. There were a total of 11 enacted story frames and 7 text frames across 4 stories. Enacted story frames lasted on average 50.18 seconds. We describe ways in which the children used the system under three headings:

i) Actor-Director Collaboration Strategies: We identified three main approaches used by the children to author stories collaboratively during enactment. Collaborative actions were seen at 2 levels: in terms of the actual content of the story and at a meta-level management of the storytelling process (enactment recording, timing, etc.):

A. The *director's initiative* was especially evident in Pair D (ref. Table 1). The director allows the actor to make up the story, but decides to terminate the recording of the enactment by himself when he notices long pauses or repetitions in the actor's acting. E.g., the actor acts out repetitively fighting against a lion until the director says "Alright" and stops the recording. In this case, story content is determined by the actor while the meta-level is controlled by the director; **B.** *Co-creation in real-time* was an approach used by Pairs B, C and D. The director frames the story on the fly or reads off a planned script, that the actor acts in response. E.g., the director announces: "She's looking for her friend Mary." The actor acts out searching around and calls out "Where are you?". Here, the director and the actor co-create both the story content and the meta level; **C.** *Communicating through acting* was seen in Pairs A and C. The actor indicates to the director that she wants to terminate the enactment by acting out the story character exiting the scene in some way. E.g., while acting out hitting on a cave wall, the actor calls out still in-character "I'm tired. I'm going to take a rest." In this case, the actor determines both the story content and the meta-level.

ii) The Role of Text Story Scenes: The children did not seem to understand the concept of continuous story frames represented by the filmstrip metaphor that we used in the story creation interface of the system. The filmstrip is a series of frames that the user 'fills' either with text or an animation to construct the scenes in her story (ref. Figure 6). The children used text frames in four ways:

A. To express a *summary of the enacted story scenes* that precede it. E.g., after an enactment of using an 'axe' (virtually) to hit around the space, Pair A typed in the following text frame: "once there was a boy and girl named Mary and John and they lived in a cave. one day they got an axe and hit there cave and hit it. and rebuilt it and it looked like the best cave ever."

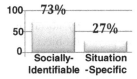

Fig. 10. Role identification

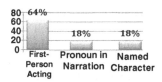

Fig. 11. Methods of character identification

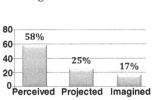

Fig. 12. Pretend play with object

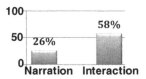

Fig. 13. Expression of environmental elements

B. To construct *disconnected, self-contained stories*. E.g., Pair B enacted a story about two friends being separated in the jungle in the first two frames, and then started another story about two sisters getting bitten by a dog in the text frame.

C. To *contextualize the enacted story*. E.g,, Pair D used the text frames to set the overall topic of their story ("this story is about this boy finding some gold") and to provide an epilogue after all their enacted scenes ("well that was a good aventure i found gold thats good now im rich and played my catar [guitar] and it was good.").

D. To *continue enacted story* scenes. This was the approach that we expected the children to use for the text frames, but it was surprisingly used consistently only by one pair. E.g, Pair C used two frames to enact a girl falling off a plane into the jungle and being attacked by a tiger, and continued the story using text, writing about a gang of monkey that came to harass her next.

iii) Extent of Imagination: We analyzed how DiME supported the child's imagination during story enactment in terms of the three components of pretend play:

I. *Character play*. We coded for the roles that the children created during story enactment. 73% of the enacted scenes contained roles that were socially or culturally identifiable (e.g., pop star, baseball player, gold miner). The other 27% (Figure 10) acted story roles that were situation-specific (e.g., losing a friend in the jungle). We also looked at how the children made explicit the various roles in their story scenes (Figure 11). Most acted the roles in the *first-person* with no explicit referencing (64%), some used *third-person pronouns* (18%) such as "she lost her friend" especially in the director's narration, and some *named the characters* they were acting (18%).

II. *Object substitution*. We coded the stories created for objects that the story characters used. We classified the objects according to Kirsh's model of 'thinking with external representations'. His model specifies three types of representations: *Perception* – entirely dependent on the physical stimulus present (i.e., the physical object used for enacting, the graphical prop onscreen, and the imagined object in the child's mind all align. E.g., in Figure 8, the physical stick object is the digital axe, and is imagined as an axe by the child); *Projection* – anchored to the physical stimulus but not entirely dependent on it (i.e., the physical object and the graphical prop align,

but the imagined object does not. E.g., the physical stick object controls a digital axe, but is imagined as a baseball bat); and *Imagination* – entirely not anchored to any physical stimulus (i.e., an object is imagined, but no physical object is used and no graphical prop can be seen. E.g., the child imagines picking up gold nuggets that have no physical representation in reality). Figure 12 shows the distribution of objects.

III. *Fantasy worlds.* We coded each enacted story scene for environmental elements, i.e., objects, characters and animals that the child imagines in the story setting as she enacts. Across all enacted scenes, 73% had some degree of setting imagined by the children. There were on average two environmental elements evident in the enacted scenes. Figure 13 shows the manner in which environmental elements were manifested. Most of the environmental elements were made evident through *enactment of interacting with the element* (58%), e.g., targeted picking-up action of a gold nugget, looking around at the "real beautiful flowers" in the jungle. The rest (26%) were evident only through *narration by either the director or the actor's speech*.

6 Discussion

The goal of performative authoring is to enhance the creativity, coherence and richness of children's storytelling by tapping into the imaginative power of pretend play to provide children with the freedom to imagine and the transparency to translate their imagination into actual story-products. We used the DiME prototype system in an exploratory study to understand its impact on children's story creation. Our results show that children had a positive response to the system, as compared to the traditional story authoring techniques of keyboard typing and pen-and-paper writing.

Children showed great flexibility in how they collaborated within DiME's director-actor framework to create the story content and the meta-level management of process through the director's initiative, co-creation, and in-character acting. All of the three collaboration methods were spontaneous, a lot more like improvisational theater rather than a scripted play. DiME itself did not enforce/integrate story planning as part of the system interface. Instead, we allowed children to plan their story using large drawing sheets and markers before enacting, but few of them used them. When used, the children wrote out the enactment scenes in their planning sessions. We posit that performative authoring as a storytelling method may lead to holistically better stories when narrative structuring is also supported through the system, or external means.

We expected text in the story enactment system to be used to describe scenes that advance the story. Instead, text in a performative authoring system was integrated in several ways, e.g., as summary textboxes, story scene textboxes, encapsulation textboxes (for prologues and epilogues). This also shows that the filmstrip metaphor that we decided to use to convey the idea of a story as a series of animation frames in DiME may be hard to grasp in the mental model of some children. A filmstrip is common knowledge for an adult with a basic understanding of movies. For a child however, authoring a story by creating a collection of scenes may not seem intuitive. This runs counter to our intention of extending and sustaining the child's story imagination, and suggests the need to investigate appropriate visual interface metaphors

that can convey the connectedness of an animated storyline to children. Moreover, the tendency of children to use a single frame to enact whole, self-contained short stories may also be counter to the quick editing and iterative process that is critical to creation or authoring. While using frames for whole stories may not be a problem for consumption-oriented storytelling systems, the capability for quick editing is important in creativity-oriented systems. The problem is that long and continuous enactment segments are unwieldy, and not amenable to the kind of iterative/rapid editing that support creative manipulation. We may need to study features that from the child's perspective, allow the system to encourage and support the creation of shorter, micro-enactments that can be edited quickly and constituted into larger story arcs.

The support of the layering of imagination over reality through DiME in terms of character play occurred mostly through first-person acting. Taking the role of a character in their story from an egocentric point-of-view required children to engage in perspective-taking and the development of a theory of mind. Object imagination was satisfactory with a good proportion of perceived, projected and imagined props used. However, children were less engaged in the imagination of story environments. One reason may be our design decision of having the animated character against a white background instead of a contextual picture. Research is needed to understand design factors to support children's imagination of fantasy worlds during story enactment.

7 Conclusion

We proposed an enactive approach called performative authoring for children to author digital stories using pretend play or body enactment. We used a systematic design methodology to develop DiME, a prototype system that embodies the authoring approach, and conducted an exploratory study to understand how children use such a system and approach to create stories. Pretend play brings with it many benefits in terms of cognitive and social development for the child. In mapping pretend play to a story authoring approach, we seek to preserve these benefits while investigating factors to support the child's ability to tell stories. Based on our study results, performative authoring appears to have great potential for children's storytelling.

References

1. Launchpad Toys. ToonTastic: Lights, Camera, Play (2014),
 http://www.launchpadtoys.com/toontastic/ (cited June 8, 2014)
2. Fein, G.G.: Pretend play in childhood: An integrative review. Child Development, 1095–1118 (1981)
3. Vygotsky, L.S.: Imagination and Creativity in Childhood. Journal of Russian and East European Psychology 42(1), 7–97 (2004)
4. Finke, R.A., Ward, T.B., Smith, S.M.: Creative Cognition. MIT Press, Cambridge (1992)
5. Pederson, D.R., Rook-Green, A., Elder, J.L.: The role of action in the development of pretend play in young children. Developmental Psychology 17(6), 756 (1981)

6. Widjajanto, W.A., Lund, M., Schelhowe, H.: Wayang Authoring: a web-based authoring tool for visual storytelling for children. In: Proceedings of the 6th International Conference on Advances in Mobile Computing and Multimedia, pp. 464–467. ACM (2008)

7. Widjajanto, W.A., Lund, M., Schelhowe, H.: Enhancing the Ability of Creative Expression and Intercultural Understanding through Visual Story. In: Spaniol, M., Li, Q., Klamma, R., Lau, R.W.H. (eds.) ICWL 2009. LNCS, vol. 5686, pp. 444–453. Springer, Heidelberg (2009)

8. Barnes, C., Jacobs, D.E., Sanders, J., Goldman, D.B., Rusinkiewizsz, S., Finkelstein, A., Agrawala, M.: Video puppetry: a performative interface for cutout animation. ACM Transactions on Graphics (TOG) 7(5), Article 124 (2008)

9. Svensson, A., Björk, S., Åkesson, K.-P.: Tangible handimation real-time animation with a sequencer-based tangible interface. In: Proceedings of the 5th Nordic Conference on Human-computer Interaction: Building Bridges, pp. 547–550. ACM (2008)

10. Eccles, J.S., The development of children ages 6 to 14. The Future of Children, 30–44 (1999)

11. Piaget, J.: The language and thought of the child. World, New York (1923)

12. Vygotsky, L.S.: Mind in Society: The Development of Higher Psychological Processes. Harvard University Press (1978)

13. Kim, S.-Y.: The Effects of Storytelling and Pretend Play on Cognitive Processes, Short-Term and Long-Term Narrative Recall. Child Study Journal 29(3), 175–191 (1999)

14. Chu, S.L., Quek, F., Tanenbaum, J.: *Performative Authoring:* Nurturing Storytelling in Children through Imaginative Enactment. In: Koenitz, H., Sezen, T.I., Ferri, G., Haahr, M., Sezen, D., Çatak, G. (eds.) ICIDS 2013. LNCS, vol. 8230, pp. 144–155. Springer, Heidelberg (2013)

15. Lillard, A.S.: Pretend play skills and the child's theory of mind. Child Development 64(2), 348–371 (1993)

16. Zunshine, L.: Why we read fiction: Theory of mind and the novel. Ohio State University Press (2006)

17. Kirsh, D.: Projection, Problem Space and Anchoring. In: 31st Annual Conference of the Cognitive Science Society, pp. 2310–2315. Cognitive Science Society, Austin (2009)

18. Chu, S., Quek, F.: MAIA: A Methodology for Assessing Imagination in Action. In: CHI 2013 Workshop on Evaluation Methods for Creativity Support Environments. ACM, Paris (2013)

19. Chu, S.L., Quek, F., Wang, Y., Hartson, R.: *Finding-NEVO*: Toward radical design in HCI. In: Winckler, M. (ed.) INTERACT 2013, Part I. LNCS, vol. 8117, pp. 471–478. Springer, Heidelberg (2013)

20. Natural Point Inc. Optitrack: Body Bundles (2013), http://www.naturalpoint.com/optitrack/products/motive-body-bundles/ (cited October 14, 2013)

21. Read, J.C., MacFarlane, S.: Using the Fun Toolkit and Other Survey Methods to Gather Opinions in Child Computer Interaction. In: IDC 2006: International Conference for Interaction Design and Children, Tampere, Finland, pp. 81–88. ACM (2006)

Interweaving Story Coherence and Player Creativity through Story-Making Games

Mirjam P. Eladhari, Philip L. Lopes, and Georgios N. Yannakakis

Institute of Digital Games, University of Malta,
Msida MSD 2080, Malta

Abstract. In story-making games, players create stories together by using narrative tokens. Often there is a tension between players playing to win using the rules of a story-making game, and collaboratively creating a good story. In this paper, we introduce a competitive story-making game prototype coupled with computational methods intended to be used for both supporting players' creativity and narrative coherence.

Keywords: story-making games, computational creativity, co-creation.

1 Introduction

Tabletop *analog* story-making games such as *Fiasco* (Bully Pulpit Games, 2009), *Once Upon a Time* (Atlas Games, 2004) and *Microscope* (Lame Mage Productions, 2011) allow players to make stories together in a playful manner, where the resulting narratives is the product of play. Within the C2Learn Project the aim is to foster human-human creativity (co-creativity), via games and novel computational approaches. The domain of story-making games is highly co-creative in that players, via game rules, use tokens for narrative play in order to partake in a playful process that results in told stories. Our hypothesis in this paper is that the use of innovative computational tools that support a players' creativity in a story-making game could further foster human co-creativity, and also potentially result in story-making games that both support a players' creativity and help the creation of more coherent stories. With that hypothesis in mind, we are developing several varieties of *digital* storytelling games for use with tablet computers to be tested for their capacity to foster human co-creativity. The tablet platform allows for retaining the play modality of analogue table-top story-making games while, at the same time, facilitating the addition of computational aids as a core part of the games.

By *creativity* in our context, we define a process that results in the creation of story elements and artifacts within a story domain which are perceived by humans as novel and valuable [2]. Within the games proposed here co-creativity emerges through the unique collaboration of players with each other as well as players with advanced computational assistants.

To test our hypothesis we designed a table-top story-making game, we name *4Scribes*, that we playtested in an informal manner with our planned computational tools in mind. In particular we developed a deck of cards as narrative

A. Mitchell et al. (Eds.): ICIDS 2014, LNCS 8832, pp. 73–80, 2014.
© Springer International Publishing Switzerland 2014

tokens representing a set of storytelling elements such as characters and events to function as creative stimulus for players. Our playtests indicated that the tokens could function well as such, although a certain level of abstraction was necessary. Tests also showed that players easily got carried away on exploratory associative journeys.

Our key challenge during the design process was that the digital story-making game would not only be enjoyable to play but also result in coherent narratives that would justify for both novelty and value [12]. The above defined the design goals of this project. In order to achieve those two goals we are inspired by three popular aspects of computational creativity defined by Ritchie [12]: *novelty, typicality* and *quality* of machine-generated artifacts. Those aspects are integrated within a number of computational game "Assistants" that choose which artifacts (i.e. digital card tokens in a story-making game) players will use during play, in such a way that artifacts chosen maximize either a) the coherence (i.e. *typicality*) between an artifact and a set of expert-defined artifacts; or b) the *novelty* of an artifact by choosing the most novel out of a set of artifacts that has been played; or c) the *quality* of an artifact by picking the most valued artifacts rated (or ranked) by the players themselves.

First, this paper provides a brief overview of story-making games and approaches from creativity theory that are promising for the genre. Second, the game prototype *4Scribes* is described along with a brief recount of observations made during early playtests. Thirdly, we describe the computational approaches that will be used in the digital tablet version of the game, that may support both co-creativity and coherence in the narrated stories that are the product of play.

2 Background

While the literature is rich on the investigation of collaboratively emerging stories and storytelling in massively multiplayer role playing games, live action role play, and table top role playing games, it is rather sparse when it comes to cooperative story-making games. One important difference between the other game genres above-mentioned and story-making games is that in the latter, players do not act via an avatar or a game persona. Instead, players act as authors or narrators, collaboratively telling stories *about* the story tokens represented in the games, such as characters or objects. However, both Mitchell [9] and Wallis' [13], (whose work define, to the best of our knowledge, the only studies on story-making games) recognize that there often is an inherent tension in the genre between winning a story-making game and creating a good story through the game.

Creativity is an important facet of story-making games and creative writing in general. Boden [2] describes creativity as a process that results in novel, valuable and surprising outcomes for the creator and her society. Some game mechanics such as the tokens in *Once Upon a Time* or *Dixit* (Libellud, 2008) do have a clear creative purpose, such as stimulating multiple interpretations of an artifact during play. Lateral Thinking [5] theory suggests that problems

that seem unsolvable can be solved through an indirect and creative approach through the aid of random (or heuristically-driven) stimuli that help thinking *out-of-the-box* or braking one's lateral path of thought. The *random stimulus* principle of lateral thinking [1] implies the introduction of a foreign conceptual element with the purpose of disrupting preconceived notions, ideas and habitual patterns of thought, by forcing the user to integrate and/or exploit the foreign element in the creation of an idea.

This random stimulus concept is a predominant feature of analogue story-making games. In such games a large amount of predefined sets of stimuli — which are hand-picked by designers and specifically ad-hoc designed — are usually provided to the players; although, arguably, the novelty capacity of such stimuli eventually decreases after multiple play sessions. By bringing story-telling games into a digital medium this limitation can be combated through player- or machine-created stimuli, which can then be picked for play algorithmically. Specifically for story-making games, the semantic difference between two artifacts can be used [8,4] in order to estimate the distance between a word in relation to a set of words associated to a specific theme or domain. Alternatively, a crowd-sourcing methodology, where players rank created artifacts, can be used to machine learn their value within the domain. In *4Scribes* artifacts are automatically chosen by applying Ritchie's [12] creativity metrics which rely on the semantic difference between words as well as their peer-evaluated quality (player ratings or ranks of artifacts). The metrics are described in detail in section 4.

3 Prototype Design and Testing

The design of the story-making games and the computational approaches supporting co-creativity for the C2Learn Project have been conducted in an iterative manner where simple prototypes have been tested and refined [7]. Our designs are inspired by existing story-making games. We use both symbolic images such as in *Story Cubes* (Rory OConnor, 2005) and words such as in *Once Upon a Time* as the narrative artifacts (i.e. game cards), and we use a similar way of generating the starting setting for a game as in *Fiasco*. Also inspired by *Once Upon a Time* players have a "hand" of cards as narrative tokens that they use during play creating a cooperative story.

The most promising of our early story-making game prototypes was *4Scribes*. In this section the *4Scribes* prototype and observations from its playtests are described. Due to space constraints the description herein is brief; instead, the section focuses on those observations we consider most relevant to coherence and creativity for story-making games.

In the *4Scribes* paper prototype three to five players collaboratively create a story while secretly steering it towards their own personalized endings. At the start of each gameplay session the game master sets a theme and a setting for the story. Players are dealt cards from a deck containing character, scene (that can be emotions or events), and myth cards that represent more dramatic

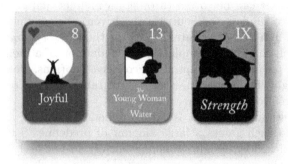

Fig. 1. Examples of narrative tokens in *4Scribes*. From the left: A Scene card, a Character card, and a Myth card.

story changing events (see Figure 1). Players each formulate a secret ending. The game is played in rounds where each player tells the continuation of the story by selecting one card from their hand, taking turns, until all cards are played. Each card has both a semantic meaning (i.e. a set of words) and a diagrammatic representation of that semantic meaning (see Figure 1). At the end, players reveal their endings and vote for whose ending best fits the story.

Ad-hoc Playtest. *4Scribes* underwent "ad-hoc" tests [6]. These tests are typically the first to be conducted, ensuring that the game is mechanically sound before the work of piloting with end users and software prototyping starts.

Five playtest sessions were conducted with three to five players in each session. Of these, three sessions were conducted in Malta and two in Greece.

In total, the game was played by 10 players, 3 of which were female. Their average age was 37.5. All participants except one had experience playing board games, and all participants had experience of playing digital games.

In each playtest session, players were first briefly introduced to the key concepts of the game and encouraged to "think aloud" during the whole playtest. After playing, the players were interviewed about experience playing the game, followed by a survey for each player to answer with similar questions.

Observations. In our playtest, we paid attention to those instances where players' creativity seemed hampered, in that they did not know what to do, or that the affordances given in at a particular time did not help them to come up with ideas on how to progress the story. With regards to the cards (creative stimuli) given to players, we made observations that led us to change both (1) what mix of cards players got in their hand at the beginning of play, and (2) the deck of cards. For example, we noted that too many character cards caused confusion and hesitation. Limiting the hand to contain only one character card appeared to work better, and resulted in the general pattern that players tended to use that card first, introducing 'their' character.

On several occasions players hesitated when they were to use numbered cards with only a single word on them, noting that it was too abstract to them. We also noted that the cards with images on them seem to sparkle more ideas, in comparison to those cards that did not have images on them. Players stated that they liked the myth cards better because they had illustrations. For the character cards, the feedback from players was quite the opposite: they were too concrete. The first naming of the cards used the traditional card deck names for them, such as "King" and "Queen". This was, in two sessions, interpreted in a literal fashion so that the settings became those of royal courts. To us, it seemed as it was crucial for the play experience to have the tokens used as external stimuli to be at the 'right' level of abstraction: concrete enough to give stimuli, but abstract enough to allow for the own creative input.

We saw that players gradually, while playing, forgot the initial theme and setting of the game session. Instead, players got carried away and created stories that albeit interesting, sometimes were extravagant and with a low degree of coherence.

Given the limited number of players and the early stage of the design, the players' responses can only be seen as illustrations and indications. However, the observations allowed us to further develop the computational approaches used for the story-making games in C2Learn as described in the next section.

4 Computational Approaches for Supporting Creativity and Coherence in Story-Making Games

In the ad-hoc playtests we noted the dichotomy identified by Mitchell [9] and Wallis [13] between players *cooperating* to create a good story and *competing* to win; in *4Scribes* they achieve the latter by steering the story towards players' own secret endings. This player behavior opened new opportunities for using computational approaches that would steer towards typicality as a possible means to increase story coherence but while still maintaining the competitive goals of the game which act as an important driving force for the game play. In this paper we explore the use of user-generated digital content (i.e. cards) — see section 4.2 — and computational assistants that serve as heuristically-driven stimuli to player's creativity (see section 4.3) within story-making games.

4.1 The Tokens for Narrative Play in *4Scribes*

The deck of cards used in *4Scribes* are the narrative tokens used by players as creative stimuli during play. The deck was reiterated several times in order to present a balance of characters, events, objects, and actions that may be used across games. When creating the deck we took into account common game elements from adventure games and story-making games along with inspiration from basic components from narrative theory, mostly from Propps Morphology of the FolkTale [11], Campbells The Hero with a Thousand Faces [3], and Poltis 36 dramatic situations [10].

The tablet version of *4Scribes* has a deck consisting of 95 to 114 cards. It has several suits with 19 cards each: Fire, Water, Wind, Earth, Fifth and Myth. The purpose of the suites is to provide a structured set of tokens that contain types of stimulus that can aid in the creation of narratives. The Fire, Water, Wind and Earth are of two different types: Character or Scene. The Scene cards are of four types, loosely corresponding to their suits. The Fire Scene elements represent emotions, The Water elements represent actions, the Wind elements represent events, and the Earth elements represent objects. Each suit has 12 scene cards and 7 character cards. The Character cards represent different roles and character archetypes (see Figure 1 for a sample of cards available within the deck of *4Scribes*).

4.2 Co-creation of Narrative Tokens

The tests indicated that the tokens for creative stimulus needed to be of an abstraction level that both gave enough information for allowing creative association, but at the same time not be too specific. In order to address this we reiterated the card deck along with the playtesting. In addition we devised features for players to create their own cards that can be used in play in the tablet version of *4Scribes*. The aim with the player-created cards is that they would further increase the co-creative aspects in a story-making game and would allow players to add elements that have individual meaning to them.

Players can modify the cards, and make their own varieties that they can use in play in *4Scribes*. These modified cards become part of each players personal decks. Players can also create their own, completely customised cards - these become cards in the 'the fifth element' suite. The 19 Myth cards cannot be changed, each representing an important story changing event such as Justice or Death.

The card tokens created will be stored in a shared virtual space, that will contain an increasing amount of cards that players create. Players can rate each others card by 'liking' them, and as such some cards will have higher ratings than others. At the start of each new game session, the game master may define a setting (such as 'space' or 'London in the Victorian Era') and a theme, (such as 'Love conquers all'). They can also, optionally, define a set of typical terms by picking tokens from the virtual space. This provides information that the Assistants use when picking cards for use in a play session as described in the following section.

4.3 Selection of Narrative Tokens Using Computational Assistants

Three game Assistants developed for *4Scribes* pick from a deck of cards, including player-created ones, and provide a starting hand for players. In order to stimulate creativity, improve the quality of cards available within a story domain, and provide semantically-coherent cards within the *4Scribes* game three metrics have been developed to drive the card selection from each of the three Assistants. In particular, the novelty, quality, and typicality metrics designed (and

their corresponding Assistants) are associated with creativity stimulation, card quality, and story coherence, respectively. These three metrics are inspired by Ritchie's [12] criteria on evaluating computational creativity and are described below.

The first metric is *novelty*, n, which is calculated as follows:

$$n(i) = \sum_{j=1}^{k} d_s(i,j)/w_i \tag{1}$$

where $d_s(i,j)$ is the semantic difference (as e.g. the one used in WordNet [8]) between the words of card i and the words of a predefined set of initial cards — that progressively gets larger as players create new cards — which we name *card pool*; w_i is a parameter between $[0,1]$, which represents the i's card playing weight. The game keeps track of the number of times a specific card has been played and adjusts the w_i weight accordingly, so that novelty is influenced by the number of times a card is played. In brief, novelty in *4Scribes* is proportional to the semantic difference of a card (compared to all cards existent in the card pool) and inversely proportional to its use in the game.

The second metric is a card's *quality* which relies on player (peer-) evaluation. Each card has a value attributed to it via crowd-sourced ratings (or ranks) and the Assistant associated with this metric will pick the highest-valued card for the players' hand.

The typicality aspect of creativity [12] is used for the design of the last metric: *typicality*. In order for it to be calculated an additional, typical, set of cards is necessary for comparison, henceforth called *comparison pool*. That set of cards is selected by the game designer and defines the typical set of cards that are expected to be used under a story domain. This approach makes it possible for a game master to define a set of cards with words that they think are 'typical' for the chosen theme and setting for the story of a session. Typicality of a card is measured in the same fashion as the novelty metric, with the difference that the comparison pool (instead of the card pool) is used for the calculation of d_s. The Assistant associated will choose cards that minimize the semantic difference between a card i from the card pool and all cards j from the comparison pool.

5 Future Work

Future work with the *4Scribes* game includes piloting the tablet version of the game in schools in Austria, UK and Greece. In the intended scenarios teachers lead the set-up play sessions, setting the theme and scenario, after which players are divided in groups who play 4Scribes using tablet computers. During these pilots the balancing of stimulating creativity and maintaining story coherence will be further investigated. Towards that aim, variants of the *4Scribes* game will be implemented. One will use the notion of role play, setting the player in a situation where one of the character cards is used as an avatar. Another version will enable players to have diametrically opposing story goals where one

or several players are to secretly steer the ending in a way that opposes the main theme of a play session. The metrics of the Assistants will be further iterated and used in the game design to the design goals. Based on these results, as well as further design work, we aim to implement a story-making game that suggests creative stimuli (selecting tokens from the virtual shared space) during the game play, i.e. suggesting new creative stimuli in real-time during play sessions.

6 Conclusions

This work in progress paper presented the story-making game *4Scribes* where players cooperatively make a story by using different types of tokens as creative stimuli. The game is part of the C2Learn Project which aims to foster creativity of players in social educational settings. *4Scribes* uses a set of narrative tokens, a deck of cards, as building blocks for the story creation. Players can add their own custom made cards to this set, allowing them to co-create both by adding structural elements, and by spinning narratives about them. A common issue in story-making games is that the competitive aspects can hinder the coherence of the story that the play results in. In this paper we have explored how computational approaches using artifact creativity aspects such as novelty, quality and typicality can be used as a means to select cards that may result in play sessions that both support creativity and coherence in the narrative that is the product of competitive play.

References

1. Beaney, M.: Imagination and creativity. Open University Milton Keynes, UK (2005)
2. Boden, M.A.: The creative mind: Myths and mechanisms. Psychology Press (2004)
3. Campbell, J.: The Hero with a Thousand Faces. Princeton University Press (1949)
4. Chang, C.Y., Clark, S., Harrington, B.: Getting Creative with Semantic Similarity. In: 2013 IEEE Seventh International Conference on Semantic Computing (ICSC), pp. 330–333. IEEE (2013)
5. De Bono, E.: Lateral Thinking: Creativity step by step. HarperCollins (2010)
6. Eladhari, M.P., Ollila, E.M.I.: Design for Research Results: Experimental Prototyping and Play Testing. Simulation & Gaming 43(3), 391–412 (2012)
7. Fullerton, T., Swain, C., Hoffman, S.: Game Design Workshop: Designing, Prototyping, and Playtesting Games. CMP Books (February 2004)
8. Miller, G.A.: WordNet: A Lexical Database for English. Communications of the ACM 38, 39–41 (1995)
9. Mitchell, A., McGee, K.: Designing storytelling games that encourage narrative play. In: Iurgel, I.A., Zagalo, N., Petta, P. (eds.) ICIDS 2009. LNCS, vol. 5915, pp. 98–108. Springer, Heidelberg (2009)
10. Polti, G.: The Thirty-six Dramatic Situations. The Editor Company, Ridgewood (1917)
11. Propp, V.: Morphology of the Folktale. University of Texas Press (1968)
12. Ritchie, G.: Some empirical criteria for attributing creativity to a computer program. Minds and Machines 17(1), 67–99 (2007)
13. Wallis, J.: Making games that make stories. In: Second Person: Role-Playing and Story in Games and Playable Media. MIT Press, Cambridge (2007)

Remain Anonymous,
Create Characters and Backup Stories:
Online Tools Used in Internet Crime Narratives

Andreas Zingerle

University of Art and Design, Linz, Austria
andreas.zingerle@ufg.at

Abstract. This research takes a closer look at online tools that anti-scam activists use when in contact with Internet scammers. These tools are used for defining one's online character, for progressing the narrative or maintaining anonymity while uncovering the scammer's identity. The tools are easy to use and, when combined together, they offer powerful methods to narrate stories online. This research draws mostly upon primary sources, like interviews with scambaiters or Internet forums, where scambaiters share their stories and discuss the authenticity of dubious online businesses. The discussed methods and tools are utilized while communicating with scammers. In conclusion, this paper illustrates how these tools can also used in other genres such as digital fiction, investigative journalism and advocacy.

Keywords: 419scam, scambaiting, digital narratives, Internet fiction, Computer mediated communication, online communities.

1 Introduction

Today the Web 2.0 is the stage for people's digital stories and online performances. By constantly updating our social media profiles we create a kind of 'accessible privacy' for others, where we display intimate thoughts, share private photos or make small-talk with colleagues [12, 18]. These social media platforms allow us to cultivate and curate our online personas – both our self-representation and self-preservation. Within these complex social structures, we often trust systems more than individuals. Francis Fukuyama defines 'trust' as 'the expectation that arises within a community of regular, honest and cooperative behavior, based on commonly shared norms, on the part of other members of that community' [8].

Online criminals use these social media platforms to construct and backup their online identities. Hiding behind fake characters and stolen identities, they scour the net for gullible victims. They contact people with business proposals, where the victim has to pay a small amount of money in advance in order to gain huge profits. In order to gain the victim's trust, the fraudsters mimic real companies and backup their stories with fake websites and legitimate phone numbers. It is difficult to take official actions against online advance fee fraud due to the fact that they operate on a global scale and individual cases do not meet the financial threshold for international investigations [1].

A. Mitchell et al. (Eds.): ICIDS 2014, LNCS 8832, pp. 81–90, 2014.

On one hand criminals tend to hide behind fake characters and the anonymity offered by online communication, and on the other hand, they discuss their daily lives and habits openly. Criminal organizations like the 'Knights Templar Cartel' use social media to advertise their activities, strengthen public relations and connect to their Facebook followers [4]. By connecting several social media channels, it is possible to trace back 'when' and 'where' a person was and with 'whom'. These kinds of strategies have also been used by Taliban fighters, who created fake Facebook profiles to get in contact with Australian soldiers stationed in war zones around the globe. By analyzing status updates and geo-tagged photos it was possible to detect troop positions and their movements. Ignorant of the consequences, families and friends of the soldiers unwittingly shared classified information with the enemy [7]. Fake personas or identities are also used by law enforcement to apprehend criminals. Although it is against most social media network policies to create fake profiles, cyber-threat analysts like Robin Sage [21] or police officers all over the country use social media for sting operations [5] to gather intelligence during investigations [11, 19]. Additionally, investigative journalists or advocacy organizations are known to use fake profiles to bring forth some of the more troubling sides of computer mediated communications. This was the case when 'Terre des hommes', an organization advocating Children's Rights, carried out a 'sting operation' with a computer-generated profile of a 10-year old Filipina girl. In law enforcement, a 'sting operation' is a deceptive campaign designed to catch a person committing a crime. Normally a law-enforcement officer or a cooperative ordinary citizen play a role as a potential victim or criminal partner and go along with a suspect's actions to gather evidence of the suspect's criminality. In this case, the computer-generated girl posed on video chat rooms as a 'honeypot', a trap set to detect illegal attempts, to catch online predators. The setup ran over two and a half months and more than a thousand men, willing to pay to see her undress in front of a webcam [6], were caught in the act.

Scambaiters also use different digital storytelling tools to monitor scammers, expose their false narratives and dubious businesses, and warn the online community of their practices. As revealed in previous examples, scammers and scambaiters are not the only ones playing hide and seek online. Yet the diverse online communities of scambaiters have developed and made use of several 'easy-to-use' online tools to support their storyline, create believable characters and to cover their digital tracks to stay anonymous. These scambaiters establish communication with scammers and try to gain their trust to either waste the scammers' time or to document their working practices and methodologies. In one interview a scambaiter explained that through his actions he aims to raise online safety issues and make his friends and family more alert in their use of the Internet [2]. In the documentary 'Wham Bam Thank You Scam', the scammed victim Keith, frustrated by the ineffectiveness of local law enforcement, starts to investigate the scam by himself, gathers vital information about the scammers and travels to their offices in Thailand to meet them. This paper reviews scambaiters' storytelling tools, which have been shared and discussed on the popular forums thescambaiters.com and 419eater.com or the online radio show 'Area419'.

Chapter 2 has been divided into three parts, each one addressing a set of tools that scambaiters use:

— Part 2.1 assesses tools that are used to backup the invented storyline, e.g. faking news reports or using forged forms to collect sensitive data.
— Part 2.2 describes methods that are used to develop an online character; e.g. character generators, social media profiles or VoIP communication.
— Part 2.3 lays out online skill-sets to cover your identity and uncover others' fake characters, e.g. Email IP stripping, message trackers to study the scammers' communication behavior, proxies and anonymity networks.

Online tools are developed and used in a number of ways. Chapter 3 examines the use and application of similar storytelling tools in other practices like digital fiction, investigative journalism and advocacy.

2 Storytelling Tools to Gain the Trust of the Counterpart

Scambaiters follow different methods [23] when contacting scammers and use a variety of techniques to enter '419-fictional narratives' [24]. The documentation of a scam connects the personal with larger public issues [13], such as reporting scammers' methods and warning the public about new scam forms on dedicated web forums or reporting bank account details to bank officials. Anthony 'the Failure' DiSano, - the former initiator of the thescambaiter.com anti-scam forum, once claimed that his site members had contributed information leading to dozens of arrests, most recently involving a 419-ring based in Dubai [14]. As earlier examples have shown both law enforcement personnel as well as vigilante scambaiters have to represent a believable character and stick to a concise story to gather information from the counterpart. Both need to stay safe and in digital anonymity. In order for this to happen, scambaiters use proxy servers, TOR routers, fake characters and corresponding e-mail addresses to create their own stories. With a 'fresh' identity they get in contact with scammers, try to gain their trust and creatively improvise with each email to keep the story going. These digital stories often incorporate stereotypical worldviews of other countries and cultures and are used to record, reveal, analyze and interrogate the counterpart [16]. In order to tell their stories, scambaiters (mis)use various vernacular tools and spread their stories over different media channels online. Once contact with the scammer is established, the stories become interactive, where one has to constantly improvise in order to keep the story going and not loose the scammer's trust. In the following paragraphs, I outline popular tools that are used in this genre -

2.1 Story Backup

Forms: When businesses operate on an international level, administrative barriers can easily get in the way. This is a tactic often used by scammers and scambaiters for their own reasons.

To appear professional and gather sensitive data, scammers use forms that victims have to fill out in order to proceed with the business. The forms are either taken from real companies or they mimic businesses like banks, shipping traders, state institutions. Most famous bogus certificates are the Anti-Drug clearance form, the Anti-Terrorist certificate and the Anti-Money laundering certificate. These certificates are allegedly issued by the United Nations, the International Court of Justice or by the local government in the country where the business takes place. Scammers often use these certificates to request another money transfer.

Scambaiters use forms either to waste the scammers time by making them fill out long documents or to gain more information about their various identities. They collect these forms as proof that the scammers believe the scambaiters stories. The filled out forms are considered a trophy and are shared on online forums. A codex amongst scambaiters states that documents sent to the scammers should not provide them with well-designed material that they can reuse on real victims. A widespread example that nearly everyone can use in their storyline is a supposed document from a money transfer company. As an additional security measure for sending money to West African countries, the receivers have to fill it out and attach other documents to proof their identity. Besides standard personal information about the receiver (name, address, phone number) it also includes questions about the money transfer, what the money will be used for or how international money transfer security can be improved. Some forms ask for detailed bank account information, photographs, handwriting proof in form of signatures, or even fingerprints of the receiver. Once the form is filled out it has to be scanned and sent to the scambaiter and then taken to the money transfer agency in order to be able to receive the money. Scambaiters often hide additional information in the form that exposes the fund collector as a scammer to the transfer agents. When the scammer provides the form to the clerk it can cause additional hassles for the scammer, like the involvement of law enforcement. Most often the forms look similar to money transfer institutions and are named: 'Anti-Fraud form', 'Anti-Money laundry form', 'Gold Import Form' or 'Secure Validation form'. Depending on the narrative, other documents can come into use.

Online Generators: 'Online generators' are programs that can perform a certain task quickly and efficiently. The programs are performed online and do not require in-depth editing or programming skills. Most of these programs offer visual previews to adjust the final outcome in real time. There are various generators, ranging from color-matching profiles to instant-poetry. One example is the 'newspaper-clip generator', which lets you create authentic looking newspaper articles. Once details like the name of the newspaper, date, headline, photo and story text are provided, it generates an image with the look of a scanned newspaper article. This tool can be used to furnish evidence to a narrative and foster trustworthiness. Similar generators are used to create magazine covers, concert tickets, receipts, airline boarding passes or handwritten signatures.

2.2 Support Character Building

Character Creator: Each scam narrative needs actors who engage in wild stories on stereotypical corrupt politicians and large sums of money that one can claim as a next-of-kin. An 'identity creator' lets you create a virtual persona with a few clicks of the mouse. By choosing parameters like gender, age, name set and country it is possible to create quite an accurate fake identity. It also provides random street addresses and background information like birth date, occupation, blood type, weight and height. These basic traits help to lend authenticity once the characters' personality, physical appearance or soft skills are further defined. Similar and more advanced avatar creators are well known from computer games e.g. World of Warcraft. During the gameplay according to the users interactions the chosen character is further specialized ('leveled up') in a certain skillset.

VoIP: The 'Voice-over-Internet Protocol' (VoIP) enables the transfer of voice communication and other multimedia communications (voice-messaging, fax, SMS, video) over IP networks. There are several VoIP programs, some are even incorporated in webmail services like 'Google Talk', 'Yahoo Messenger' or 'Outlook's integration of Skype. Scammers are increasingly using these services to be in more direct contact with their marks.

Scambaiters use software to record these calls and share them amongst each other. When assuming the role of a fake character, they use voice-morphing plugins for VoIP programs to pitch their voices, imitating a different gender or someone of a different age. Similar plugins exist for webcam software, where one can edit the video chat in real time and flip through prerecorded files to demonstrate different gestures.

There are also platforms that provide one with call-forwarding numbers, also known as 'global redirects'. That way you get a virtual phone number of your chosen country and whoever calls that number will get routed through to your cell phone number. This is a powerful tool to deceive others of your actual location.

A similar tool provides free voicemail and fax message services. It is possible to personalize one's mailbox message so that it fits to any identity. When someone leaves a voice message or sends a fax, it will be forwarded as a digital file to the provided email account.

In this example the scammer claims to be a businessman from the UK and provides a UK phone number as a form to contact him:

```
Dear Sir, […] I find it pleasurable to offer you my part-
nership in business, for which purpose I have tried to
call your telephone number several times but it seems
disconnected or changed, I only pray at this time that
your address is still valid. […] I look forward to your
response and our partnership, you can call me with this
number + 44 7087624521 anytime.
Regards, Arthur Roy.
```

Tracing the origin of the email reveals that the sender is actually based in Lagos, Nigeria. The phone number is blacklisted as a scammer's phone that uses a call-forwarding service.

2.3 Cover and Uncover

Email IP Stripping: Both scammers and scambaiters use popular email services to create their fake characters. Nowadays these free webmailers include other services like instant messaging, implementation of social media contacts or cloud storage. Depending on the user's needs, these features can be personalized by plugins to show the receivers' social media platforms or delay the sending of the message [20]. A basic feature that scambaiters use is analyzing the email header of the received message. By scanning the header of the message, information like originating IP-address, hostname, country of origin, used protocols and used X-mailing software can be detected (see Fig. 1.). This can provide vital information about the sender's origin. Anonymous webmail services like Tormail are seldom used due to unpopularity and security issues [15].

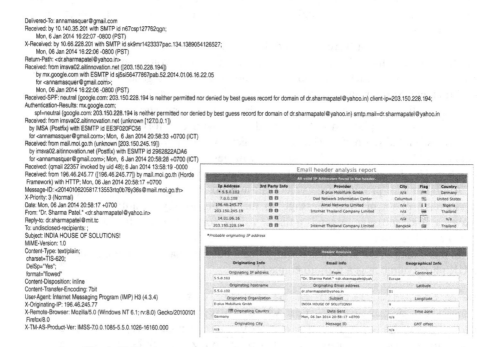

Fig. 1. IP-Header text and screenshot of the online tracking program

Email Trackers: This is another important tool widely used by online marketers to track the email delivery process and study consumer behavior. The tool embeds a tiny, invisible tracking image (e.g. a single-pixel gif) that activates a notification once it has been opened. Similar notifications are sent when the email gets deleted, printed

or forwarded to a different email address. Email trackers normally work on most web-based email services, although there is no 100% guarantee.

A third tool is to use fake mailers as a narrative instrument. A fake mailer enables one to send an email by faking the recipient's email address. This way, it is possible to contact scammers and either play the role of a gang member or persuade the scammer that their inbox got hacked.

Image Analyzers: Scammers often send images to prove their authenticity to their victims. Images that come in the .jpg or .tiff format carry metadata that is stored as 'Exchangeable image file format' data (short Exif-data). When taking a photo, metadata like date, time, camera settings (e.g. camera model, aperture, shutter speed, focal length, metering mode, ISO speed), GPS location information and a thumbnail of the image is saved and embedded within the image file itself. This is mostly done by default without the camera owner's knowledge. This Exif-data is also saved in .wav-audio files.

Scambaiters can analyze the Exif-data and see whether a photo has been edited or where and when it was taken. This can often help to prove the authenticity of a story. According to leaked documents by whistleblower Edward Snowden, the NSA also analyzes Exif information under a program called 'XKeyscore' [9].

In Dec. 2012, when John McAffee was on the run after suspected murder charge, he was interviewed by reporters from Vice magazine in Guatemala. As proof that the reporters were actually with John, they published a photo, which included the Exif-data GPS-coordinates. This revealed McAffee's location to the police who arrested him two days later [22].

Another way to put the authenticity of an image to test is to use 'reverse image search' engines, which specifically search for matching images rather than finding content according to keywords, metadata or watermarks. When an image is submitted, a digital fingerprint is created that gets compared to every other indexed image. The different engines and plugins vary in their accuracy in finding exact matches to similar images, including those that have been cropped, modified or resized.

Websites Archives and Metadata: When fraudsters want to appear more professional and gain the victims' trust they register top-level domains and create fake websites to promote their dubious businesses, e.g. international banks, shipping and logistic companies, rental organizations, law firms or factories. Scambaiters try to uncover these fake websites by searching DNS-database entries for domain setup dates, registration expiration dates, or tracking down the administrator or registrant of a domain name through publicly available (non privacy-protected) directories. They use website archives to trace back the website's history, which is recorded in form of snapshots. These snapshots can serve as evidence when a given website was accessible to the public.

JavaScript Injections: JavaScript is one of the main programming languages of the Web. By using JavaScript code in the browser window, it is possible to access browser cookies, change form input tags and website preferences or perform other real-time

actions like temporary website editing, locating Cross-site scripting (XSS) vulnerabilities and performing malicious operations. The changes one can perform with JavaScript injections are not permanent and won't affect any server information.

An example of a JavaScript injection illustrates how it can be used in storytelling when communicating with scammers. For this, the user types a code snippet in the browser's address bar that makes the content of the page editable. Once the text is changed, a screenshot of the website is taken and used in the upcoming email conversation as evidence. This way, every website can be easily manipulated and no complicated graphic editing software is needed to edit a message into a website.

3 Tools Used in Other Narratives

The tools referred to in this paper as well as similar easy-to-use tools and tactics, can be utilized in other areas of digital storytelling, e.g. tactical activism, investigative journalism or Transmedia activism. Through the use of vernacular media tools character's believability can be reinforced. The following three examples illustrate how diversely these tools and tactics can be (mis)used.

Between 2009 and 2011 an Austrian Neo-Nazi group invoked a witch-hunt for Austrian politicians and NGO workers on their website 'alpen-donau.info'. The website was hosted on US-servers making it impossible to uncover the administrators' identities. The Austrian Data Forensic Scientist Uwe Sailer impersonated a young right wing group 'Tirol1809' and setup a 'canary trap' by sending marked images to a circle of right-wing politicians. A canary trap is a method for exposing an information leak by giving different versions of a sensitive document to several suspects and observing which version gets leaked. The images were scans from a local newspaper where an additional code was embedded in the Exif-data to detect the images once they appear on the website. By doing so it was possible to prove the ties of a right wing politician to the administrators of the illegal website [3].

Investigative journalism programs like 'Exposing the Invisible' by the Tactical Technology collective collect the tools that journalists use in their investigations. Through trainings like 'Privacy and Expression', people learn how to use these tools for their own purpose.

Fognews.ru is a Russian news satire website that publishes fake news of Russian life. It comments on real and fictional events and parodies traditional news websites. On their website they warn their readers with the Latin quote 'Novae res a nobis confictae', meaning 'new things we have made up'. On a number of occasions the published news gone viral and none of the inadvertent participants have had a chance to clarify the situation. For example, on Aug 5, 2012, Fognews reported that the famous pro-Putin conductor Valery Gergiev interrupted a performance of 'Carmen' in London's Covent Garden to give a speech in support of the jailed punk group Pussy Riot. This speech went viral and Valery Gergiev, despite repeated attempts to deny the story, but got very little attention [10].

4 Conclusion

This study has shown that scambaiters use vernacular online tools to create virtual characters and tell stories. These fake personas are used to hide their real identities and to remain anonymous, and also to avoid being prosecuted by the scammers once they find out that they have been tricked. Scambaiters play with these tools to see how easy it is to create a believable online character. Some of the tools are used to examine information received from the scammers. This is used either to validate or negate scammers' stories or to possibly identify the scammers. In this paper these tools are divided into three categories. The tools described in the categories 'story backup' and 'support character building' are used for defining the character and telling the story. Whereas tools outlined in the category 'cover & uncover' enhance media competence skills in both staying anonymous online and proving the authenticity of others. Scambaiters publish their findings on online platforms to expose the working practices of scammers and to warn others. As demonstrated in a number of examples, the discussed tools and tactics can also be used in other avenues – from investigative journalism to transmedia storytelling and online activism.

References

1. Advance fee fraud coalition AFF, `http://affcoalition.org/`
2. Channel 4, Secrets of the Scammers (January 2, 2014),
 `http://youtu.be/KoTNuZmF_ws`
3. Cms, Simo, Post an Neonazis: FP-Politiker unter Verdacht, (March 8, 2011),
 `http://derstandard.at/1297819867094/Post-an-Neonazis-FP-Politiker-unter-Verdacht`
4. Cox, J.: Mexico's drug cartels love Social Media (November 4, 2013),
 `http://www.vice.com/en_uk/read/mexicos-drug-cartels-are-using-the-internet-to-get-up-to-mischief`
5. Crates, J.: ATF and D.C. Police Impersonate Rap Label; Arrest 70 in Year Long Guns and Drug Sting (December 19, 2011), `http://allhiphop.com/2011/12/19/atf-and-d-c-police-impersonate-rap-label-arrest-70-in-year-long-guns-and-drug-sting/`
6. Crawford, A.: Computer-generated 'Sweetie' catches online predators (November 5, 2013), `http://www.bbc.co.uk/news/uk-24818769`
7. Deceglie, A., Robertson, K.: Taliban using Facebook to lure Aussie soldier (Sepember 9, 2012), `http://www.dailytelegraph.com.au/taliban-using-facebook-to-lure-aussie-soldier/story-e6freuy9-1226468094586`
8. Fukuyama, F.: Trust: The social virtues and the creation of prosperity, pp. 61–67. Free Press, New York (1995)
9. Greenwald, G.: XKeyscore: NSA tool collects 'nearly everything a user does on the internet'. The Guardian (2013)
10. Hoeller, H.: Threatening fake news. Springerin (2012),
 `http://www.springerin.at/dyn/hefttext.phptextid=2695&lang=en`

11. Maher, J.: Police create fake Facebook profiles to bust criminals (September 6, 2012), `http://archive.news10.net/news/world/208252/5/Police-using-controversial-social-media-tactic-to-bust-criminals`

12. Pearson, E.: All the World Wide Webs a stage: The performance of identity in online social networks. First Monday14(3) (March 2, 2009), `http://firstmonday.org/ojs/index.php/fm/article/view/2162/2127`

13. Lambert, J.: Digital Storytelling. Capturing Lives, Creating Community. Digital Diner Press, Berkeley

14. Milestone, K.: Catching rats - Sporting scambaiters turntables on foreign scammers (April 3, 2007), `http://articles.chicagotribune.com/2007-04-03/features/0704030230_1_scammers-con-artists-fraud-center/2`

15. Poulsen, K.: If You Used This Secure Webmail Site, the FBI Has Your Inbox (January 27, 2014), `http://www.wired.com/threatlevel/2014/01/tormail/`

16. Renov, M. (ed.): Theorizing Documentary. Routledge, New York (1993)

17. Schneier, B.: Liars and outliers: enabling the trust that society needs to thrive. John Wiley & Sons (2012)

18. Stoate, R.: Internet Detectives: Performativity and Policing Authenticity on the Internet (2007), `http://dichtung-digital.de/2007/Stoate/stoate.htm`

19. Kelly, H.: Police embrace social media as crime-fighting tool (August 30, 2012), `http://edition.cnn.com/2012/08/30/tech/social-media/fighting-crime-social-media/`

20. Waddilove, R.: What's the best free email service? We compare the top 6 providers (March 10, 2014), `http://www.pcadvisor.co.uk/features/internet/3448241/whats-the-best-free-email-service/?pn=1`

21. Waterman, S.: Fictitious femme fatale fooled cybersecurity (July 18, 2010), `http://www.washingtontimes.com/news/2010/jul/18/fictitious-femme-fatale-fooled-cybersecurity/`

22. Wilhelm, A.: Vice leaves metadata in photo of John McAfee, pin-pointing him to a location in Guatemala, Thenextweb Online Insider (December 3, 2012), `http://thenextweb.com/insider/2012/12/03/vice-leaves-metadata-in-photo-of-john-mcafee-pinpointing-him-to-a-location-in-guatemala/2012/!zX5oN`

23. Zingerle, A.: Towards a characterization of scambaiting techniques. International Journal of Art, Culture and Design Technologies (IJACDT), IGI-Global, doi:10.4018/IJACDT

24. Zingerle, A.: The Art of Trickery: Methods to establish first contact in Internet scams. In: xCoAx Conference, Porto, Portugal (June 26, 2014)

Objective Metrics for Interactive Narrative

Nicolas Szilas and Ioana Ilea

TECFA, FPSE, University of Geneva, 1211 Genève 4, Switzerland
{Nicolas.Szilas,Ioana.Ilea}@unige.ch

Abstract. This paper describes, implements and assesses a series of user-log indicators for automatic interactive narrative evaluation. The indicators include length and duration, diversity, renewal, choice range, choice frequency, and choice variety. Based on a laboratory experiment with players, a significant positive correlation has been observed between two indicators and some aspects of the interactive narrative experience measured by validated scales based on questionnaires.

Keywords: interactive storytelling, interactive narrative, interactive drama, evaluation, metrics, analytics.

1 From Theory-Driven to Player Data-Driven Interactive Narrative Design

Research in Interactive Narrative has only recently focused on the issue of evaluation. This is a central issue for the sake of scientific acceptance. It is also essential to guide the iterative design of a given system, to compare systems with each other and to "articulate overarching research directions for the field overall" [26].

Early systems were evaluated by merely showing one or more examples produced by the system [26], either manually chosen [3] or randomly selected [21]. This raises two issues:

- It is scientifically insufficient for it lacks enough examples to reach the threshold of statistical significance. Thus, neither proper evaluation criteria are set, nor independent observer is involved.
- The outputted story is evaluated, which is right for story generation systems but possibly inappropriate for systems targeting a moment-to-moment interaction, such as Defacto, IDtension, Façade, Thespian, U-DIRECTOR, Scenejo, etc. From a theoretical point of view, the interactive narrative experience is fundamentally different from the outputted story and the evaluation of the latter may not be equivalent to that of the former [1], [22].

The first above issue can be properly solved by adopting a more rigorous protocol for story evaluation. For example, Michael Young and his colleagues have a long standing experience in evaluating story generation algorithms by asking a pool of subjects to rate stories produced in various conditions (e.g. [4]). However, the second

A. Mitchell et al. (Eds.): ICIDS 2014, LNCS 8832, pp. 91–102, 2014.

issue mentioned above illustrates the necessity to include users (not readers) in the evaluation, because interactivity is the finality of most interactive narrative systems.

In the rest of the paper, we will only consider the case of an interactive experience that is in contrast to generated story.

Recent research has proposed a range of techniques to evaluate interactive narratives: post-experience questionnaires, in-game questionnaires, and interviews. These methods have their respective advantages and drawbacks. Post-experience questionnaires have a long tradition in user studies. They consist of building aggregated scales from several questions in order to describe one aspect of the experience (e.g. immersion, characters' believability, etc.). When validated, these scales can be used to compare different instances of a system and different systems, as for the IRIS scales [24]. In-game questionnaires help to better measure the user experience while paying, rather than user interpretation after playing [16], but it may disrupt the experience. All questionnaire-based methods suffer from the known limits as difference between the real experience and the recollected experience, social desirability bias, bias related to the context of questionnaire answering and the literacy level, etc. Less quantitative methods based on free or semi-structured interviews partially alleviate the problem. For example, Façade was evaluated via a protocol involving eleven users who played with the interactive narrative and who were then interviewed by researchers [18]. The transcripts were later analyzed by psychologists who extracted some emerging themes and concepts. This kind of approaches provides a better understanding of user perception.

All above-mentioned evaluation methods are costly, because they require organizing a playing session, setting questionnaires or interviews, processing the data. There exists a less costly approach that, surprisingly, has been rarely employed so far in the field of interactive narrative: computer traces (logs) extracted from playing sessions. Typically, as we deal with interactivity, it should be commonplace to measure the number of choices given to the player on average. However, this measure is only rarely adopted (but see [5], [20]).

In this paper, we claim that such objective measures, automatically extracted from real user experiencing the system, should be researched and implemented. Contrary to the above methods, such metrics may deliver quantitative feedback with limited requirements in terms of experiment setting and manual data analysis. In particular, if the interactive narrative is online, only a few dozens of users are required to play with a certain version of the system to get an immediate measure concerning this version. As we will show, what can be measured by using this kind of methods is limited. Therefore, this approach cannot replace the other evaluations. Instead, our claim is that a certain type of user feedback data is potentially there within the implemented systems, but it is largely unexploited today. Metrics for interactive narratives carry the goal of exploiting these data to provide to the system designers and the research community in general, more data to compare and improve systems.

This approach is related to the use of game analytics in research and industry [17]. Effectively, we are looking for metrics that help understanding the user experience, in what may be viewed as a specific type of game. The main two differences are: 1) no business goal is concerned but design and research goals only; 2) We are not concerned with the improvement of a specific interactive narrative, or even a specific engine; Instead, we aim at finding general metrics that should be useful for the vast majority of systems.

This system-independence restricts the range of analysis that may be carried out from computer traces, such as how many times this specific game element has been triggered, which character is most interacted with, etc. This kind of analysis is highly valuable and should be conducted in parallel with others. The system-independent approach brings another type of information that concerns the field as a whole: information across systems, that help to characterize the interactive narrative experience. In the long run, this may support a benchmarking approach that is currently lacking in the field.

Before getting straight to the heart of the matter, we would like to precise that the interactive metrics we propose is valuable but limited in scope. It only covers some features of the experience and may not apply to all systems. In particular, it requires access to a fully working system, preferentially accessible online, so that data can be collected in a central server. Our research lab hosts such an online interactive narrative [23].

In the rest of the paper, we are going to formalize a small number of indicators that are aggregated data representing certain features of the interactive narrative experience. Then, their implementation, as well as an attempt to validate these indicators on a sample of users will be described, followed by a conclusion.

2 Preliminary Indicators, Based on System-Independent Player Data

2.1 Raw Data Selection

Game analytics usually consist of two phases: The selection of raw data and the construction of meaningful indicators from these data [17]. Given our constraint of engine-independence, data that are external to the selection/calculus of actions by the engine will be considered. For that purpose, we will provide a loose formalization of the process of interactive narrative.

We will consider that an interactive narrative session contains a succession of narrative actions that include system narrative actions and player narrative actions; each of these actions is selected among a list of narrative actions called choices, including system choices and player choices. This statement calls for several comments:

- Narrative actions correspond to a certain level of granularity, above the physical actions such as moving in space. This distinction between narrative actions and physical actions is observed in many interactive narrative systems.
- This framework is discrete, in the sense that we do not consider the case in which the player chooses a continuous value in a given range. Furthermore, the framework is best suited to interactive narrative in which choices are explicitly given to the player, by a menu system for example [5], [9], [11], [19]. Nevertheless, the free input systems where the input is internally converted into one action among a list of possible actions also fit into the framework. It is for example the case of Façade, in which the player's input is converted into one of around 40 possible discourse acts [10].

- Despite the sequential nature of the above statement, it does not preclude parallelism and overlapping between actions. Also, there is no strict alternation between system and player actions.

To a session s is associated:

- a tuple with all performed narrative actions ai
- a tuple with all sets of choices C_i $(a_i \in C_i)$

with i being an index over the successive narrative actions, $i \in T(s)$. $T(s)$ can be understood as the turns of session s, keeping in mind that there is no turn-by-turn requirement. A subset of these indices, called $P(s)$, contains all indices corresponding to the player's narrative actions.

In addition to these data, information related to the timing of these actions is also recorded. It consists of an additional tuple with a pair of dates: the starting date and ending date of the action $(start(ai),end(ai))$.

To summarize, raw data for a session consists of played actions – a_i – , choices – C_i –, turns – $T(s)$ –, player turns – $P(s)$ – and timing data – $(start(a_i),end(a_i))$ –. As stated in introduction, these data are general and do not consider the meaning of each action.

2.2 Aggregated Indicators

The first type of indicators simply concerns the total length of a session, which is a useful hint about the size of an interactive narrative. Two kinds of lengths can be considered: the discrete length (in terms of number of actions) and the continuous length (in terms of time), which we denote respectively length (LEN) and duration (DUR). They are calculated as follows, in which card means the cardinality of a set (number of elements):

$$LEN(s) = card(T(s)) \qquad\qquad DUR(s) = end(a_{LEN(s)}) - start(a_0)$$

Another feature that can be easily measured is the number of different actions displayed. We therefore introduce the *diversity* that can be assessed in two ways: either from the point of view of a unique session, the intra-diversity, or from the point of view of a set of sessions, the global diversity.

Let us define S as a set of individual sessions. The intra-diversity is calculated as follows:

$$IDIV(s) = card(\underset{i \in T(s)}{U} a_i)$$

$$IDIV(S) = \frac{\Sigma_{s \in S} IDIV(s)}{card(S)}$$

The first line in the above formula consists in constructing a set of all actions that have been played in a session (symbol U above being the union symbol) and counting

the number of elements in this set. In other words, it involves counting the number of unique displayed actions in a session. The second line is the mean among a set of sessions.

The global diversity is calculated as follows:

$$GDIV(S) = card(\underset{s \in S}{U}(\underset{i \in T(s)}{U} a_i))$$

In this case, the counting of unique displayed actions is performed throughout all sessions. If the interactive narrative system is generative at the level of individual actions, that is if actions are not author-written but generated by combining small authored piece, the global diversity may be very high, typically several hundreds. Nevertheless, global diversity is not a measure of generativity, because an intensive authoring work may also lead to a high diversity. What is interesting to measure is the ratio between the global diversity and the intra-diversity. It represents the ability of the system to generate new content at each session and is denoted the renewal rate:

$$RENEW(S) = 1 - \frac{IDIV(S)}{GDIV(S)}$$

For example, a renewal rate of .6 would indicate that after one session, 60% of possible actions are still to be discovered by replaying. A renewal rate of zero corresponds to the case in which $IDIV=GDIV$, that when exactly the same set of actions are displayed in each session.

Artificial Intelligence-based researches in Interactive Narrative have often been explicitly driven by the goal of increasing player's freedom, in comparison with hypertexts and other branching-based approaches [8], [10], [14], [20]. This freedom, as one aspect of agency, has been advocated as a key promise of interactive narrative, in terms of enjoyment. Furthermore, in terms of motivation in a learning context, such freedom is also sought to increase player's motivation [8]. This freedom can be measured through range of choices and frequency of choices [7]. In order to effectively measure this range that is the number of choices offered to the player, we introduce an indicator called the *choice range*. A large choice range is often desired in interactive narrative research – otherwise usual branching techniques would be sufficient –, but this criteria must not be taken in isolation: a large choice range does not make sense if most choices lead to narrative incoherence. Furthermore, choice range is not the goal per se of interactive narrative research; rather, it is agency that is pursued [12], [25]. Nevertheless, choice range is a well-defined and measurable criterion that participates to more complex features such as motivation, control or agency. From the raw data exposed in the previous section, choice range (CR) is calculated as follows:

$$CR(s) = \frac{\sum_{i \in P(s)} card(C_i)}{card(P(s))}$$

Choice range is simply the mean of the number of choices (“*card(C_i)*”), over turns in which the user made a choice (“*P(s)*”). It may be defined at the level of a session, but also at the level of a set of sessions. This enables the researchers to evaluate an

interactive narrative, providing that the set is representative of a certain population. This may also be used to compare different populations playing the same interactive narrative. The range of choices of a set of sessions is defined as follows:

$$CR(S) = \frac{\sum_{s \in S} CR(s)}{card(S)}$$

The next indicator also concerns the player's degree of freedom, but along the temporal dimension. It consists of the frequency of choices [7]. It can be determined either in discrete time, in terms of the proportion of actions that are played by the player or in real time, based on the elapsed time between two player actions. These indicators are calculated as follows:

$$DCFREQ(s) = \frac{card(P(s))}{card(T(s))} \qquad RTCFREQ(s) = \frac{card(P(s))}{DUR(s)}$$

The discrete choice frequency (DCFREQ) varies between 0 (no player action) and 1 (no system action). None of these extreme values make sense, but a discrete frequency of 0.5 means that there are as many player actions as system actions, while a value of 0.1 would indicate that for one action chosen by the player, nine system actions are displayed, which corresponds to a far more passive situation. The real time choice frequency (RTCFREQ) is measured in hertz (provided that dates are expressed in seconds), a value of 1 meaning one user action per second on average, which would constitute a very strong involvement of the player, comparable to an action game. Lower values are expected, and therefore, we will use centi-hertz (cHz) below.

Beyond the number of choices, what is also relevant is the content of the offered choices. More precisely, it would be relevant to distinguish an interactive narrative with the same choices repeated over all successive turns, from an interactive narrative when new choices appear while others disappear. We therefore propose an indicator called *variability* that measures, for each player turn, the difference between the choices offered since the beginning of the session and at the moment. For that purpose, we introduce $P_i(s)$, the set of indices of the player turns from the beginning of the session to the turn i, with $i \in P(s)$. The variability is calculated as follows:

$$CVAR(s,i) = 1 - \frac{card((\bigcup_{j \in P_{i-1}(s)} C_j) \cap C_i)}{card(C_i)}$$

This formula simply calculates the intersection ∩ symbol) between the current set of choices ("C_i") and all the choices proposed before. If the choices are entirely new, the intersection is empty, and $CVAR(s,i)=0$. The formula is extended to a whole session s and to a set of sessions S as follows:

$$CVAR(s) = \frac{\sum_{i \in P(s)} CVAR(s,i)}{card(P(s))} \qquad CVAR(S) = \frac{\sum_{s \in S} CVAR(s)}{card(S)}$$

We have defined a certain number of indicators based on raw generic data that can be extracted from an interactive narrative session. These indicators approximate

intuitive properties that are usually sought by interactive narrative research such as generativity, replayability, degree of freedom, and variability. In the rest of the paper, these indicators will be implemented and tested.

3 Indicators' Evaluation

3.1 Goal

The goal of this experimental study is twofold. First, we want to check the practical usefulness of the indicators, in particular whether they differentiate effectively between interactive narratives. Second, we want to explore whether they relate to the subjective interactive narrative experience of users measured through a questionnaire. This questionnaire consists of a number of *scales* that are extracted from the measurement toolkit for interactive storytelling developed within the IRIS European project [6], [24]. The selected scales are, with the number of questions per scale in parentheses: Curiosity (3), Enjoyment (2), User satisfaction (2), Flow (5), Emotional state (positive (3) and negative (3)), Believability (3), Suspense (4), Role adoption (3), Aesthetic (3) and Usability (3). The English version of this questionnaire has been tested and validated on various games and interactive narratives. We translated it into French and used it in our research.

3.2 Method

The experiment consists of creating two interactive narratives, IN0 and IN1 that correspond to two variants of the same story-world. Both interactive narratives are based on the interactive drama *Nothing For Dinner*, a playable 3D interactive drama [5], [23]. *Nothing For Dinner* is generative in the sense that its individual actions and the order of these actions are not prewritten but generated from a calculation. It is build with *IDtension*, an Artificial Intelligence-based narrative engine [20]. The difference between the two variants lies in one parameter termed the *complexity*. This complexity defines the optimal number of narrative threads (or *nuclei*) that should be active in parallel. IN0 sets this number at two, which means whenever possible, two nuclei are active – this corresponds to the default value of the work. IN1 raises this value to ten, which is more than the total number of nuclei in this story-world. As a result, it is expected that IN1 will overload the user.

The narrative engine was modified to export raw data into a database. A separate Java program enriches the database with indicators. Subjects play with either one of the variants and fill the questionnaire composed of the IRIS scales (see above) and a few open questions. Given the modifications made on the second variant, significant differences are expected between the two groups, in terms of range of choice, and variability, while the global diversity and the duration should remain statistically identical. We expect a slight difference for the frequency of choice: because there is more to read in the second version, the user may take more time to play. Furthermore, the experiment will explore possible correlations between the questionnaire's scales

and indicators. Note that this paper will not report the differences for the scales between the two groups, but focuses on the indicators.

40 subjects, mostly students, were recruited, 21 assigned to condition IN0 and 19 assigned to condition IN1. Experiments were conducted in groups of up to 8 subjects. After a short introduction to the experiment and the signing of consent forms, subjects played online with *Nothing For Dinner* until the end of the story or a maximum of 30 minutes. Then subjects were requested to fill-in a computer-based questionnaire that included the scales-related questions and open questions. They finally received 10 Swiss francs for their participation. A whole session lasts about 50 minutes.

3.3 Results and Interpretation of Indicator Measurements

During the experiment, some technical problems were encountered, which required us to restart the interactive narrative. Therefore, for some subjects, more than one single session was recorded. In these cases, only sessions with a whole duration above a given threshold (8000 sec.) were selected. In case two sessions remained for the same subject, the first one was selected. As a result, two subjects were discarded from group IN0, leading to 19 subjects for each condition. Also, this led us to not compare the indicators related to durations, because the stop criterion was not reliable.

The comparison of indicators between the two versions is displayed in Table 1. It includes four session indicators, for which an independent samples t-test was performed to calculate the statistical significance of the difference and two system indicators not aggregated from session indicators.

Table 1. Comparison of indicators result on the two conditions (N=19 for each condition). For the four session indicators, mean and standard deviation (in parenthesis) are displayed.

	Intra-diversity	Choice range	Choice frequency (cHz)	Choice variability	Global diversity	Renewal
IN0	65.05 (20.7)	**23.3** (5.37)	2.54 (.92)	**.208** (.083)	382	0.829
IN1	65.16 (16.6)	**34.9** (7.94)	3.00 (1.08)	**.139** (.051)	337	0.801
Sig.	>0.05	<.001	>0.05	.004	-	-

In both versions, users could act and see 65 different actions per session, on average. There is a slight difference between the two versions regarding the global diversity, which gives a renewal of 0.829 or 0.801. Therefore, in both versions, after one session, more than 80% of the content (in terms of distinct actions) has not yet been experienced. Choice range (CR) is 23 for IN0 and 35 for IN1, the difference being significant. This means that for the normal version, the user had 23 choices on average, while in the second version, 35 choices. Real-time choice frequency (RTCFREQ) varies from 2.54 cHz to 3 cHz in the two versions, the difference is not significant. This corresponds to a slow pace game, with 36 seconds between two player actions on average for both groups. Regarding choice variability (CVAR), IN0 has a variability of 0.21, while IN1 has a variability of 0.14, which means that on average, 21% of choices were new for IN0, while only 14% for IN1. The difference is statistically significant.

According to our hypothesis, choice range and choice variability changed between the two conditions. Because IN1 did not restrict the number of nuclei, more choices were offered on average for the user. However, because in both versions the narrative material is identical (it is the same story-world), the additional choices in IN1 were generated from the same data, hence a lower variability for IN1. Therefore, the greater choice range is compensated by a lesser choice variability. In other words, IN1 has more choices, but they are more repetitive. It is difficult to interpret the difference in Global diversity (GDIV) because the story-world is the same in the two conditions. With more sessions, the global diversity should increase and reach a plateau. Its value, in the order of the hundreds, illustrates the generative nature of the narrative engine, because these actions were produced with 144 elementary narrative elements. Finally, contrary to our hypothesis, we have not observed any significant difference in the choice frequency (RTCFREQ).

3.4 Results and Interpretation of Questionnaires-Indicators Correlations

In the correlation analysis, the two groups were merged into one single group of 38 subjects, in order to maximize the chances to obtain some correlations. Results of questionnaires comprised 13 scores regarding the IRIS scales – aggregated themselves from questionnaires answers – and 4 scores for indicators (intra-diversity, choice range, choice frequency, choice variability). All the data were normalized between 0 and 1. Intra-diversity and choice range were divided by the maximal value of the data in our sample.

Spearman correlations were performed between all these variables, and in particular between the scales and the indicators, which generates 48 correlation coefficients. Three correlations were found significant (significance lower than 0.05):

- The choice variability (CVAR) is correlated with the Flow scale, with a coefficient of .322 (sig. = .049). The flow scale's internal consistency is acceptable (Cronbach's alpha of 0.654, N=38).
- The choice variability (CVAR) is correlated with the Positive emotional state scale, with a coefficient of .442 (sig. = .005). This scale measures the positive affective response of the user via questions concerning specific emotions such as "Now, after the experience, I feel enthusiastic" [6]. The internal consistency is good (Cronbach's alpha of 0.802, N=38).
- The choice range (CR) is negatively correlated with the Positive emotional state scale, with a coefficient of -0.489 (sig. = .002).

Therefore, the fact that choices offered to the user change during the narrative experience is positively correlated with both the flow and positive emotional state, while the choice range is negatively correlated with positive emotional state. Note that Flow is also correlated with the Positive emotional state (.535). Note also that the scores for Flow and Positive emotional state are, for the first group 2.81 and 3.23 respectively, in a 5-point Likert scale (1–5), which correspond to rather high values (see [15] for comparisons with other systems tested with the same scales).

It is not straightforward to interpret the results. Regarding the flow, one interpretation could be that repetitive choices disrupt immersion and engagement. This is in line

with some answers we had to the open question "What did you not like in the game?": "The repetitive aspect of some situations"; "the repetition of some possible actions". Another interpretation is that low variability, with many choices persisting between turns, gives the impression that user's actions are useless, because it does not change (enough) the choice list. This is in line with the fact that, at the level of individual questions, the highest correlation was between the variability and the answer to the question (before translation): "I had a good idea while I was performing about how well I was doing" (Spearman Correlation of 0.498).

Regarding the emotional state, it seems that choice variability, in a narrative context, tends to provide stronger positive emotions to the user. The positive effect of variability on user's emotion is interesting because, as game designer, one may consider that repetition is not bad, as it is frequent in many games. This result suggests that in a narrative context, users do not expect to have recurring choice but rather new choices appearing during the experience.

The negative correlation between choice range and the positive emotional state is puzzling, because it would tend to favor less choice range. Two remarks regarding the context of these measures are worth mentioning. First, we are dealing with a rather high choice range (35 for IN1), meaning that there may be a kind of saturation. The impact of choice range is certainly not linear. Second, our user interface for choosing an action consists of a flat list of actions for each Non Player Character. When too many choices are provided, a dozen of actions may be displayed to the user, creating a negative experience. This illustrates the facts that our first results must be interpreted in the context of the specific interactive narrative system used for the experiment.

Finally, correlations that were not observed may be interesting. For example, choice range, which seems a strong indicator in interactive narrative, did not correlate with the agency scale. This can be explained by the fact that in the proposed protocol, the difference in choice range is created by superimposing more content at the same time. To obtain an effect on agency, the additional choices should have been added around the same situation, while guaranteeing the impact of these new choices on the story.

4 Conclusion

We have proposed a series of indicators based on logs to assess various properties of an interactive narrative. The indicators have been created in a system-independent manner: they could be used for a large variety of systems. These indicators include length and duration, diversity, renewal, choice range, choice frequency, and choice variability. The indicators have been implemented on a fully implemented interactive drama, *Nothing For Dinner*, and have been tested with 38 subjects (plus 2 subjects later discarded) dispatched in two groups that corresponded to two variants of the interactive drama. Choice range and choice variability were different in the two variants, showing the interest of theses indicators to qualify an interactive narrative. Correlations were found between indicators and validated scales for assessing the interactive narrative experience. For example, choice variability was positively correlated with Flow (feeling immersed and engaged) and Positive emotional state (feeling excited). Therefore, choice variability appeared to be a relevant indicator of some

experiential qualities of interactive narratives, which was not anticipated. This result illustrates that objective indicators constitute a promising complementary tool to evaluate interactive narrative works and systems.

To extend the approach, two research directions are envisioned. First, correlations between objective and subjective metrics need to be sought out beyond the scope of a unique system. The correlations that we found need to be reproduced for other interactive narratives, possibly with a different narrative engine and a different visualization engine. Second, more indicators could be built and tested. For example, we have not explored indicators that may use the *distance* between two sessions. This distance could either be calculated specifically by the interactive narrative engine or be calculated on the base of the presence/absence of actions and their ordering so as to stay in a system-independent approach (e.g. by adopting the *diff* function in Unix, or the Levenshtein distance as in [13]). With a distance metrics, dispersion values can be estimated, which provides a better measurement of story diversity. Clustering could also provide interesting insights on the variability of the gameplay. Indeed, indicators can be particularly useful for system designers and authors to obtain automatic feedback from users as initiated in [2].

References

1. Aylett, R., Louchart, S.: Being There: Participants and Spectators in Interactive Narrative. In: Cavazza, M., Donikian, S. (eds.) ICVS-VirtStory 2007. LNCS, vol. 4871, pp. 117–128. Springer, Heidelberg (2007)
2. Ben, S., McCoy, J., Treanor, M., Reed, A., Wardrip-Fruin, N., Mateas, M.: Story Sampling: A New Approach to Evaluating and Authoring Interactive Narrative. In: Foundations of Digital Games 2014, FDG 2014 (2014)
3. Cavazza, M., Charles, F., Mead, S.J.: Characters in Search of an author: AI-based Virtual Storytelling. In: Balet, O., Subsol, G., Torguet, P. (eds.) ICVS 2001. LNCS, vol. 2197, pp. 145–154. Springer, Heidelberg (2001)
4. Cheong, Y.-G., Young, R.M.: Narrative Generation for Suspense: Modeling and Evaluation. In: Spierling, U., Szilas, N. (eds.) ICIDS 2008. LNCS, vol. 5334, pp. 144–155. Springer, Heidelberg (2008)
5. Habonneau, N., Richle, U., Szilas, N., Dumas, J.E.: 3D Simulated Interactive Drama for Teenagers Coping with a Traumatic Brain Injury in a Parent. In: Oyarzun, D., Peinado, F., Young, R.M., Elizalde, A., Méndez, G. (eds.) ICIDS 2012. LNCS, vol. 7648, pp. 174–182. Springer, Heidelberg (2012)
6. Klimmt, C., Roth, C., Vermeulen, I., Vorderer, P.: The Empirical Assessment of The User Experience In Interactive Storytelling: Construct Validation of Candidate Evaluation Measures - IRIS FP7 D7.2, http://ec.europa.eu/information_society/apps/projects/logos/4/231824/080/deliverables/001_IRISNoEWP7DeliverableD72.pdf
7. Laurel, B.: Computers as Theatre. Addison-Wesley Professional, New York (1993)
8. Lester, J.C., Rowe, J.P., Mott, B.W.: Narrative-Centered Learning Environments: A Story-Centric Approach to Educational Games. In: Emerging Technologies for the Classroom, pp. 223–237. Springer, Heidelberg (2013)

9. Marsella, S.C., Johnson, W.L., LaBore, C.: Interactive pedagogical drama. In: Proceedings of the fourth International Conference on Autonomous agents - AGENTS 2000, pp. 301–308. ACM Press, New-York (2000)

10. Mateas, M., Stern, A.: Integrating Plot, Character and Natural Language Processing in the Interactive Drama Façade. In: Göbel, S., et al. (eds.) Proceedings of the Technologies for Interactive Digital Storytelling and Entertainment (TIDSE) Conference, pp. 139–151. Fraunhofer IRB, Darmstadt (2003)

11. Miller, L.C., Marsella, S., Dey, T., Appleby, P.R., Christensen, J.L., Klatt, J., Read, S.J.: Socially Optimized Learning in Virtual Environments (SOLVE). In: André, E. (ed.) ICIDS 2011. LNCS, vol. 7069, pp. 182–192. Springer, Heidelberg (2011)

12. Murray, J.H.: Hamlet on the Holodeck: The Future of Narrative in Cyberspace. Free Press, New York (1997)

13. Porteous, J., Charles, F., Cavazza, M.: NetworkING: Using Character Relationships for Interactive Narrative Generation. In: Gini, et al. (eds.) Proceedings of the 2013 International Conference on Autonomous Agents and Multi-agent Systems, pp. 595–602. IFAAMAS, Richland (2013)

14. Riedl, M.O., Young, R.M.: From Linear Story Generation to Branching Story Graphs. IEEE Comput. Graph. Appl. 26(3), 23–31 (2006)

15. Roth, C., Klimmt, C., Vermeulen, I.E., Vorderer, P.: The experience of interactive storytelling: Comparing "Fahrenheit" with "Façade". In: Anacleto, J.C., Fels, S., Graham, N., Kapralos, B., Saif El-Nasr, M., Stanley, K. (eds.) ICEC 2011. LNCS, vol. 6972, pp. 13–21. Springer, Heidelberg (2011)

16. Schoenau-Fog, H.: Hooked! – Evaluating Engagement as Continuation Desire in Interactive Narratives. In: André, E., et al. (eds.) ICIDS 2011. LNCS, vol. 7069, pp. 219–230. Springer, Heidelberg (2011)

17. Seif El-Nasr, M., Drachen, A., Canossa, A.: Game Analytics - Maximizing the Value of Player Data. Springer, Heidelberg (2013)

18. Seif El-Nasr, M., Milam, D., Maygoli, T.: Experiencing interactive narrative: A qualitative analysis of Façade. Entertain. Comput. 4(1), 39–52 (2013)

19. Short, E.: Versu, http://emshort.wordpress.com/2013/02/14/introducing-versu/

20. Szilas, N.: A Computational Model of an Intelligent Narrator for Interactive Narratives. Appl. Artif. Intell. 21(8), 753–801 (2007)

21. Szilas, N.: IDtension: a narrative engine for Interactive Drama. In: Göbel, S., et al. (eds.) Proceedings of the Technologies for Interactive Digital Storytelling and Entertainment (TIDSE) Conference, pp. 187–203. Fraunhofer IRB, Darmstadt (2003)

22. Szilas, N.: Requirements for Computational Models of Interactive Narrative. In: Finlayson, M. (ed.) Computational Models of Narrative, papers from the 2010 AAAI Fall Symposium, pp. 62–68. AAAI Press, Menlo Park (2010)

23. Szilas, N., Dumas, J., Richle, U., Habonneau, N., Boggini, T.: Nothing For Dinner, http://tecfalabs.unige.ch/tbisim/portal/

24. Vermeulen, I., Roth, C., Vorderer, P., Klimmt, C.: Measuring user responses to interactive stories: Towards a standardized assessment tool. In: Aylett, R., Lim, M.Y., Louchart, S., Petta, P., Riedl, M. (eds.) ICIDS 2010. LNCS, vol. 6432, pp. 38–43. Springer, Heidelberg (2010)

25. Wardrip-Fruin, N., Mateas, M., Dow, S., Sali, S.: Agency reconsidered. In: Proceedings of DiGRA 2009 (2009)

26. Zhu, J.: Designing an Interdisciplinary User Evaluation for the Riu Computational Narrative System. In: Oyarzun, D., Peinado, F., Young, R.M., Elizalde, A., Méndez, G. (eds.) ICIDS 2012. LNCS, vol. 7648, pp. 126–131. Springer, Heidelberg (2012)

The PC3 Framework: A Formal Lens for Analyzing Interactive Narratives across Media Forms

Brian Magerko

Georgia Institute of Technology
Technology Square Research Bldg. 319
85 5th St. NW, Atlanta, GA 30308, USA
magerko@gatech.edu

Abstract. This article presents the PC3 framework, an analytical lens for dis-
secting interactive narrative systems across different media forms, such as in
theatre, digital media, and board games. It proposes the use of *process*, *con-
tent*, *control*, and *context* as the important components of an interactive system
that must be considered when comparing it to the makeup of other systems. It
describes each component, the rationale behind the component, and relates
them to interactive narrative systems in a variety of media forms and contexts.

1 Introduction

The concept of an interactive narrative as a medium of participatory and procedural
stories [1] has existed in its most primitive digital form since the late 1970's with the
creation of interactive fictions like *Zork* [2]. Predating this digital form, *Choose Your
Own Adventure*-style books were introduced several years earlier, which were in turn
preceded by Borges' *The Garden of Forking Paths* several decades earlier [3]. Con-
sidering interactive narrative as not only an artifact but as a performance medium, it
has existed in human culture as a formal performance medium for centuries, dating at
least as far back as the 16th century improvisational Italian theatre form of commedia
dell'artes. When non-formal versions (such as pretend play) of these experiences are
taken into account, interactive narrative likely predates human history [4]. In other
words, interactive narrative experiences have been entrenched in human culture as a
form of expression and entertainment far longer than the ubiquity of computer
games. They are a form of expression and performance that have existed as long as
we have been performing and making stories together.

Interactive narrative continues to grow within multiple media forms, resulting in
new kinds of board games, improvisational theatre forms, combinations of game me-
chanics and narrative functions, etc. Commercial games have focused heavily on
integrating gameplay, story, and narrative techniques (e.g. *Gone Home* [5], *The Stan-
ley Parable* [6], *Bastion* [7], and *Heavy Rain* [8]). Board games, which have expe-
rienced a resurgence in ubiquity and creative design, have increasingly involved
elements of story creation and roleplaying games into their design (e.g. *Once Upon a
Time* [9], *Dread* [10], and *Fiasco* [11]). Theater has evolved from the commedia

A. Mitchell et al. (Eds.): ICIDS 2014, LNCS 8832, pp. 103–112, 2014.
© Springer International Publishing Switzerland 2014

dell'arte into the modern short form improv theater scene of the 1970's to more experimental forms involving audience participation, new narrative forms, and game styles (e.g. *Too Much Light Makes the Baby Go Blind* [12], The Frantic Assembly [13], and the Viewpoints contemporary movement method for theatre [14]). Interactive narrative in its myriad forms has involved into a complex mosaic of approaches, styles, performance technologies, and forms.

The above-mentioned mosaic of interactive narrative (IN) forms makes it difficult to distinguish the performance medium (e.g. board games) from the conceptual system that forms the interactive narrative. *Understanding the properties of the conceptual narrative system would allow us to better understand how to dissect, compare, and contrast systems within similar as well as across different presentation media.* Terminology from game design has often been used to describe these systems, but too often focuses on aspects of the presentation medium rather than on the abstract system. While the computer game is an interactive media form that has some lenses for dissection (e.g. the MDA framework [15], Ermi and Mayra's immersion model [16], or the play framework of Costello and Edmonds [17]), these lenses are not particularly helpful for a field that has little vocabulary or understanding of its components aside from high level concepts like "agency", "variability", or "story mediation". While systems can be compared across those terms (e.g. "My system has way more agency than yours!?"), they do not provide a systematic set of dimensions for considerations in system design or for useful comparison across the relevant features of interactive narrative systems.

Initial work by Koenitz et al. [18], which builds on earlier work by Bevensee et al. [19], serves as a prototypical framework for describing IN systems. This work focuses on viewing properties of IN systems as dimensional opposites (e.g. flexible vs. fixed narrative, scripted vs. procedural, multi-user vs. single user). This work is an initial step in helping us understand - given the above pan-media, history-rich view of IN - the central problem addressed in this article: *how do we dissect interactive narrative systems, particularly across media forms for comparison, in a standardized and meaningful way?*

This article proposes a set of dimensions for describing IN systems within and / or across different media forms called the *PC3 model*, which dissects systems into the *Processes* employed, the *Content used and its structure*, the *system of Control* used in the system, and finally the *social Context* that the system is intended for use in. The content below describes the definition of each dimension, the rationale behind its inclusion, and is applied to several systems across domain forms (e.g. board games, theater, computational media, etc.). This model can be useful for teachers, designers, and media theorists interested in the overlap between narrative systems (e.g. identifying the similarities and differences between the narrative systems behind *Fiasco* [11], *Façade* and *Dungeons & Dragons*).

2 The PC3 Framework

2.1 Process

The *processes* that define an interactive experience are highly related to Murray's definition of procedurality [1], Crawford's concept of *process intensity* [20], and the computational concept of algorithms. The processes in an IN system are the actions that can be executed in the multi-agent story creation system between and within the agents involved. In the case of computational IN systems (c.f. [21], [22]), *process* refers to the different sets of algorithms used to generate / manage the story experience (e.g. drama management, story planning, story optimization, etc.). The IN dimension of process acknowledges the existence of "things happening" extradiegetically (e.g. behind-the-scenes algorithms) that enable the experience to occur as well as the actions executed diegetically within the story world (e.g. story management actions).

Processes can be formal routines, like mentioned above, but can also be more implicitly learned ones, akin to the sociocognitive processes employed in group creativity (e.g. [23], [24]). Improvisational actors rely heavily on learned performance functions, such as "finding the tilt" [25], "yes and-ing" [26], [27], and "establishing the platform of a scene" [28]. Underneath these more formal processes are specialized versions of processes like communicating character prototypes [29], [30] and negotiating shared mental models between each other and with the audience [31], [32].

In between the more learned, formal rule systems of improvisation and the highly formalized algorithms of computational story systems, story-based board games are clearly defined by the processes outlined in the rule set. For example, the tabletop game *Fiasco* [11] uses a combination of human collaborative story writing, die rolls, and narrative functions (e.g. "this scene has to end well / poorly for a character" or "more story connections are made after the first act") to create a compelling, short form game experience. The board game *Once Upon Time* [9], in comparison, uses story element cards that are akin to BINGO numbers. As they are mentioned, story element cards are played and used to retain or steal control of telling the story.

The processes employed in an interactive narrative are relatively domain independent means of moving a story along, like the rotation of the motor in a film projector moves 35mm film between the lamp and the projection lens to show a film to an audience regardless of the film's content. However, certain approaches may work better for certain classes of stories. Systems that employ models of specific narrative forms, for instance, are obviously best suited for stories within that form (e.g. Fairclough's OPIATE system, which uses Proppian functions, being best suited for Russian folktales [33]).

All of the above examples cover ground that is heavily domain independent and crucial to understanding the systems and what they do / provide / involve in interaction between performative agents. Discussing systems within the dimension of process allows us to distinguish between the algorithms & techniques being employed, the kinds of experiences they afford, and the nature of the content they operate on [34].

2.2 Content

While the processes involved in an IN system may be a mixture of diegetic and extra-diegetic (as well as explicit and implicit) procedures, the *content* of an IN is clearly at the surface of the interactive experience. The *content* of an IN is the combination of story elements and story structure that combine to define a space of possible story experiences (i.e. the story space). For instance, the diegetic content (as well as syuzhet and fabula) of a narrative is a clear component of the system's content. Content, in other words, is what is manipulated by the narrative processes.

While the "story element" aspect of content may be obvious, what may be less obvious is the concept of content structure and how it relates to IN systems across media forms. For example, *Choose Your Own Adventure* books are defined by both the words on the page and the linkages across pages that the reader chooses between (which is, incidentally, the single process of most branching story novels). In other words, *story structure*, a common facet of structuralist approaches to narratology [35], is heavily intertwined with the processes employed in an IN system [34].

The differences between how content is structured can radically alter how an IN is experienced and performed. For instance, the game constraints given to short form improv actors often involve story elements as well as ordering and / or causal constraints to be adhered to (e.g. see the short-form improv games often used on the popular *Whose Line is it Anyway?* television show [36]). The ordering of events may even be explicitly what the game's process operates on, as in when a scene is performed once and then a second time backwards as part of an improv game.

In the digital realm, structuring content in the form of generative rules, story beats, planning operators, plot points, or autonomous character goals, etc. heavily influences the potential processes being used within the system as well as biases the provided experience towards certain kinds of narratives. For instance, story as autonomous character goals will err the experience towards character-centric experiences while a system that employs story beats will likely experience a more author-centric narrative [37]. Futhermore, Mateas' keynote at the Sixth AAAI Interactive Narrative Technologies workshop pointed out how story content, in terms of potential genre elements and narrative structures, is a ripe field for inspiration for creating new interactive experiences [38].

2.3 Control

As with process and content, the *control* involved in an IN system is interwoven with the other aspects of the system to create the overall experience, but can be viewed on its own as a unique and highly important feature that differs between approaches. The concept of narrative control is related to the function of the narrator in traditional storytelling; the agent with control in an interactive narrative is the gatekeeper of the story content. The agent or agents in control ultimately dictate where the story goes, whether participants in the story world are proverbially predestined by an omniscient story manager or have free will in being the ultimate deciders of their fate. While an observer may view process and control as similar concepts, different control

mechanisms (e.g. drama management) may employ radically different approaches to story process (e.g. story improvisation) and vice versa.

Control schemes in IN systems tend to fall a spectrum of centralization of story control. At one end of the spectrum is the *centralized power structure*. Story centralization means that there is a "conductor" at the heart of the story, a puppetmaster that is figuratively pulling all of the strings to coordinate the syuhzet of an IN experience in response to the agents acting within it. In different domains, this controlling agent may be called a *drama manager* (in computational systems (c.f. [21])), a *dungeon master* or DM (in tabletop roleplay), or possibly a *director* (in experimental theater).

The use of centralized story control has a direct effective on player agency - relying on perceived agency in the experience rather than actual. For instance, a dungeon master in a traditional roleplaying game may guide the players towards the next preauthored plot point using a variety of coercive techniques, but will ultimately make certain that the content is reached (as opposed to the story going in a completely unplanned and unscripted direction). Drama managers function in a similar manner, mediating the story experience to either incorporate unplanned events or discouraging them from occurring in the first place [21]. The Sims are an interesting example of turning story control around, putting the player in the role of story coordinator while the computational agents are at the player's disposal.

At the other end of the spectrum is naturally the *decentralized power structure*. This relates closely to group improvisation, where there is no totalitarian figure serving as gatekeeper. Rather, story content is *co-created* by the agents participating in the experience. This means that each agent is actively sharing responsibility in creating story elements and structuring the story across time. For example, improvisational actors on stage typically share equal responsibilities in performing a scene. Improv acting training in fact includes tenets about each actor's responsibility being to support the others on stage rather than themselves, leading to a more coherent and cohesive group performance [23].

Decentralization in computational systems typically refers to *strongly autonomous* approaches where AI agents operate independently in concert with an interactor. Decentralization can be diminished when the system does not exhibit parity in the co-creative process; in other words, if the AI agents in the IN system can coordinate behind the scenes, the amount of control over the story shifts away from the human interactor and towards the group of AI agents as a whole.

Decentralized approaches do not necessarily have to be completely spontaneous in nature, akin to improv theatre. For example, games like *Fiasco* involve players in a decentralized, parity-based co-creative IN system; however, they allow for revision, discussion, and pre-planning of story content as part of the game system. This allows novice story improvisers / writers to co-create a story without the expert performance knowledge of an improvisational actor for co-creating on stage in real-time.

The above, as stated, describes the ends of a spectrum of story control, in between which there are many points that exist in between (such as non-parity-based decentralized systems or semi-autonomous AI systems (e.g. [39], [40])). Recognizing control as a key aspect of IN systems allows one to see the similarities in experience between improvisational acting and *Fiasco*, or between traditional tabletop roleplaying and

drama managers. As crowdsourcing becomes more prevalent in the author of narratives (e.g. [41], [42]), this lens is equally applicable for describing more non-interactive forms like branching narratives (in the vein of *Choose Your Adventure* books) as well.

2.4 Context

Context in the PC3 framework refers to the social elements of system use and the intended purpose of the system. Interactive narrative systems have been used for training [40], [43], [44], for expert theatrical performance [45], [46], and learning experiences for children [47], etc. These same systems also have a myriad of social groups and involvements on the part of those involved in the system (e.g. performers vs. audience, high vs. low degrees of audience involvement, etc.)

The social context of a system plays a key part in the decisions made in terms of the other components of the framework for a system. For instance, if a system is intended for pedagogical use vs. entertainment, or for novice story creators vs. expert, for children vs. adults, audience as passively involved vs. actively, etc., it all can affect the choices in content, in structure, and in narrative control. For example, the IDA system [48] directly informed the design and development of the ISAT training system [49], with the added influence of intelligent tutoring approaches given the pedagogical nature of ISAT's target domain, training combat medics.

This framework component does allow us to take the use of a system into account along with its theoretical components and consider an IN not just as a disembodied system, but as an experience grounded in a social system. In other words, as in any medium, the audience and use of a media artifact is important in that artifact's design, development, and analysis.

3 Discussion

This article represents the first formalization of the PC3 framework; however, it has been used in the past several years as a lens for examining IN works in the graduate course in Interactive Narrative in the Digital Media program at Georgia Tech. It has shown to be applicable in numerous IN works across multiple domain forms, ranging from one-short live action roleplay experiences (e.g. *Shelter in Place* [50]), to improvisational theatre, to story-centric computer games, to board games. Students have successfully employed this lens in the construction of term papers, which has served as positive feedback on the breadth and applicability of PC3. Students are able to clearly reflect on the relationship between systems across media within different elements of the PC3 framework (e.g. recognizing the *control* relationship between drama managers in computational IN systems and dungeon masters and how they can differ in terms of the *processes* and *content* they employ).

This framework provides a broader lens for thinking about interactivity and story regardless of platform (computational, theatrical, etc.). Within this lens, pretend play

Fig. 1. A screenshot of the Viewpoints AI protonarrative installation piece

between children can be readily compared with professional improv acting (where they differ primarily in terms of context), live-action roleplaying (where control, process, and content primarily differ), or improvisational contemporary movement (where content and context primarily differ). Previous attempts at categorization systems for IN have not attempted to consider interactive narrative in its various media forms as PC3 does.

PC3 has been informally used in practice in the author's research on building interactive narrative systems for several years. It has been used as a tool for reflecting on current work and identifying potential changes in the iterative design of systems and whole research agendas. For example, the Digital Improv Project [23], [30], [45], focused on creating co-creative improvisational theatre pieces, was observed as creating pieces that had significant bottlenecks: content authoring (to no surprise) and user knowledge (i.e. novices had a hard time performing with systems built as models of expert theatre improv knowledge). This analysis resulted in a design challenge to build on the lessons learned in this system and create a system that a) relied on as little pre-authored instantial narrative *content* as possible, b) focused on the same co-creative, autonomous agent-based approach as the *control* mechanism, c) represented social narrative construction *processes* between the computer agent and human interactor, b) was social *contextualized* as a "walk up" installation piece and as an observed performance for an audience. The resulting work, Viewpoints AI (see Figure 1), is a data-driven "protonarrative" experience (i.e. events that have causality and temporality, but are devoid of grounded semantic content, such as in some contemporary dance pieces) that co-creates a movement-based, performance with a user employing only a formalization of the Viewpoints movement theory [14] and intelligent use of stored memories of previous movement interactions it has seen [51].

In this way, PC3 was used as a lens for examining current research practices and considering new directions for exploration.

This work directly compares to the aforementioned prototypical work of Koenitz et al. [18]. While there are distinct overlaps (e.g. the attention to procedurality and processes), both cover ground with different intended levels of specificity. One conclusion of this work is that future iterations of the PC3 could be synthesized with other approaches to provide a more taxonomical categorization scheme (e.g. breaking down the concept of *process* down to the known possible kinds of story creation processes). That being said, this high-level framework has served as a useful tool in pedagogy and practice, as described in this article, for comparing and dissecting IN systems to make informed theoretical leaps and design decisions.

References

1. Murray, J.H.: Hamlet on the Holodeck: The future of narrative in cyberspace. MIT Press (1997)
2. Lebling, P.D., Blank, M.S., Anderson, T.A.: Special Feature Zork: A Computerized Fantasy Simulation Game. Computer 12(4), 51–59 (1979)
3. Borges, J.L.: Collected Fictions. Penguin Books, New York (1999)
4. Caillois, R.: Man, play, and games. University of Illinois Press, Urbana (2001)
5. Gaynor, S.: Gone Home. The Fullbright Company (2013)
6. Wreden, D.: The Stanley Parable (2011)
7. Rao, A.: Bastion. SuperGiant Games (2010)
8. Cage, D.: Heavy Rain. Quantic Dream (2010)
9. Once Upon a Time. Atlas Games (1994)
10. Ravachol, E., Barmore, N.: Dread. The Impossible Dream (2004)
11. Morningstar, J.: Fiasco. Bully Pulpit Games (2009)
12. Rizzolo, J.: 225 Plays: By The New York Neo-Futurists from Too Much Light Makes the Baby Go Blind. Hope and Nonthings, Chicago (2011)
13. Graham, S., Hoggett, S.: The Frantic Assembly Book of Devising Theatre, 1st edn. Routledge, London (2009)
14. Bogart, A., Landau, T.: The Viewpoints Book: A Practical Guide to Viewpoints and Composition. Theatre Communications Group, New York (2004)
15. Hunicke, R., LeBlanc, M., Zubek, R.: MDA: A formal approach to game design and game research. In: Proceedings of the AAAI Workshop on Challenges in Game AI, p. 04 (2004)
16. Ermi, L., Mäyrä, F.: Fundamental components of the gameplay experience: Analysing immersion. In: DIGRA, p. 37 (2005)
17. Costello, B., Edmonds, E.: A study in play, pleasure and interaction design. In: Proceedings of the 2007 Conference on Designing Pleasurable Products and Interfaces, pp. 76–91 (2007)
18. Koenitz, H., Haahr, M., Ferri, G., Sezen, T.I., Sezen, D.: Mapping the Evolving Space of Interactive Digital Narrative - From Artifacts to Categorizations. In: Koenitz, H., Sezen, T.I., Ferri, G., Haahr, M., Sezen, D., Çatak, G. (eds.) ICIDS 2013. LNCS, vol. 8230, pp. 55–60. Springer, Heidelberg (2013)
19. Bevensee, S.H., Dahlsgaard Boisen, K.A., Olsen, M.P., Schoenau-Fog, H., Bruni, L.E.: Project Aporia – An Exploration of Narrative Understanding of Environmental Storytelling in an Open World Scenario. In: Oyarzun, D., Peinado, F., Young, R.M., Elizalde, A., Méndez, G. (eds.) ICIDS 2012. LNCS, vol. 7648, pp. 96–101. Springer, Heidelberg (2012)

20. Crawford, C.: Process intensity. Journal of Computer Game Development 1(5) (1987)
21. Roberts, D.L., Isbell, C.L.: Desiderata for managers of interactive experiences: A survey of recent advances in drama management. In: Proceedings of the First Workshop on Agent-Based Systems for Human Learning and Entertainment, ABSHLE 2007 (2007)
22. Riedl, M.O., Bulitko, V.: Interactive Narrative: An Intelligent Systems Approach. AI Magazine 34(1), 67–77 (2013)
23. Magerko, B., Manzoul, W., Riedl, M., Baumer, A., Fuller, D., Luther, K., Pearce, C.: An Empirical Study of Cognition and Theatrical Improvisation. In: The Proceedings of ACM Conference on Creativity and Cognition, Berkeley, CA (2009)
24. Sawyer, R.K.: Explaining Creativity: The Science of Human Innovation, 2nd edn. Oxford University Press, New York (2012)
25. Brisson, A., Magerko, B., Paiva, A.: Tilt Riders: Improvisational Agents Who Know What the Scene Is about. In: Vilhjálmsson, H.H., Kopp, S., Marsella, S., Thórisson, K.R. (eds.) IVA 2011. LNCS, vol. 6895, pp. 35–41. Springer, Heidelberg (2011)
26. Baumer, A., Magerko, B.: Narrative development in improvisational theatre. In: Iurgel, I.A., Zagalo, N., Petta, P. (eds.) ICIDS 2009. LNCS, vol. 5915, pp. 140–151. Springer, Heidelberg (2009)
27. Baumer, A., Magerko, B.: An analysis of narrative moves in improvisational theatre. In: Aylett, R., Lim, M.Y., Louchart, S., Petta, P., Riedl, M. (eds.) ICIDS 2010. LNCS, vol. 6432, pp. 165–175. Springer, Heidelberg (2010)
28. Magerko, B., O'Neill, B.: Formal Models of Western Films for Interactive Narrative Technologies. In: Proceedings of the 2nd Workshop on Computational Models of Narrative, Istanbul, Turkey (2012)
29. Lakoff, G.: Cognitive models and prototype theory. In: Margolis, E., Laurence, S. (eds.) Concepts and Conceptual Development: Ecological and Intellectual Factors in Categorization, pp. 63–100 (1987)
30. Magerko, B., Fiesler, C., Baumer, A.: Fuzzy Micro-Agents for Interactive Narrative. In: Proceedings of the Sixth Annual AI and Interactive Digital Entertainment Conference, Palo Alto, CA (2010)
31. Sawyer, R.K.: Improvisational Cultures: Collaborative Emergence and Creativity in Improvisation. Mind Culture, And Activity 7(3), 180–185 (2000)
32. Fuller, D., Magerko, B.: Shared Mental Models in Improvisational Theatre. In: Proceedings of 8th ACM Conference on Creativity and Cognition, Atlanta, GA (2011)
33. Fairclough, C., Cunningham, P.: A Multiplayer OPIATE. International Journal of Intelligent Games and Simulation 3(2), 54–61 (2004)
34. Magerko, B.: A Comparative Analysis of Story Representations for Interactive Narrative Systems. In: Proceedings of the 3rd Annual AAAI Conference on Artificial Intelligence for Interactive Digital Entertainment, Marina del Rey, CA (2007)
35. Rimmon-Kenan, S.: Narrative Fiction: Contemporary Poetics, 2nd edn. Routledge, London (2002)
36. Whose Line is it Anyway? BBC (1988)
37. Riedl, M.O., Young, R.M.: Narrative planning: balancing plot and character. Journal of Artificial Intelligence Research 39(1), 217–268 (2010)
38. Mateas, M.: Interactive Narrative. In: Proceedings of 6th AAAI Workshop on Interactive Narrative Technologies (INT6), Boston, MA (2013)
39. Blumberg, B.M., Galyean, T.A.: Multi-level direction of autonomous creatures for real-time virtual environments. In: Proceedings of the 22nd Annual Conference on Computer Graphics and Interactive Techniques, pp. 47–54 (1995)

40. Riedl, M.O., Stern, A.: Believable agents and intelligent story adaptation for interactive storytelling. In: Göbel, S., Malkewitz, R., Iurgel, I. (eds.) TIDSE 2006. LNCS, vol. 4326, pp. 1–12. Springer, Heidelberg (2006)

41. Frycook, http://dumbandfat.com/comic/title-0001-2/ (accessed: July 20, 2014)

42. Li, B., Lee-Urban, S., Riedl, M.: Crowdsourcing interactive fiction games. In: Foundations of Digital Games, pp. 431–432 (2013)

43. Johnson, W.L., Marsella, S., Vilhjalmsson, H.: The DARWARS tactical language training system. In: Proceedings of I/ITSEC, Marina del Rey, CA (2004)

44. Hartholt, A., Gratch, J., Weiss, L., The Gunslinger Team: At the Virtual Frontier: Introducing Gunslinger, a Multi-Character, Mixed-Reality, Story-Driven Experience. In: Ruttkay, Z., Kipp, M., Nijholt, A., Vilhjálmsson, H.H. (eds.) IVA 2009. LNCS, vol. 5773, pp. 500–501. Springer, Heidelberg (2009)

45. Magerko, B., Dohogne, P., DeLeon, C.: Employing Fuzzy Concepts for Digital Improvisational Theatre. In: Proceedings of the Seventh Annual AI and Interactive Digital Entertainment Conference, Palo Alto, CA (2011)

46. O'Neill, B., Piplica, A., Fuller, D., Magerko, B.: A knowledge-based framework for the collaborative improvisation of scene introductions. In: André, E. (ed.) ICIDS 2011. LNCS, vol. 7069, pp. 85–96. Springer, Heidelberg (2011)

47. Ryokai, K., Vaucelle, C., Cassell, J.: Virtual peers as partners in storytelling and liter-acy learning. Journal of Computer Assisted Learning 19(2), 195–208 (2003)

48. Magerko, B.: Evaluating Preemptive Story Direction in the Interactive Drama Architecture. Journal of Game Development 2(3) (2007)

49. Magerko, B., Stensrud, B., Holt, L.: Bringing the Schoolhouse Inside the Box – A Tool for Engaging, Individualized Training. In: Proceedings of the 25th Army Science Conference, Orlando, FL (2006)

50. Blackwell, J.R.: Shelter in Place. Galileo Games (2010)

51. Jacob, M., Coisne, G., Gupta, A., Sysoev, I., Verma, G., Magerko, B.: "Viewpoints AI.". In: The Proceedings of the Ninth Annual AAAI Conference on Artificial Intelligence and Interactive Digital Entertainment (AIIDE), Boston, MA (2013)

Storytelling Artifacts

Toke Krainert

IT University of Copenhagen
Rued Langgaards Vej 7, 2300 Copenhagen S, Denmark
tokk@itu.dk

Abstract. In this text, I investigate *storytelling artifacts*, virtual objects representing events in a game's storyworld. I analyze the phenomenon using existing literary theory, propose a specific model of *ordering*, *availability*, and *mechanical significance*, and argue for the uniqueness of their narrative capabilities.

1 Introduction

One of the means by which video games tell stories is their worlds and the virtual artifacts within them. Authors such as Espen Aarseth [2] have examined how game worlds and objects facilitate storytelling while others, such as Tanya Krzywinska [15], have investigated their creation of *worldness*, unifying consistency in virtual worlds [15, p. 386]. However, whereas all virtual entities contribute to the depth of the setting and may elaborate on its fictional history, some go beyond this and supply more concrete narrative components; artifacts such as the audio tapes throughout Batman: Arkham Asylum [16], the emails on the computers of Deus Ex: Human Revolution [8], the diary pages around Amnesia: The Dark Descent [9], the newspapers on the wall of Eli's lab in Half-Life 2 [20], and even the serial glyphs on the temple walls in Journey [18] all tell embedded stories adding to the worldness and narratives of their games.

In this paper, I will investigate theory applicable to storytelling artifacts as mediators of narrative, propose a framework within which the artifacts can be differentiated, and examine their role as contributers to games' worlds and stories.

Outline. I begin by defining storytelling artifacts in section 2 and reviewing tangent literature in section 3. I then account for my theoretical background and games for analysis in section 4 and section 5, respectively, and apply the former to the latter in section 6. Based on the above, I then propose a model for the specific parameters of storytelling artifacts in section 7 and argue for their significance for the narratives of games in section 8. Finally, I conclude on my findings in section 9.

2 Definition

Since every object in a game's virtual world is a component of the whole and can thus be considered a constituent of its worldness and history, a useful definition for the storytelling artifacts in question must include a rigorously specified

A. Mitchell et al. (Eds.): ICIDS 2014, LNCS 8832, pp. 113–124, 2014.

delimitation of a subset thereof. In the terms of H. Porter Abbott [5], I will therefore limit myself to entities [5, p. 19] explicitly representing (or presenting [5, p. 15]), events or other entities within the game's storyworld, that is, the implied world within which the story unfolds [5, p. 75]. [5, p. 20] [1] Furthermore, to omit non-story references, my scope is limited to those entities either *a*) representing events; or *b*) belonging to a group of at least two objects representing the same entities at different points in time, thus in combination making a serial expression of temporal development. I will call these objects *storytelling artifacts*, based on their storytelling, if not narrative, ability of representing events and their inferred property of being artificial given their explicitly intentional representation. Consequently, I define storytelling artifacts as *entities in a game representing events in the game's storyworld either explicitly or through a serial relationship with other entities.* Notice how the definition captures the examples mentioned in section 1 while excluding non-storytelling entities such as recipes, framed pictures (insofar they are not part of a series), and non-vocal music (ignoring interpretive developments, e.g. the traversal of the meteorological seasons in Antonio Vivaldi's *Le quattro stagioni* [21]).

3 Literature Review

Although storytelling artifacts form a very specific niche, some tangent work can be identified.

Aarseth argues that the elements *world*, *objects*, *agents*, and *events* are found in games and stories alike [2, Section 3] and proposes a corresponding four-dimensional model. [2, Section 9] In this model, all axes span from the narrative to ludic poles, and each contains a number of intermediate steps. [2, Section 9] For objects, these steps are based on degrees of malleability and comprise *a*) static, non-interactible; *b*) static, usable; *c*) destructible; *d*) creatable; and *e*) inventible objects. Aarseth argues that an objects' level of malleability "[determines] the degree of player agency in the game; a game which allows great player freedom in creating or modifying objects will at the same time not be able to afford strong narrative control." [2, Section 6] Insofar a game's narrative depends on the objects in question, Aarseth's point is certainly valid and relevant to storytelling artifacts as the artifacts relaying a specific sequence of events is contrary to the entire *inventible* category (ignoring hypothetical cases in which users contribute to the storyworld by creating their own storytelling artifacts). However, despite its similar domain and inclusion of objects, Aarseth's text offers no further insights into storytelling artifacts.

[1] Note here that the distinction between abstract and representational can be considered on a gradual scale [14, p. 130], and that the explicitness of representation may therefore be non-binary. This complexity, however, falls within the domain of semiotic denotation (c.f. Albert Atkin. *Peirce's Theory of Signs* [6, Section 2]), and to avoid theoretical sidetracking, I will maintain a binary discrimination for the purpose of this definition.

Krzywinska examines World of Warcraft [7] as an example of world creation, highlighting its semantic ties to mythology and tropes in the fantasy genres. [15] Specifically, she claims that *thick text* "populated with various allusions, correspondences, references, and connotations [...] lend breadth and depth to a game and make use of player's knowledge". [15, p. 383] Simultaneously, "myth and the mythic [...] have a structural function; play a role in shaping the experience of the game world and its temporal condition; and are also apparent in the registers of style, resonance, and rhetoric." [15, p. 384] She ultimately argues that this mythological world creation "and its concomitant meanings enables players to live virtually in 'once upon a time' and has a significant impact on types of play and particularly role-play encouraged by the game." [15, p. 395] Again, Krzywinska's text does not provide any insight into storytelling artifacts specifically, although it does emphasize the significance of entities in the game world to manifest its history and corroborate particular themes.

4 Theory

This section covers the theory employed in the subsequent analysis.

4.1 H. Porter Abbott and Narrative Theory

In his 2008 book *The Cambridge Introduction to Narrative*, Abbott unifies and relates a number of concepts within narrative theory [5], a subset of which I will adopt.

First of all, Abbott defines narrative as "*the representation of an event or a series of events*" [5, p. 13] where *representation* can be understood as either *a)* strictly the *told* or *written*; or *b)* both the above and the *acted*, which otherwise falls within *presentation*. [5, p. 15] For the purpose of this text, I will operate with both, noting divergences as they occur.

Abbot distinguishes between the temporal layers of *story* and *discourse*, where

story is the time of the told events; and
discourse is the time of the narration. [5, p. 16]

Here, the story is composed of "*events* and the *entities* [...] involved in the events" [5, p. 19], and the events can again be divided into *constituent events* and *supplementary events*, where

constituent events are "necessary for the story to be the story it is" and "the turning points [...] that drive the story forward and that lead to other events"; while
supplementary events are "not necessary for the story", "don't lead anywhere", and "can be removed and the story will still be recognizably the story that it is." [5, pp. 22–23]

A narrative may also be said to be *embedded* into another, which is then called its *framing narrative*, when the discourse of the former occurs within the story of the latter. [5, p. 28]

Finally, a narrator has the parameters of *voice*, *focalization*, and *distance*, where

voice is either the narrating character within the storyworld or a narrating non-character outside of it [5, p. 75], including the grammatical person (first, second, or third) and whether the narrator is *omniscient*, that is, knows everything within the storyworld [5, pp. 70–73];

focalization is the "lens through which we see characters and events in the narrative", or colloquially the perspective or "*point of view*" [5, p. 73]; and

distance is "the narrator's degree of involvement in the story she tells", or the closeness of the narrator's relationship with the narrated events [5, p. 74].

4.2 Henry Jenkins and Embedded Narratives

In his 2004 article *Game Design as Narrative Architecture*, Henry Jenkins examines the spatial aspects of stories and proposes a perspective on narrative in games as "*environmental storytelling*". Specifically, Jenkins identifies four ways in which space "creates the preconditions for an immersive narrative experience": *a)* "[evoking] pre-existing narrative associations"; *b)* "[providing] staging ground where narrative events are enacted"; *c)* "[embedding] narrative information within [the storyworld]" ("mise-en-scene"); or *d)* "[providing] resources for emergent narratives". [12, Spatial Stories and Environmental Storytelling]

Here, Jenkins' analysis of embedded information, particularly embedded narrative, is relevant. The author adopts a model in which "a story is less a temporal structure than a body of information"; "narrative comprehension is an active process by which viewers assemble and make hypotheses about likely narrative developments on the basis of information drawn from textual cues and clues." Rephrasing in Abbott's terms, the receiver thus continuously estimates the story based on the statements in the discourse. Jenkins exemplifies this with an analysis of cinema, where "spectators test and reformulate their mental maps of the narrative action and the story space" "As they move through the film". For games, then, this invitation to exploration is integrated into the structural level as "players are forced to act upon those mental maps, to literally test them against the game world itself", that is, games are interactive, requiring the player to incorporate the output in his or her choice of input to successfully complete them. Embedded narratives, in the same sense as Abbott's, can thus occur as "the game designer [develops] two kinds of narratives – one relatively unstructured and controlled by the player as they explore the game space and unlock its secrets; the other prestructured but embedded within the mise-en-scene awaiting discovery." [12, Embedded Narratives]

5 Games

Before applying to them the theory above, I will here elaborate on a sample of storytelling artifacts and the games in which they exist.

5.1 BioShock: Audio Diaries

In BioShock [1], the player must navigate through the underwater city of Rapture while uncovering its history of genetic experimentation, political conflict, and civil war as well as the protagonist's role within it. Many aspects of this history are revealed through audio diaries of implicated characters found sporadically throughout the city. For example, an entry left at the front desk of a medical facility contains its author's speculations about her situation following her involvement in a rebel attack:

> Dr. Steinman said he'd release me today. Ryan didn't come to see me since the New Year's attack. Not once. But Dr. Steinman was very attentive. He told me that once the scar tissue was gone, he was going to fix me right up. Make me prettier than any girl I've ever seen. He's sweet all right... and so interested in my case![2]

This entry elaborates on the personalities and relationships of Ryan and Steinman, both significant characters in the game's story, while foreshadowing a subsequent encounter with the doctor.

Other diaries have more pragmatic content, such as one regarding a stash of munitions:

> Ryan sent over extra munitions. He must suspect trouble. I've locked them up near the Protector Labs and set the code to 1921. I don't expect we'll ever be needing them though. Once Big Daddy is ready, nobody cross the Big Daddy.[3]

Again, the diary elaborates on characters, but in this case a code is included, providing the player with concrete information applicable in his progress. Since the player is able to replay previously acquired diaries, the game allows for thorough investigations of the recordings to understand the fictive history of the setting and gain advantages alike.

5.2 Journey: Ancient Glyphs

In Journey [18], the player traverses a desert landscape filled with puzzles and ancient architecture towards a rise in the horizon. The structures on and hidden along the path are decorated with large plaques which when activated turn into mosaics of events from the history of their creators. For example, the very first glyph depicts a large number of fallen people, each positioned next to a tombstone corresponding to the distinctive stones found around the environment.

[2] Source: `http://bioshock.wikia.com/wiki/Released_Today`, visited 2014-04-16.

[3] Source: `http://bioshock.wikia.com/wiki/Extra_Munitions`, visited 2014-04-16.

5.3 L.A. Noire: Newspapers

In L.A. Noire [17], the player must solve a series of cases in the role of an ex-military officer of the Los Angeles Police Department in 1947. During the main missions, newspapers with articles relevant to the plot can be found on critical locations, triggering cinematic depictions of the events behind their contents when picked up and activated. For example, the headline of the first newspaper reads "Shrink says: The mind is the final frontier" and triggers a scene in which the friend of a traumatized army veteran addresses a psychiatrist for help after a lecture.

5.4 World of Warcraft: Quest Items

In World of Warcraft [7] (version 5.4.7.18019), the player must level up a character and collect equipment by defeating enemies and completing quests. The latter usually require the player to slay particular adversaries, collect specific items, or bring an item to a given destination. In the last case, the items in question are often textual in nature and occasionally allow the player to read their contents. For example, to complete the quest *Vital Intelligence*, the player must deliver the item *Scarlet Crusade Documents* to the non-player character Deathguard Simmer. The item itself can be activated to trigger a display of its contents to the player, making it not only a component in the player's progress of leveling up his or her character but also a textual description of events within the game's story.

5.5 Little Inferno: Letters

In Little Inferno [19], the player is given a virtual fireplace in which to burn a range of items which are gradually unlocked and purchased using an in-game currency. Throughout the game, the player receives letters from various characters gradually unveiling its plot while occasionally requesting or offering items, and these mostly arrive in a specific order for each sender. For example, an unknown girl by the name of Sugar Plumps sends the player a picture of herself, a number of somewhat obscure notes, a few gifts, and requests for some odd items she claims to need.

6 Analysis

Invoking Abbott's terminology, all of the above-mentioned storytelling artifacts are narrative in the wide sense. Furthermore, the audio logs, Scarlet Crusade Documents, and letters of BioShock, World of Warcraft, and Little Inferno, respectively, qualify even in the more narrow sense of the "told or written" (subsection 4.1). Assuming for this analysis the wider perspective, the artifacts match Jenkins' third sense of spatial storytelling: each relays an embedded narrative, the events of which exist on a new story level relative to which the artifacts

reside on a discourse level. This discourse level is then simultaneously a story level relative to the discourse level of the game's presentation or representation. That is, the artifacts exist within the told story of the game while telling stories within that story, and the game is thus a narrative frame.

The significance of the events of the embedded narratives range from supplementary for BioShock and World of Warcraft to mixed or intermediate for L.A. Noire and Little Inferno, and finally to constituent in Journey. For all of these games, with the exception of Little Inferno, it holds that the embedded narratives concern events prior to the main story level of the game and correspond to Jesper Juul's notion of *back-story* [13, Ideal stories / back-stories]: they are part of a larger plot alongside the events of the game, and given their precedence of the latter, their significance is historical.

In BioShock, World of Warcraft, and Little Inferno, the voice is the proposed author of the items in the storyworld, while no voice applies in the case of Journey given that the embedded stories are presented rather than represented, and no narrator is thus present. The focalization in the embedded narratives follows the voices, and in Journey it resides with the creators as observers of history. L.A. Noire is a more complicated matter since the newspapers are written and within the storyworld while evoking cinematics that are acted and outside of it; for the newspaper entities themselves, the voice and focalization is and follow the proposed writer, respectively, and for the cinematics, the voice is absent, and the focalization follows the central character of each scene. The distance varies between items depending on the range of the events from personally to historically or generally significant; it is intimately short for the first diary of BioShock and the cinematics of L.A. Noire, less so for the second audio diary and the Scarlet Crusade Documents of World of Warcraft, and near-objectively far for the glyphs of Journey and L.A. Noire's newspapers. The letters of Little Inferno, having diverse authors and contents, span this entire range of distance. Finally, none of the analyzed artifacts have omniscient narrators, and indeed such a case would imply that the artifact's author was himself all-knowing within the storyworld, assuming he doubles as the narrating voice or the determinant of focalization, as seen in most of the above games.

Consequently, the range from supplementary to constituent events appears related to the narrative distance while the focalization tends to follow the author, if present, or possibly the protagonist of the framed narrative (for the cinematics of L.A. Noire, at least). The creator is also generally the voice of the narration for represented narratives.

Relating further to Jenkin's approach, storytelling artifacts are constituents to the bodies of information that are their games' stories. Here, the structured level of the story is the plot of which the stories of the embedded narratives are part, and the unstructured counterparts are the framing game worlds within which the artifacts reside. The specific conditions under which the player constructs maps of the story space is then given by the variables in the presentation of the artifacts, the details of which I will investigate below.

7 Model

Based on the variations between the five accounted for games, the following operational parameters of storytelling artifacts can be identified:

Ordering: The level of rigidity of the order in which the objects can be obtained; a) *fixed*, wholly predetermined (such as letters from each sender in Little Inferno); b) *sequential*, predetermined but allowing the player to skip artifacts in the sequence (such as the newspapers in L.A. Noire); c) *restricted*, player-determined within certain limitations (such as most quest items in World of Warcraft); or d) *arbitrary*, wholly player-determined (such as the majority of audio diaries in BioShock).

Availability: Whether each storytelling artifact may be reread or replayed at will after being initially obtained; a) *stored*, capable of being reread at will once found (such as the diaries in BioShock); or b) *bound*, the opposite, available only when and/or where they are encountered in the game (such as the glyphs in Journey).

Mechanical Significance: Each object's level of significance for the gameplay; a) *scripted*, having a mechanical function in the game's progression (such as the Scarlet Crusade Documents in World of Warcraft); b) *semiotic*, containing information significant for the progression (such as the code required to access extra munitions in one of the audio diaries in BioShock); or c) *insignificant*, having no relevance for the progression (such as the newspapers in L.A. Noire).

These parameters complement the existing analytical tools relevant to storytelling artifacts and allow for an understanding of the objects' significance and style of operation. I will now apply the model to each of the introduced games to demonstrate its use.

In BioShock, the game world contains few restrictions to back-tracking, thus allowing all but the first two audio diaries to be obtained in any order. The diaries can be listenedd to at will once picked up, and although the game does not require them to be acquired, they occasionally contain information relevant for the gameplay. Consequently, their ordering is (mostly) arbitrary, their availability is stored, and their mechanical significance is semiotic.

For Journey, the glyphs are spread along the partially open environment, thus being restricted in ordering. They cannot be recalled outside of their spatial location and are therefore bound in availability, and as they are neither required for the game to progress nor contain any concrete information relevant to the gameplay, they are mechanically insignificant.

In L.A. Noire, the newspapers are found at locations accessible only at specific points during the linear chain of primary missions, and so their ordering is sequential. Furthermore, the newspapers, and the cinematics presenting their contents, cannot be recalled outside of their locations in the game world, and they are thus bound in availability. Although the newspapers elaborate on the story behind some of the cases for the player to solve, they offer no leads or any

other concretely relevant information, and as they are not required for the game to progress either, they are mechanically insignificant.

The particular quest item Scarlet Crusade Documents in World of Warcraft belongs to the dominant category of those whose ordering is restricted; although the relationships between certain quests and other parameters of the game's progression limit the possible orders in which the items may be acquired, the player retains a profound influence. As all items in the game are carried, quest items have stored availability, and since the Scarlet Crusade Documents like most quest items are explicitly required for the player to complete the associated objective, its mechanical significance is scripted.

Lastly, as the letters from each sender in Little Inferno are always acquired in a specific sequence, their ordering is fixed. The player is able to keep and reopen them at will, making their availability stored, and as some but not all of them either hint towards goals within the game or are explicitly required for progress, they span all three categories of mechanical significance.

Based on the above, storytelling artifacts are both similar or related in their narrative mode and vastly heterogenic in their specific operational parameters. Furthermore, certain trends can be identified among the latter: ordering can follow either the structure of a game's plot, such as fully linear for Little Inferno versus highly non-linear for World of Warcraft, or the spatial structure of the game world, such as arbitrary for BioShock versus restricted for Journey. Finally, objects of semiotic significance may mostly be stored, as in Journey and BioShock, likely to avoid forcing the player to return to where they were encountered to recall their critical contents when needed.

8 Significance

Given our findings thus far, storytelling artifacts have several flavors of unique narrative abilities on which I will elaborate below.

8.1 World Making

Through the concreteness of their embedded stories, storytelling artifacts contribute to worldness not only as artifacts in the present and implied relics but also as functional vessels for concrete back-story or narrative in general. This allows games to tell embedded stories integrated into both storyworld and the flow of gameplay. Furthermore, as storytelling artifacts as embedded narratives may have individual focalization, voice, and distance, they can be more personal than the framing narrative and reveal the thoughts and personalities of its characters as narrators. Even in the cases where the game in itself has one or more narrators, the embedding of narratives within it allows for a more nuanced narration through a wider range of narrators on different narrative levels. The highly subjective audio diaries of BioShock and the heterogeneity in the nature and authors of quest items in World of Warcraft are pertinent examples.

8.2 Active Reading

Through their fragmentation and distribution across the game space, storytelling artifacts require a larger amount of cognitive effort from the player to derive from their bodies of information the plot in question. This demands an investigative approach to the plot compatible with the experimental nature of navigation in a spatial game world, and through stored availability the complexity of the narrative puzzle may reach quite significant levels. For example, understanding the full depth of the fate of the setting and its prominent characters in BioShock requires the player to piece together the storyline from the various audio diaries, and the back-story of Journey is hinted exclusively through its glyphs.

8.3 Optional Content

Since the player may often ignore the contents of storytelling artifacts, particularly in the cases of mechanically insignificant or scripted items, they allow games to offer a deepening of the storyworld and a widening of the encompassed stories without forcing the player to invest further time and effort in their engagement with the narrative. For example, activating the newspapers of L.A. Noire is completely voluntary[4], and the player is rarely required to read textual contents of items in World of Warcraft to complete the quests for which they are needed. Thus, games can cater for diversity in the preferences in their players from highly motivated by storytelling to utterly uninterested in or even oblivious to its presence.

8.4 Mechanical Relevance

Finally, in the cases of scripted or semiotic mechanical significance, the storytelling artifacts represent a concrete merging of story and game in a virtual item that both exists within and embeds narrative and is a potentially critical component of the gameplay. The artifacts thereby represent a category of condensed ludonarrative[5] bridges between their mechanical roles and the contributions of their embedded narratives to the storyworld. A pertinent example is the Scarlet Crusade Documents in World of Warcraft which connect the player's actions and the larger developments in the game's fiction.

9 Conclusions

I have reviewed existing literature tangent to storytelling artifacts, defined the category, applied narrative theory to several cases, and identified a range of parameters as a framework for for analysis. Narrative artifacts have a number

[4] With the single exception of the very last newspaper which must be activated for the game to progress.

[5] Ludonarrative, or *ludo-narrative*, as in Aarseth's sense of a paradigm for the understanding of the narrative components of games. [2, Section 3]

of characteristics giving them a unique ability to both deepen and widen the narrative of games while being integral to the gameplay on a mechanical level. They are excellent mediators of back-story and personality of characters while capable of offering objective-critical information to the player from within the storyworld. Finally, although both the narrative and specific properties of the artifacts vary widely, certain patterns can be identified, and the domain affords further study into their workings and relations to other narrative and mechanical components of games. Particular scopes of relevance here are ludonarrative (e.g. Hocking 2007 [10], Aarseth 2012 [2]), quest theory (e.g. Aarseth 2005 [4], Howard 2008 [11]), and computer game semiotics (e.g. Aarseth 2007 [3, pp. 24–41]).

Acknowledgements. Thanks to Yun-Gyung Cheong for encouraging me to submit this paper.

References

1. 2K Boston and 2K Australia. Bioshock. Microsoft Windows, Xbox 360, PlayStation 3, OS X, OnLive (August 21, 2007)
2. Aarseth, E.J.: A Narrative Theory of Games. In: Foundations of Play and Games 2012 Proceedings (2012)
3. Aarseth, E.J.: Allegories of Space: The Question of Spatiality in Computer Games. In: von Borries, F., Walz, S.P., Bottger, M. (eds.) Space Time Play: Computer Games, Architecture and Urbanism - the Next Level, September 1, pp. 152–171 (2007)
4. Aarseth, E.: From hunt the wumpus to everQuest: Introduction to quest theory. In: Kishino, F., Kitamura, Y., Kato, H., Nagata, N. (eds.) ICEC 2005. LNCS, vol. 3711, pp. 496–506. Springer, Heidelberg (2005)
5. Porter Abbott, H.: The Cambridge Introduction to Narrative, 2nd edn. (April 17, 2008)
6. Atkin, A.: Peirce's Theory of Signs. In: Zalta, E.N. (ed.) The Stanford Encyclopedia of Philosophy, Winter 2010 (November 15, 2010), `http://plato.stanford.edu/archives/win2010/entries/peircesemiotics/` (visited on April 11, 2012).
7. Blizzard Entertainment. World of Warcraft. Microsoft Windows and Mac OS X (November 23, 2004)
8. Montreal, E.: Deus Ex: Human Revolution. Microsoft Windows, OS X, PlayStation 3, Xbox 360 (August 23, 2011)
9. Frictional Games. Amnesia: The Dark Descent. Microsoft Windows, OS X, Linux, OnLive (September 8, 2010)
10. Hocking, C.: Ludonarrative Dissonance in Bioshock (October 7, 2007), `http://clicknothing.typepad.com/click_nothing/2007/10/ludonarratived.html` (visited on December 05, 2014).
11. Howard, J.: Quests: Design, Theory, and History in Games and Narratives (February 26, 2008)
12. Jenkins, H.: Game Design as Narrative Architecture. In: Computer 44 (July 10, 2004)
13. Juul, J.: Games Telling stories? In: Game Studies 1.1 (2001), `http://www.gamestudies.org/0101/juul-gts/` (visited on April 24,2013)

14. Juul, J.: Half-Real: Video Games between Real Rules and Fictional Worlds (2005)
15. Krzywinska, T.: Blood Scythes, Festivals, Quests, and Backstories: World Creation and Rhetorics of Myth in World of Warcraft. In: Games and Culture 1.4 (October 2006)
16. Rocksteady Studios. Batman: Arkham Asylum. PlayStation 3, Xbox 360, Microsoft Windows, OS X (August 25, 2009)
17. Team Bondi, Noire, L.A.: PlayStation 3, Xbox 360, Microsoft Windows (May 17, 2011)
18. Thatgamecompany. Journey. PlayStation 3 (March 13, 2012)
19. Tomorrow Corporation. Little Inferno. Wii U, Microsoft Windows, iOS, OS X, Linux, Android (November 18, 2012)
20. Valve Corporation. Half-Life 2.MicrosoftWindows, Xbox, Xbox 360, PlaySta- tion 3, and Mac OS X (November 16, 2004)
21. Antonio Lucio Vivaldi. Le quattro stagioni. 1723

Toward a Hermeneutic Narratology
of Interactive Digital Storytelling

Fanfan Chen

Department of English – National Dong Hwa University
Shoufeng 97401, Hualien County, Taiwan
ffchen@mail.ndhu.edu.tw

Abstract. This paper attempts to frame a hermeneutic narratology of interactive digital storytelling in light of Paul Ricoeur's philosophy and the narratology of the French New Rhetoric. For starters, I propose to bring to light an underlying rationale to demonstrate the significance of interactive storytelling in videogames that go beyond entertainment. This rationale rejoins the perennial ontological and epistemological questions. I will then analyze how the threefold mimesis functions *par excellence* in interactive storytelling. Lastly, my theoretical framing will be completed with the praxis dimension of mimesis, a discussion of semiotic and morphological orientation for emplotment, for future digital *poiesis*.

Keywords: interactive digital storytelling, videogame, digital narrative, hermeneutics, rhetoric, narratology, mimesis, semiotics.

1 Introduction

Interactive storytelling in digital games is an activity for which nothing fits better than the concept of mimesis in light of Aristotle, who highly esteemed the creative, cognitive and psychological functions in this imitating *poiesis*. Paul Ricoeur insightfully interpreted this mimesis as a threefold mimesis through Aristotle's rhetorical perspective [1]. Interactive storytelling, this state-of-the-art mode of game narrative, has enjoyed a surge in popularity in recent years. It is true that many die-hard defenders of traditional artistic media frown at the rapid growth and popularity of digital media for artistic creation, generally taken as distancing for the humanities; nonetheless, some others embrace the entailed ramifications of scientific improvement and try to look into its poetic and philosophical profundity. In the last century, the anti-novel trend in modernism and postmodernism that defies narrative as storytelling has entailed stories 'going missing' and thus given rise to a new desire among our human abstract minds. This missing link is being bridged by the mediation of digital games, which present a new style of human mimetic craftsmanship upgraded by the advances in science and technology.

I will set out to frame an underlying philosophical rationale behind the game and narrative designs to demonstrate that the significance of interactive storytelling in videogames goes beyond entertainment. It indeed reaches out and harks back to the

A. Mitchell et al. (Eds.): ICIDS 2014, LNCS 8832, pp. 125–133, 2014.

perennial ontological and epistemological questions that have gnawed at philosophers since ancient Greek times. I will then analyze how the threefold mimesis functions *par excellence* in interactive storytelling in videogames. Lastly, my theoretical framing will be completed with a consideration of the praxis dimension of mimesis, a discussion of semiotic and morphological orientation for emplotment, for future digital *poiesis*.

2 Epistemology of Interactive Digital Storytelling

There is more to interactive digital storytelling than meets the eye. Digital-game narrative in general, and interactive digital storytelling in particular, embody what Ricoeur set forth as the third way of being: narrating and acting. This narrative mode is a serious issue that merits study from philosophical, poetic and rhetorical aspects. In Book Three of Aristotle's *Rhetoric*, narrative is emphasized as an important strategy of rhetorical composition [2]. In addition, the fictional narrative, *muthos*, in *Poetics*, demonstrates the best rhetorical means of representing the probable in reality, as more philosophical than history [3]. Besides, interactivity presents the essential element of rhetoric: the art of persuasion or convincing; it further epitomizes the three rhetorical elements: *ethos*, *logos*, and *pathos*. Interactive digital games indeed best boast Aristotelian rhetorical features: narrative, *muthos*, and interaction. Grant Tavinor even identifies interactivity in videogames: "I have argued elsewhere that if one is careful in specifying exactly what it is that is interactive about interactive fictions, then videogames can often be counted as such things" [4, p 24]. As Ian Bogost also identifies the function of argumentation and persuasion in videogames and coins "procedural rhetoric" in his *Persuasive Games*, videogames opens a new domain of rhetoric through procedurality, which presents expressive power in three fields – politics, advertising, and learning [5]. The *poiesis* of videogames is more than rhetoric and narrative, it touches upon something more profound. Tavinor also points out the effort within the circle of philosophy to frame this study while examining disjunctive and explicative definitions of videogames [6].

As Tavinor declares, "There is a general epistemological precept [in defining videogames]: concepts do our bidding, and we are not their slaves" [6, p 10], we need to explain and understand this genre via epistemological detour in order to reach an ontology of videogames. Ricoeur applies Socrates' maxim that an unexamined life is not worth living to the relation between narrative and life in order to argue for his thesis that human life is in quest of narrative. In response to this insight, Ricoeur claims that an examined life "is a life recounted" [7, p 31]. His comments evoke the significance of the player's interaction with and participation in digital narrative today: "What Aristotle calls plot is not a static structure but an operation, an integrating process, which, as I shall try to show later, is completed only in the reader or in the spectator, that is to say, in the living receiver of the narrated story" [7, p 20]. This "living receiver of the narrated story" here can be better characterized as the living receiver of the digital story – interactive player. The ludological argument often emphasizes the gameplay gestalt [8] of digital games at the expense of the semantic depth of the game narrative. If the gameplay gestalt concerns reflexive and cognitive functions and training in the player, the game narrative covers a much broader range of human mind and body. A "recounted life" is marked with the will to understand, interpret and

actualize life as a text. To narrate is to understand; more precisely, narrative constitutes doing and understanding. Stressing the importance of emplotment, Ricoeur claims that followability of a story is understanding: "Recounting, following, understanding stories is then simply the continuation of these unspoken stories" [7, p 30]. And interactive storytelling substantially demands followability. This third dimension of linguistic imagination constitutes self-understanding, for narrative understanding is at the same time the Aristotelian *phronetic* understanding. As mimesis is better interpreted as 'imitating of action', interactive game storytelling embodies synchronically imitating and acting. If Aristotle lived in our times and played videogames, he would be amazed by the actualization of mimesis in this new media, not least the mode of interactive narrative.

Game storytelling is similar to a poetic work inasmuch as it creates and represents the probable, as Aristotle indicates. It is different from history, which presents what happened in the past through factual narrative. Like a literary work, it is the mediation between man and time, man and nature or the world, man and himself, and man and others: "the mediation between man and the world is what we call referentiality; the mediation between men, communicability, the mediation between man and himself, self-understanding" [7, p 27]. This mediation is made possible and effected through the narrative function. Like fiction and history, digital game narrative also possesses the aforementioned three dimensions – referentiality, communicability and self-understanding. These are manifested ostensively in interactive digital narrative, which configures a form of virtual life. Wittgenstein claimed that the form of life is a language-game, whereas Ricoeur specified that narrating is a unique language-game. This integration of language-game and narrative is best consummated in videogame narrative and interactive digital narrative in particular. The metaphorical figure of 'life is a story', though a cliché in interpreting our life, assumes a new look in digital storytelling. This metaphor seems to resume its literal appearance in the interaction of game playing, reversely implying 'a story is a life'. Can we not say that playing digital games and interacting with the plot is not simply the continuation of the unspoken stories but also a configuration while refiguring the stories? Stories lead us back to life. Ricoeur argues the process of configuration is not completed in the text but with the reader. This thesis can be further extended to the configuration of game narrative. The configuration is completed with the player, especially in the narrative configuration of interactive storytelling. As Ricoeur says, "A text is not something closed in upon itself, it is the projection of a new universe" [7, p 26]. It concerns a process of 'unrealization': "in reading, I 'unrealise myself'" [9, p 94]. In game narratives, the player unrealizes himself to see a new world and a new self. This new universe is more tangible for 'readers', precisely 'players'.

3 Threefold Mimesis of Interactive Digital Storytelling

Emphasizing Ricoeur's idea of "meaningful action as text," Harviainen proposes a hermeneutical approach to role-playing analysis. He especially highlights Ricoeur's idea of "action as text," "appropriation" and "metaphor" in developing his reductionist approach by layers [10, p 72]. As Harviainen's study covers a broader scope encompassing non-digital and digital, mainly tabletop-centric theory, and his

hermeneutical circle refers rather to traditional hermeneutics in general [10, p 69], not Ricoeur's in particular, I propose to complement his application of Ricoeur's theory by expounding threefold mimesis and the ascending hermeneutic circle, particularly in interactive videogame narrative. Ricoeur endeavored to steer a third course beyond the aporia between cosmic time and lived time. This third way is the time of narrative. He establishes the mediating role of emplotment between *mimesis 1* and *mimesis 3* to resolve the problem of the mediation between time and narrative. As interactive videogaming is a temporal event *per se* and its narrative design revolves around event, constituted by elements such as event content and event sequence in Rhetorical Structure Theory [11], the Ricoeurian threefold mimesis that serves to mediate time and narrative provides a best-fit analytical approach. *Mimesis1* concerns *ethos* and *inventio* in rhetoric; *mimesis 2* refers to *logos* and *dispositio* as well as *elocutio*; *mimesis 3* corresponds to *pathos* and rhetoric in its totality. Ricoeur's *mimesis 3* operates in a more concrete way in interactive game storytelling than it does in conventional written/spoken storytelling, for the player actively participates and interacts, which harks back to the essential meaning of mimesis as 'imitating of action,' with the configured story processed through *mimesis 1* and *mimesis 2*. The latter process concerns closely the narrative designer of games, consisting as it does of thematic and semiotic preunderstanding and emplotment. In short, *mimesis 1* is the stage of prefiguration, *mimesis 2* that of configuration, and *mimesis 3* refiguration.

Mimesis 1 is the most relevant to the praxis in narrative. It is also the field of potentiality and referentiality, or in videogame narrative, of the virtual and the referentially real. The composition of the plot is grounded in a preunderstanding of three elements of the world of action – its meaningful structures, its symbolic resources, and its temporal character. Structural preunderstanding concerns a "conceptual network ... of action" [1, p 55] or the conceptual network of the semantics of action. This network governs human actions and interactions, which encompass elements in the practical field, such as motives, agents, why, who, and other circumstances. Like the linguistic rule that governs the paradigmatic to the syntagmatic parts, the writing and reading of a plot requires the rules of composition that govern the diachronic order of a story. Therefore, "to understand a narrative is to master the rules that govern its syntagmatic order" [1, p 56]. This rule understanding can best be applied to narrative design in digital games – rule following – to orient toward a comprehensive conception of digital storytelling. The second element, symbolic preunderstanding, means the symbolic resources of the practical field in which our practical understanding lies. It involves issues of ethical quality, such as moral and value. This symbolic mediation evokes the rhetorical *ethos* and *inventio* since it rejoins the "ethical" presupposition and topics. In interactive narrative design, symbolic mediation should be taken more seriously. Humans are in fact symbolic beings; incorporation of symbolism in game narrative draws players to be immersed in the virtual world in an implicit yet profound way; an example is the symbolism of light and darkness in *The Child of Light*. The last element, temporal preunderstanding, designates "the temporal elements onto which narrative time grafts its configurations" [1, p 59]. An "inductor" of narrative, this temporal preunderstanding essentially concerns the temporal context of our act or the temporality of action. And it concerns closely the temporality in interactive videogaming, which involves configuration and refiguration in real time; it can thus be considered as event vs. sense in speech act. Moreover, what is most

instrumental in applying Ricoeur's *theory* lies in the parallelism between speech-act and play-act. Following his argument for the correlation between text and action, precisely the transposition from text *to* action, to life, we may characterize game playing as an action-event backed up by sense-content. The dialectic between sense and event in a speech act extends to the dialectic between the semiotic elements in narratology and the temporal action-event that configures and refigures the emplotment in digital games.

As Ricoeur's *mimesis 2* refers mainly to the territory in the preoccupation of formalist narratology, it will be elaborated in the next section on semiotics and morphology. *Mimesis 3* presents the very moment for verifying the true state of the hermeneutic circle. Through the process of refiguration in *mimesis 3*, narrative has its full meaning restored to the time of action and suffering. In reading and with the reader, or more evidently in game 'reading' and playing with the player, the traversal of mimesis reaches its fulfilment. At this stage, the intersection of the text world (the world configured by the text) and the reader's or player's world (where real action occurs and unfolds its specific temporality) is in operation. In interactive storytelling, the stage of *mimesis 3* involves a double figuration, namely configuration and refiguration for the player to understand and refigure while reading visually, intellectually and audibly the potential plots configured by the game designer(s). The player's participation and interaction in *mimesis 3* crosses the limitation of reader passivity, with a text world represented merely by words or imagery as in cinema; a third world unfolds before the reader's eye. This triple digital mimetic process best hypostatizes Ricoeur's ascending/spiral hermeneutic circle. In interactive digital games, a player is able to influence a world, which in turn responds to his doings. In this manner, he can experience the feeling of *agency*, a feeling that one is in control of a situation, and can exert his will on the world to some extent [12].

From *mimesis 1* to *mimesis 3*, the relationship between narrativity and reference is all the more evident as discourse resumes its status of communication. The act of communication entails referential interweaving, which enables a fusion of horizons through the three mimetic moments. The Ricoeurian concept of unreality against absence is best illustrated in the virtual reality of videogames. In parallel manner, this process can be characterized as moving from "distantiation" through to "appropriation". "Distantiation" is important in forming the hermeneutic dialectic pair with "appropriation", yet Harviainen focuses only on "appropriation" while drawing on Ricoeur's hermeneutics. This fusion of horizons rests upon three presuppositions underlying three kinds of discourse: acts of discourse; literary works; narratives [1, p 77]. These three genres of discourse correspond respectively to three levels of reference: dialogical reference, metaphorical reference, and the interweaving of reference between reference of trace and metaphorical reference. In digital games, the player that interacts with the digital story executes the transference in two directions. On the one hand, the player participates in the discourse in general in the virtual world as he interacts in action and in speech with characters and plot sequences; on the other, the game story is at the same time an artistic rendering through digital mediation, which can be considered as a genre of literary discourse and in particular, a narrative discourse. In the course of playing, interacting and creating the story, the player also goes through a process moving from distantiation to appropriation to generate a further polarity between these two experiences of time, atemporalization vs. temporalization.

These three mimetic phases manifest the importance and indispensability of the designer (*ethos*), textual, visual and audible emplotment (*logos*) and most importantly, the player (*pathos*). Through a living and engrossing narrative art and a communication of messages and thought, the player interacts with, interferes in and experiences the story so as to undergo the process of what Aristotle calls "catharsis" or emotion purification, while interpreting in an active and participating way.

4 Semiotic and Morphological Orientation for Emplotment

At the outset of his hermeneutic argumentation, Ricoeur clearly distinguishes it from semiotics. The latter focuses on sense and explanation while the former focuses on meaning (sense and reference) and understanding/interpretation based on explanation. Nevertheless, his scrutiny of French new rhetoric enables him to reconcile literary theory with positivist epistemology. The structural analysis of plot is crucial to the configuration of *mimesis 2*. Instead of repeating the formalist textual analysis, encompassing characters, time, space, action and narrative voice and focalization in his analysis of *mimesis 2*, Ricoeur concentrates his arguments on the dialectic of event and story, of heterogeneity and homogeneity, of temporal discordance and concordance in emplotment, and the articulation between *mimesis 2* and *mimesis 1*. His greatest contribution to the study of emplotment lies in temporalization of the atemporal and paradigmatic analysis of structuralism by raising two concepts: schematism and traditionality. This schematism is not an atemporal pattern but rather a narrative Kantian one, irreducible to abstract patterns, based on productive imagination. This narrative irreducibility can be useful in designing constructive units for digital games. By the same token, the second concept, traditionality, is also of temporal character. It operates on the dialectic of sedimentation and innovation. Reflecting on the dialectic of innovation and sedimentation in traditionality in narrative design will shed better light on the degree of narrative creation and re-creation in terms of traditional narrative genres, such as myth, epic, history, fantasy, gothic and science fiction.

The dialectic of sense and reference and of the Same and the Other in language systems and speech discourse analysis presents an ontological presupposition in discourse in general. Nonetheless, the semiotic system is yet important and useful in the process of emplotment. This is all the more true when it comes to digital narrative design as invariant patterns, the side of semiotic signs underlying senses, are useful in setting functions with variables such as space, time, *actant*, and action. Different narrative models or modes have been created and classified in interactive digital storytelling. Reviewing the old models of story vs. game and game-story simulation, Aarseth proposes a four-dimensional model based on the four dimensions in which games and narratives have in common: world, objects, characters, and events [13]. We may also refer to basic modes that present the player with a choice at a certain point to decide how the story progresses and alternative mode where the story is not pre-authored in a strict sense but "emerges from interaction between simple components" [14, p 84]. While the former pivots on the player's or the agent's or the protagonist's choice, the latter is based on the actions taken, which touch upon the main objective of mimesis. In addition to characters and actions, more morphological elements in narrative also feature as possible orientation for narrative unfolding in

interaction with the player. Interactive storytelling aims to move away "from the usual linearity in stories by enabling the receiver to influence the narrative. This effects a change in the role of the receiver as he interacts with the narrative instead of merely 'consuming' it passively" [15, p 1]. Reducing this passivity in the player in interactive storytelling brings into play the dialectic between plot and freedom. Therefore interactive narrative requires two conflicting requirements – coherent narrative and user agency [16]. A reconciliation between a high degree of agency and narrative plot control is at stake in narrative design. This narrative paradox between interactive storytelling experience and set storyline evokes the ontological aporia between freedom and nature or world in ontology. If Ricoeur's recourse to narrative is viable in solving this aporia, then narrative itself is enabled to steer a third course for balancing the tradeoff between the designed plot and the player's freedom. To make narrative function as a third being that comprises potentiality and actuality, it is necessary to scrutinize all dimensions and constituents of narrative and configure the plot in the most probable ways in praxis.

The semiotic elements of narrative include space, time, characters/narrators/players and action. Aarseth uses four dimensions as the basic units: world, objects, characters, and events [13]. These four dimensions are not really irreducible elements in narratological terms, yet might be feasible in digital narrative design. Based on the structure of subject and predication, the designer can structure the syntactic pattern by applying variations in paradigmatic elements, such as characters or spaces or actions. On the other hand, emplotment can be oriented by syntactical patterns. For example, the plot can be designed as an ascending line leading to the climax of the story, or it can start with the climax, such as a murder or an incident with the plot then unfolding as it unravels the enigma. Be it character-based interactive storytelling or space-oriented storytelling, the most important element for French narratology – narrative time and mode – should be seriously considered and studied. In terms of narrative time, the order (analepsis and prolepsis) of narrative makes great difference, and essentially distinguishes story from plot. I particularly raise temporal issues here, in response to the existing concept of linear story in digital games, for further reflection on temporality in videogame narrative, where linearity is currently defined against players' choices and influence. Here linearity is correlative rather to a smooth advancing of the storyline than to temporal linearity. It is an in-our-face issue because advances in technology will provide more sophisticated narrative renderings. Thus, order, frequency and pace should be included in plot conception. Whether the story will be told in pause, mimetic mode, summary or ellipsis depends on what effects it is intended to create for different demographics of players by age, gender, aesthetic taste, etc. If an episode might be intended to be engrossing, mimetic narration is better than a summary narration. This can be interwoven with temporal frequency, viz. the consideration of significant elements in iterative, repetitive or singulative mode. In terms of narrative mode, narrative voice and focalization are most important in narratology. The combination of narrative voice of homodiegetic/autodiegetic and heterodiegetic narration and focalization of internal, external and zero can generate different narrative patterns of plot.

In current videogames, narrative complexity already manifests in the narrative focalization, for example internal focalization in *BioShock Infinite* or the external focalization in *Assassin's Creed*. There is still room for creating more sophisticated

narrative voice and focalization in future digital emplotment. Space, apart from its geographical and static setting design, can be treated as abstract or kinetic plot structure patterns. In this sense, spatial structure can involve labyrinthine structure, spiral, vertical, horizontal, circular, etc. Even characterization in videogames can be more complex in personality building if we refer to Nakasone's interest-based storytelling model that elaborates on the player's emotion [11]. This concerns designing a flat or round character, which even extends to speech act interaction. Other elements can be taken into consideration when it comes to narrative design, such as narrative genres (imaginary or realistic), and sequential, integral, and episodic story. In short, designing intricate, profound, yet smooth and engrossing interactive stories in digital games requires seamless interdisciplinary understanding, cooperation and creation.

5 Conclusion

Interactive digital storytelling is multiphase reaching out to various fields which involve professional techniques ranging from characterization, action, time-space setting, symbolic mediation, configuration of a virtual world, game design document conception, through to narrative rhetoric. The proposed theory of a hermeneutic narratology considers this multiphase character. Most importantly, it goes beyond semiotics and technical analysis and extends to profound and essential dimensions, such as the poetic, epistemological, psychological and ontological. The three basic elements which comprise classical rhetoric manifest the importance and indispensability of the designer (*ethos*), textual, visual and audible emplotment (*logos*) and the player (*pathos*). In our twenty-first century, Aristotle's poetics still stands as being veritable: mimesis, though a creative imitation of action, still holds cognitive function. It transmits 'truth' better than history. Through living and engrossing narrative art and communication of messages and thought, the player interacts with, interferes in and experiences the story so as to undergo the process Aristotle calls "catharsis". When the player's real world fuses with the configured virtual world into a transcendental third world, potential and actualized, the player also refigures a narrative identity with self-understanding and meaning. The key to players' addiction lies in a comprehensive narrative design rich in poetic artistry and emotion as well as epistemological and ontological depth.

References

1. Ricoeur, P.: Time and Narrative, vol. 1. The University of Chicago Press, Chicago (1990)
2. Aristotle: Rhetoric. Rhys Roberts, W. (trans.). The Pennsylvania State University, An Electronic Classics Series Publication (2010)
3. Aristotle: The Poetics of Aristotle. Epps, P. H. (trans.). The University of North Carolina Press, Chapel Hill (1970)
4. Tavinor, G.: The Art of Videogames. Wiley-Blackwell, West Sussex (2009)
5. Bogost, I.: Persuasive Games: The Persuasive Power of Video Games. The MIT Press, Cambridge (2010)
6. Tavinor, G.: The Definition of Videogames Revisited. In: The Philosophy of Computer Games Conference, Oslo (2009)

7. Ricoeur, P.: Life in Quest of Narrative. In: On Paul Ricoeur: Narrative and Interpretation, pp. 20–33. Mariner Books, Boston (1991)
8. Lindley, C. A.: The Gameplay Gestalt, Narrative, and Interactive Storytelling. In: Proceedings of Computer Games and Digital Cultures Conference. Tampere University, Tampere (2002)
9. Ricoeur, P.: Hermeneutics and the Human Sciences. In: Thompson, J. B. (eds. & trans.). Cambridge University Press & Editions de la Maison des Sciences de l'Homme, Cambridge & Paris (2005)
10. Harviainen, J.T.: A Hermeneutical Approach to Role-Playing Analysis. International Journal of Role-Playing (1), 66–78 (2008)
11. Nakasone, A., Ishizuka, M.: ISRST: An Interest Based Storytelling Model Using Rhetorical Relations. In: Hui, K.-c., Pan, Z., Chung, R.C.-k., Wang, C.C.L., Jin, X., Göbel, S., Li, E.C.-L. (eds.) EDUTAINMENT 2007. LNCS, vol. 4469, pp. 324–335. Springer, Heidelberg (2007)
12. Mateas, M., Stern, A.: Towards Integrating Plot and Character for Interactive Drama. In: Working Notes of the Social Intelligent Agents: The Human in the Loop Symposium, pp. 113–118 (2002)
13. Aarseth, E.: Narrative Theory in Games. A Lecture about Narrative Theory in Games (2010), http://www.itu.dk/en/Uddannelser/Podcasts/Narrative-Theory-of-Games (accessed August 2014)
14. Aylett, R.: Narrative in Virtual Environments – Towards Emergent Narrative. In: Proceedings of the 1999 AAAI Fall Symposium on Narrative Intelligence, pp. 83–86 (1999)
15. Linssen, J.: A Discussion of Interactive Storytelling Techniques for Use in a Serious Game. Technical Report TR-CTIT-12-09, Centre for Telematics and Information Technology, Unviersity of Twente, Enschede (2012)
16. Riedl, M.O., Stern, A.: Believable agents and intelligent story adaptation for interactive storytelling. In: Göbel, S., Malkewitz, R., Iurgel, I. (eds.) TIDSE 2006. LNCS, vol. 4326, pp. 1–12. Springer, Heidelberg (2006)

Five Theses for Interactive Digital Narrative

Hartmut Koenitz

University of Georgia, Department of Telecommunications,
120 Hooper Street, Athens, GA 30602-3018, USA
hkoenitz@uga.edu

Abstract. The field of Interactive Digital Narrative (IDN) can look back at more than 25 years of research. Considerable technical advances exist alongside open questions that still need full attention. With the discussion of five crucial aspects - narrative analysis, interoperability between different implementations, sustainability of digital artifacts, author-centered view, and user-focused perspective - the paper starts a conversation on successful methods and future goals in the research field.

Keywords: Narratology, Narrative theory, Software Interoperability, Software Sustainability, Narrative Authoring, Authoring Tools, User-centered perspective, Interactive Digital Narrative, Interactive Digital Storytelling.

1 Introduction

Interactive Digital Narrative (IDN) has been a research topic for more than 25 years. There have been many technical advances, especially in the area of artificial intelligence, improvements in theoretical understanding, and artistic achievements. At the same time, discussions amongst scholars frequently identify areas of concern regarding the direction of the field. While some of these concerns find their way into research papers, they are usually not presented alongside each other. It seems therefore appropriate to bring together five aspects crucial for the future of IDN to create a permanent record and reach a wider audience. The aspects are presented as theses that progress from analysis to proposals for continued work; together they form a position paper intended to spur further discussions.

2 We Need a New Narratology for IDN

In the early 2000s, a sometimes heated debate took place between so called ludogists and narratologists. At the core of the debate was the claim that analytical perspectives originating in literary studies were inappropriate for the study of video games. In its most extreme form, the ludologist view also rejected the possibility of interactive narrative [1]. With the recognition of games studies as a discipline, the discussion calmed down and Janet Murray declared the end of the debate in a "final word" in 2005 [2]. However, the underlying issue about the compatibility or lack thereof

A. Mitchell et al. (Eds.): ICIDS 2014, LNCS 8832, pp. 134–139, 2014.

between narrative and interactivity was never fully resolved. And it never will, for two reasons: 1) the underlying framework of established narratology assumes fixed objects of study. The printed book and the final cut of a movie are such objects, as is the text of a stage play. IDN as a dynamic procedural digital artifact is not 2) Many narratological terms are fuzzy and therefore have become problematic in regards to clearly communicating any particular concept. For example, Espen Aarseth [3] argues that yet another re-definition of the term 'text' is inconsequential, as there have been numerous changes to the meaning beforehand. Similarly, the terms story/discourse and their variations have been re-interpreted time and again to a point where the original meaning can get reversed, as summarized by Nitsche. [4] Yet, terminology loses its most important function in communicating concepts when scholars essentially need a dictionary of private definitions to fully appreciate each other's positions. This state of affairs is particularly problematic in an interdisciplinary field in which theoretical concepts and their interpretation serve as a basis for concrete implementations and research directions. In other words, while narratology scholars might be well versed in dealing with fuzzy concepts from a purely analytical perspective, many other disciplines are used to more narrowly defined terminology.

A new narratology, in the sense of a theory of interactive narrative, with terms commonly understood in the field of IDN, is a chance to overcome both of these issues. New vocabulary is essential in this undertaking, to shed the baggage of accumulated re-interpretations.

This effort would certainly not start from scratch, but reframe existing work of scholars in the field. For example, Marie-Laure Ryan's concept of storyness as a scalar property combining story/discourse [5] and Janet Murray's affordances and phenomenological qualities of digital media [6] provide building blocks in this regard but also Nick Montfort's perspective on interactive fiction as a software [8], Additional aspects to be considered are for example characteristics of an IDN specific narrative framework proposed earlier by me [9], integration of perspectives [10], but also on specific aspects such as agency [11,12] and closure [13].

3 Interoperability is Key

It is a common joke in the field that "everybody wants to have their own authoring system" (Jay Bolter, private communication, 2010). There are many good reasons why scholars in IDN build their own systems: specific research directions, aesthetic choices, rules of academic funding, etc. However, the plethora of systems can also be seen as impeding progress if we concede that IDN is too big of a problem to be solved by any individual or research group alone.

In addition, specific research efforts are burdened with solving problems peripheral to their original goals in order to deliver complete systems. For example, an agent-based approach might need to implement a meta-narrative layer and an interface for the end-user, while neither of these issues would be central to the original research focus. At the same time, other researchers might have concentrated on exactly these

issues and consequently produced components that could fulfill these roles. However, there is no guarantee that efforts that appear complimentary on an abstract level will actually operate in concert on a technical level.

In recognition of these issues, there is an increasing understanding that collaboration across research efforts is valuable and could help avoid duplicate efforts. In terms of systems this means that technical standards are needed that enable data exchange. For a number of years now, Szilas et al have spearheaded a crucial effort in this regard, culminating in a specification for an open architecture [14]. This important work needs to continue, while researchers in the field could consider a fully qualified standard, for example an ECMA specification for XML formats and inter-application communication. Such an effort would also help to bring the field closer to the often discussed – but so far elusive – ability to compare the performance of different systems and in this way identify strengths and weaknesses. With standards for data exchange, a shared IDN test scenario seems technically more feasible.

4 Sustainability is Essential

Scholarly inquiry in IDN includes concrete implementations in the form of computer software. A growing problem in digital media is obsolescence, caused by the rapid progress of computer hardware and operating systems. Regardless of how good an idea and its original implementation are, their value for the academic community is sharply diminished if later scholars cannot observe and evaluate them. Therefore written accounts in the form of research papers are not sufficient. Unfortunately, much of the earlier research in the area of IDN, for example software developed in the Interactive Cinema Group at the MIT Media Lab, was lost in this way. Kevin Brook's early agent-based narrative system Agent Stories [15], developed as part of his PhD thesis, is a concrete case in point. Given this state of affairs we should not be surprised when experienced scholars lament a culture of "reinventing the wheel," and feel that a proportion of new projects are just reincarnations of older ideas.

IDN as a field should make strides to prevent losing earlier research and preserve operational records of software in addition to scholarly publications. Prior work in cataloging IDN research such as the Iris project can provide a start for this effort. However, more work and funding is needed; maybe the electronic literature organization [16] can provide a model in this regard. Their publication on "A Framework for Migrating Electronic Literature" [17] also includes concrete technical consideration for the preservation of digital projects that can serve as guidelines.

At the same time, future projects should adopt sustainability as a key design feature. Long-running software projects, like the World Wide Web and its underlying architecture could provide guidance in this respect. For example, the RFC technical bulletins used to explain and develop the TCP/IP networking standard can serve as a model as well as aspects of the W3C organization, in its role to maintain and develop HTML and related standards like CSS.

5 IDN Needs to Be Author-Focused

Computer science-based IDN research has focused on the development of advanced computational systems to enable highly reactive and generative experiences. Simultaneously, the humanities-derived perspective has been concerned with the analysis of the resulting experiences and the creative potential vs. traditional forms of narrative. Much less attention has been paid to the creative process of actually creating IDN experiences. Out of necessity, many toolmakers became content creators, because they best understood their own tools. Educating others in the use of the tools, and thus creating a new class of author – for which Janet Murray [6] has offered the term *cyberbard* – was not an area of focus for most projects.

This is clearly an unusual situation if compared to other forms of storytelling – as if the engineer responsible for the design and manufacturing of a camera is also the creative mind behind the movies shot with this creative tool. The division of specialized roles in the fine arts and the creative industries between technical inventors and artists/creative professionals is well established for good reason. Exceptions such as the painter Henri de Toulouse-Lautrec, who invented the color printing technology necessary to create his colorful posters, are rare. Therefore, toolmakers most likely will not be the very best in the creative application of their own systems. More focus should be put on fostering a class of interactive narrative content creators. This means to consider author's needs and aspirations, but also what steps need to be taken to get more authors of traditional narratives interested in IDN.

The European project IRIS [18] has made research on IDN authoring a focus area and consequently identified many important aspects in this regard. Spierling and Szilas uncover a "vicious circle" [19] between the need to listen to authors and adjust authoring tools accordingly and the need to educate the same authors in the affordances and potential of procedurality. During this process, the very authors' perception of IDN is in flux, and so is their perspective on what they want in authoring tools. This is a crucial problem and creators of authoring tools need to acknowledge the implications. A possible solution could be in a two-step process in which IDN researchers teach practitioners about procedurality first, and accept recommendations for changes to tools only after a basic level of comprehension has been achieved.

At the same time, we should neither concentrate only on how existing technology can be better exposed to authors, nor solely investigate how authors use existing systems. Instead, the view proposed here asks what tools authors would enjoy using and which abstractions of the underlying technology would enhance their creativity.

6 The User Experience is Crucial

A crucial goal for IDN research is to create exciting and fulfilling narrative experiences. This is one aspect that makes the field especially interesting, its promise to explore the unexplored realm and boldly go where human narrative expression has not ventured yet. However, this means that the ultimate judgment for success will

come from outside academia, from the users. In their positive evaluations will be the ultimate reward. Therefore, the user needs be included in our concepts. At the same time, we should not be surprised if a given user does not fully recognize and appreciate the hard work going on below the surface.

For user studies, we should cast the net as wide as possible and try to avoid techno-savvy users that appreciate an IDN artifact already for its technical achievements. Instead, IDN projects would profit from the potentially less understanding judgment of a more general audience, one that is more interested in a good experience than how this experience comes to pass.

Another important question is how to enlarge the audience for IDN. Michael Mateas and Andrew Stern's cyberdrama. *Façade* [20] is not only a technical achievement, but also one in visibility. The successful methods applied in *Façade* can therefore serve as role model for other projects. IDN artifacts in general should aim for visibility and outside evaluation. A central repository for projects could improve visibility while at the same time orient artists and other interested parties about developments in the field.

7 Conclusion

In this position paper, I identify several central issues in interactive digital narrative research, which need to be addressed in ongoing and future work. This overview is also designed to provide some guidance for newcomers to a growing and dynamic field. With the discussion of five key aspects pertaining to narrative analysis, interoperability between different implementations, sustainability of artifacts, author-centered views, and user-focused perspectives, I hope to start a debate on the goals and successful methods in the field.

The proposals in each of the theses are designed as starting points. In particular the paper emphasizes the need for a specific narratological framework and continued work on software exchange standards. The adoption of industry standards is significant in improving sustainability of projects, while author-focused research should include a basic orientation for authors in procedurality. Next, the paper proposes to focus more on the user experience. Especially important in this regard is the engagement with users outside technically savvy constituencies, both for user studies and as a target audience for IDN. Am important step to reach a wider audience would be a central repository for IDN projects.

References

1. Juul, J.: A clash between game and narrative. Danish literature (1999)
2. Murray, J.: The Last Word on Ludology v Narratology in Game Studies. Preface to Keynote Talk. In: DiGRA 2005: Changing Views: Worlds in Play 2005, Vancouver (2005)
3. Aarseth, E.: Cybertext: Perspectives on Ergodic Literature. Johns Hopkins University Press, Baltimore (1997)

4. Nitsche, M.: Video Game Spaces: Image, Play, and Structure in 3D Worlds. The MIT Press, Cambridge (2008)
5. Ryan, M.-L.: Avatars of Story. University of Minnesota Press, Minneapolis (2006)
6. Murray, J.: Hamlet on the Holodeck. The Free Press, New York (1997)
7. Montfort, N.: Twisty Little Passages: An Approach to Interactive Fiction. MIT Press, Cambridge (2003)
8. Louchart, S., Aylett, R.S.: Narrative Theory and Emergent Interactive Narrative. International Journal of Continuing Engineering Education and Life-long Learning, Special Issue on Narrative in Education 14(6), 506–518 (2004)
9. Koenitz, H.: Towards a Theoretical Framework for Interactive Digital Narrative. In: Aylett, R., Lim, M.Y., Louchart, S., Petta, P., Riedl, M. (eds.) ICIDS 2010. LNCS, vol. 6432, pp. 176–185. Springer, Heidelberg (2010)
10. Koenitz, H., Haahr, M., Ferri, G., Sezen, T.I.: First Steps towards a Unified Theory for Interactive Digital Narrative. In: Pan, Z., Cheok, A.D., Müller, W., Iurgel, I., Petta, P., Urban, B. (eds.) Transactions on Edutainment X. LNCS, vol. 7775, pp. 20–35. Springer, Heidelberg (2013)
11. Mason, S.: On games and links: Extending the vocabulary of agency and immersion in interactive narratives. In: Koenitz, H., Sezen, T.I., Ferri, G., Haahr, M., Sezen, D., Çatak, G. (eds.) ICIDS 2013. LNCS, vol. 8230, pp. 25–34. Springer, Heidelberg (2013)
12. Şengün, S.: Silent Hill 2 and the Curious Case of Invisible Agency. In: Koenitz, H., Sezen, T.I., Ferri, G., Haahr, M., Sezen, D., Çatak, G. (eds.) ICIDS 2013. LNCS, vol. 8230, pp. 180–185. Springer, Heidelberg (2013)
13. Bruni, L.E., Baceviciute, S.: Narrative Intelligibility and Closure in Interactive Systems. In: Koenitz, H., Sezen, T.I., Ferri, G., Haahr, M., Sezen, D., Çatak, G. (eds.) ICIDS 2013. LNCS, vol. 8230, pp. 13–24. Springer, Heidelberg (2013)
14. Szilas, N., Boggini, T., Axelrad, M., Petta, P., Rank, S.: Specification of an open architecture for interactive storytelling. In: André, E. (ed.) ICIDS 2011. LNCS, vol. 7069, pp. 330–333. Springer, Heidelberg (2011)
15. Brooks, K.M.: Metalinear Cinematic Narrative: Theory, Process, and Tool. MIT Ph. D. Thesis (1999)
16. http://eliterature.org
17. Liu, A., Durand, D., Montfort, N., Proffitt, M., Quin, L.R., Réty, J.H., Wardrip-Fruin, N.: Born-again bits: A framework for migrating electronic literature. Department of English, UCSB (2005)
18. Cavazza, M., Donikian, S., Christie, M., Spierling, U., Szilas, N., Vorderer, P., Hartmann, T., Klimmt, C., André, E., Champagnat, R., Petta, P., Olivier, P.: The IRIS Network of Excellence: Integrating Research in Interactive Storytelling. In: Spierling, U., Szilas, N. (eds.) ICIDS 2008. LNCS, vol. 5334, pp. 14–19. Springer, Heidelberg (2008)
19. Spierling, U., Szilas, N.: Authoring issues beyond tools. In: Iurgel, I.A., Zagalo, N., Petta, P. (eds.) ICIDS 2009. LNCS, vol. 5915, pp. 50–61. Springer, Heidelberg (2009)
20. Mateas, M., Stern, A.: Façade: An Experiment in Building a Fully-Realized Interactive Drama. In: Game Developer's Conference: Game Design Track (2003)

Interactive Cinema:
Engagement and Interaction

Mirjam Vosmeer and Ben Schouten

Games & Play Research Group, CREATE-IT Applied Research,
Amsterdam University of Applied Sciences, Amsterdam, The Netherlands
{m.s.vosmeer,b.a.m.schouten}@hva.nl

Abstract. Technologies that were initially developed to be applied within the domain of video games are currently being used in experiments to explore their meaning and possibilities for cinema and cinema audiences. In this position paper we examine how narrativity, interactivity and engagement are mutually reshaped within this new domain of media entertainment, addressing both the production and the user experience of new types of interactive cinematography. We work towards research questions that will direct our future studies and introduce the term *lean in* to address the kind of engagement style that applies to users within this new domain.

Keywords: interactive cinema, videogames, user engagement, narrative immersion, Oculus Rift.

1 Introduction

When around 1960 the first videogames were being played on enormous computer machines, probably no one would have guessed that this medium would ever develop in a way that it might come close to the motion pictures that were enjoyed in the cinema theatre. Nowadays, however, videogames and movies as entertainment media have come to a point that they almost seem to merge, from the viewpoint of the audience as well as on the side of production

Technologies that were initially developed to be applied within the domain of video games are currently being used in experiments to explore their meaning and possibilities for cinema and cinema audiences. On one hand game engines can now be used to produce animations that offer new possibilities for the way the user is involved in the entertainment experience. On the other hand, hardware that was initially developed to improve the experience of gameplay, is now being examined for its possibilities to enjoy movie content. However, a virtual reality-device such as the Oculus Rift not only confronts the user with a remarkable immersive experience, but also faces producers of movie content with issues around for instance camera work, set dressing and scriptwriting. In this position paper we propose to examine how narrativity, interactivity and engagement are mutually reshaped within this new domain of media entertainment, addressing both the production and the user experience of new types of interactive cinematography.

A. Mitchell et al. (Eds.): ICIDS 2014, LNCS 8832, pp. 140–147, 2014.

In the first part of the paper theoretical backgrounds into the broader field of inter-active storytelling will be discussed. The second part will address how the use of new technologies may affect this field, working towards research questions that will be the starting point for our subsequent studies.

1.1 Interactive Storytelling

When discussing interactive storytelling, many scholars have focused on questions concerning the relative freedom the user may have in choosing alternative outcomes for stories (Stern, 2008). This line of research has brought up many interesting ideas and philosophical insights, but also a number of seemingly unresolvable problems. As Andrew Stern noted (2008), any interactive story system must contain vast amounts of story content. Offering the user the possibility to choose alternative routes within a narrative often means that producers are faced with the immense task to pre-produce a multitude of different outcomes. Most users will thereby experience just one single outcome, and possibly miss out on other outcomes that might be more interesting. A solution to this issue, as is also mentioned by Stern (2008), is to work towards adaptive storytelling or real-time generation of story content. Paul, Charles, McNeill and McSherry (2011) and Nack, El Ali, Van Kemenade, Overgoor and Van der Weij (2010) (amongst others) have made promising steps in this direction.

Another option that researchers have explored is to offer some kind of 'fake' possibility for interaction: while users are given the impression that they can actually make choices and influence the outcome of a story, the design of the interaction is set up in such a way that eventually, all users will end up at roughly the same finishing point. Experiments in this field have shown that the actual entertainment experience of a fake interactive story does not differ from the experience of real interaction. In other words: when users feel that they have some kind of agency, they enjoy this experience, whether the agency is real or not (Fendt, Harrison, Ware, Cardona-Rivera and Roberts, 2012). Tanenbaum (2011) has therefore suggested to not always automatically equate interactivity with offering the user the ability to directly affect the plot of the story. For interactive storytelling, the sense of participation in a story or a scene may be just as important as the actual power to influence the outcome. In the current study, we will follow up this suggestion and further explore the concept of audience participation within the field of interactive storytelling.

1.2 Engagement Styles in Games and Movies

Although some aspects of videogames and movies may seem to merge, many classical differences between the two of course remain intact. For one, the procedural rhetoric that is characteristic for videogames is not applicable to cinema (Bogost, 2008). While in movies arguments are made through the construction of words and images, in videogames ideas are conveyed through the persuasive use of processes. These two different rhetoric styles invoke different modes of engagement of its users. While in cinema, the viewer is expected to sit back and experience the argument passively, with videogames, the user is required to actively engage in the process. Within media

studies, movie audiences and computer users have therefore traditionally been said to differ profoundly, based on these engagement styles. The term 'lean back' is used for media that allow the user to sit back, relax, and receive information in a passive manner, such as movies and television. In contrast, the term 'lean forward' is used for media in which the user is able to interact and control the flow of information, as is the case while playing video games (Katz, 2010).

Experiments that focus on the merging of games and film may need to take these different user positions in consideration. Within gameplay, the combination of the two engagement styles is already clear when it comes to cutscenes, also known as event scenes. These are the sequences within a videogame in which the player has no or limited control, but is invited to sit back and watch the narrative unfold. While gamers may appreciate the deepening of the overall narrative experience that cutscenes add to the game, they are often also disturbed by the temporary change of engagement that these sequences imply, having to switch between the modus of lean forward and lean back, and back again. While in recent games the visual differences between the parts of interactive gameplay and the cutscenes have become increasingly less distinct, the merging of these two types of sequences is still mostly linear, and the differences between active and passive user engagement remain intact.

1.3 Themes and Genres within Movies and Games

Marie-Laure Ryan has discussed the characteristics of the three main types of narrative plots, in relation to their possibilities for interactivity (Ryan, 2008). She uses the distinction that was already made by Aristotle between the epic and the dramatic plot, and adds a third kind of narrative that made its appearance in the nineteenth century, the epistemic plot. The epic plot focuses on the physical actions of a solitary hero, as is often the case in archetypical fairy tales. In dramatic narratives the focus is on evolving networks of human relations. The epistemic plot is driven by the desire to know, or to investigate, which is often the main line in a mystery story. According to Ryan (2008), the epic and the epistemic plot are quite well suited to be used within gaming and interactive narratives. While the epic plot is for instance used in shooters and adventure games, the epistemic plot is found in games that offer some kind of mystery that needs to be solved. The dramatic plot, however, is a lot more difficult to implement because of its emphasis on the evolution of interpersonal relationships.

Veugen (2011) has pointed out how videogames and movies are being classified differently into genres. With movies the genre classification is usually based on the content of the movie, such as a western movie, a horror movie or a romantic comedy. With games, however, the classification is based on the gameplay, such as action adventure or role-playing. Some movie genres such as thrillers, adventure movies or detectives can be easily translated to game content but other genres, such as drama and romance, are more difficult to transform towards gameplay. Of course there are games in which romantic storylines are apparent, such as the Japanese game series *Final Fantasy*. But also in these types of games, the romance theme is mostly dealt with within the cutscenes and is no real motivational factor within the gameplay.

In game production there have been several projects in which an existing novel or short story served as basis for a videogame. The themes from the classic children's book *Alice in Wonderland*, for instance, have already inspired several game producers, such as developer American McGee's *Alice Madness* and *Alice Madness Returns*. Also stories by Agatha Christie have been converted into a series of point-and-click third-person adventure games. For classic popular novels such as *Lord of the Rings* and *Harry Potter*, videogames were developed that were based on the movie adaptation. Usually, however, in these games the original text is mostly used as an inspiration for the theme and the atmosphere of the game. In the end, the gameplay may have little to do with the text on which the game is based and it does not offer the true immersive narrative experience that a book can.

The fact that epic and epistemic plots are well suited to be translated to gameplay is still visible in many successful commercial videogames. Even games that are acclaimed to have set new boundaries when it comes to open world storytelling, such as *GTA5* or *Watch Dogs*, consist of a succession of story driven segments and offer no real immersive dramatic development. The genres and themes that are covered within this upper segment of the game market are thereby often limited to action, adventure, crime and violence. However, several authors have discussed various smaller videogame initiatives in which other kinds of themes were included, and other types of stories explored. Ryan (2008), Murray (2011) and Sali and Mateas (2011) have for instance discussed the game *Façade*, in which the gamer can influence the way the relationship between two people evolves. Lankoski and Horttana (2008) discuss a design experiment named *Lies and Seductions*, in which social relations, seduction and tragedy have been included in meaningful gameplay. Quite recently, the stirring game *That Dragon, Cancer,* was created by game producer Ryan Green. The game has been described as an interactive re-enactment of what Green and his wife went through when their four-year-old son Joel was fighting terminal cancer (Samakow, 2013). Examples like these clearly show that new topics are entering the world of game design and interactive experience.

2 New Perspectives

New kinds of interactive experiences lead to new kinds of user engagement, and new ways in which the user may be immersed in these experiences. Both physical devices and narrative techniques may be applied to heighten this engagement. In this section we will first address some of the technological issues that movie producers are faced with, when intending to produce video content that is meant to be watched from all possible angles. We will then proceed to analyze what this point of view might imply for engagement style and how narrative and interaction might be mutually reshaped when content is created in VR. Based on this, we will formulate research questions that will be the starting point of the next phase of our research project that focuses on new forms of interactive cinema and the user experiences of people who engage with it.

2.1 Creating Content in 360'

Since Facebook bought Oculus Rift in March 2014, worldwide fascination for this VR device has skyrocketed. Wired published an intrigued exploration on the topic, stating: *Oculus is awesome for games, but it's the future of movies* (Watercutter, 2014). Indeed, in the first months of 2014, producers all over the world have been pondering the question of how movie content and storylines will be influenced by the fact that the audience no longer just faces a screen on which a film is projected, but watches the content from a 360' point of view.

When creating content that is meant to be watched from a 360' point of view, a producer has several options. One option is to make use of a game engine, in which a virtual reality is created. Another option is to record video content, in which reality is filmed with an actual camera.

The Amsterdam based company WeMakeVR has constructed such a video camera system with which experimental video content that is meant to be watched with Oculus Rift has been realized. As said, the 360' point of view implies several difficulties for the producer. Firstly, it is not possible to work with a traditional film set in which a scene may be recorded. As the camera records the world in 360', everything around the system will be seen. This problem also applies for the floor of the set, and the ceiling. As these angles will also be available for the future viewer, both the floor and the ceiling of the set need to be fully presentable, which means for instance that it is not possible to make use of elaborate lighting systems.

2.2 Video Storytelling from 360'

The use of the 360' camera system has distinct implications for the kind of stories that can be told. While the viewer takes the point of view of the camera, and is able to look around in the scene, he or she is not able to move through the space in which the scene was filmed. The only possible movement is the one that was recorded when shooting the scene. WeMakeVR has created a short VR movie that clearly illustrates this issue. In this experiment the camera has been set up on a boat that travels through the canals of Amsterdam. The viewer, wearing an Oculus, experiences the boat ride from this point of view. He can move his head around and watch the water, look at the streets or the sky above, or check the other boats that are passing by. It is not possible though, to change the direction of the boat or stop it.

Apart from issues concerning movement within a scene, the camera position within a setup like this also has profound impact on the way that stories may be told. A scene that is recorded with the intention to be watched from 360', may take different viewer perspectives into account. For instance, the story could be told in such a way that the camera is not part of the narrative, but just registers the scene like a fly on the wall. Another option however, would be to include the viewer position within the story, and have characters react towards the camera as if it is another character participating in the scene. Experiments like these, in which actors react to a camera, are of course known within traditional cinema as well. With this new technology, however, experiments with new ways of storytelling are imaginable in which the option of the viewer to look around within the scene - and for instance discover pieces of information and new interpretations - could be essential to the way a plot unfolds.

2.3 Scenescapes

Another technological development that has profound implications for the way that movies and video games are coming closer together, are VR engines that were initially meant to be used for game production. Engines such as Blender are currently also being used to create animated movies, offering producers a whole new range of possibilities for movie content that can be viewed either on a classic screen, or with a device such as Oculus Rift.

A scene that is created as a VR experience may offer its viewer a new kind of narrative immersion. Instead of telling a whole story in a linear succession of scenes that together form a plot, in this type of scene - that we propose to call *scenescape* - the viewer may be invited to look around and explore, and instead of affecting the plot, participate in the surroundings that the scene is set in. For certain parts of traditional narratives that thus far have been difficult to capture in motion picture, translation into scenescapes may be an interesting alternative. Experiences such as dreams, memories or hallucinations that are difficult to translate from literary text to movie text, may benefit from this new experience of narrative immersion. This way, the scenescape could be viewed as parallel to the cutscene. While a cutscene in a videogame offers a linear sequence to deepen the story immersion, a scenescape offers an interactive sequence within a movie, with exactly the same objective.

The concept of scenescape fits well into the larger concept of transmedia storytelling, as discussed by Henry Jenkins (2006). In transmedia storytelling, each medium tells that part of a story, background or other kind of information, for which it is best suited, and the parts all together form a storyworld. Adding a scenescape to a storyworld would mean to add a VR experience to a story that may already be spread out over different media such as a movie, a game and a series of websites, offering the user the new perspective to be engaged through interaction.

2.4 Engagement and Interaction

Within the current study, we want to explore whether and how the new technologies that are the topic of this paper impact narrativity, interactivity and engagement within the related media products. This is connected to an important aesthetic goal for interactive narratives, as discussed by Ryan (2008), which is the ability to create narrative immersion. According to Ryan, this immersion can take at least three forms: spatial, temporal and emotional. Taking this partition into account, the connection between engagement and interaction can be further analyzed. Both storytelling and hardware can be seen as strategies that can be used to heighten the immersive experience of the viewer. For instance, watching an adventure movie invites an audience member to lean back without being interactive, and be mostly immersed in a temporal sense, curiously following the succession of actions on the screen. Playing a highly interactive action adventure videogame in lean forward modus, however, elicits temporal immersion but also adds spatial immersion by offering a gameworld that is beautifully designed and enormously detailed. Yet with a movie drama, or an episode of a soap opera, viewers lean back again and will be mostly emotionally immersed, anxious to learn how characters will develop their mutual relationships.

For the new forms of media entertainment that we propose to explore, however, we imagine new combinations of engagement and immersion being possible. A scenescape, as described in the previous paragraph, may offer the viewer a form of immersion that is both emotional and spatial. On one hand, the story that the scene is set in may invite the user to be immersed through narrative. On the other hand, the physical device that the scene is viewed by may offer additional spatial immersion.

This media form does not offer a lean forward engagement because it is not interactive in the sense that a viewer can't take action in the story. Rather, he is invited to participate in the scene. The experience can not be considered as fully lean back either, as the viewer is given agency into what direction he wants to look at and what part of information he wants to consider and become emotionally involved in. It seems that with this style of media participation, the classic dichotomy between lean back and lean forward media is challenged. We therefore propose to use the term *lean-in media* for this new kind of engagement style.

2.5 Future Research

In this concluding paragraph we want to set out the lines of research that will be the starting point of the next phase of our research project on how movies and videogames as entertainment media have come closer together than ever before. In the media experiments that we intend to design, we will firstly explore the question: How can dramatic plotlines – instead of epic and epistemic plotlines - be translated to interactive content? Second, the concept of scenescape will be the starting point to further explore the question: How can narrative content be adapted towards non-linear forms of engagement, such as scenescapes? And for both inquiries, the sub question will be: can we indeed establish this engagement style that is neither fully lean-back nor lean forward, and that leads to a new kind of interactivity that we may call *lean in*?

Acknowledgement. This position paper is part of the Interactive Cinema project as part of Amsterdam Creative Industries. The Interactive Cinema project is a collaboration between the Netherlands Film Academy and the Amsterdam University of Applied Sciences.

References

1. Bogost, I.: The Rhetoric of Videogames. In: Salen, K. (ed.) The Ecology of Games: Connecting Youth, Games, and Learning, pp. 117–140. MIT Press, Cambridge (2008)
2. Fendt, M.W., Harrison, B., Ware, S.G., Cardona-Rivera, R.E., Roberts, D.L.: Achieving the illusion of agency. In: Oyarzun, D., Peinado, F., Young, R.M., Elizalde, A., Méndez, G. (eds.) ICIDS 2012. LNCS, vol. 7648, pp. 114–125. Springer, Heidelberg (2012)
3. Jenkins, H.: Convergence Culture: Where old and new media collide. New York University Press, New York (2006)

4. Katz, H.: The media handbook: A complete guide to advertising media selection, planning, research, and buying. Routledge (2010)
5. Lankoski, P., Horttana, T.: Lies and seductions. In: Spierling, U., Szilas, N. (eds.) ICIDS 2008. LNCS, vol. 5334, pp. 44–47. Springer, Heidelberg (2008)
6. Murray, J.H.: Why Paris Needs Hector and Lancelot Needs Mordred: Using Traditional Narrative Roles and Functions for Dramatic Compression in Interactive Narrative. In: André, E. (ed.) ICIDS 2011. LNCS, vol. 7069, pp. 13–24. Springer, Heidelberg (2011)
7. Nack, F., El Ali, A., van Kemenade, P., Overgoor, J., van der Weij, B.: A Story to Go, Please. In: Aylett, R., Lim, M.Y., Louchart, S., Petta, P., Riedl, M. (eds.) ICIDS 2010. LNCS, vol. 6432, pp. 74–85. Springer, Heidelberg (2010)
8. Paul, R., Charles, D., McNeill, M., McSherry, D.: Adaptive Storytelling and Story Repair in a Dynamic Environment. In: André, E. (ed.) ICIDS 2011. LNCS, vol. 7069, pp. 128–139. Springer, Heidelberg (2011)
9. Ryan, M.-L.: Interactive narrative, plot types, and interpersonal relations. In: Spierling, U., Szilas, N. (eds.) ICIDS 2008. LNCS, vol. 5334, pp. 6–13. Springer, Heidelberg (2008)
10. Sali, S., Mateas, M.: Using information visualization to understand interactive narrative: A case stury on Façade. In: André, E. (ed.) ICIDS 2011. LNCS, vol. 7069, pp. 284–289. Springer, Heidelberg (2011)
11. Samakow, J.: That Dragon, Cancer. Video Game Portrays One Family's Battle With Pediatric Cancer (2013), http://www.huffingtonpost.com/2013/08/15/that-dragon-cancer_n_3762329.html (retrieved June 13, 2014)
12. Stern, A.: Embracing the Combinatorial Explosion: A Brief Prescription for Interactive Story R&D. In: Spierling, U., Szilas, N. (eds.) ICIDS 2008. LNCS, vol. 5334, pp. 1–5. Springer, Heidelberg (2008)
13. Tanenbaum, J.: Being in the story: Readerly pleasure, acting theory, and performing a role. In: André, E. (ed.) ICIDS 2011. LNCS, vol. 7069, pp. 55–66. Springer, Heidelberg (2011)
14. Veugen, C.: Computer Games as Narrative Medium. Ph.D. thesis, Vrije Universiteit Amsterdam (2011)
15. Watercutter, A.: Oculus Is Awesome for Games, But It's the Future of Movies (2014) http://www.wired.com/2014/01/oculus-movies/(retrieved June 13, 2014)

Fleeing the Operator: The User Experience and Participation in *Marble Hornets* (2009-2014)

Devin Hartley

Carleton University, Ottawa, Canada
devin.hartley@carleton.ca

Abstract. The found-footage YouTube series *Marble Hornets* (2009-2014) uses two YouTube channels and a Twitter account to create a transmediated Alternate Reality Game (ARG) experience, allowing users to communicate directly with both the diegetic characters and each other. While it is not revolutionary in how it approaches the use of ARG elements in its narrative, it marks a starting point in the creation of a definitive model for this mode of storytelling.

Keywords: transmedia, YouTube, social media, participatory spectatorship, ARG, interactive narrative.

1 Introduction

Acknowledging that the expansion of the internet and digital media has had an effect on the creative frameworks and modes of spectatorship of media content seems to be a matter of stating the obvious. The relationship between narrative works and their users has shifted, as have the expectations of the user in their interaction with the works in question; they now desire "to engage in a more active way, to play a significant part or role in the reception of the work."[10] The growing popularity of transmedia narratives and Alternate Reality Games (ARG) has largely confirmed the magnitude of this shifting relationship, though the success of these narratives has varied widely. While there has been a growing academic movement in the study of these modes of storytelling, there remain a number of questions about how it is these narratives function, what benefits they may have in our increasingly digital culture, as well as what steps may be taken to improve this model of content production. Using *Marble Hornets*[7], and to an extent the larger Slender Man mythos, as a case study, I hope to engage with some of these questions and offer a model for the potential uses of participatory digital storytelling.

Given the increasing availability and accessibility of ARG experiences, it becomes important to explore what it takes for the game to be successful, as well as how academics should approach the study of such an experience. Transmedia and ARGs both tend to be used as overarching umbrella terms that encompass a wide variety of possible narrative modes. The fact that examples of these two methods of storytelling tend to overlap only complicates matters further. Kent Aardse has defined ARGs as "a game which often covertly encourages player participation, takes particular advantage of the networked, digital environment, distributes game content via multiple media channels, and transforms real-world locations by grafting fictional layers onto these

A. Mitchell et al. (Eds.): ICIDS 2014, LNCS 8832, pp. 148–155, 2014.

spaces."[1] While this definition is still broad, given the variety of ARGs that are available, it does provide a starting point for the analysis of this mode of storytelling.

The most successful and commonly discussed ARGs[1] have several things in common: all are based around the genres of science fiction and/or horror and most are based on pre-existing narrative properties, and as such function as a form of marketing for the film or television show of which it is a part. *Marble Hornets* shares some of these similarities, in that it is a horror story based around the popular internet figure Slender Man[2]. The narrative is mediated across two YouTube channels and a Twitter account and tells the story of a young film student, Jay, who is investigating the disappearance of his friend Alex by analyzing film recorded during the making of their independent production titled "Marble Hornets." His investigation reveals a larger conspiracy, involving people from the film production who are being controlled and manipulated by Slender Man.[3]

The two channels are different both in format and in content. The main channel, MarbleHornets, functions simply as a found-footage style horror film spread across ninety separate entries spanning over eight years of in-game time. The second channel, totheark (TTA)[14], is where the ARG elements of the series come to the fore; acting as response posts to the main channel's entries, the majority of the TTA posts are completely abstract, using distorted footage from other films, as well as seemingly random shapes, symbols, and numbers, which are often used to conceal hidden messages for the audience to decipher. In other cases, there is direct overlap between TTA's posts and Jay's posts on the main channel, which are usually moments showing that TTA is present and filming Jay without his knowledge during various events in the series. The Twitter account serves as a bridging point, both between the separate YouTube channels, as well as between the characters of the series and the participants of the game.

2 Model of User Experience

The spectatorial experience of the *Marble Hornets* narrative is one defined by duality. This plays out in three distinct yet interconnected ways. While the aspect of participation – or at the very least, engagement with the collective intelligence of those who are participating – is one that is integral to a full experience of the series, interaction with *Marble Hornets* is also defined by the experience of isolation. While users are sharing their theories and perceptions of the series on social media platforms, they are simultaneously interacting with the series as individuals, sitting alone in front of their computers. While the experience of isolation is important to the creation of fear in the genre of horror [13], the ARG's reliance on "collective intelligence" [11] makes this

[1] *The Lost Experience* (2006), *The Beast* (2001), and *Cloverfield* (2008) immediately come to mind.

[2] Discussion of Slender Man and his context of creation, while an interesting case study in crowdsourcing and internet mythmaking, is much too large to explore in the scope of this paper.

[3] Referred to in the series as The Operator.

duality difficult to negotiate. The "shared" community of an ARG is one that is both intangible and largely imagined. A key consideration for these games is how to conceal the reality of isolation in the user base by creating a shared experience that the participants perceive as both communal and social.

YouTube, Twitter, Facebook, and other social networks all have large pre-existing user bases which can be utilized by ARGs to help in the expansion of the game. The social element of these networks also simplifies the creation of these communities, as Burgess and Green argue with YouTube, specifically "the video content itself is the main vehicle of communication and the main indicator of social clustering."[2] It also facilitates access for these users since they are utilizing online accounts that they already have. The use of these platforms also allows for users who are not as well versed in ARGs to become engaged in the narrative. Inexperienced users are much less likely to be aware of ARG-devoted forums like Unfiction, which are frequently a meeting point for users in larger games. The question then becomes how fledgling ARGs can get the most out of these networks without creating redundancies or repetition of their narrative elements.

The use of direct address in *Marble Hornets* is one of the ways the series is able to highlight the existence of a larger community. The entries use text introductions and conclusions, supposedly added by Jay, as a means of acknowledging that the characters of the series are aware that there is a larger audience consuming the videos. The Twitter account of the series plays a similar role, but has the added benefit of making the dialogue between the diegetic universe and the users two-sided. Unlike the direct address of the YouTube entries, the Twitter account allows the participants to respond directly to the characters and have their contributions acknowledged.

Linked to this is the experience of immersion, something that Ndalianis highlights in relation to transmedia horror: in their varying levels of participation with the series, the users become immersed in a greater, fictional universe which is masking itself as reality[9]. However, at the same time, the user remains connected to their own present and location through the process of interruption. As Jason Jacobs argues, "Interruption alerts us to the fact that we are still connected to the continuing flow, or present tense, of the outside world."[5] For *Marble Hornets* specifically, interruption is encoded at the very level of the text itself: from the short duration of the entries, the temporal dilation that results from Slender Man's presence, the jumps between past and present in the chronology of the series, as well as the staggered release schedule of the entries – in all the series itself is designed to be in a near-constant state of interruption, and that is not even taking into account the interruption the viewer themselves create, as well as that which occurs as a result of having to navigate between the different media elements of the series.

The process of interruption is further exacerbated by the increasing commonality of multitasking: As Chinchanachokchai and Duff point to studies of college students that claim that as many as 86% use more than one media simultaneously [3] and as a result, argue that users can "choose to interact with and selectively consume media messages. Rather than messages being attended to directly, they may be in the background or periphery or competing against other messages that are being seen at the same time." [3] *Marble Hornets* seems to acknowledge the reality of multitasking

among its audience and compensates accordingly with the short duration of the individual entries.

The third duality lies in the experience of mediation in the series, which borrows heavily from Eugene Thacker's conception of "Dark Media."[16] The series is able to balance both positive mediation of Slender Man's presence, as well as negative mediation in his inaccessibility, or the inability for him to be fully mediated. The former plays out as mediation through the bodies of the characters themselves, which manifests as coughing, seizures, hallucinations, violent outbursts, amnesia, and the dilation of space and time which occur in Slender Man's presence. At the same time, there is the latter, negative mediation, which Thacker would define as the element of dark media known as "weird media," for which "mediation comes up against an absolute limit, while also mediating beyond what is normally expected…mediation only indicates a gulf or abyss between two ontological orders."[16] While there are brief, visual glimpses of Slender Man's presence throughout the series, he is largely mediated through the audio and video distortion that occurs in his presence, thus turning his presence into an absence through the damage to the very formal elements of the entries themselves. Often, the viewer does not need to see Slender Man to know that he or his agents are near; the noticeable distortions are able to signal the camera's inability to mediate him. In fact, in "Entry 84," one of the cameras used by the characters ceases to function entirely, as if its extended contact with Slender Man has rendered it inoperable.

2.1 The Experience of Horror

Angela Ndalianis argues that for transmediated horror "the sensation of horror takes a back seat…and is replaced by a cognitive and sensory satisfaction that relishes in the performativity and playfulness of the text."[9] However, this is a simplistic view of the experience of transmediated horror, and one that certainly does not apply to Marble Hornets, for a number of reasons. First of all, the accessibility of the series being hosted on YouTube conceals an implicit threat that is made throughout the series: anyone linked to Jay's investigation inevitably falls victim to Slender Man and those under his control. The posts on the main YouTube channel allow for a relationship of complicity to be forged between the audience and the motives of the protagonist in posting the videos online in the first place. Arguably, the videos of the investigation are posted for the express purpose of sharing the investigation with a wider, public audience; at one point in the series he directly states that all he wants is for "people to know" what is happening. The public nature of the YouTube posts and the constant threat of Slender Man's omniscience lend a sense for the audience that they, like the characters in the series, are at risk of attracting Slender Man's attention through their own participation.

Second, much of the experience of fear in Marble Hornets is centered on an imbalance of narrative knowledge, something that is almost inherent to horror as a genre; fostering the creation of tension by having the spectator know and understand the presence of a deadly threat long before characters themselves do. The main channel's entries, focused as they are on Jay, highlight how little he knows and understands the

events going on around him, as well as the negative consequences for his lack of knowledge; on more than one occasion, Jay is accused of only making things worse through his intervention. Jay's lack of knowledge is also frequently referenced by TTA, who often mocks the him for knowing so little about the events in which he has become entangled. If the viewer has fully participated in all of the transmedial elements, this imbalance between the spectator's knowledge and Jay's becomes even more marked: between the clues given by TTA and the existence of a greater Slender Man mythology, fans who has engages with all the story elements possess significantly more narrative understanding than Jay, or any of the characters in the series.

3 Model of Participation

There are multiple opportunities for those watching the series to participate in its narrative, both directly or indirectly. Participation, and in particular collective participation, is a key element in the success of an ARG; the act of participating through decoding and deciphering, along with sharing the results with others, is the only way to get access to the full narrative. One of the main concepts associated with the participation in ARGs is the importance of "collective intelligence [which is] enabled by the rapid exchange of ideas and information over a digital network."[11] Not only are the users solving puzzles and decoding clues, but they are collaborating and sharing information with one another, largely using resources such as forums and wikis.

As a result of the collective nature of the user experience, there exists the possibility of varying levels of participation. Discussions of ARGs tend to generalize the experience of the players, when in reality "there are many different levels of participation ranging from active and obsessive to relatively passive and casual."[11] The mysteries to be solved in ARGs are often encoded in such a way as to encourage this idea of collaboration between users; the complexity of the clues allow for some users to undertake the actual decoding, while others can discuss and justify the narrative consequences of the results. As well, with *Marble Hornets* specifically, because so many of its messages are hidden within the audio track, audio editing software and spectrographic analysis are often required to decipher the clues; since most people do not have access to such software, the hive mind relies on the few users that do have such access to post their results to compensate for those users that cannot access that information themselves.

Other users may limit their participation to nothing more than watching the series, and letting the more passionate fans do the leg work in deciphering the messages and clues scattered throughout the TTA entries. There are entire YouTube channels that are devoted to sharing the explanations for the hidden content of the TTA videos, such as TTADecoded[15] and MarbleHornetsTruth[8]. There are also a number of wikis devoted to both *Marble Hornets* itself, as well as Slender Man, which also give access to analyses of the various elements of the series. As well, there are those who choose essentially "troll" or sabotage the participants by posting links to fake entries; this has become such an issue that the *Marble Hornets* section of the Unfiction forum has an entire thread devoted to dealing with saboteurs[17].

The idea of participation is something that is important not only for *Marble Hornets*'s status as an ARG, but also to the fact of its transmediation. The ideas of collaboration and collective knowledge are also frequently discussed by scholars examining transmedia narratives. Henry Jenkins highlights the importance of the "knowledge community" in the experience of transmedia storytelling[6]. He also argues that "more and more consumers are enjoying participating in online knowledge cultures and discovering what it is like to expand one's comprehension by tapping the combined expertise of these grassroots communities."[6] As with ARGs, there is a level of research involved in order to receive the full narrative experience. While TTA's responses are referenced a few times in the main entries, it is unlikely that one would realize the existence of the second YouTube channel without first having at least done some research on the series; the same would apply to the existence of the Twitter account.

There is a level of self-reflexivity to the ways in which the users interact with the narrative universe of the game. This awareness is made clear in the discussions between participants, particularly on the Unfiction forum. Posts are often prefaced with tags denoting whether the topic is referring to in-game (IG) or out-of-game (OOG) elements, and their phrasing and conversations are adjusted accordingly. In general, OOG conversations should be avoided, as one of the central tenets of ARGs is the suspension of disbelief [11]; so long as you are in-game, the universe it depicts is the only reality. This emphasis on differentiating between IG and OOG discussion may also explain why narratives focusing on science fiction or horror are typically more successful.

3.1 The Danger of Lurking

Discussion of passive participants, or "lurkers," has been an area in need of further development in the academic study of ARGs[12]. One of the things that must be considered in any attempt at improving the model of ARGs is this question of "lurkers" and their role in the overall experience of the narrative. While there is no definitive way of determining the demographic breakdown between active participants and lurkers, it is fairly safe to assume that lurkers make up the majority. Studies of participatory media tend to focus exclusively on the role of active participants; this is unsurprising, as those who are posting commentary and analysis leave behind an archive of information that can be mined, whereas those who merely observe leave no trace of their presence, making it difficult to make any sort of judgment on their experience or what it is they are getting from the game.

There have been attempts by other ARGs to mitigate the impact of passive users outnumbering the active ones. The recent self-defined Massively Multiplayer Online game *Cloud Chamber*[4] serves as an example of strictly enforced participation. While *Marble Hornets* encourages community involvement and shared discussion through its social media presence and the obtuseness of the *totheark* channel, *Cloud Chamber* actually demands active participation in order to advance the narrative. Using the aggregate site Reddit as a model, *Cloud Chamber* requires its users to post comments and analysis on the various narrative elements of the series; other users can

then "upvote" or "downvote" the contributions based on their own subjective judgment. The only way a user can gain access to more parts of the story is by receiving a certain level of "upvotes" on their contributions. While this seems to be a potential means of avoiding too much passive engagement, it also runs the risk of alienating its user base, by having their knowledge of the story elements determined by the arbitrary subjectivity of the other players. This also could lead to a saturation of participation, in that users will feel the need to make a contribution – any contribution – for the sole purpose of receiving the points they need, rather than because they actually have information or analysis to share.

4 Conclusion

There remains some work to be done in the academic study of ARGs and transmedial modes of narration. The emphasis on the contributions of active users, while ignoring the experience of those who passively observe the game, is one area of the field which needs to be further explored. *Marble Hornets* as a case study does allow for the analysis of certain key elements of ARG storytelling, such as the seemingly paradoxical elements of user experience and the nature of participation. The series itself is far from perfect; while the TTA channel is interesting both in its formal construction and its role as the driving force of the interactive elements of the game, the series still relies heavily on its status as one of the original incarnations of Slender Man, and its main channel at times seems to be an extended recreation of *The Blair Witch* project in the age of YouTube. Despite its shortcomings, the series does engage with some of the key issues that must be discussed in relation to participatory narratives, as well, it provides an alternative to the large-scale marketing ventures that many of the more popular ARGs tend to be.

References

1. Aardse, K.: Alternate Reality Games, Narrative Disbursement and Canon. In: Barton, K.M., Lampley, J.M. (eds.) Fan CULTure: Essays on Participatory Fandom in the 21st Century, pp. 106–117. McFarland and Company Inc., Jefferson (2014)
2. Burgess, J., Green, J.: Youtube: Online Video and Participatory Culture. Polity, Cambridge (2009)
3. Chinchanachokchai, S., Duff, B.R.L.: Jack of All Trades, Master of...Some? Multitasking in Digital Consumers. In: Belk, R.W., Llamas, R. (eds.) The Routledge Companion to Digital Consumption, pp. 367–377. Routledge, New York (2013)
4. Cloud Chamber, Investigate North (2014), http://cloudchambermystery.com/
5. Jacobs, J.: Television, Interrupted: Pollution or Aesthetic?". In: Strange, N., Bennett, J. (eds.) Television as Digital Media, pp. 255–279. Duke University Press, Durham (2011)
6. Jenkins, H.: Searching for the Origami Unicorn: *The Matrix* and Transmedia Storytelling. In: Convergence Culture: Where Old Media and New Media Collide, pp. 95–134. New York University Press, New York (2006)
7. MarbleHornets, https://www.youtube.com/user/marblehornets

8. MarbleHornetsTruth,
 https://www.youtube.com/user/marblehornetstruth
9. Ndalianis, A.: Transmedia and the Sensorium: From Blair Witch to True Blood. The Horror Sensorium: Media and the Senses, pp. 163–194. McFarland and Co., Jefferson (2012)
10. Oddey, A., White, C.: Introduction: Visions Now: Life is a Screen. In: Oddey, A., White, C. (eds.) Modes of Spectating, pp. 7–14. Intellect, Chicago (2009)
11. O'Hara, K., Grian, H., Williams, J.: Participation, Collaboration and Spectatorship in an Alternate Reality Game. Paper presented at OZCHI 2008: Australasian Computer-Human Interaction Special Interest Group Conference Proceedings, Cairns, QLD, Australia, December 8-12 (2008)
12. Parmentier, M.-A., Fischer, E.: Interactive Online Audiences. In: Belk, R.W., Llamas, R. (eds.) The Routledge Companion to Digital Consumption, pp. 171–181. Routledge, New York (2013)
13. Royer, C., Royer, D.: The Spectacle of Isolation in Horror Films. The Hayworth Press, New York (2005)
14. totheark, https://www.youtube.com/user/totheark
15. TTADecoded, https://www.youtube.com/user/ttadecoded
16. Thacker, E.: Dark Media. Excommunication: Three Inquiries in Media and Mediation, pp. 77–149. University of Chicago Press, Chicago (2013)
17. UnfictionForums, http://forums.unfiction.com/forums/index.php?f=248&sid=9b47fd09784fe077669734fa00ac819b

Mapping Trends in Interactive Non-fiction through the Lenses of Interactive Documentary

Arnau Gifreu-Castells

Konekto, Universitat de Vic-Universitat Central de Catalunya, Spain
Open Documentary Lab, Massachusetts Institute of Technology, USA
agifreu@mit.edu

Abstract. Interactive digital media have greatly affected the logics of production, exhibition and reception of non-fiction audiovisual works, leading to the emergence of a new area called "interactive non-fiction". One of its key points is that it can deal with factual material in such a way that it influences and transforms the real world around us. The present work gives a brief insight into the interactive non-fiction area and presents some trends/hypotheses obtained from studying one of its main formats: interactive documentary. The aim is to introduce new dynamics, logics and trends that could shape the interactive non-fiction field in forthcoming years.

Keywords: Documentary, Digital Media, Interactive Storytelling, Interactive Non-fiction, Interactive Documentary.

1 Introduction

Interactive digital media have impacted the logics of production, exhibition and reception of traditional audiovisual works. In recent years these new dynamics have changed the nature of communication processes and the agents involved, leading to the emergence of a new area called "interactive non-fiction" or "interactive factual narratives".

Interactive non-fiction works create a new logic for the representation of reality. The emphasis of this new logic is placed on the relationship that evolves between the text and the user, rather than on how the author constructs a specific discourse on reality for traditional viewers. This new discourse is constructed using new methods – navigation and interaction– rather than modes of representation [1].

In this article we define and study one of the main formats of the interactive non-fiction field, "interactive documentary", to gain insight into certain trends that could also be applied to the macro-genre of interactive non-fiction. The trends, logics and dynamics detected and characterised in this work could offer some leads on how to make interactive non-fiction works more appealing. These interactive formats can have a deep impact and as they are able to deal with factual material they can influence, affect and transform the real world.

A. Mitchell et al. (Eds.): ICIDS 2014, LNCS 8832, pp. 156–163, 2014.

2 The Interactive Non-fiction Area

The term "non-fiction" has been used in film language to describe movies that are not in the area that the industry and the audience define as "fictional cinema". However, the boundaries between fiction and non-fiction are still disputed today. Some authors [2, 3] question the current basic distinction between fiction and non-fiction, arguing that there are many factual works that use fictional devices. To illustrate this Michael Renov [3] cited the film *Nanook of the North* (Robert Flaherty, 1922) and the big city symphonies such as *A man with a Movie Camera* (Dziga Vertov, 1929), *Berlin: Symphonie der Grosstadt* (Walter Ruttman, 1927) and *A Propós de Nice* (Jean Vigo, 1930). The concept of non-fiction was forged over different historical periods and results from the great transformation of the culture industry, which needed its processes to be well defined in order to expand and break up into different categories. As film became more complex, developing its own language, literary fiction and non-fiction began to be applied to cinema [4]. However, contemporary theory concludes that there are no clear boundaries between documentary film and fictional movies: they nourish each other in form and content. In its ideal state, non-fiction film tends towards fiction and fictional film tends towards documentary.

The controversial but now widely applied term "non-fiction", used by various film theorists [2,3,4,5,6], is conceived as a large genre of which one of the possible forms or modes of representation is the documentary. In reality, beyond the documentary, audiovisual non-fiction is a vast field containing scientific films, digital journalism and reports, institutional, industrial or propaganda videos, film essays, educational videos, nature films and tourist travel films, among others.

With the emergence and consolidation of interactive digital media in the last decades of the twentieth century, the field of interactive non-fiction can be considered a distinctive narrative type that focuses on an interactive discourse whose intrinsic characteristic is that it includes the management of user actions. The digital environment makes it possible to incorporate unlimited forms of dialogue and integrate different media.

Videogames as a prominent genre of interactive fiction have been dealing with nonlinear narratives from the very beginnings of the medium, almost 40 years ago, and the results, in terms of ways to interact with the story, are remarkable. The documentary, one of the counterparts of videogames in the interactive non-fiction field, aims to achieve a more objective narrative. Apart from documentary, journalism is one of the major genres that form a part of this macro-genre we have defined as "non-fiction".

3 Interactive Documentary

If the definition of traditional documentaries is only approximate and in a constant state of construction and deconstruction, the definition of interactive documentaries is at an even earlier stage. It is difficult to reach a general consensus about a precise definition mainly due to the changing nature of the documentary genre. Apart from

authors like Glorianna Davenport, who began experimenting with multimedia narrative films in the 80s at Massachusetts Institute of Technology –and who in 1995 developed the concept of "evolving documentary" [7]– there is some literature on interactive documentary in general or a definition of the domain [8,9,10,11,12, 13,14,15,16]. Although in recent years the amount of literature on the interactive documentary has increased, there are still some gaps to be filled in this field. Given its complexity, the literature uses this term without defining it precisely [8,10,12,13]. The concept of "interactive documentary" is used as a generic term for a kind of interactive textuality [1]. Some authors, however, propose variations to classify this type of format, such as "i-Docs" or "Living docs" [1], "Expanded documentary" [17] or "Collab Docs" [10].

The two creative directors of the i-Docs group, Judith Aston and Sandra Gaudenzi, define interactive documentary as "*any project that starts with an intention to document the 'real' and that does so by using digital interactive technology*" [18]. According to Aston and Gaudenzi, what counts is the link between digital interactive technology and documentary practice. This is inspired in the simple definition given by Galloway *et al.*, who consider that interactive documentary is "*any documentary that uses interactivity as a core part of its delivery mechanism*" [14].

It seems clear that any definition of interactive documentary will have to take into account the complex open nature of this genre, its cross-over between cinema and interactive fields, and finally its identification as a discourse intended to convey a particular kind of knowledge connected to reality. Recapping some of the ideas discussed, we are now able to define interactive documentaries as online or offline interactive works made with the intention of representing, documenting and constructing reality through the mechanisms of conventional documentaries –forms of representation– as well as new mechanisms that we will call interaction and navigation modes, depending on the level of participation and interaction involved.

Interactive documentaries aim to document, represent and interact with reality, a process which includes considering and using a set of techniques (types of interaction and navigation) that are, in this new form of communication, essential for achieving the goals of the documentary. The final objective is to complement, extend and enlarge the documentary experience by offering new systems of perception as the viewer is immersed in the experience of interactive digital media. One of the aims in categorising this new form is to establish a distinction between three main categories: representation, navigation and interaction. While in linear documentaries the viewer is not obliged to interact (there is only the optional cognitive interpretation of what is portrayed and subjective conclusions based on perception) [1], in interactive documentaries this necessity is negotiated through navigation and interaction and is structured around the different modes involved. The modes of representation show the director's point of view or attitude to the world filmed, resulting in a specific discourse given a particular form according to established conventions (poetic, expository, reflexive, interactive, observational, performative) [19]. The navigation modes facilitate different ways of browsing or penetrating reality and lead to a multimodal non-linear deployment that does not exist in the modes of representation (temporal, spatial, witnessing, narrative branching, hypertextual, preferential, audiovisual, sound,

immersive/simulated, divided) [20]. Modes of interaction go a step further and propose a scenario in which the receiver becomes in a sense an emitter: they can leave a mark or trace of their journey through the work (generative, physical, 2.0 applications) [1, 20].

4 Mapping Trends

Now that we have defined the field of interactive non-fiction and its main genre in gestation, the interactive documentary, we will use the analysis of the object of study [20] to introduce new dynamics, logics and trends that could shape the interactive non-fiction field in the following years.

4.1 Design through Modes and Processes

Janet Murray [21] considers the concepts of interactivity and immersion as the two specific aspects of the digital medium. The territory of interactive documentaries is producing ground-breaking works that combine discourses and communication systems (multimodality) with new interactive experiences where users play a central role (interactivity). The main distinguishing feature of the interactive medium is that the progression of the discourse is based on the actions of the user. Multimodality is the mixture of textual, audio and visual modes in combination with media to create meaning [22].

In the design of the modalities for use in an interactive documentary we propose to achieve a balance between navigation and interaction modes. After the selection of modes, we have to consider the different processes involved in the experience offered by the interaction system, such as exploring (browsing, interacting, contributing and collaborating), learning (understood as knowledge transfer) and finally sharing (interacting with others). This will determine the level or degree of interactivity of the project. Interactive documentary proposes a challenge (encourages, motivates, stimulates), provides data to make decisions (informs, complements, experiments) and forces the brain to retain the data to make sense of the story and connect knowledge (learning). Both strategies –modes and processes– become key elements in the final shape of the documentary. This means going from analysing "what" is represented (modes of representing reality) to analysing "how" it is intended to be represented (the concept itself is not as important as how it is formulated). This set of new dynamics and practices in the design of these projects requires new professional skills that have evolved in response to the new level of complexity.

4.2 The Double Hybridisation and the Impact on Education

This is an emerging genre, a new territory waiting to be explored and defined, the result of a double hybridisation: between audiovisuals (the documentary) and interaction (interactive digital media), and between information (content) and entertainment (supports, platforms and experiences). We believe that, thanks to the connections

which could emerge from this hybridisation process, this genre is destined to become one of the most important informative formats and will become a natural replacement from traditional media such as television and photojournalism. In addition, interactive non-fiction works, applied in the field of education and hybrid domains (educational games, edutainment, etc.), could influence and transform the real world, allowing to implement the processes previously described (explore, learn, share) in different contexts such as classrooms, training, online courses, etc.

4.3 The Mixture of Formats and Genres

In recent years interactive documentary has experienced remarkable growth due to several favourable factors. Recently there have been a considerable number of interactive documentaries produced, enough for a systematic, differentiated and consistent conceptual framework of the new genre to be developed. Besides initial experiments using optical technologies (Laserdic, CD-DVD Rom) in the early 90s in France and the United States, ARTE, with remarkable co-productions such as *Gaza/Sderot* (2008), *Prison Valley* (2010) and *Alma. A tale of violence* (2012), or the National Film Board of Canada, with productions such as *Highrise* (2009-2014), *Welcome to Pine Point* (2010) or *Bear 71* (2012), or collaborations between these two organisations (*Fort McMoney*, 2013), have emerged as the most awarded and recognised works in this field.

In addition to the Canadian and French entities, there has been some movement and development around this kind of documentary: production companies and agencies (Upian, Honkytonk Films, Submarine Channel, Helios Design Labs, Barret Films, etc.), digital newspapers (Le Monde, The New York Times, etc.), festivals and conferences (IDFA Doclab, i-Docs conference, interDocsBarcelona, Webdox), research labs (MIT Open Documentary Lab, i-Docs Lab), platforms and initiatives (interDOC), interactive and transmedia markets (Cross Video Days, Sunny Side of the Doc, Sheffield DocFest, etc.), private funding (Tribeca Film Institute, Sundance Institute, etc.), indexes of projects (MIT Docubase, Docshift Summit, interDOC_indice), etc. This is just a partial state of the art because this institutional landscape of the field is changing fast and the range of possibilities is currently expanding, with the changes being even greater because newspapers, NGOs, academia, multimedia companies, festivals, labs and museums have joined in. Due to the different nature of the actors involved, interactive documentary contributes to the growth of the interactive non-fiction field. The interactive documentary of the coming years will be a kind of transmedia meta-genre located in the fields of both interactive fiction and non-fiction. According to this idea, the new documentary forms would be a "container" or "umbrella" genre in which various experiences can come together and coexist. It is precisely this "chameleon" and adjustable character that gives this textuality momentum in relation to interactive formats so that it is currently one of the main genres of interactive non-fiction production.

4.4 Gamification and Transmedia Logics

Galloway *et al.* [14] argue that there are enough parallels between film and the aims of documentary game to be a fair comparison, and suggest that because videogames have an innate ability to create stories and engaging characters, players become immersed in the simulation. Mixing documentary (non-fiction) and games (fiction) seems a strategy that many producers are considering for interactive documentary because combining reality with a structure that includes the interactor and places him/her at the centre of the action creates a much more immersive and engaging scenario for the documentary and its participants. Some specific formats such as Documentary Games (*Fort McMoney*, *JFK: Reloaded*, *Waco Resurrection*, *911 Survivor*, etc.) or Serious Games (*Hazmat:Hotzone*, *Food Force*, *Re-mission*, etc.), or initiatives such as *Games for Change* are examples of this interesting trend.

The interactive documentary is a form which includes multiple media platforms for its production, distribution and exhibition, such as the Web (webdocumentary), hardware (installation, Head Mounted Display, etc.), visual (film and television), offline media (CD-DVD ROM, videodisc) and multiplatform (transmedia documentary), among others. This new form of interactive non-fiction facilitates the expansion of the story across different platforms.

The concept of "transmedia narrative" was introduced by Henry Jenkins in an article published in the MIT Technology Review in 2003; it describes the narrative experiences that unfold through different media or platforms in which a part of consumers take an active role in the process of expansion [23]. According to Scolari [24], at the most basic level, we can understand transmedia stories as the latest step in the evolution of narrative forms. Transmedia documentary is a format in expansion that provides immensely interesting narratives for documentaries as well as recreational possibilities. New devices such as Head Mounted Displays (Oculus Rift) and incoming projects based on immersive reality (*Clouds*, *Zero Point*) will enrich the scenario for transmedia non-fiction stories.

5 Conclusion

The interactive non-fiction narratives have transformed the processes of producing, distributing and showing documentaries, and especially the processes involved in how the viewer relates to the text. Videogames, comics, animation, infographics, television, journalism and other media are transforming the nature of the non-fiction film discourse to the point where it is no longer possible to refer to the medium of film in general as an autonomous discourse, it needs to be understood in relation to the emerging new media. By characterising interactive documentary we have determined some trends that can be taken from the interactive non-fiction area to improve production, always assuming the fact that this field is evolving so rapidly that it is difficult to reflect and produce at the same time. This new scenario has changed the way we produce and approach media because in this new ecosystem we have to balance narrative and interaction in a new equation in which education also has something to say. The possibility for the viewer/user to interact with the content and consume a variety of

modes of communication has led to a profound change in the traditional models of production, distribution and exhibition and by extension the players involved. The director has turned into an author/designer of experiences, the text now has different paths and the passive viewer is now an active player who determines the choices of the story.

We are facing a transition era in which the term documentary is expanding. All new actors and initiatives should lead to a certain institutionalisation of the form, thus differentiating it from the linear documentary and other interactive non-fiction genres/formats. This expansion of the form makes it possible to enrich the story in new directions so that terms such as collaboration, co-creation and gamification have become part of this new lexicon and praxis. But until the business model is consolidated we cannot reach this new stage; it is still too fragile, although new actors who consider this new narrative form as something interesting are entering the field. The foreseeable trends indicate that interactive documentary and, by extension, interactive non-fiction, will become an umbrella format and/or macro-genre because many discourses, formats and genres intersect in this area.

Interactive film is a genre that fits the logics of transmedia, cross-media and mixing formats, which make it one of the most explored and used genres for the purposes of interactive non-fiction production. This type of storytelling makes it possible for audiovisual projects to include elements that complement, enrich and expand the viewer/user's overall experience so that it is more varied, complete and immersive.

Acknowledgements. This work is part of the Project "Active Audiences and Journalism. Interactivity, Web Integration and Findability of Journalistic Information". CSO2012-39518-C04-02. National Plan for R+D+i, Spanish Ministry of Economy and Competitiveness.

References

1. Gaudenzi, S.: The Living Documentary: from representing reality to co-creating reality in digital interactive documentary [PhD]. University of Goldsmiths. Centre for Cultural Studies, London (2012)
2. Nichols, B.: Blurred Boundaries. Question of meaning in contemporary culture. Indiana University Press, Bloomington (1994)
3. Renov, M.: Theorizing Documentary, p. 2. Routledge, New York (1993)
4. Cock, A.: Retóricas del cine de ficción postvérité. Ampliación de las fronteras discursivas audiovisuales para un espíritu de época complejo, p.44 [PhD]. Universitat Autònoma de Barcelon, Bellaterra (2009)
5. Plantinga, C.: Rhetoric and representation in nonfiction film. Cambridge University Press, Cambridge (1997)
6. Meran Barsam, R.: Nonfiction Film: a Critical History. Indiana University Press, Bloomington (1992)
7. Davenport, G., Murtaugh, M.: ConText: Towards the Evolving Documentary. In: ACM Multimedia 1995, San Francisco. Electronic Proceedings, p. 1 (1995)

8. Almeida, A., Alvelos, H.: An Interactive Documentary Manifesto. In: Aylett, R., Lim, M.Y., Louchart, S., Petta, P., Riedl, M. (eds.) ICIDS 2010. LNCS, vol. 6432, pp. 123–128. Springer, Heidelberg (2010)

9. Choi, I.: Interactive documentary: A production model for nonfiction multimedia narratives. In: Nijholt, A., Reidsma, D., Hondorp, H. (eds.) INTETAIN 2009. Lecture Notes of the Institute for Computer Sciences, Social Informatics and Telecommunications Engineering, vol. 9, pp. 44–55. Springer, Heidelberg (2009)

10. Dovey, J., Rose, M.: We're Happy and We Know it: Documentary:Data:Montage. Studies in Documentary Film 6(2), 260 (2012)

11. Whitelaw, M.: Playing Games with Reality: Only Fish Shall Visit and interactive documentary. In: Brunt, B. (ed.) Halfeti: Only Fish Shall Visit, Artspace, Sydney (2002)

12. Hudson, D.: Undisclosed Recipients: Database Documentaries and the Internet. Studies in Documentary Film 2(1), 89–98 (2008)

13. Ursu, M.F., Zsombori, V., Wyver, J., Conrad, L., Kegel, I., Williams, D.: Interactive Documentaries: A Golden Age. ACM Computers in Entertainment 7(3), 27–41 (2009)

14. Galloway, D., McAlpine, K.B., Harris, P.: From Michael Moore to JFK Reloaded: Towards a working model of interactive documentary. Journal of Media Practice 8(3), 325–339 (2007)

15. Bole, N., Mal, C.: Le webdoc existe-t-il? Le Blog documentaire, Paris (2014)

16. Nash, K., Hight, C., Summerhayes, C.: New Documentary Ecologies. Emerging Platforms, Practices and Discourses. Palgrave Macmillan, London (2014)

17. Sucari, J.: El documental expandido: pantalla y espacio. UOC Press. Editorial UOC, Barcelona (2012)

18. Available online at the i-Docs website, http://i-docs.org/about/

19. Nichols, B.: Introduction to documentary. Indiana University Press, Bloomington (2001)

20. Gifreu-Castells, A.: El documental interactiu com a nou gènere audiovisual. Estudi de l'aparició del nou gènere, aproximació a la seva definició i proposta de taxonomia i d'un model d'anàlisi a efectes d'avaluació, disseny i producció. [PhD]. Barcelona: Universitat Pompeu Fabra. Departament de Comunicació (2013)

21. Murray, J.: Hamlet on the Holodeck: The Future of Narrative in Cyberspace. MIT Press, Cambridge (1998)

22. Murray, J.: Composing Multimodality. In: Lutkewitte, C. (ed.) Multimodal Composition: A Critical Sourcebook, Bedford/St. Martin's, Boston, Massachusetts (2013)

23. Jenkins, H.: Transmedia storytelling. Moving characters from books to films to video games can make them stronger and more compelling. Technology Review (2003)

24. Scolari, C.A.: Narrativas transmedia. Cuando todos los medios cuentan. Deusto, Barcelona (2013)

Narrative Cognition in Interactive Systems: Suspense-Surprise and the P300 ERP Component

Luis Emilio Bruni, Sarune Baceviciute, and Mohammed Arief

Augmented Cognition Lab
Department of Architecture, Design and Media Technology
Aalborg University, Copenhagen, Denmark
{leb,sba}@create.aau.dk, arief@live.dk

Abstract. In this article we explore some of the methodological problems related to characterizing cognitive aspects of involvement with interactive narratives using well known EEG/ERP techniques. To exemplify this, we construct an experimental EEG-ERP set-up with an interactive narrative that considers the dialectical relation between suspense and surprise as a function of expectancy, which in turn can be correlated to the P300-ERP component. We address the difficulties of designing a coherent narrative with a suitable level of closure while meeting the requirements of the ERP experimental procedures. We stress the necessity of fine-tuning the highly specific ERP paradigms necessary for the investigation of user experience in interactive narratives and storytelling.

Keywords: Narrative cognition, interactive narrative, ERP, P300 component, EEG, suspense, surprise, expectancy, interactive storytelling.

1 Introduction

Since the late 1980's and early 1990's, there has been an increasing interest on what today could be called the psychophysiology of narrative experience, for instance [1-4]. Perhaps due to the complexities inherent in electroencephalographic methods and the cognitive aspects of narratives that could be assessed in this way, EEG methodologies have been less common. The field of interactive storytelling not only can profit from this line of research, but also can contribute to enrich the empirical methodologies, thanks to the technical possibilities of digital media for creating innovative interactive narrative artifacts and experimental set-ups.

If we acknowledge Ryan's account of the problematic relation between cognitive and narrative studies [5], the main challenge remains bridging the gap between bottom-up approaches that tend to biologize human cognition and experience (sometimes becoming excessively reductionist) and top-down approaches that consider the phenomenological level (but face the empirical problem of assessing subjective experience by first-person accounts). Therefore, an empirical direction that consciously accounts for this kind of reduction could consider the following two steps. First, one has to identify what are the "features" or "parameters" in an interactive narrative

A. Mitchell et al. (Eds.): ICIDS 2014, LNCS 8832, pp. 164–175, 2014.

experience that could be of interest, for example narrative intelligibility, closure, surprise, suspense, etc. Second, one has to define what are the cognitive processes, faculties or tasks that relate to the narrative features or parameters that have been chosen as relevant, which in turn are the ones that could be linked to some psychophysiological marker.

In this article we explore some of the methodological problems related to characterizing cognitive aspects of involvement with interactive narratives using well known EEG/ERP techniques. To exemplify this, we construct an experimental set-up that considers the subtle dialectical relation between suspense and surprise – as one narrative "feature" that can be linked to a "lower level" or, a more general cognitive process (i.e. expectancy), which in turn can be correlated to a specific EEG marker – in this case the P300 ERP component. As we will see, these methodologies require the subject to be exposed to many repetitions of "equivalent" events. This fact precludes the natural progression in a narrative dramatic arc and therefore compromises the possibility of applying ERP techniques to interactive narratives that have not been specifically designed to fit this experimental requirement.

2 EEG/ERP and Narrative Cognition in Interactive Systems

Between such "higher-level" features of user experience and the actual psychophysiological correlates (e.g. heart rate, GSR, EEG), there are a myriad of embedded and related processes, which can be linked to many physiological and cognitive properties. These can be seen either as "prototypic" forms at lower levels or as more developed manifestations of the kind of semiotic freedom that characterizes the open and creative instantiations of narrative communication [6] [7].

The concern of cognitive and psychological approaches to narrative has been so far not the elucidation of important aspects of narratives but rather the investigation of higher order cognitive processes elicited by narratives [5]. For example, in brain-imaging experiments, the narratives are just stimuli for the investigation of complex cognitive processes such as "understanding" (e.g.: [8-11]) or "empathy" (e.g.: [46]). As implied above, we see the necessity to invert this kind of relation. Therefore, we focus on the possibilities of using Event-Related-Potentials (ERP) to characterize the involvement of a user with an interactive narrative. ERP is a well-established EEG technique, which has been a useful tool to characterize different verbal and non-verbal communication modalities [12-19]. Few studies have used these techniques to investigate issues directly related to narrative cognition [18-23]. Even fewer have directly related EEG/ERP techniques to interactive narrative or storytelling, and those that have, have been more oriented to BCI solutions than to monitoring user experience [4], [24], [46].

3 Suspense and Surprise as Features of Narrative Cognition

There is a subtle relation in a narrative between the building of suspense and the suddenness of surprise. There is no clear consensus on how this relation works. Some authors see suspense and surprise as two completely separate categories in the sense

that surprise is not considered to have any role in the building of suspense; however it may play an important role in its resolution [25-27]. Other authors hint to a more complex dynamics between these two categories of "emotions" or cognitive processes [28], [29]. For instance, in [28] it is pointed out that surprise and suspense need not be contradictory or mutually exclusive but may work complementarily in complex ways, perhaps in networks of local and global surprises [28], [27]. Incidentally, the trade-off will actually depend on the kind of suspense we are talking about [25].

Perhaps the link between surprise and suspense can be found in their common relation to a third notion – that of expectancy. Since the development of suspense is related to uncertainty about future outcomes, people's reactions to a given narrative will be framed in terms of prior knowledge and expectations [26], [30-34]. Contrary to the projection towards the future implied by suspense, surprise is usually associated with the unmet expectations of the "here and now". A surprising situation is one in which the perceived facts are in disagreement, or somehow incongruent, with an expectation that was aroused by the situation that preceded them [35] [26]. The surprise can then be resolved by processing the uncertainty that it created. Therefore, uncertainty and expectation appear to be constitutive elements of both suspense and surprise.

Summarizing, we could say that the dialectic link between suspense and surprise lies in the dynamic shift between expectation and "un-expectation" as a function of uncertainty. The synchronic-diachronic dynamics of the suspense/surprise duality means that suspense (in time) may be built by a succession of (small or big) local surprises (i.e. unexpected and up-to-now-unavailable information) that shape the expectations about the future. One may be expecting some things to happen, or more information to be revealed (suspense), but one doesn't know exactly when or how it will arrive. Every increase of (unexpected) information that reduces (or increases) uncertainty may have an element of surprise. This is the essence of the kind of expectancy that is claimed to be encapsulated in the P300 ERP component.

The P300 ERP is a positive peak in amplitude of the EEG signal between 5 to 20 μV (micro volts), which occurs around 300 to 400 ms after presenting a subject to a particular stimulus or cognitive task [12], [36-38]. Although the definite source of the P300 is still a matter of discussion, this ERP usually is manifested when a subject attends an expected event without knowing exactly when it will happen – until he or she is *surprised* by its sudden occurrence. Therefore P300 is a marker that may somehow relate to the dialectics between suspense and surprise via expectancy.

4 The Limits of ERPs to the Study of (Interactive) Narratives

The electrical potential evoked in the cerebral cortex by a particular stimulus, the so-called "event", is said to be time-locked to the signal (this is actually what defines an ERP). The amplitudes of these potentials, detected and recorded by EEG, tend to be very low (in the microvolts scale). These signals are hidden in the background of many other biological signals and ambient noise, so-called artefacts. In order to resolve these low-amplitude potentials against the background noise the usual procedure applied is "signal averaging". The assumption behind this procedure is that

anything that is not uniquely time-locked to the stimulus, i.e. noise, will occur randomly. Therefore the averaging of repeated responses to the same (or very similar) stimuli is assumed to cancel out most of the random artifacts. In order to detect ERPs in EEG experiments, it is suggested that a minimum of around 30-40 trials per subject are necessary to apply the averaging procedure [12].

This procedure poses a great challenge if these methods are to be used for characterizing "user experience" with narratives. It means that a single test subject has to be presented with at least 30 similar or "equivalent" events during the narrative experience. Many of the "features" or "parameters" in a narrative experience that could be of interest may turn out to be unique singular events, which are not amenable to repetition without affecting the very nature of what a narrative experience is – with the uniqueness of all the stages in its unfolding (e.g. exposition, conflict, climax, denouement, resolution, the building of suspense, etc.). Since narrative *per se* has not been the central issue in most cognitive psychological experiments with ERPs involving narratives, experimental designs have not found an unsurmountable limitation in the necessary averaging procedures for "cleaning" the signals and the necessary repetition of events that this entails. On the contrary, in the field of interactive narratives and storytelling it is the uniqueness of these events which is the central issue.

Historically, the averaging procedures have in a sense overlooked the fact that variance among trials contains idiosyncratic information about subjects or cognitive states. The result is an imperfect but representative sample of the activity that is time-locked to the stimulus (which is supposed to be constant) [39]. It follows that averaging may be misleading by presenting an "abstract signal" that does not belong to any of the individual subjects or to the single events [40]. An alternative to averaging-EEG that is starting to get considerable attention are the so-called "single-trial" analytical methods. In recent years, various methods have been developed but so far it has been mainly the BCI community that has profited from these advancements [39]. Progress in this direction has been made by addressing a fundamentally different question: whether a particular response to a stimulus occurred, rather than how does the brain respond to a particular stimulus [39]. Usually, this is approached by constructing a classifier that can be trained to discriminate the patterns of the signal that characterizes the event of interest, a so-called "template" [41]. Therefore these techniques allow more for the binary *detection* of the signal, rather than for its idiosyncratic *characterization*, which would be needed for investigating narrative cognition. A limitation of single-trial methods is that one still needs to produce the "template" and the training data for the classifier, which in a sense brings back the problem of designing "equivalent" events. The template needs to be based on previous findings obtained by standard averaging procedures [42].

5 Experimental Design

Based on these limitations we are bound to design an interactive narrative, which meets the following criteria: 1) the narrative has to contain at least 30 equivalent events, which will be the events time-locked to the signal, and 2) these events have to

encapsulate the essence of the relation between suspense and surprise via expectancy, as explained above. In this regard, the difficulty of subordinating the design of the narrative to this procedure is to try to maintain a good level of narrative closure, or at least a sensation of being exposed to some sort of narrative. For this reason the test includes a very brief questionnaire with the following two questions: 1) did you perceive a story in the game? , 2) was the story complete?

For comparison purposes we also introduce the subjects to a parallel cognitive task – i.e.: spelling with a standard P300 BCI device – which we assume to be "equivalent" to the task proposed in the interactive narrative, since they are both based on a similar kind of expectancy. This allows us to manually compare a well-known signal based on expectancy (from the P300 speller) with the one generated by the suspense/surprise features of the narrative, in order to evaluate the eventual variation in both tasks. The idea with this comparison is to explore the degree of particularity that a possible "template" of a P300 component characterizing the kind of expectancy implicit in the relation between suspense and surprise may have. To find a scheme for the repetition of suspenseful/surprising events, the interactive narrative was developed around the logic of a "treasure hunt" game. The "equivalent events" include a series of riddles that prepare the subject to what he or she should expect in the next step.

6 Implementation

6.1 Interactive Narrative

The interactive narrative was implemented using the game engine Unity 3D. The theme of the narrative revolves around solving a series of riddles that the user encounters when he finds himself alone in a deserted island with signs of civilization after surviving an airplane crash. To introduce the context of the story, a prologue was produced in the form of an animated cut-scene with a narrative voice over. This provides the user with some background information about the character, and about what the character already knows about the island. At the end of this introduction the user is informed about his quest in this island. The quest consists in finding the answers to a series of 30 riddles placed at different locations in the environment, which will lead him to the final goal in the narrative – finding a treasure in a light house. The riddles are short enigmatic questions that should lead to a concrete object in the environment. The first riddle is provided orally in the introduction, and the remaining 29 riddles are revealed in a written note when clicking on the object that "answered" the previous riddle. In order to guide the user to the object that will correspond to the riddle, the object is covered by a "magical sphere" that will reveal the object once the user enters its field. Therefore, the 30 events are cyclically structured in the following manner: first a riddle is given; then a "magical sphere" is found (which signals the user the location of the corresponding object); and, once the character enters in the field of the sphere, the object appears. Finally, when clicking on the object, the next riddle is revealed, and so the cycle continues until the final epiphany (see figure 1). The climax occurs once the player reaches the 29th event, which unlocks a bridge leading to the light tower. Once the player reaches the light tower the last event will reveal the treasure and the story ends.

Fig. 1. The three elements of one event: the riddle, the "magic sphere" and the object

The rationale of these cycles is given by the design constraints related to the nature of the P300 component and the averaging procedures for its detection. The riddles have the purpose to create the expectation in the user's mind, which will be fulfilled by finding out that the encountered object matches this expectation. This is why the riddle must be easy to solve in terms of imagining which object it refers to, and at the same time should give a sense of enigma in order to add suspense to the global narrative. The objects need to be hidden by the sphere and revealed only after collision with it, in order to ensure a very precise synchronization of the moment when the expectation is met and the recorded EEG signal. In other words, entering the sphere constitutes the "trigger" implemented in the EEG recording and analysis set-up (see below).

6.2 The P300 Spelling Task

For the spelling exercise we used the P300 Speller Simulink Model included in the g.Tec Simulink software package for Matlab. A task was devised where each participant had to spell the 3 letter-word "dog", where each letter in the word is highlighted 10 times, for a total of $3 \times 10 = 30$ trials, to match the number of events that the subject will encounter later in the interactive narrative. The speller contains characters which are represented in a six by six matrix. Each of the characters will flash up for a certain time in a random and sequential order.

6.3 The EEG Recording and Analysis Set-up

For recording and analyzing the EEG data, we used a g.Tec system consisting of g.USBamp biosignal acquisition device, g.GAMMAbox, g.Cap with an array of 8 electrodes plus reference and ground, Simulink high-speed on-line processing blocks and the g.BSanalyze off-line processing toolbox. Based on standard procedures for measuring and recording EEG data of the P300 component [12], [43-45], the following parameters were used. A standard electrode configuration (based on the 10/20 system) for recording P300 ERPs was adopted (Fz, Cz, Pz, Oz, P3, P4, P07, P08). To ensure artefact reduction in eye blinking and tongue/jaw movement, a sensitivity of ± 100 µV was used. Band pass filter was set in a range from 0.01 to 100 Hz. Sample frequency was predetermined at 256 Hz. The epoch length was defined from 150 ms pre-stimulus to 700 ms post-stimulus for data analysis. For the interactive narrative, an ad hoc Simulink model was created to connect the narrative stimuli in the Unity environment to the EEG recording unit via a UDP in order to ensure proper synchronization of the trigger events and the recorded signals.

The final set-up of the test includes (see figure 2): the subject wearing the EEG cap which sends data to the g.USBamp amplifier (via the g.GAMMAbox). These data is then recorded and analyzed in the PC working station. On the stimulus presentation side, one PC runs the spelling device from the g.Tec software, while another computer runs the interactive narrative in Unity 3D. Both stimuli are presented in two sequential sessions in the same monitor while the subject is still connected to the EEG cap. The EEG recording and analysis station is in the same PC that runs the speller. The Unity PC and the recording station are connected via UDP.

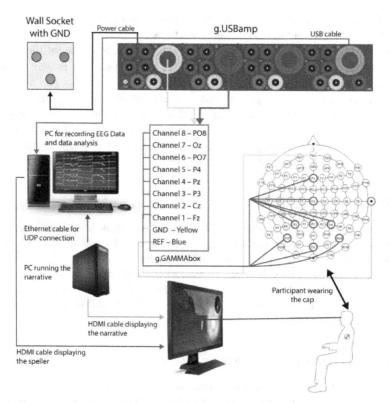

Fig. 2. Diagram of the final experimental set-up

7 Procedures

The test was conducted in a controlled environment at Aalborg University Copenhagen, with 20 voluntary participants. It consisted of two consecutive sessions for all participants. The subjects were first exposed to the P300 spelling exercise and, after a short pause, they experienced the interactive narrative session. Finally, they were asked to fill out the questionnaire. The participants were seated in a comfortable chair in front of the screen. While being fitted with the EEG cap, participants were given

oral instructions about the procedure of the test. The electrode placement was maintained the same during both sessions. All subjects gave informed consent about their participation and they were oriented that they could interrupt the test at any time.

8 Results

The results are based on data gathered from 20 voluntary healthy male participants (ages between 19 and 30) who participated in both testing sessions and answered the questionnaire. For each participant the data consists of 30 epochs (150 ms pre-stimulus to 700 ms post-stimulus) per session. For each participant the 30 epochs of each session were averaged per each channel. The eight averaged channels for each subject per session (speller and narrative) where manually inspected to identify P300 occurrences.

In the spelling session, a P300 ERP was detected in 10 subjects in at least one channel. In the interactive narrative session, the ERP was also detected in 10 subjects in at least one channel (although not necessarily the same channels). 5 subjects had P300 ERP occurrences in both the spelling and interactive narrative sessions, while in 5 subjects there were no P300 ERPs detected in any session. The single channel with most P300 occurrences was Cz with 13 subjects, of which 10 were in the spelling session and 8 in the narrative session, given that 5 were in both sessions. Therefore this channel was chosen to compare the results from both sessions. Because we wanted to perform an equivalent grand average (across subjects) in channel Cz for each session, data from two subjects of the spelling session in that channel was eliminated (see figure 3).

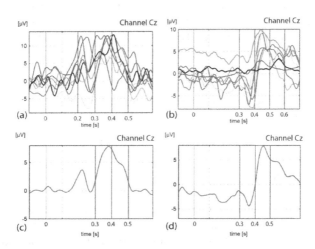

Fig. 3. P300 recordings for electrode Cz in both sessions (see explanations in the text)

Figure 3a and 3b show the P300 waveform in channel Cz for the eight subjects in the spelling and the narrative condition respectively. Figures 3c and 3d show the

grand average for each session with the selected subjects. Regarding the results of the questionnaire, 18 test participants indicated to have perceived a story from the interactive narrative. However, only 5 subjects reported that the story felt complete.

9 Discussion

An inspection of the overlapped waveforms of the 8 subjects for each session show on the one hand a similarity of shapes across subjects within one session, and on the other a difference in shape between the two sessions. It is possible to appreciate that the two classes of events are diverse in amplitude and latency. The P300 components in the narrative experience occur later than in the spelling exercise, with a latency for the highest peaks in the range of 450-500 ms, and with amplitudes under 10 μV (micro volts) (see figure 3b). In the spelling session it can be seen that the highest peaks occur between 280-400 ms with amplitudes above 10 μV (see figure 3a). These differences are also somehow noticeable in the grand average waveforms of both sessions. The grand average for the narrative session shows a negative voltage deflection around 0.35 ms with an amplitude of - 4 μV, followed by the positive peak at 0.45 ms with an amplitude of 10 μV (see figure 3d). The grand average for the spelling session, on the other hand, shows a negative voltage deflection around 0.28 ms with the amplitude at the 0 μV line, followed by the P300 peak at 0.38 ms, also with an amplitude of 10 μV.

Although both cognitive tasks are related to expectancy, these noticeable differences in the two types of P300-ERP components may be related to the context of each task and the particular kind of expectancy that each involves. The lack of closure reported by most subjects in the questionnaires may be a consequence of the constraint of having to repeat equivalent events, which poses a problem in the creation of a more coherent interactive narrative. However, most subjects manifested to have had the feeling of being exposed to some sort of story. Therefore it can be said that the kind of expectancy that we implemented in the "treasure hunt" logic can be related to the building of suspense/surprise which contributed to the reception of a narrative. This leads us to speculate that the more accurate the kind of expectancy involved in narrative suspense/surprise is implemented in the interactive narrative, the more idiosyncratic its P300 will become.

10 Conclusions

Although the number of subjects with occurrences of P300 in at least one channel was the same in both sessions (spelling and narrative), it is not possible to conclude that both cognitive tasks were equivalent in nature and that therefore one could derive a generic template from one task that could be expected (or used) in another task, which elicits some sort of P300. It is foreseeable in the near future that signal processing and machine learning techniques will allow for reliable detection of ERPs in single events without the need of averaging procedures. This will greatly aid the investigations of user experience in interactive narrative systems. However, these methods will always

require a sound benchmarking and previous characterizations in order to obtain accurate templates to be used by the detecting classifiers in order to maintain the singularity of the particular process under study. Therefore, further research and theory is needed in order to identify and characterize the cognitive processes, features and parameters in the interaction with narrative systems that are amenable to be investigated with these methods. This would then allow harvesting from the vast growing body of ERP research, and to identify the relevant ERP paradigms that correlate to these processes. The idiosyncratic effects given by the singularity of individuals and by exogenous factors inherent to the events should also be considered at the highest level possible when defining, theorizing and characterizing the key processes involved in our interactions with narratives. These processes will require the fine-tuning of highly specific ERPs in order to delineate strategies that do not overly reduce the correlation of "high" level narrative processes to generic kinds of ERPs in our investigations of user experience in interactive narratives and storytelling.

References

1. Vecchiato, G., Astolfi, L., Tabarrini, A., Salinari, S., Mattia, D., Cincotti, F., Bianchi, L., Sorrentino, D., Aloise, F., Soranzo, R., Babiloni, F.: EEG Analysis of the Brain Activity during the Observation of Commercial, Political, or Public Service Announcements. Computational Intelligence and Neuroscience (2010)
2. Ravaja, N.: Contributions of Psychophysiology to Media Research: Review and Recommendations. Media Psychology, 193-235 (2004)
3. Ganglbauer, E., Schrammel, J., Deutsch, S., Tscheligi, M.: Applying psychophysiological methods for measuring user experience: possibilities, challenges and feasibility. In: User Experience Evaluation Methods in Product Development (UXEM 2009) (2009)
4. Kivikangas, J.M., Ekman, I., Chanel, G., Järvelä, S., Salminen, M., Cowley, B., Ravaja, N.: Review on psychophysiological methods in game research. In: Proc. of 1st Nordic DiGRA (2010)
5. Ryan, M.-L.: Narratology and Cognitive Science: A Problematic Relation. Style 44(4) (2010)
6. Bruni, L.E., Baceviciute, S.: On the Embedded Cognition of Non-verbal Narratives. Sign Systems Studies (in press)
7. Sanford, A.J., Emmott, C.: Mind, brain and narrative. Cambridge University Press (2012)
8. Speer, N.K., Reynolds, J.R., Swallow, K.M., Zacks, J.M.: Reading Stories Activates Neural Representations of Visual and Motor Experiences. Psychological Science 20(8), 989–999 (2009)
9. Zacks, J.M., Speer, N.K., Swallow, K.M., Maley, C.J.: The brain's cutting-room floor: segmentation of narrative cinema. Frontiers in Human Neuroscience 4, 1–15 (2010)
10. Yarkoni, T., Speer, N.K., Zacks, J.M.: Neural substrates of narrative comprehension and memory. NeuroImage 41, 1408–1425 (2008)
11. Mar, R.A.: The neuropsychology of narrative: story comprehension, story production and their interrelation. Neuropsychologia 42, 1414–1434 (2004)
12. Duncan, C.C., Connolly, R.J.B.J.F., Fischer, C., Michie, P.T., Näätänen, R., Polich, J., Reinvang, I., Van Petten, C.: Event-related potentials in clinical research: guidelines for eliciting, recording, and quantifying mismatch negativity, P300, and N400. Clinical Neurophysiology 120(11), 1883–1908 (2009)

13. McPherson, W.B., Holcomb, P.J.: An electrophysiological investigation of semantic priming with pictures of real objects. Psychophysiology 36, 53–65 (1999)
14. Federmeier, K.D., Kutas, M.: Picture the difference: Electrophysiological investigations of picture processing in the two cerebral hemispheres. Neuropsychologia 40(7), 730–747 (2002)
15. Wu, Y.C., Coulson, S.: Meaningful gestures: Electrophysiological indices of iconic gesture comprehension: Psychophysiology, vol. Psychophysiology 42, 654–667 (2005)
16. Sitnikova, T., Kuperberg, G., Holcomb, P.: Semantic integration in videos of real–world events: An electrophysiological investigation. Psychophysiology 40(1), 160–164 (2003)
17. Chao, L.L., Nielsen-Bohlman, L., Knight, R.T.: Auditory event-related potentials dissociate early and late memory processes. Electroencephalography & Clinical Neurophysiology 96, 157–168 (1995)
18. Cohn, N., Paczynski, M., Holcomb, P., Jackendoff, R., Kuperberg, G.: Comics on the Brain: Structure and Meaning in Sequential Image Comprehension. Psychophysiology 48 (2011)
19. Cohn, N., Paczynski, M., Jackendoff, R., Holcomb, P., Kuperberg, G. (Pea)nuts and bolts of visual narrative: Structure and meaning in sequential image comprehension. Cognitive Psychology 65(1), 1–38 (2012)
20. Batterink, L., Neville, H.: Implicit and explicit mechanisms of word learning in a narrative context: An event-related potential study. Journal of cognitive neuroscience 23(1), 3181–3196 (2011)
21. Baretta, L., Lêda, M.B., Tomitch, N., MacNair, V., Kwan, L., Waldie, K.E.: Inference making while reading narrative and expository texts: an ERP study. Psychology & Neuroscience 2(2), 137–145 (2009)
22. Thierry, G., Martin, C., Gonzalez-Diaz, V., Rezaie, R., Roberts, N., Davis, P.: Event-related potential characterisation of the Shakespearean functional shift in narrative sentence structure. Neuroimage 40(2), 923–931 (2008)
23. Cohn, N.: Visual narrative structure. Cognitive Science 37(3), 413–452 (2013)
24. Nijholt, A.: BCI for games: A 'State of the art' survey. In: Stevens, S.M., Saldamarco, S.J. (eds.) ICEC 2008. LNCS, vol. 5309, pp. 225–228. Springer, Heidelberg (2008)
25. Ryan, M.-L.: Narrative as virtual reality. Johns Hopkins University Press, Baltimore (2001)
26. Cupchik, G.: Suspense and disorientation: Two poles of emotionally charged literary uncertainty. In: Peter Vorderer, Hans J. Wulff, and Mike Friedrichsen (eds.) Conceptualizations, theoretical analyses, and empirical explorations, pp. 189-197. Lawrence Erlbaum Associates, Mahwah (1996)
27. Iwata, Y.: Creating Suspense and Surprise in Short Literary Fiction: A stylistic and narratological approach. University of Birmingham, Birmingham (2009)
28. Chatman, S.B.: Story and discourse: Narrative structure in fiction and film. Cornell University Press, Ithaca (1980)
29. Tan, E., Diteweg, G.: Suspense, predictive inference, and emotion in film viewing. In: Vorderer, P., Wulff, H.J., Friedrichsen, M. (eds.) Conceptualizations, theoretical analyses, and empirical explorations, pp. 149–188. Lawrence Erlbaum Associates, Mahwah (1996)
30. Mikos, L.: The experience of suspense: Between fear and pleasure. In: Vorderer, P., Wulff, H.J., Friedrichsen, M. (eds.) Conceptualizations, theoretical analyses, and empirical explorations, pp. 37–50. Lawrence Erlbaum Associates, Mahwah (1996)
31. de Beaugrande, R.: The story grammar and the grammar of stories. Journal of Pragmatics 6, 383–422 (1982)

32. Carroll, N.: The Philosophy of Horror or Paradoxes of the Heart. Routledge, New York (1990)
33. de Wied, M.: The role of temporal expectancies in the production of film suspense. Poetics 23, 107–123 (1994)
34. Wulff, H.: Suspense and the influence of cataphora on viewers' expectations. In: Vorderer, P., Wulff, H.J., Friedrichsen Conceptualizations, M. (eds.) Theoretical Analyses, and Empirical Explorations, pp. 1–18. Lawrence Erlbaum Associates, Mahwah (1996)
35. Berlyne, D.E.: Conflict, arousal, and curiosity. McGraw-Hill, New York (1960)
36. Fazel-Rezai, R., Ahmad, W.: P300-based Brain-Computer Interface paradigm design. Recent Advances in Brain-Computer Interface Systems, pp. 83–98 (2011)
37. Kutas, M., Hillyard, S.: Reading Senseless Sentences: brain potentials reflect semantic incongruity. Science, 203–205 (1980)
38. Polich, J., Kok, A.: Cognitive and biological determinants of P300: an integrative review. Biological Psychology 41(2), 103–146 (1995)
39. Marathe, A.R., Ries, A.J., McDowell, K.: Sliding HDCA: Single-trial EEG classification to overcome and quantify temporal variability. IEEE Transactions on Neural Systems and Rehabilitation Engineering 22(2), 201–211 (2014)
40. Pernet, C.R., Sajda, P., Rousselet, G.A.: Single-trial analyses: why bother? Frontiers in Psychology 2, 1–2 (2011)
41. Li, K., Raju, V.N., Sankar, R., Arbel, Y., Donchin, E.: Advances and challenges in signal analysis for single trial P300-BCI. Foundations of Augmented Cognition. Directing the Future of Adaptive Systems, pp. 87-94 (2011)
42. Zhang, D., Luo, W., Luo, Y.: Single-trial ERP analysis reveals facial expression category in a three-stage scheme. Brain research 1512 , 78-88 (2013)
43. Quitadamo, L., Cincotti, F., Mattia, D., Cardarilli, G., Marciani, M., Bianchi, L.: Finding the Best Number of Flashes in P300-based BCIs: a Selection-Cost Approach. In: TOBI Workshop 2010, Graz, Austria, p. 54 (2010)
44. Ortner, R., Prückl, R., Putz, V., Bruckner, J.S.M., Schnürer, A., Guger, C.: Accuracy of a P300 Speller for different conditions: A comparison. In: Proc. of 5th Int. BCI Conf. 2011, pp. 196–199 (2011)
45. g.Tec, P300 Spelling Device V2.12.00. g.Tec – medical engineering GmbH, Austria (2012)
46. Gilroy, S.W., Porteous, J., Charles, F., Cavazza, M., Soreq, E., Raz, G., Ikar, L., Or-Borichov, A., Ben-Arie, U., Klovatch, I., Hendler, T.: A brain-computer interface to a plan-based narrative. In: Proceedings of the Twenty-Third international joint conference on Artificial Intelligence, pp. 1997–2005. AAAI Press (2013)

Ontology–Based Visualization
of Characters' Intentions

Vincenzo Lombardo[1] and Antonio Pizzo[2]

[1] CIRMA and Dipartimento di Informatica, Università di Torino
corso Svizzera 185, Torino, Italy
vincenzo.lombardo@unito.it
[2] CIRMA and Dipartimento di Studi Umanistici, Università di Torino
via Sant'Ottavio 20, Torino, Italy
antonio.pizzo@unito.it

Abstract. The visualization of the characters' intentions in a drama is of great importance for scholars and professionals. The characters' intentions provide the motivations for the actions performed in a drama, and support its interpretation. This paper presents an interactive ontology–driven tool for the visualization of a drama analysis based on the mapping between the characters' actions and intentions, respectively. An automatic mapping establishes the correspondence between the actions, distributed on the linear timeline of the drama, and the intentions that motivate such actions, which form a forest of trees, one tree per character, spanning portions of the timeline. A tool provides a graphical representation of such correspondences and an immediate appraisal of the motivations of the actions in terms of tree projections. The system was tested on the analysis of a scene from *Hamlet* and has been employed in support of drama studies and didactics.

Keywords: Drama ontology, tree visualization, intelligent mapping.

1 Introduction

This paper presents a visual interface for improving the access to the drama content through a visualization of the content expressed in terms of the mapping between the characters' intentions and the linear unfolding of the story incidents on a timeline. In particular, the characters' intentions that motivate the incidents are represented by hierarchical plans arranged on trees, one tree per character; plans that commit to short–term goals are components (i.e., children in tree terminology) of plans that commit to longer–term goals.

The visualization of the characters' intentions in a drama is of great importance for scholars and professionals, as the analysis of intentions is one of the most important differences between drama analysis and literary criticism. The system represents the drama elements in an ontological form and implements an automatic mapping between the characters' intentions and actions, respectively, and then visualizes the relationship between the story incidents and the characters' intentions in terms of tree projections. The system has been appraised in

A. Mitchell et al. (Eds.): ICIDS 2014, LNCS 8832, pp. 176–187, 2014.

the analysis of a scene from *Hamlet* and has been employed in support of the drama analysis.

2 Background and Related Work

The applicative scenarios of the visualization of characters' intentions in a drama range from the media production industry, to the preservation of drama as intangible cultural heritage, to drama studies and teaching.

Though the visualization of story relations has been addressed by visual artists and amateurs to provide unique maps for orientation, especially in dramas that are difficult to grasp on behalf of the audience (see, e.g., the visualization of two Nolan's films *Memento*[1], 2000, and *Inception*[2], 2010), on a more productive side, a number of visual interfaces are provided with software tools that have been developed to assist the creation and production of dramas. For example, the writing assistant Dramatica Pro[3] visualizes the building blocks of a plot structure, with diagrams for plot progression and story points, that helps the writer in controlling and balancing the tension within the story development. Some works [14,13], propose the metadata annotation of dramatic heritage items, assuming an ontological approach (ontology called Drammar) to the representation of the drama elements, encoding the widely acknowledged relationship between the drama abstraction and one of the concrete shapes a drama can assume [19, p. xviii]. There exist other approaches that guide the annotation for the formal encoding of the drama elements. The Story Intention Graph [6] relies on the representation of the short–term characters' intentions to build an interpretive layer of a narrative text. This approach is very similar to what we propose in this paper, though missing the long–term relationships of the characters' intentions represented by the hierarchical nature of plans (see below), being oriented to the immediate interpretation of the actions. The Stories ontology[4], developed in collaboration with the BBC for the application in news, the storylines of *Doctor Who* episodes, and historical facts, is an event–(instead of character–) based description of the timeline of story incidents, with no interpretive intents. In both cases, we do not know of a visualization tool for presentation and analysis purposes.

Within the specific domain of drama, we recall a so–called constructivist approach, which departs from the linguistic and literal forms to focus on the constitutive elements of drama. The analyses of Lavandier [12], Ryngaert [20], Hatcher [10], and Spencer [21] distill the dramatic elements that the playwriter has to handle in order to produce a well formed play, relying on the well known vocabulary of dramatic elements, e.g. character, plot, action, deliberation, emotion, conflict [16].

[1] http://visual.ly/memento-scene-timeline
[2] http://visual.ly/inception-timeline-visualisation
[3] http://www.writersstore.com/dramatica-pro-story-development-software/
[4] http://www.contextus.net/stories

In this paper, we build on the Drammar approach: dramatic media are described by representing both the intentions of the characters and the timeline of story incident in a single formal representation. Here we use the word intentions to mean all the complex deliberative construct that guides the character's actions in the drama. With the word timeline, we summarize the temporal deployment of the executed action that will be experienced by the audience. Later in the paper, we show how, to be formally represented, these two notions forth a number of different features in our ontology. The challenges posed by the visualization concern the display of a timeline, with a fixed order of the component of incidents, and the superimposition of a number of trees that represent the characters' intentions. However, incidents and intentions should be aligned to reveal the structure of motivations that holds the plot.

3 Ontology Representation of Story Metadata

The notion of "story" is widely acknowledged to be a construction of an incident sequence that, abstracting from the mise–en–scène properties, is motivated by the cause–effect chain [18]; this chain results from a complex interplay among agents and events, well known in playwriting techniques [5]. In this section, we introduce the ontology Drammar, taking as a running example *Hamlet*. In particular, we address the "nunnery" scene in the Third Act, where Ophelia is sent to Hamlet by Polonius (her father) and Claudius (Hamlet's uncle) to confirm the assumption that the Prince's madness is caused by his rejected love. According to the two conspirers, Ophelia should induce him to talk about his inner feelings. At the same time, Hamlet tries to convince Ophelia that the court is corrupted and she should go to a nunnery. In the middle of the scene Hamlet puts Ophelia on a test to verify her honesty. Because he guesses (correctly) that the two conspirers are hidden behind the curtain, he asks the girl to reveal where her father Polonius is. She decides to lie and replies that he is at home. As a consequence, Hamlet becomes very angry in realizing that even Ophelia is corrupted and there is no hope to redeem the court.

The ontology Drammar (encoded in the OWL2 RL language) has been designed with the twofold goal of providing a formalized conceptual model of the dramatic elements [2,13,14], and an annotation schema for encoding the description of a dramatic item. So, along with classes that represent the domain of drama, it contains specific classes that are intended for interfacing the representation of drama with linguistic and common sense knowledge. The main classes of Drammar are: DramaEntity, grouping all the elements that belong to the drama domain, including the structural elements; Description Template, containing all the patterns for encoding linguistic schemata; External Reference, bridging the core elements of the ontology onto the external knowledge bases that allow the description of instantiated drama. Each class has then a number of subclasses; here we will describe the most relevant for the scope of this paper. The Drama Entity class is divided into three subclasses, each describing specific drama elements. Drama Perdurant and Drama Endurant represent, respectively,

the processes that occur in drama, and the entities (characters and objects) that participate in them. **Drama Structure** subsumes specific classes for representing the structures of the story, which include sequential structures (**DramaList**), such as plans of the agents and timelines of incidents, and set structures (**DramaSet**), such as units, which group the incidents occurring in a specific story fragment. The **Timeline** class represents the indexing of units along time, while the **Plan** class encompasses the agents' intentions, and is organized hierarchically. The former accounts for the linear ordering of units as determined identifying intuitively the boundaries of the actions, the latter accounts for the intentions of the characters that motivate the actions occurring in the units. The **DramaEndurant** class subsumes the story entities participating in the unit, namely **Agent** (representing the characters that intentionally act in the incidents), and **Object** (any entity that is relevant to the action and does not have goals). The **Drama Perdurant** class provides the elements for the story dynamics, namely processes and states (subclasses **Process** and **State**, respectively), subdivided into *eventive* and *factual*, following a tradition dating back to 1927 [17]. The **EventiveProcess** class refers to what we have so far called incidents, and includes intentional and unintentional processes (**Action** and **UnintentionalEP** respectively) that occur in units or are committed in plans (**ActionInUnit** and **ActionInPlan**). The **EventiveState** class is divided into **StateOfAffairs**, **MentalState**, and **Done**; the latter class includes those states that represent the completions of processes. Mental states describe the intentional behavior of agents [7]; they encompass the following classes: **Belief**: the agent's subjective view of the world; **Emotion**: what the agent feels; **Goal**: the objectives that motivate the actions of the agents and help to describe the character's dramatic intention; **Value**: the moral values acknowledged by an agent; values can be put at stake by the unfolding of the story (specific class **ValueAtStake**).

The **Description Template** class has the purpose of binding a situation (e.g. either a process or a state) to its linguistic description. Each situation in Drammar is described by a template (linked to external knowledge repository - see next paragraph) that will provide an explicit shared pattern: for example, the process of *eating* will be univocally described as the relation between, at least, two entities (the eater and the eaten). The subclasses, namely **Schema** and **Role**, provide the primitives needed to realize this description. The **Schema** class represents the description of the situation in terms of the roles involved in it (i.e. the eating process[5]). In order to map the participant entities (i.e. the role eater and the role eaten), the class **Schema** is related to the **Role** class via the **hasRole** property.

The **ExternalReference** class is aimed at representing the qualities needed to describe specific drama entities. Following the paradigm of linked data [11], each different value of a quality is referred via an IRI (Internationalized Resource Identifiers)[6] pointing to some external common sense or domain

[5] See the Situation Description ontology pattern [8].

[6] The IRI is a generalization of the uniform resource identifier (URI), that extends the string of characters used to identify a name of a resource from ASCII to Unicode.

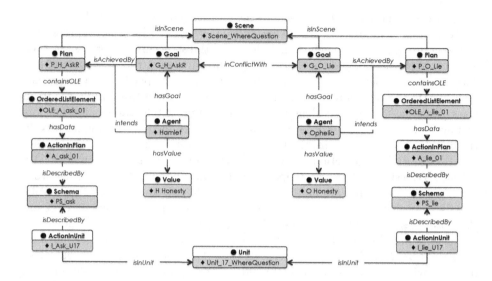

Fig. 1. The annotation of the example scene. Hamlet asks to Ophelia where her father is, and she answers with a lie.

specific ontology. [3] presents the linguistic interface for the annotation of linguistic schemata and commonsense knowledge information (involving the FrameNet roles and linguistic frames [1] and YAGO–SUMO commonsense ontology [4]). In Fig. 1, we illustrate how our running example, the "nunnery" scene, is represented in Drammar conceptual terms. The scene (Scene_WhereQuestion, see top of Fig. 1) encompasses the conflicting goals of Hamlet and Ophelia (G_H_AskR and G_O_Lie respectively), and the plans they have devised to achieve them (P_H_AskR and P_O_Lie), to which they are committed (i.e., that they intend, as expressed by the intends property). Both agents care for the value of honesty (O_Honesty and H_Honesty). Here, we show only the plan-related individuals that are relevant to the excerpt. Hamlet's plan contains the action of asking (A_ask_01, OLE_A_ask_01); Ophelia's plan contains the action of lying (O_lie_01, OLE_O_lie_01). The same schema, PS_ask, describes both Hamlet's action of asking in the unit and the corresponding action committed to by the plan; the same holds for Ophelia's planned and executed actions, both described by the schema PS_lie. Hamlet's and Ophelia's executed actions belong to the same unit (i.e., the basic container of the actions of the drama), Unit_17_WhereQuestion, to which they are linked through the isInUnit property. The unit (Unit-_WhereQuestion) is positioned in the Timeline of the "nunnery" scene (TL_-Hamlet_Nunnery). The ordering is provided by the precedes property: for example, the element that "stands for" the Unit_WhereQuestion is preceded by the recommendation that Hamlet provides to Ophelia to go to a nunnery and precedes Hamlet's outburst.

4 Mapping and Visualization

In this section, we focus on the core phases of mapping and visualization. Mapping is the intelligent phase that connects the plans and the incidents, by taking into account the coincident actions and the states that hold as preconditions and effects of the plans; visualization then takes into account the correspondences and provides a diagram that informs about the dramatic qualities.

4.1 Mapping

In the Drammar approach, the incidents in the units of the timeline are viewed as operators that carry on the story development from one state to the next one; states are projected from the plan structure onto the timeline, connecting the motivations (goals and plans intended by the characters) to the actions actually carried out. The projections of states onto the timeline and the connection of plans to incidents are yielded by if–then rules (encoded in SWRL language).[7] The rules aim at detecting the matching of the actions (incidents) occurring in the unit and the actions in plans, according to some shared properties of the linguistic schemata.[8] The automatization of the mapping corresponds to a workflow in which some scholar or enthusiast annotates a timeline of units and incidents and a drama scholar operates independently by identifying the characters' intentions, encoded in plans and goals; then, the SWRL rule finds what intentions match with what incidents, to augment the annotation and form the base for the visualization. In particular, the application of such rules aligns Plans and Units and augments the Timeline by interspersing units with precondition and effect states (called UnitStates).

The mapping works as follows (see Fig. 2):

- match plan actions and unit incidents through the equality of the description schema in the antecedent of the rule (see curved dotted line "mapping" in Fig. 2); in the antecedent the rule also identifies the individuals to be connected in the consequent part;
- project the states required by the plan as preconditions or effects, the plan states, onto the unit preconditions and effects, the unit states (see curved dotted lines "hasSetMember" and "spans" in Fig. 2) .

The ontology is initialized with the Timeline that includes empty unit states that precede and follow the units. Then, each application of the rule fills the

[7] If–then rules, combined with ontological description, allow the derivation of novel knowledge through the form of an implication between an antecedent (body) and consequent (head). In particular, the Semantic Web Rule Language (SWRL) is the language born form the merge of Rule ML and OWL DL, that integrates OWL with a rule layer built on top of it, adding the possibility to declare arbitrary Horn clauses expressed as if–then rules.

[8] The current implementation is based on simple operations, such as the exact equality of the linguistic frame, but it may potentially based on more complex algorithms for the computation of similarity indices.

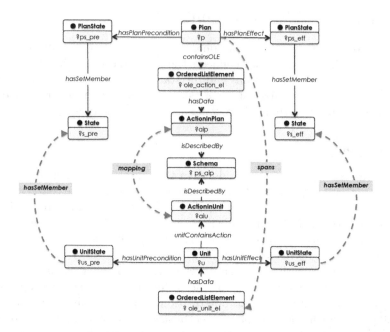

Fig. 2. The main mapping rule, that accounts for the spanning relation between plans and units. Another rule accounts for the spanning of hierarchically higher plans with a number of units.

unit states with states contained in the plans. In the excerpt of the "nunnery" scene, we have Hamlet's plan P_H_AskR and its action A_ask_01 mapped onto the action I_Ask_U17 (Hamlet asking Ophelia: "Where is your father?") of the Unit_17_WhereQuestion; the same happens for Ophelia's plan P_O_Lie, between the action A_lie_01 and the unit action I_lie_U17 (Ophelia lying about Polonius' location: "At home, my lord."). The higher plan P_H_LearningHonesty (Hamlet) is then triggered because of the mapping of the subplan P_H_AskR, though the latter fails in achieving its goal (see the visualization below).

4.2 Visualization

The visualization module addresses the representation of multiple trees of characters' plans, arranged hierarchically on a tree that spans a timeline of events. Tree layout, especially in the case of multiple trees spanning the same set of basic elements (usually the leaves of a tree) has been the object of several approaches of information visualization (see the survey in [9] on single and multiple trees); each approach brings specific advantages and disadvantages, depending on the task at hand. We have implemented a form of containment (or nested) approach, which has the advantage of a bounded space; this approach typically leaves no room for node content, but in our system this content is retrievable through mouse interaction on the node.

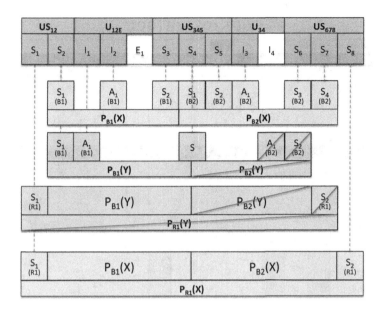

Fig. 3. General schema of the visualization: top) timeline, made of units U (made of incidents I and E) and unit states US (made of states S projected from plans P); bottom) agents' plans, made of actions A and states S aligned with unit incidents I and states S, respectively. Notice that two incidents were not matched by the plans actions.

The multiplicity of trees is visualized as different layers. The abstract structure of visualization is in Fig. 3. In the top row there is the Timeline, consisting of units (U) and unit states (US). Units are made of incidents, which can be either intentional actions (I), so mapped to actions in agents' plans, or unintentional events (E). Unit states are collections of single states, which are retrieved from the agents' plans and projected onto the timeline. Unintentional events and unmapped intentional incidents are filled in white. In the lower part of the figure we visualize the plans of the agents, arranged hierarchically (root at the bottom). X and Y are the agents that commit to the plans; S is a state and A is an action. Plans closer to the timeline consist of an action bordered by precondition and effect states, respectively; plans higher in the hierarchy consists of a sequence of subplans bordered again by precondition and effect states. All actions and states are mapped onto the timeline (dotted lines in the figure). Each incident or state is represented by a box; boxes filled with white color and barred diagonally indicates elements that have not been realized in the timeline, thus the plan failed.

The visualization algorithm proceeds left to right by following the mapping between incidents and plan actions. It assumes the timeline distribution of the states and incidents over the x axis as fixed and aligns the plan actions and consequently the precondition and effect states as a consequence. The plan hierarchy

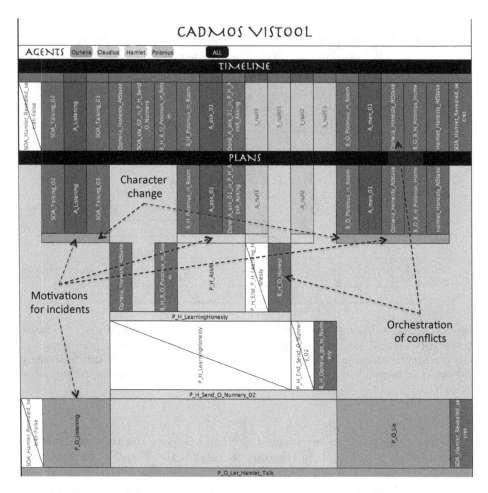

Fig. 4. Screenshot of the visualization - excerpt of *Hamlet* "nunnery" scene incident represented in Fig. 1. In overlay, the characterizations of different interesting phenomena for drama visualization (see text).

is built downwards, so higher layers will be lower in the visualization. Each agent features a color, which is declared in the agents' area with a clickable button. All the plans of an agent are displayed with the agent's color. The timeline incidents pivot the horizontal alignment: each realized plan action is aligned with the matching timeline incident; at the same time, states of the plans are projected onto the timeline to fill the unit states between adjacent units. The plan is a horizontal box that spans all the states and actions that belong to it. Fig. 4 shows the visualization of the motivations of the excerpt of the "nunnery" scene incident represented in Fig. 1. The content of a box appears in a text within a balloon when the mouse goes over the box. The current working implementation

of the visualization tool is in D3[9], after a preprocessing phase made in Processing[10], which also produces a static image. These double implementation and exit was adopted after we realized that the visualization was very slow when the diagram had a relevant size (e.g., the whole "nunnery" scene). The current D3 visualization adapts to our case the "zoomable icicle" solution[11] that provides some interesting interactivity features for zooming on a specific area of the scene and displaying tooltips for having a synoptic view while accessing the content.

5 Effectiveness of the Interface

Now we address the use of the interface in the experience of teaching drama to students by quickly fleshing out interesting aspects of the drama. In the last decades, the drama courses focus moved from literary to structural and actional qualities. This means that the text is more and more intended both as an incident design (either on stage or on screen) and as a network of relations over agents' intentions. For example, McKee [15] guides the author through the scene splitting into beats according to the characters' goals and value changes. This leads to a larger use of visualization systems to clearly stress the structural elements in the dramatic text, and to map the connection with the performance, i.e., to show the continuity between event design and event performance. For example the drama map provided by the ReadWriteThink website allows the students to focus on the elements of the drama posing key questions about the conflict's structure.[12]

Our visualization helps the class to understand how the text of the dramatic medium is bound to the character's deliberation, and thus how to read the *characters' behaviors*. For example, the more successful the mappings, the more the narrative text of the dramatic medium is bound to characters' deliberation (i.e. the performance is consistent with the play). Therefore, our system can be used as a qualitative evaluation tool both in teaching drama authoring and in drama analysis. In Fig. 4 we propose a schema of how to interpret the actual visualization of an annotated example, and we highlight three examples of how our system can visualize some key features of drama.

Motivation for Incidents. In drama, it is important that the character's plans show some consistency with the incidents that occur in the sequence of events. This is the fundamental feature that gives to the audience the perception of a logical sequencing of action, thus helps to create the believability of the story in terms of consistent list of incidents within the units. In our visualization, the list of incidents is grounded on the perceived behaviors of the agents involved. In other words, it is graphically clear how the action of asking (where Polonius is) is motivated by Hamlet's plan of learning about Ophelia'shonesty.

[9] http://d3js.org/
[10] http://processing.org/
[11] http://bl.ocks.org/mbostock/1005873
[12] http://www.readwritethink.org/classroom-resources/student-interactives/drama-30012.html?tab=2#tabs

Orchestration of Conflicts. Normally the units listed in the timeline are the results of the synchronous occurrence of two agents' plans (such as the ones by Hamlet and Ophelia in the "nunnery" scene). We adopt a visualization that shows a layer of parallel plans that map onto the same chunk of the timeline. When the two plans have a similar goal, they both aim at the same effect: thus, they map the same final state onto the timeline, and are described as a shared plan. Our visualization piles up different plans with opposite goals. When this occurs, very often it means that only one plan will achieve its goal and thus only one state is mapped onto the timeline. In Fig. 4, we see that plan P_H_LearningHonesty and plan P_O_Lie lead to conflicting states, Ophelia honesty at stake and Hamlet believes Ophelia is honest (B_H_B_O), but the latter state is not realized (null box in the Timeline).

Change. Drama is not reality but the essence of reality [5]; hence the actions are selected to give the sense of intensity and meaningfulness. Within this framework, any kind of failure bears some sort of change in the character (beside other opportunities in the story development). For example, in the "nunnery" scene, the failure of the Hamlet's plan is a clear indication of the *characters' change*. The sequence of null states and actions in the timeline in the Fig. 4 is a clear visualization of Hamlet's plans failures.

6 Conclusion

This paper has presented an approach to the mapping of the characters' intentions onto actions and the visualization of such information. Character's intentions form multiple trees that span a timeline of incidents. The system is able to build the mapping between a library of plans and the timeline of incidents, and to visualize the contributions of the several characters' intentions to the whole plot.

The system relies on an ontology of drama and builds upon the unrestricted annotation provided by narrative enthusiasts and media students. The system was tested on the analysis and exposition of the case of a short classical scene in *Hamlet* in drama studies teaching and analysis. Though oriented and tested to the didactics of drama structure, our system can be applied to the analysis of news stories, blog entries, or the fruition of cultural heritage. Other significant features should be added to the visualization, namely the Dramatic Arc and a dynamic/interactive construction of the mapping.

References

1. Baker, C.F., Fillmore, C.J., Lowe, J.B.: The berkeley FrameNet project. In: Proceedings of the 36th Annual Meeting of the Association for Computational Linguistics and 17th International Conference on Computational Linguistics, ACL 1998, vol. 1, pp. 86–90. Association for Computational Linguistics, Stroudsburg (1998)

2. Cataldi, M., Damiano, R., Lombardo, V., Pizzo, A.: Representing dramatic features of stories through an ontological model. In: Si, M., Thue, D., André, E., Lester, J.C., Tanenbaum, J., Zammitto, V. (eds.) ICIDS 2011. LNCS, vol. 7069, pp. 122–127. Springer, Heidelberg (2011)
3. Cataldi, M., Damiano, R., Lombardo, V., Pizzo, A.: Lexical mediation for ontology-based annotation of multimedia. In: Oltramari, A., Vossen, P., Qin, L., Hovy, E. (eds.) New Trends of Research in Ontologies and Lexical Resources. Theory and Applications of Natural Language Processing Series, Springer (2012)
4. De Melo, G., Suchanek, F., Pease, A.: Integrating yago into the suggested upper merged ontology. In: 20th IEEE International Conference on Tools with Artificial Intelligence, ICTAI 2008, vol. 1, pp. 190–193. IEEE (2008)
5. Egri, L.: The Art of Dramatic Writing. Simon and Schuster, New York (1946)
6. Elson, D.K.: Dramabank: Annotating agency in narrative discourse. In: Proceedings of the Eighth International Conference on Language Resources and Evaluation (LREC 2012), Istanbul, Turkey, pp. 2813–2819 (2012)
7. Ferrario, R., Oltramari, A.: Towards a computational ontology of mind. In: Varzi, A.C., Vieu, L. (eds.) Proceedings of the International Conference FOIS 2004, Torino, Italy, pp. 287–297 (2004)
8. Gangemi, A., Presutti, V.: Ontology design patterns. Handbook on Ontologies, pp. 221–243 (2009)
9. Graham, M., Kennedy, J.B.: A survey of multiple tree visualisation. Information Visualization 9(4), 235–252 (2010)
10. Hatcher, J.: The Art and Craft of Playwriting. Story Press, Cincinnati (1996)
11. Heath, T., Bizer, C.: Linked data: Evolving the web into a global data space. Synthesis Lectures on the Semantic Web: Theory and Technology, pp. 1–136 (2011)
12. Lavandier, Y.: La dramaturgie. Le clown et l'enfant, Cergy (1994)
13. Lombardo, V., Pizzo, A.: Ontologies for the metadata annotation of stories. In: Digital Heritage International Congress (Digital Heritage), vol. 2, pp. 153–160. ACM, IEEE, Marseille (2013)
14. Lombardo, V., Pizzo, A.: Multimedia tool suite for the visualization of drama heritage metadata. Multimedia Tools and Applications, pp. 1–32 (2014)
15. McKee, R.: Story. Harper Collins, New York (1997)
16. Pizzo, A.: Neodrammatico digitale. Scena multimediale e racconto interattivo. Mimesis Journal Books, Accademia University Press (2013)
17. Ramsey, F.P., Moore, G.E.: Symposium: Facts and propositions. Proceedings of the Aristotelian Society, Supplementary Volumes 7, 153–206 (1927)
18. Rimmon-Kenan, S.: Narrative Fiction: Contemporary Poetics. Routledge (1983)
19. Ryan, M.: Avatars of Story. University of Minnesota Press (2006)
20. Ryngaert, J., Bergez, D.: Introduction à l'analyse du théâtre. Collection Cursus. Série Littérature, Armand Colin (2008)
21. Spencer, S.: The Playwright's Guidebook: An Insightful Primer on the Art of Dramatic Writing. Faber & Faber (2002)

Interactive Storytelling in a Mixed Reality Environment: How Does Sound Design and Users' Preknowledge of the Background Story Influence the User Experience?

Marija Nakevska, Mathias Funk, Jun Hu, Berry Eggen,
and Matthias Rauterberg

Department of Industrial Design, Eindhoven University of Technology,
P.O. Box 513, 5600 MB Eindhoven, The Netherlands
{m.nakevska,m.funk,j.hu,j.h.eggen,g.w.m.rauterberg}@tue.nl

Abstract. Interactive storytelling in a mixed reality environment merges real and virtual worlds, and physically immerses the participant in a narrative. The participant is engaged to participate in an exploratory experience, which is influenced by personal and situational factors. We used three stages from the ALICE installation to investigate the effects of sound design and participants' preknowledge of the background story. The study was carried out with 60 participants and the results show that immersiveness (presence) is influenced by both factors. Furthermore we discuss the user experience through observations and information gathered in interview sessions.

Keywords: interactive storytelling, user experience, mixed reality.

1 Introduction

Interactive storytelling in a mixed reality environment merges digital and physical information and features. The participants are engaged in an interaction taking place in a real physical environment that does not involve direct use of a computer and interaction devices. We use the first three stages from the ALICE installation [1], to explore the challenges in designing an interactive narrative in mixed reality. The ALICE installation consists of six consecutive stages, creating an experience based on selected parts from the novel "Alice's Adventures in Wonderland" by L. Carroll [3]. In this paper we present the technical and storytelling mechanisms in the ALICE project, and the implemented sound design. Dow [5] refers to embodied narrative engagement as a combination of: the feeling of being in a story world (presence), the feeling of empowerment over unfolding events (agency), and the feeling of being caught up in the plot and characters of a story (dramatic involvement). We study the effects of sound design and participant's preknowledge of the narrative on the feelings of presence.

Sound Design. The film industry has recognized the importance of sound and has developed techniques for producing sound that allows the audience to

A. Mitchell et al. (Eds.): ICIDS 2014, LNCS 8832, pp. 188–195, 2014.

feel immersed. There are several types of sound used in the entertainment industry: speech, sound effects and music [8]. Speech and dialog convey clear messages, usually from characters or an off-screen narrator. Sound effects are the sounds that result of events in the physical world. Ambient sound creates a sense of physical presence that can set the basic mood, and can communicate emotions and tension. Music can be used to set the basic mood, to induce feelings, or to encourage activity; it can create tension, expectation, and suspension. Music and sound effects can convey semantics in a very universal way as the participants often can immediately relate to familiar music, which greatly enhances the experience and creates a sense of recognition and presence. We investigate how an elaborate sound design with music and ambient sound (effects) can affect the user experience in a mixed-reality environment like the ALICE installation.

Preknowledge of the Background Story. The participant should be intrinsically motivated to keep participating in the exploratory experience in the ALICE installation. The background story increases the participants' familiarity with the characters, context, and environment, and ultimately helps them quickly understand the designed story. Each participant has different preknowledge of the background story as they might have seen movies, played games, or visited attractions that are inspired by the narrative "Alice's adventures in Wonderland" [3]. We investigate the practical implications that are coming from different preknowledge of the background story and to which extent different preknowledge will affect the participants' experience.

Related Work. The importance of sound in media like film, theater and video games is well recognized. Many projects show that sound based games give more freedom in movement and the users have rich and immersive experiences [6,9]. The interactive storytelling community also recognizes the importance of sound design to enrich the interactive narrative experience [7,2]. A number of research projects report on sound and audio's ability to create rich, strong and immersive experiences in mixed and virtual reality [9,11]; also that music is able to increase or decrease immersion depending on the choice of music and suggests that music could be an important factor in the perception of time whilst playing video games. The effects of pre-game stories on the feeling of presence and evaluation of computer games is empirically demonstrated [10,12]. However, there is a lack of empirical research that will explain the user experience in an interactive storytelling in mixed reality environment.

Overview and Hypothesis. A between-groups, two-by-two factor design was employed with the two factors being the *sound design* and the participants' *preknowledge* of the narrative. We expect that the enhanced sound design and richer preknowledge of the narrative both to increase the feelings of spatial presence and the experience to be evaluated more positively. In the remainder of the paper, we present the experimental setup with the statistical results, interviewing data and discussion, resulting in several conclusions summarized in the last section.

2 Experiment

2.1 The ALICE Project and Installation

In this experiment, we focus on the first three stages of the ALICE installation. We designed two different sound conditions: (1) AMSS–a sound scape that consists of ambient sound effects, music, and speech (for all three stages); (2) SS–a sound scape without ambient sound effects and music, but with speech (only in the first stage). In the following, we describe the design of each stage with the implemented sound scape.

Fig. 1. *Stage-1 "In the park"* and *Stage-2 "Down the rabbit hole"* (a) *Stage-1*, with the printed canvas and artificial arrangements and "rabbit hole" in the left back corner (b) "Moving grass" prototypes (c) the projected VR rabbit

Stage-1: "In the Park". The first scene of Carrolls original book is represented in stage 1: *Alice is bored [...] Her curiosity is triggered by white rabbit which runs, looking at its pocket watch and cries out "Oh dear! Oh Dear! I shall be late!"*. The spatial setting represents a park environment, a picture from nature depicted on a printed canvas and artificial arrangements, see Fig. 1(a). In the left back corner is the "rabbit hole", the entrance of the rabbit hole is closed with a curtain, attached with electrical magnets. The white Rabbit "running" in the scene is simulated as movements in artificial grass (implementing using vibration motors) and virtual projections, see Fig. 1 (b) and (c). After the rabbit "runs" through the scene, the entrance of the "rabbit hole" is opened (by deactivating the magnets) and a light points to a seat that is mounted on a rail (Fig. 2 (c)). The sound scape was different for the two sound conditions: (1) Ambient sound and music (AMSS)–The ambient sound in *Stage-1* consists of nature ambiance and singing birds combined with pleasant piano music. Next to the "rabbit hole", a pressure sensor is positioned to detect if the participant walks too close by. If this happens before the rabbit is shown on the scene, the "grass module" that is close to the entrance is moved, ambient sound featuring crows and dramatic piano music. However, when the participant is expected to continue in the next stage, the ambient sound fades out from *Stage-1*, while a "wind" sound starts

from *Stage-2*. If the participant does not enter the second stage within three minutes, an inviting "fantasy" piano sound is played from direction of *Stage-2*. (2) Speech (SS)–An ambient sound or music is not included. If the participant does not enter the "rabbit hole" after the rabbit runs in the scene she is invited with one of several pre-recorded samples, e.g., *"Come on, follow me!"* or *"In the left corner, follow me!"*, played randomly every 3 minutes until the participant decides to go further.

Fig. 2. *Stage-2 "Down the rabbit hole"* (a) *Stage -2*, the "rabbit hole" with bookshelves and lighting (b) The electronic seat and the security gate in the background

Stage-2: "Down the Rabbit Hole". The second stage is the point where "the journey begins", and return to the pleasant and safe "park" environment is blocked. When entering the "rabbit hole", the participant finds a seat that is mounted on a rail (Fig. 2 (b)), a security gate closes the physical entrance to keep the participant safe. When the participant is safely seated, the security gate opens and the seat starts moving downwards slowly. The "rabbit hole" is a vertical cylindrical room that is decorated with bookshelves, lamps, clocks and old-fashioned objects (Fig. 2 (a)). The lamps are gradually dimmed one by one, as the the participant passes them. At the bottom of the rabbit hole is a corridor that leads to the next stage.

In this second stage there is no sound for the SS condition, only for the AMSS condition: Music is composed for each part of this ride, directly matched to the participant's ride. The sound scape was designed as a mixture of fantasy and mysterious music, and incorporates sound effects from the physical objects, such as electricity from the lighting or ticking clocks.

Stage-3: "Shrinking and Growing". The third stage is associated with the perception of personal space and the changing thereof in relation to the environment. After the participant enters, a sliding door behind her closes and she is trapped. This stage is implemented as a CAVE [4] with five side projections. Each side of the CAVE shows one projected door (see Fig. 3 (c)), however, only one VR door is shinny white and smaller than the others, (Fig. 3(a) and (b)). On a table in the middle of the CAVE, a box is placed, which is labeled "eat me" and

Fig. 3. Stage-3 "Shrinking and growing": (a) VR small white door, (b) opening of the door and view on the garden, (c) one of the VR doors projected on one of the other four sides, (d) bottle "Drink me", cookie box "Eat me"

next to it a bottle labeled "drink me" (see Fig. 3(d)): the box detects with an IR sensor when the participant takes a cookie from the box, while the bottle detects with a tilt sensor when the participant drinks from the bottle (reacting on tilting angle). Eating or drinking triggers the projected room to become bigger, creating a feeling of getting smaller. A second action (eat or drink) afterwards lets the room become smaller. The floor of the CAVE is covered with pressure sensors. If the participant approaches the door where she should be able to exit the room, the virtual door will open and a beautiful garden will be shown, see Fig. 3 (b). If she goes away from there, the door will be closed, see Fig. 3 (a).

Similar to Stage 2, in the third stage there is no sound for the SS condition, only for the AMSS condition: Each activation of a pressure sensor on the CAVE floor is manifested as a cracking sound. The cracking sounds are different depending on the previously taken actions, if the participant is "big", the cracking sound of the floor is heavier, and vise versa, if "small" the cracking sounds are more short and light.The ambient sound is composed by fantasy music and the sound of water drops. Also the "water drop" sound has different echo depending on the relative size of the room (and the participant).

2.2 Procedure and Participants

The experiment was advertised as "an experience in a designed environment". Participants were introduced to *Stage 1* and instructed to "explore and have fun". Information about the consecutive spaces was not given. Each of the participants experienced Stage 1, 2, and 3 with just one of the sound conditions (AMSS or SS). Immediately after the experience, the participants completed several questionnaires and were interviewed by the experimenter. The duration of each session was approximately 45-60 minutes, including briefing and instructions (5-7 min.), experience in the installation (15-30 min.), filling out the questionnaires (10-15 min.) and the closing interview (5-10 min.). Sixty participants joined the study, from 18 to 39 years old (26 male, 37 female, mean age 25, SD = 4), of which 29 were in the AMSS condition and 31 in the SS condition. All participants received an incentive of 10 euros for their participation.

2.3 Measurements

We used the MEC–Spatial Presence Questionnaire [13], which consists of several scales that measure different dimensions of spatial presence. This instrument assesses nine constructs associated with spatial presence, from which we included: attention allocation, self location, possible actions, higher cognitive involvement, and suspension of disbelief. The items were adapted to refer to *story* as a mediated environment instead of "environment of presentation" in the original questionnaire.

The participants were asked to rate their preknowledge of the background story: *How familiar they are with the story "Alice's Adventures in Wonderland"; the characters and events and the character of Alice.* Also, whether they *have watched any movies, played games or have other experience inspired or related to the story "Alice's Adventures in Wonderland".* After the survey, the participants were asked to share their experiences within the environment in a semi-structured interview, and to think about possible improvements.

3 Results

Six participants withdrew from the experiment, and five participants were excluded from the data analysis because there were technical problems during their experimental sessions. From the participants who withdrew, four were afraid to continue in *Stage 2* because it seemed too dark, and two failed to discover the rest of the story. In summary, we analyzed the data from 49 participants as shown in the following: Based on the data regarding the preknowledge of the background story we could divide the participants into two groups: (a) participants that have high preknowledge of the background story (HPKS) and (b) participants that have low preknowledge of the background story (LPKS). The number of participants per conditions are presented in Table 1.

A two-way ANOVA of sound design conditions (AMSS, SS) and preknowledge of the story (HPKS, LPKS) on presence and subjective rating of the experience was conducted.

Table 1. Number of participants per condition

Preknowledge of the narrative	Sound	
	AMSS	SS
High (HPKN)	14	12
Low (LPKN)	7	16
Interruptions	5	1
Technical problems	3	2

A significant main effect of the sound condition on *Self location* was found, $F(1, 45) = 4.59, p = 0.038$. *Self location* was rated higher for [Sound, AMSS]

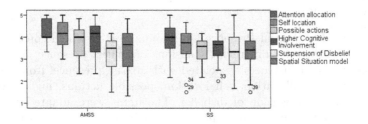

Fig. 4. Presence indicators in the AMSS and SS sound conditions

($M = 4, 04$) than for [Sound, SS] ($M = 3, 67$). The main effect of *Attention allocation, Possible Actions, Higher Cognitive Involvement, Suspension of disbelief* and *Spatial Situation Model* was not significant.

A significant main effect of the preknowledge of the narrative was found on *Attention Allocation* $F(1, 45) = 10.98, p = 0.002$, on *Self location* $F(1, 45) = 20.24, p < 0.001$, and *Higher Cognitive Involvement* $F(1, 45) = 1.72, p = 0.001$. *Attention allocation* is higher for high ($M = 4.36$) than for low ($M = 3.78$) preknowledge of the story; *Self location* rated higher for high ($M = 4.25$) than for low ($M = 3.47$) preknowledge of the story; *Higher Cognitive Involvement* is higher for high ($M = 3.98$) than low ($M = 3.33$) preknowledge of the story. The Sound x Preknowledge of the story interaction was significant for *Higher Cognitive Involvement* factor, though it did not qualify the main effects, $F(1, 45) = 4.55, p = 0.038$.

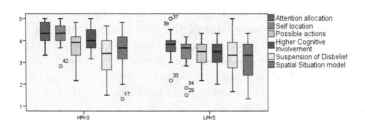

Fig. 5. Presence indicators in the HPKS and LPKS variables

4 Conclusion

We described a fully realized interactive story inspired by three chapters from the narrative "Alice's adventures in Wonderland", and present the interactive story with the design choices and designed sound scape. In this setting, we investigate the immersiveness and the overall user experience. The results show that the enriched sound design affects self location in the storytelling environment, while participants' preknowledge of the underlying story has significant

effect on attention allocation, self location, and higher cognitive involvement presence indicators. One limitation of this study is the usage of subjective post-hoc measures of experience such as MEC, where presence is measured based on the overall perception of the immersive environment. As future steps we will research the effect of *separate* sound types, and how the *quality* of the sound design influences the experience in the installation. Further studies will explore the user experience in more detail, focusing on smaller parts of the overall experience.

References

1. Bartneck, C., Hu, J., Salem, B., Cristescu, R., Rauterberg, M.: Applying virtual and augmented reality in cultural computing. IJVR 7(2), 11–18 (2008)
2. Berndt, A., Hartmann, K.: The functions of music in interactive media. In: Interactive Storytelling, pp. 126–131. Springer (2008)
3. Carroll, L.: Alice's adventures in wonderland. Broadview Press (2011)
4. Cruz-Neira, C., Sandin, D.J., DeFanti, T.A., Kenyon, R.V., Hart, J.C.: The cave: audio visual experience automatic virtual environment. Communications of the ACM 35(6), 64–72 (1992)
5. Dow, S.P.: Understanding user engagement in immersive and interactive stories. ProQuest (2008)
6. Ekman, I., Ermi, L., Lahti, J., Nummela, J., Lankoski, P., Mäyrä, F.: Designing sound for a pervasive mobile game. In: Proceedings of the 2005 ACM SIGCHI International Conference on Advances in Computer Entertainment Technology, pp. 110–116. ACM (2005)
7. Leonardo, A., Brisson, A., Paiva, A.: Influence of music and sounds in an agent-based storytelling environment. In: Ruttkay, Z., Kipp, M., Nijholt, A., Vilhjálmsson, H.H. (eds.) IVA 2009. LNCS, vol. 5773, pp. 523–524. Springer, Heidelberg (2009)
8. Liljedahl, M.: Sound for fantasy and freedom (2011)
9. McCall, R., Wetzel, R., Löschner, J., Braun, A.K.: Using presence to evaluate an augmented reality location aware game. Personal and Ubiquitous Computing 15(1), 25–35 (2011)
10. Park, N., Lee, K.M., Jin, S.-A.A., Kang, S.: Effects of pre-game stories on feelings of presence and evaluation of computer games. International Journal of Human-Computer Studies 68(11), 822–833 (2010)
11. Sanders, T., Cairns, P.: Time perception, immersion and music in videogames. In: Proceedings of the 24th BCS Interaction Specialist Group Conference, pp. 160–167. British Computer Society (2010)
12. Schneider, E.F.: Death with a story. Human Communication Research 30(3), 361–375 (2004)
13. Vorderer, P., Wirth, W., Gouveia, F.R., Biocca, F., Saari, T., Jäncke, L., Böcking, S., Schramm, H., Gysbers, A., Hartmann, T., et al.: Mec spatial presence questionnaire (2004)

Structuring Location-Aware Interactive Narratives for Mobile Augmented Reality

Ulrike Spierling and Antonia Kampa

Hochschule RheinMain, University of Applied Sciences,
Unter den Eichen 5, 65195 Wiesbaden, Germany
{ulrike.spierling,antonia.kampa}@hs-rm.de

Abstract. In the ongoing project SPIRIT, we design entertaining forms of heritage communications through mobile augmented reality. The SPIRIT concept is based upon a strong storytelling metaphor. By using mobile devices (smartphones, tablets) as 'magic equipment', users can meet the restless spirits of historical characters. The paper describes the overall narrative and technical concept. In particular, it explores the narrative structures that are specialized for the intended kind of experience. Further, we show our first use scenario and demonstrator.

Keywords: location-based interactive storytelling, cultural heritage communication, augmented reality, narrative metaphor, narrative structure.

1 Introduction

In the ongoing project SPIRIT, we design and implement a framework for mobile and location-aware interactive digital storytelling, turning history lessons into adventures by serious games. Through the installation of our App, off-the-shelf mobile devices (smartphones, tablets) get transformed into 'magic equipment'. It allows users to meet the 'restless spirits' of historical figures, by interacting with virtual characters in augmented reality. This fictional metaphor serves as a narrative framing for all further design tasks. Beyond the use of a mobile device as a guide, our system enables enjoyable experiences of interactive storytelling, involving users emotionally as players.

After describing our first use scenario and demonstrator implementation, we focus on our structural design of all narrative aspects, such as authored story, plot evolution and interactive participation.

2 Related Work

Since the advent of mobile technology in work places and for entertainment, there has been continuing development on the identification of the user's 'context' in order to deliver suitable information situation-dependently. First and foremost this concerns the tracking of the location of a device, complemented by other environmental data such as

A. Mitchell et al. (Eds.): ICIDS 2014, LNCS 8832, pp. 196–203, 2014.

time, noise, orientation, concurrent tasks or social environments. In cultural heritage (CH) settings, also the proximity of objects and artefacts plays an important role, as they often induce a narrative. Consequently, location-aware storytelling applications—especially, but not only for tourism—mostly structure a tour based on connecting places and objects [7, 10, 12]. In the CH context, the augmentation of perceivable physical remains with different kinds of digital information, including views into the past, point to attractive alternatives of educating about history. [10, 16, 18]

However, only few such augmented reality (AR) applications also involve mimetic storytelling or visualized drama [6]. Integrating all the above concepts towards mobile interactive storytelling has recently started to become a field of applied research. A pioneer example was the project GEIST [11], augmenting stages in the great outdoors with 3D animated historical figures. Long before mobile devices and services became ubiquitous on the market, this project explored the metaphor of magic equipment for CH that we now build upon, as it also used reference image data to achieve marker-less tracking. Meanwhile, a trend towards Mobile AR games has become visible [2]. For example, Haunted Planet provides "outdoors mystery adventure games" [8] with the task to track down single ghosts in the neighbourhood, but without further interaction nor educational content.

Various applications of storytelling on mobile devices for CH have been described [11]. REXplorer [1] used the device metaphor of magic wands to cast spells, in order to combine history information with fun. Set in a graveyard, the project Voices of Oakland made voices of deceased inhabitants audible to visitors with appropriate equipment, providing location-based narratives [5]. Similar to SPIRIT, their goal was to achieve a genuine tone of the voices, avoiding funny "ghost and goblins stories".

Our conceptual approach is different in the sense that a coherent storyworld beyond ancient artefacts or locations is created by authoring and rule design, following our narrative framework. The storyworld can be experienced as an interactively evolving plot that is dynamically built through user interaction with the magic equipment. Further, it may include gaming elements (depending on the choice of authors) to reward and motivate players. We explore the use of video snippets for visualizing the AR ghosts, following the concept of [14] for conversational storytelling. This also involves the development of chroma-keyed video as an additional ARML 'Visual Asset'. [15]

3 Concept and Demonstrator

The SPIRIT approach relies on a holistic story metaphor that integrates all design levels—from logical content and narrative structure down to special media effects and interaction. Our mobile interface is an intrinsic part of the 'story', being designed as 'magic equipment' that users need to master in order to encounter ghosts. At the highest narrative level, 'contacting' and 'revealing' (visualizing) ghosts with the equipment implies that it is not easy to hold 'the connection', which playfully challenges one to use the interface 'the right way' and excuses for imperfections. This idea constrains further design decisions at other levels in a constructive way. Within

the humorous metaphor, 'reality' is not an issue, but 'believability', to be achieved by consistent behavior of the equipment and of the characters. For example, ghosts are known to be able to float in thin air, avoiding the problem with rendering believable floor contact in AR, which was reported by [6].

Figure 1 shows our first concept demonstrator, for which a story scenario has been developed. It can be played at any geographic location. Starting anywhere outside, a visual radar screen feedback on the device indicates the proximity of a spirit (similar to [8]), which can then be tracked down by walking closer. In Figure 1, the magic equipment has visualized a Roman soldier for the first time nearby a group of trees. Since the haunting Roman in the story literally had become accustomed to being invisible to today's Humans, he is at first startled and asks the user whether she can really see him and if she is able to understand Latin. Users can be given little tests and quests in order to let them create confidence with the spirits. The Roman soldier finally invites the player to visit him at his Roman fort, the CH site. If the site is visited with the magic equipment at some point after this encounter, the soldier will welcome the user there, being responsive to the previous encounter.

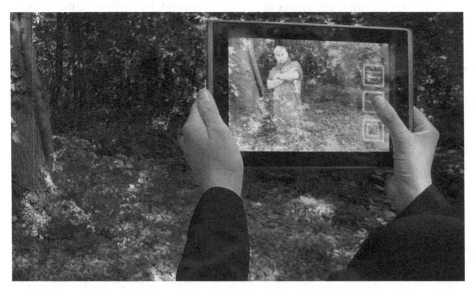

Fig. 1. First concept demonstrator of the magic equipment with basic interaction possibilities. The hovering Roman spirit waits for the user to act.

This first demonstrator has been built to not only set up the mobile media technology, but also to explore production steps. Tests on authoring, video and post production streamlining will be continued in repeated passes. Envisaged user input possibilities include change of location, physical movements, touch, video recognition and voice input without full natural language processing. Thereby the content structure evolves from simple to higher complexity, leading to a combined game and story engine development. A further research area concerns the addition of indoor positioning methods to the current GPS solution.

4 Narrative Structure

Many location-based narrative museum systems present one "object story" about each artefact or place encountered, at first quite structurally similar to audioguides. This often results in a narrative structure of single nodes that is either linear or minimally branched. [10] In some cases a hierarchical ontology is built [13] that holds together semantic units of several storylines.

However, in interactive storytelling research, there is a wide-spread perception that branching strategies are limiting the variability of experiences and thereby the user's freedom, because of the effort to produce the necessary ramifications explicitly. Different and intelligent methods to adapt an evolving plot to user actions have been researched in the community. So far, in mobile interactive narrative, these approaches have not yet been fully considered. This may be due to the fact that typical interaction is not as fast paced as for example in a Facade conversation. [6] On the other hand, users can walk around almost anywhere. Thus, the interaction scenario is physically barely constrained, letting it benefit from becoming semantically constrained by design, such as by metaphor (in our case 'magic equipment' and 'spirits'). Furthermore this results in an increased need to adapt the narrative dynamically.

4.1 Media Structure

At the media level, 'spirits' are visually represented as concatenations of short video clips. Adapting an approach of a previously implemented conversational story system based on video-snippets [14], for each narrative dialog act of one character, one video clip needs to be produced. During runtime, the dialog acts (and hence, the corresponding videos) are to be connected ad hoc in variable ways according to set rules that depend on each situation the user may run into. These rules contain default conversational turn-taking rules, as well as specific game rules invented by authors. The dialog acts include several 'tags' categorizing them into abstract types.

We also explore the production pipeline and design efforts involved, especially as there need to be produced many single bits of conversational parts. Our hypothesis is that typical teams involved in CH media projects may include media managers and designers who rather feel familiar with video production than with complex 3D animation projects including life-like characters. While both production techniques are labor-intensive for our purpose, it has been proven a challenge to create 'believable' characters by 3D animation without tremendous effort. [17] To avoid effects such as the "uncanny valley", designers either have to create totally realistic representations of humans or abstract the visualization toward cartoon or other simplistic style. However, as – with AR – we are embedding our visuals into the 'real' image of the environment and we do not want to fall into a funny-spooky ghost and goblin genre, we tend to avoid too cartoony styles. Consequently, we expect a video solution to be more accessible for CH media designers than comparatively believable 3D animation.

On the other hand, clear disadvantages of the video solution will remain, lying in the inflexibility of the medium when it would need adaptation to circumstances. These can partially be compensated by the metaphor of magic effects, allowing to rate

believability over reality. For example, some abstraction or rather diffuse styling is added by ghost-like visual effects overlaying the original video (compare Figure 1). This aspect also has to be tackled by more research into production principles as well as rendering and delivery. Current work includes the attempt to improve the transition effect between video snippets. Beyond rendered artefacts that simulate a constantly visible 'connection issue' attributed to the magic equipment, we need production principles that ensure some local registration of the 'center of gravity' of the spirit's body.

4.2 Story and Plot Structure

For the more abstract story logic, we distinguish between the 'storyworld' and the 'plot'. This is a similar distinction as the one made by Chatman [3] between story and discourse, with the characteristic that our plot (the 'discourse') will evolve dynamically during user interaction. We conceive a plot planning engine that is capable of interpreting the rules set by authors for a storyworld. The following list describes elements of the runtime plot.

Plot. The visitor's plot consists of a sequence of states that are influenced by encounters with our spirits. Although users can be given the task to look for such encounters by moving around, it may also be possible that they will be approached by ghosts at their current location when the plot planner launches an according event.

Encounter. In each encounter with one or more spirits, the magic equipment is used to let the user visualize ghosts and take turns in a conversation with them. Each turn consists of either user turns via the magic equipment, or spirit turns built of 'atomic narrative acts'. Each encounter also contains functions of the magic equipment to visualize and organize the spirit connection at a meta level, such as entry and vanishing behavior, and some help function.

Turn. Each turn organizes a set of 'atomic narrative acts' resulting in a video playlist. For a spirit's turn, one or more (e.g., dialog) acts can be concatenated. For a user's turn, one or more (e.g., physical) acts of the type 'feedback' or 'idle' need to be concatenated, in order to visualize the ghost waiting for the user to act.

AtomicNarrativeAct. Each act needs to correspond to at least one media asset (usually a video file in our first demonstrator). There are dialog acts and physical acts. All 'atomic narrative acts' of a spirit build its 'behavioral repertoire' defined in the storyworld. At each turn, selected acts are bundled into turns as elements of a structured turn-taking. Acts are tagged by one or more type attributes. Current types of the first demonstrator include 'Greet', 'Leave', 'Idle', 'Feedback', 'Location', 'Character', 'Info', 'QuestGoal'. The tags can be considered in the match making of appropriate acts.

Storyworld. All abstract diegetic (story-related) elements are defined during authoring in the storyworld. The main components are the atomic narrative acts, together with rules for their sequencing. They are associated with characters that have further

parameters corresponding to the location. Also the user is modelled as part of the storyworld, with variable states concerning location, information processed and achievements earned in the mobile game.

Figure 2 illustrates the three levels that all adhere to the spirit metaphor, regarding the choice of acts.

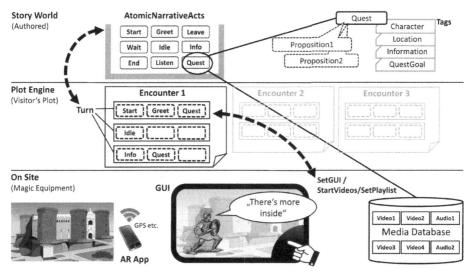

Fig. 2. Visualization of the three levels of the content structure. The *storyworld* contains all abstract elements that can be used by the *plot engine* to form the turn-taking with the user, who needs the *magic equipment* to visualize spirits.

4.3 Information Delivery

Unlike CH applications that focus on letting objects 'tell stories', the SPIRIT project creates a diegetic layer of a consistent world of spirits. Although a case study is currently produced for a Roman fort CH site, the concept is meant to be universal and adaptable to other historic sites. In the ongoing project, story templates and patterns will be further developed that can be reused in different contexts, easing the authoring involved in future applications by a standard modus operandi.

Informational bits are classified through tags attached to each narrative act. There are possibilities to convey fictional content and quests, as well as historical information. Ideally, each kind of information should be tagged accordingly during authoring. In our case study, fictional information is requested to be in line with the educational concept of reenactment of the partner site. After all, it is possible to structure content in a more entertaining way or strictly based on historically authentic locations and objects, depending on the authors.

4.4 Implementation

Our first demonstrator has been used to explore the content structure described above. The goal is to enable longer lasting experiences than only one tour by saving a game state of the visitor's plot at all steps (depending on preferences and privacy adjustments). The implementation of the first version of the structure is in progress, according to the diagram in Figure 3.

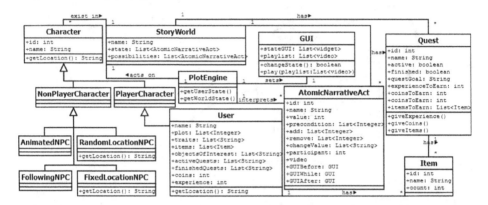

Fig. 3. UML diagram of narrative structural elements (here without the magic equipment and its encounters)

5 Conclusion

We presented a description of the ongoing project SPIRIT, its concept and first results. Our first demonstrator illustrates the basic interaction principle with the magic equipment. It has been used for specifying further development of the system and the content structure. Future work includes the development of indoor tracking technology, in order to be able to use all kinds of locations at museum sites. Further, we will develop a plot engine with authoring tools catering to our video-based approach for media designers. Finally, exhaustive content for a case study will be completed with the support of the Roman fort museum, including a business concept.

Acknowledgments. This work has been funded (in part) by the Federal Ministry of Education and Research (BMBF) in Germany (03FH035PA3/B3). We thank all project members for their support.

References

1. Ballagas, R., Kuntze, A., Walz, S.P.: Gaming tourism: Lessons from evaluating rEXplorer, a pervasive game for tourists. In: Indulska, J., Patterson, D.J., Rodden, T., Ott, M. (eds.) PERVASIVE 2008. LNCS, vol. 5013, pp. 244–261. Springer, Heidelberg (2008)
2. Broll, W., Lindt, I., Herbst, I., Ohlenburg, J., Braun, A.-K., Wetzel, R.: Toward Next-Gen Mobile AR Games. IEEE Comput. Graph. Appl. 28(4), 40–48 (2008)

3. Chatman, S.: Story and Discourse. Narrative Structure in Fiction and Film. CORNELL University Press, Ithaca (1978)
4. Dionisio, M., Nisi, V., van Leeuwen, J.P.: The iLand of Madeira Location Aware Multimedia Stories. In: Aylett, R., Lim, M.Y., Louchart, S., Petta, P., Riedl, M. (eds.) ICIDS 2010. LNCS, vol. 6432, pp. 147–152. Springer, Heidelberg (2010)
5. Dow, S., Lee, J., Oezbek, C., MacIntyre, B., Bolter, J.D., Gandy, M.: Exploring spatial narratives and mixed reality experiences in Oakland Cemetery. In: Proceedings of Advances in Computer Entertainment Technology (ACE 2005), pp. 51–60. ACM, New York (2005)
6. Dow, S., Mehta, M., Lausier, A., MacIntyre, B., Mateas, M.: Initial lessons from AR Façade, an interactive augmented reality drama. In: Proceedings of the ACM SIGCHI international conference on Advances in computer entertainment technology (ACE 2006). ACM, New York (2006), doi:10.1145/1178823.1178858
7. Gustafsson, A., Bichard, J., Brunnberg, L., Juhlin, O., Combetto, M.: Believable environments: generating interactive storytelling in vast location-based pervasive games. In: Proc. of the 2006 ACM SIGCHI international Conference on Advances in Computer Entertainment Technology. ACE 2006., vol. 266 (2006)
8. Haahr, M.: Telling Ghost Stories with Physical Space. Games and Narrative Blog (2012) (Online), http://gamesandnarrative.net/?p=170
9. Hansen, F.A., Kortbek, K.J., Grønbæk, K.: Mobile Urban Drama – Setting the Stage with Location Based Technologies. In: Spierling, U., Szilas, N. (eds.) ICIDS 2008. LNCS, vol. 5334, pp. 20–31. Springer, Heidelberg (2008)
10. Keil, J., Pujol, L., Roussou, M., Engelke, T., Schmitt, M., Bockholt, U., Eleftheratou, S.: A digital look at physical museum exhibits. In: Proceedings of the Digital Heritage 2013, Marseille (2013)
11. Kretschmer, U., Coors, V., Spierling, U., Grasbon, D., Schneider, K., Rojas, I., Malaka, R.: Meeting the Spirit of History. In: Proceedings of the International Symposium on Virtual Reality, Archaeology and Cultural Heritage, VAST 2001, Glyfada, Greece, pp. 161–172 (2001)
12. Lombardo, V., Damiano, R.: Storytelling on mobile devices for cultural heritage. New Review of Hypermedia and Multimedia 18(1-2) (2012)
13. Mulholland, P., Wolff, A., Zdrahal, Z., Li, N., Corneli, J.: Constructing and Connecting Storylines to Tell Museum Stories. In: Koenitz, H., Sezen, T.I., Ferri, G., Haahr, M., Sezen, D., Çatak, G. (eds.) ICIDS 2013. LNCS, vol. 8230, pp. 121–124. Springer, Heidelberg (2013)
14. Müller, W., Spierling, U., Stockhausen, C.: Production and Delivery of Interactive Narratives Based on Video Snippets. In: Koenitz, H., Sezen, T.I., Ferri, G., Haahr, M., Sezen, D., Çatak, G. (eds.) ICIDS 2013. LNCS, vol. 8230, pp. 71–82. Springer, Heidelberg (2013)
15. OGC, Lechner, M. (ed.): OGC Augmented Reality Markup language 2.0 (ARML 2.0) specification document, https://portal.opengeospatial.org/files/?artifact_id=52739
16. Schmalstieg, D., Wagner, D.: A Handheld Augmented Reality Museum Guide. In: Proceedings of IADIS International Conference on Mobile Learning (ML 2005), Qawra, Malta (2005)
17. Spierling, U., Hoffmann, S., Struck, G., Szilas, N., Mehlmann, G., Pizzi, D.: Integrated report on formative evaluation results of authoring prototypes. Deliverable 3.4, IRIS NoE FP7-ICT-231824 (2012), http://iris.scm.tees.ac.uk/
18. Stricker, D., Dähne, P., Seibert, F., Christou, I., Almeida, L., Carlucci, R., Ioannidis, N.: Design and development issues for archeoguide: An augmented reality based cultural heritage on-site guide. In: Proc. Int'l Conf. Augmented Virtual Environments and 3D Imaging, Myconos, Greece, pp. 1–5 (2001)

Fictional Realities: Augmenting Location-Based Stories through Interaction with Pervasive Displays

Xiao Emila Yang and Martin Tomitsch

Design Lab, Faculty of Architecture Design and Planning, University of Sydney
148 Wilkinson Road, Sydney, NSW, Australia
xyan6683@uni.sydney.edu.au, martin.tomitsch@sydney.edu.au

Abstract. This paper proposes the use of pervasive displays in location-based interactive story experiences. We've explored three distinct interaction techniques for linking a mobile story application with pervasive displays and implemented a prototype to demonstrate the interaction techniques as part of a story experience.

1 Introduction

"Storytelling is a core human activity, one we take into every medium of expression", Murray wrote in her essay, From Game-story to Cyberdrama [1]. Even in modern society, storytelling permeates every medium and every aspect of our lives, including communication, entertainment, marketing, and education to name but a few [2]. It makes sense then for stories to expand into new mediums available for us in the information age and take on new and unique characteristics, as it does with each newly introduced medium of expression. Interactivity, a defining element of digital technologies has already become a key characteristic of narratives on digital mediums.

As ubiquitous devices begin to pervade our everyday environments, opportunities arise for such devices to be explored as a new medium for storytelling. In his proposed plan to implement a ubiquitous city, Ha [3] defined several stages. The last stage, "anything", is seen as the maturity of ubiquity, when connections transgresses personal computers to encompass humans and objects. As we progress towards this ubiquitous maturity, it makes sense for to explore devices such as pervasive displays as a medium for storytelling. These intelligent screens (or other types of displays) are situated in public or personal spaces and can interact with humans, other devices, or environmental elements to create a new dimension to storytelling.

The research consultancy company, Latitude, conducted a study in 2012 [4] on 150 early adopters on their view of the future of storytelling. Their findings imply that people are expecting the boundaries between reality and story to become increasingly blurred, creating a new type of *fictional reality* in the near future.

In exploring the evolution of interactive storytelling in alignment with these expectations and the progression towards the ubiquitous maturity, we constructed an experimental, location-based story experience using pervasive displays. The aim was to investigate whether current location-based story experiences could be improved to better match the expectation of a fictional reality, by adding context-aware pervasive displays. This study evaluated 3 types of interactions with pervasive displays.

A. Mitchell et al. (Eds.): ICIDS 2014, LNCS 8832, pp. 204–207, 2014.
© Springer International Publishing Switzerland 2014

2 Related Work

Ventures into ubiquitous location-based storytelling have been mostly mobile-focused thus far, with a wide range of non-fiction applications such as the *Audio-tactile Tourist Guide* [5] and historical or cultural guides such as *GEIST* [6] and *Mapping Footprints* [7].

The study presented aligns more closely with fictional applications such as Hansen's *Corridor* [8] and Paay's *Who Killed Hanne Holmgaard?* [9]. Hansen [8] suggested the notion that the "real (possibly responsive) urban environment becomes the scenography". So far actors and props have been used to achieve this. The limitations of this are that experiences have to be specifically staged and carefully controlled. Pervasive screens may be able to overcome some of these limitations as they become more widespread in the public environment at bus stops, shop fronts, information and advertisement boards. Furthermore pervasive displays allows for an easier augmentation of reality for genres such as fantasy or science fiction.

The development of interaction techniques for location-based storytelling was inspired by projects such MIT's *ALIVE* project [10], which explored the 'magic mirror' metaphor, where a projected video wall that displayed live video of the user is augmented by a virtual world filled with autonomous characters that respond to the user's gestures. The concept of proxemics [11], for example to adapt and personalise content as a user approaches the display, and the use of contextual information to present information relevant to the situation [12] further informed the development of the prototype.

3 Story Experience Prototype

The experience involved 3 interactive screen setups utilising a multi-touch screen, two projectors, and a Kinect. The audio of a linear story was delivered through a mobile application. Participants listened to this story as they walked through physical settings that were connected visually to each scene in some way. The physical environment was not always mapped 1 to 1. For example, a university laboratory was used for a courtroom scene. The interactive screens were designed to be aware of the participant's presence and where they were up to in the story so it would either switch on, or change its content to match the audio the participant was listening to.

The focus of this initial study was to develop and evaluate selected interactions, so the experience was limited to a short, single-user, linear story to be tested in a controlled lab environment. The prototype story experience took approximately 20-30 minutes, and played out through locations within the faculty building.

The main plot of the story consisted of the main character, Anne coming to terms with a tragic loss on her journey through a surrealistic dream world based on Alice in Wonderland. It begins on the rooftop, where Anne wakes up in dream-like surroundings. There she sees a young boy, who disappears down the fire escape and she is mysteriously compelled to follow him. Anne moves through several different settings in her pursuit of the boy, including a birthday party scene where a magician leaves her

a puzzle as a clue, a meeting with the Cheshire Cat, and eventually she comes to realise that the boy is her son. She pursues him to a 'courtroom', and stumbles across what seemed to be her own trial. The Red Queen, a representation of the internal guilt Anne felt as a mother, reveals during the trial that her son had in fact died on the day of his 10th birthday. Anne's memories return and the dream world begins to collapse. With the help of the Cheshire Cat, Anne escapes the trial to meet with her son for the final time, where she finally overcomes her denial and begins to accept the grief. The boy gives Anne a torch which reveals a door in the darkness that she was previously unable to see. Exchanging a final, sentimental goodbye, Anne walks through the door and leaves the boy and the crumbling dream world behind.

The first interactive element was the **puzzle** from the magician, which appears on the multi-touch screen in the center of the room. The user has to rearrange the pieces of the puzzle to receive instructions on how to continue. The second element was the **reactive window**, which displayed images of the courtroom in sync to the audio story playback on two large, adjacent, projected screens. No actions were required from the user as the screens were responsive to the user's presence and the audio they were listening to. The final interactive element was the **torch,** created using a Kinect to detect the user's hand as they pointed their phone at the screen, projecting a 'light' onto the screen in the direction they are pointing and revealing the door in the 'darkness'.

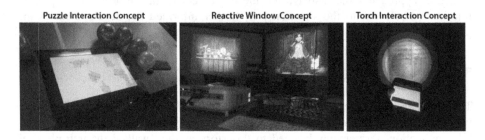

Fig. 1. The three interaction concepts used in the story experience prototype

4 Discussion

Results from a preliminary evaluation study comparing the story experience with and without pervasive displays indicates that the experience was improved when pervasive displays were added. However the type of content and interaction affected the effect of the pervasive displays. Generally we found that the responsive interaction (reactive window) was more effective for seamlessly creating a fictional reality. Interactions requiring more participation or instruction often "break the illusion" and can distract the user, impairing the immersion, flow and the user's comprehension of the story. However these interactions were also found to be engaging and should not be completely excluded from such story experiences.

5 Conclusion

This project focused on a small facet of interactive storytelling and demonstrated 3 interactive techniques developed for using pervasive displays in location-based stories. There is potential for pervasive displays to improve the implementation of fictional realities while providing authors of interactive stories with more freedom, provided the interactions are chosen with careful consideration of the effects the author wishes to achieve. As pervasive displays become more prevalent in society in the near future, storytelling will be able to freely move beyond the traditional constraints of the page or screen and seep into the world around us to create new fictional realities.

References

1. Murray, J.H.: From game-story to cyberdrama. Electronic Book Review (2004)
2. Ryan, M.: Beyond myth and metaphor: The case of narrative in digital media. Game Studies 1(1), 1–17 (2001)
3. Ha, W.: A study on action plan and strategies for building u-Korea: Vision, issue, task, and system. Telecommunications Review 13(1), 4–15 (2003)
4. Latitude°.: The future of storytelling: Phase 1 of 2 (2012)
5. Szymczak, D., Rassmus-Gröhn, K., Magnusson, C., Hedvall, P.: A real- world study of an audio-tactile tourist guide. In: Proceedings of the 14th International Conference on Human-computer Interaction with Mobile Devices and Services (2012)
6. Malaka, R., Schneider, K., Kretschmer, U.: Stage-Based Augmented Edutainment. In: Butz, A., Krüger, A., Olivier, P. (eds.) SG 2004. LNCS, vol. 3031, pp. 54–65. Springer, Heidelberg (2004)
7. Veronesi, F., Gemeinboeck, P.: Mapping footprints: A sonic walkthrough of landscapes and cultures. Convergence: The International Journal of Research into New Media Technologies 15(3), 359–369 (2009)
8. Hansen, F.A., Kortbek, K.J., Grønbæk, K.: Mobile urban drama: interactive storytelling in real world environments. New Review of Hypermedia and Multimedia 18(1-2), 63–89 (2012)
9. Paay, J., Kjeldskov, J., Christensen, A., Ibsen, A., Jensen, D., Nielsen, G., Vutborg, R.: Location-based storytelling in the urban environment. In: Proceedings of the 20th Australasian Conference on Computer-Human Interaction: Designing for Habitus and Habitat, pp. 122–129. ACM (2008)
10. Maes, P., Darrell, T., Blumberg, B., Pentland, A.: The ALIVE system: full-body interaction with autonomous agents. In: Computer Animation 1995 Proceedings, pp. 11–18. IEEE (1995)
11. Ballendat, T., Marquardt, N., Greenberg, S.: Proxemic interaction: designing for a proximity and orientation-aware environment. In: ACM International Conference on Interactive Tabletops and Surfaces, pp. 121–130. ACM (2010)
12. Favela, J., Rodriguez, M., Preciado, A., Gonzalez, V.M.: Integrating Context- Aware Public Displays Into a Mobile Hospital Information System. IEEE Transactions on Information Technology in Biomedicine 8(3), 279–286 (2004)

Comparison of Narrative Comprehension between Players and Spectators in a Story-Driven Game

Miki Nørgaard Anthony[1], Byung-Chull Bae[2], and Yun-Gyung Cheong[3]

[1] IT University of Copenhagen, Copenhagen 2300, Denmark
mnoa@itu.dk
[2] Sungkyunkwan University, Seoul, South Korea
byuc@skku.edu
[3] Sungkyunkwan University, Suwon, South Korea
ygcheong@gmail.com

Abstract. In this paper we compare how differently players and spectators comprehend narrative in a game, employing a story-driven indie game called Skyld. Our preliminary study results show that the players, compared to the spectators, had a tendency of being goal-oriented, being less willing to interpret and build possible worlds, and having hard time to reconstruct the story time.

Keywords: narrative comprehension in games, situation model.

1 Introduction

Researchers in both game and narrative communities have argued for long time if narrative can be successfully combined into games [1]. In this paper we want to explore the following research question.

- How does interactivity in games affect narrative comprehension? More specifically, do games need to be more explicit in their storytelling?

To explore this research question, we chose a story-driven indie game called Skyld, which is developed with an intention of satisfying spectators as well as game players[1]. This paper presents our preliminary interview results that we conducted with Skyld, where interviewers were divided into two groups - players and spectators of Skyld. To have a common ground of analyzing how differently they perceive the narrative both in terms of time and space, we have them describe the narrated situation of which they built when they experienced the story by asking them a set of questions based upon the six elements (that is, space, time, goals, causation, people, and objects) in the situation model illustrated by Zwaan [5], focusing upon storytelling in games based on Abbott's [2] and Nitsche's [4] theories.

[1] A gameplay example of Skyld can be seen here: http://youtu.be/cGxQDIko6GO

A. Mitchell et al. (Eds.): ICIDS 2014, LNCS 8832, pp. 208–211, 2014.

In order to understand a story, according to Zwaan, we construct a mental representation of what the text is about, not of the words, sentences or phrases, but of the objects, locations, events and people known as the situation model [5]. We become part of the story and imagine ourselves within the world created, a world which David Herman coined as "storyworld" and Abbott (2008) since adopted [2, p. 165]. For Abbot all narrative represents a storyworld situated in both time and space, in which the characters and readers inhabits [2, p. 164].

The situational awareness is true to games as well. The player needs to know his or her character's situation and position, in order to take action and act upon it, by reading, using, and predicting the game world they are situated in [4, p. 42 - 43]. Nitsche claims that "evocative narrative elements" that give context to the world and its situations are necessary to maintain a narrative structure and avoid misinterpretation [4, p. 44]. This could well be seen in relation to Abbott's "constituent events" [2, p.22] or Chatman's "kernels" [3, p.53], that is, events which progress the story forward. If we consider that player-interactions with narrative elements leads to events, we could argue that each time a player interacts with an evocative narrative element within the game world, it creates a constituent event.

2 Method

To find out how interactivity affects narrative comprehension, we conducted interviews with players and spectators of a story-driven game, that is, Skyld, based upon Zwaan's theory of the situation model. After playing (or watching) the game, the participants are asked to describe the situation from which they experienced the narrative.

Skyld, the testbed game that we have used, is an interactive adventure game. Its underlying intention is about how to cope with the guilt and grief of losing somebody you care about. Skyld is split into two modes - a third person adventure mode and a first person horror mode. The game can be switched between two modes depending on certain events. The testbed game features both modes, but only one switch between them and with the main focus on the adventure mode. In the gameplay of the adventure mode, Silja, the main character, walks around the apartment discovering objects (see Fig. 1 for a screenshot of Skyld). Overall the game is structured as Cut scene - Adventure mode - Cut scene - Horror mode.

The way in which we test people's comprehension of the story is through the situation model. We asked each of them to create the situation from which they experienced the story in, by using a set of questions based upon the six elements described by Zwaan [5, p.15].

- Space: Where are we?
- Time: When is it taking place?
- Goals: What are you trying to do, or figure out?
- Causation: What has happened?
- People: Who are you? And what other characters do you meet?
- Objects: Any important objects or things you noticed?

Fig. 1. A screenshot from Skyld, a story-oriented adventure game

The interviews were conducted on 8 people (all males in their 20s) from IT University of Copenhagen, Denmark. Four of them (i.e., player group) played the game before the interview, while the other four (i.e., spectator group) watched a playthrough. Among the participants in the spectator group, two of them watched a recorded playthrough from a previous participant and the other two were present during a playthrough.

3 Results and Discussion

Our preliminary study showed that players and spectators grasped the story in games differently. Players comprehended the story through goals and actions, whilst spectators used the space which the story was situated in. The players saw the world through the eyes of the protagonist, whereas the deictic center of the spectators was relative to the position of the camera.

The goal-oriented approach from the players lead to overlooking and underreading narrative elements which were not interactive. For the player the game was more important than the story. Even if the game was story-driven, they would still find ways to just "play" the game. On the other hand if the game turned goals and actions into story plots, they would feel the achievement of both story and game. The goal-oriented focus gave the players an excellent memory over anything interactive, from objects to actions. If this was somehow related to the story, the players had no trouble reciting it later on and connecting its implication to the story. And due to the immersion and personal investment, the actions would then also feel to have greater impact both in terms of story and emotion.

Players had trouble when it comes to time, understanding when things occurred. This is properly due to the weird relationship between actual time and story time

in games. That time often does not have an impact, unless you can see a timer. But the players are also used to unexplained gaps in games, skipping to the action.

For the spectators time was easy to comprehend. Nobody had trouble getting the time passing from intro to adventure mode. The spectators also viewed the story through the surroundings, interpreting every little detail. They had no trouble in making the storyworld and had a tendency to make a lot of possible worlds as well. They picked up on everything, that could be related to the story, analyzing its implication of what it could mean, which leads to a great amount of overreading and misinterpretations. The opposite could be said about the players, who avoided making too many assumption. The players had a tendency to underread and overlook a lot of the non-interactive story elements. It was like they were already thinking ahead of what they should do next and ignored what was just in front of them in terms of story.

To sum up, the followings, in our humble opinion, are what need to be taken into consideration when creating a story-driven game:

- How the story is told through the environment? How can we use the interactable objects as kernels for the story?
- Translating story elements into actions and interactions, instead of scripted events, making the story more immersive.
- Think in goal-oriented strategies. Why should the player do this story-related thing? What would she gain from it?
- Create believable characters. The protagonist is the most important interactable object in the game, so make it to your advantage. Tell the story through the eyes of the protagonist.

Acknowledgments. The authors would like to thank the ITU students who voluntarily participated in the pilot study. The authors are also grateful to the Brain Korea 21 Plus Program through the National Research Foundation (NRF) funded by the Ministry of Education of Korea (10Z20130000013).

References

1. Aarseth, E.: A narrative theory of games. In: Proceedings of the International Conference on the Foundations of Digital Games, FDG 2012, pp. 129–133. ACM, New York (2012), http://doi.acm.org/10.1145/2282338.2282365
2. Abbott, H.P.: The Cambridge Introduction to Narrative, 2nd edn. Cambridge University Press (2008)
3. Chatman, S.B.: Story and Discourse: Narrative Structure in Fiction and Film. Cornell University Press (1978)
4. Nitsche, M.: Video Game Spaces: Image, Play, and Structure in 3D Game Worlds. The MIT Press (2008)
5. Zwaan, R.A.: Situation models: the mental leap into imagined worlds. Current Directions in Psychological Science 8, 15–18 (1999)

Moral Values in Narrative Characters: An Experiment in the Generation of Moral Emotions

Cristina Battaglino, Rossana Damiano, and Vincenzo Lombardo

Dipartimento di Informatica and CIRMA, Università degli Studi di Torino, Italy

Abstract. In this paper, we model a set of narrative scenarios, taken from well known literary works, and show how they require the role of moral values to generate the appropriate emotions for the characters. For each example, we compare the generated emotions with and without moral values and show how the absence of moral values would lead to an insufficient moral range.

1 Value-Based Characters

Moral emotions deserve special attention in interactive storytelling, since narratives have a universally recognized moral dimension, as argued by drama scholars and narratologists [7,8], also acknowledged by cognitive studies [2]. So, characters are expected to respond emotionally to the moral valence of story incidents, with emotions such as shame, pride, admiration, etc.

In this paper, we focus on moral emotions, given their relevance for narrative and drama, and try to assess the suitability of a value–based model of moral emotions for the implementation of synthetic narrative characters by means of a pilot experiment conducted with human testers. For each narrative scenario, its main characters were modeled by using the FATIMA agent architecture to implement characters [6], enriched with the Value Component described in [3]. The *Value Component* generates appraisal variables according to the model in [4]. The Value Component adds to the FAtiMA Core the following capabilities: monitoring of moral values (at stake or re-balanced) and goals (achieved or not); the generation of the appraisal variables based on goals and values processing; and finally the computation of the expected emotional reward of plans, based on the values re-balanced and put at stake and the goals it achieves or not by each plan. The Value Component generates the following emotions:

- Joy (or Distress) if a goal is achieved (not achieved) (i.e. desirability (undesirability) appraisal variable is generated);
- Hope (or Fear) if a plan has an high (low) probability of success (i.e. likelihood appraisal variable is high (or low));
- Pride (or Shame) if a value is re-balanced (put at stake) (i.e. a praiseworthy (blameworthy) appraisal variable is generated and the responsibility is self-caused);

A. Mitchell et al. (Eds.): ICIDS 2014, LNCS 8832, pp. 212–215, 2014.

– Admiration (or Reproach) if a value is re-balanced (put at stake) (i.e. a praiseworthy (blameworthy) appraisal variable is generated and the responsibility is other-caused).

When both appraisal variables regarding actions and goals are generated, the Affect Derivation Model generates the following compound emotions: **Gratification** (Joy and Pride), **Gratitude** (Joy and Admiration), **Remorse** (Distress and Self-Reproach), **Anger** (Distress and Reproach). Details about the computational model of emotions we adopt can be found in [4].

2 Narrative Scenarios

In order to test the generation of moral emotions, we selected three scenes taken from well-known literary works and we encoded the characters' beliefs, goals and values using the *Value Component*. The scenes were selected from famous works of fiction with the help of a drama expert, who identified them based on availability of well established critical interpretations of the emotions felt by the characters [7,5]. The selected scenes are taken from: *Hamlet* (Shakespeare), *The count of Monte Cristo* and *The Vicomte of Bragelonne: Ten years later* (Alexandre Dumas). For the sake of brevity, we describe only Hamlet's scenario reporting the moral component (the range of emotions generated without the moral component can be simply obtained by removing moral emotions).

We modeled the behavior of Hamlet and Ophelia during the well known "nunnery scene" in the Third Act of the tragedy, in which Hamlet asks Ophelia about the location of her father in order to know if Ophelia is worthy of being saved. At this stage of the drama, Hamlet has the goal of saving his beloved Ophelia from the corruption of the court (*Save(Hamlet, Ophelia)*) and the goal of asking Ophelia where her father is (*Ask(Hamlet, Ophelia)*). Hamlet owns the value *Honesty*, while Ophelia has the moral values *Honesty* as well, and *Loyalty* to her father. Ophelia has to decide if she wants to tell the truth about the location of her father. Ophelia decides to lie. Hamlet knows Ophelia lied. According to the appraisal variables generated by the Value component, Hamlet feels Joy for the achievement of his goal (*Ask(Hamlet, Ophelia)*), with a low intensity due to a minor importance of the goal (see [4] for details), and Anger towards Ophelia because she lied. Ophelia feels Shame for being dishonest with Hamlet, because she puts aside the *Honesty* in favor of the loyalty to her father Polonius.

3 Evaluation and Discussion

In order to assess the validity of the generated emotions against the audience expectations, we run a pilot experiment with human testers. Each scenario was presented to the participants in a text-based form, via a web based platform. For each scenario, the narrative situation was described, and the characters' goals and values were illustrated. The characters' emotions were described to

the user (e.g. "Hamlet feels *Distress* towards Ophelia"), with the exceptions of moral emotions, that were omitted. Our aim was to assess if participants associated moral emotions, related to values, also if they were not presented in a given scenario. We collected a convenience sample of ten subjects, 4 female and 6 male, aged 24-35. Given a scenario, participants first read the scenario, then received the post questionnaire about the scenario where they were asked to list the emotions they would feel if they were to identify with the story characters, using multiple-choice questions based on OCC categories of emotions [1].

Table 1. The emotions felt by characters according to the computational model, without the Value Component (second column) and with the Value Component (third column)

Character	No values	Value Component
Hamlet	Distress	Distress, Reproach, Anger
Ophelia	-	Shame
Count of Montecristo	Joy	Reproach, Joy, Pride, Gratification
Fernand	Distress, Joy	Distress, Joy
Aramis	Joy	Joy, Pride, Gratification
Philippe	Joy	Joy, Admiration, Gratitude

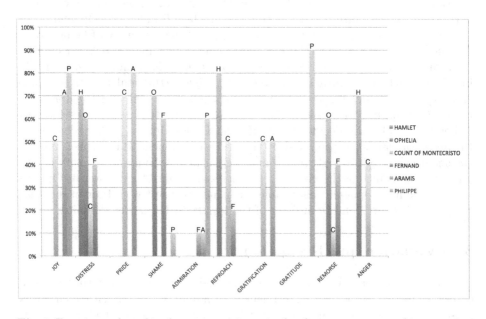

Fig. 1. Emotions selected in the post questionnaire for characters presented in narrative scenarios

3.1 Results

Summarizing, the analysis of the results suggests that participants perceived moral values and they attributed to the characters the emotions predicted by the moral emotional agent model implemented in the Value Component. The range of emotions generated by the model by removing the Value Component (see Fig. 1) does not account for the actual range of emotions selected by the participants to the experiment, which are covered by the Value Component. However, the emotional range predicted by the value based model of moral emotions is not complete due to the richer interpretation provided by the audience. For example, in the Count of Montecristo, participants perceived both emotions regarding the imprisonment (Reproach 50%) and the revenge (e.g. Gratification), but attributed to the Count of Montecristo also Anger (40%) and Distress (20%), thus suggesting a perception of some threatened goal that we did not model.

4 Conclusion

In this paper we present a study in which characters are modeled with a moral dimension and they are able to react to the moral aspect of story incidents. We run a web experiment in which narrative scenarios are presented to human testers who associated emotions to characters. The results of the web experiment show that the role of moral emotions is perceived by the audience.

References

1. Ortony, A., Collins, A., Clore, G.L.: The cognitive structure of emotions. Cambridge University Press, Cambridge (1988)
2. Bruner, J.: The narrative construction of reality. Critical Inquiry 18(1), 1–21 (1991)
3. Dias, J., Battaglino, C., Damiano, R.: Telling the difference between asking and stealing: moral emotions in value-based narrative characters. In: Seventh Workshop on Intelligent Narrative Technologies (2014)
4. Lesmo, L., Battaglino, C., Damiano, R.: Emotional range in value-sensitive deliberation. In: AAMAS, pp. 769–776 (2013)
5. Freytag, G.: Technique of the drama, an exposition of dramatic composition and art. S.C. Griggs and Company, Chicago (1985)
6. Mascarenhas, S., Dias, J., Paiva, A.: Fatima modular: Towards an agent architecture with a generic appraisal framework. In: Proceedings of the International Workshop on Standards for Emotion Modeling (2011)
7. Polti, G.: Les trente-six situations dramatiques. Mercure de France, Paris (1895)
8. Williams, S.D.: The Moral Premise. Michael Wiese Productions (2006)

Three Is a Magic Number: Virtual Cameras for Dynamic Triadic Game Dialogue

Bingjie Xue and Stefan Rank

Drexel University, Philadelphia, USA
stefan.rank@drexel.edu

Abstract. Interactive storytelling games can benefit from a century of film cinematography and established cinematic conventions. Conversation scenes in games are highly dynamic and pre-authored camera parameters impractical. We propose a combined theoretical and empirical approach towards an automatic Visual Director System focused on dynamic conversation scenes involving three characters and encoded as AI game component that selects suitable shots.

1 Introduction

Interactive storytelling (IS) games provide the players with opportunities to participate in stories in real time and, compared to other types of games, they are more like films, in that the major focus is on narrative. Further, 3D IS games often have an open environment allowing players to navigate the game's scenes. Such games present "excellent opportunities for integrating and combining new possibilities with traditional film viewpoints" [7]. Virtual cameras play a vital role in 3D IS games because they directly affect player experience and game enjoyment [6]. The current work considers in particular games that do not employ a first or third-person camera but that rather use other means of automatic and dynamic camera positioning, framing and editing, sometimes only in conversation scenes, to achieve cinematic aesthetics.

This paper reports on work towards an intelligent camera system, the Visual Director System, focusing on triadic conversations, i.e. scenes that involve three characters, accounting for mood and directorial style, and easy integration into a game engine. We provide an overview of our two-pronged theoretical and empirical approach towards system design that combines research on cinematic idioms and the analysis of cinematographic and directorial choice in conversation scenes selected from successful movies. See also [8] for a previous report on preliminary results with a basic set of film idioms and more details on related work.

2 Towards VDS' Intelligent Camera Algorithm

Our approach towards an automatic camera system, the Visual Director System (VDS) aims to find out how cinematic conventions and styles are used in three-people conversations in film, rather than positing suitable AI methods, in order to iteratively encode identified conventions as game AI components useful for dynamic scenes in

A. Mitchell et al. (Eds.): ICIDS 2014, LNCS 8832, pp. 216–219, 2014.
© Springer International Publishing Switzerland 2014

IS games. Many of the cinematography techniques in film can fruitfully be applied to virtual cameras in video games leveraging the players' understanding of cinematic language [3, 5]. Ideally, camera parameters should be adjusted dynamically as players experience and affect the virtual scenes.

The VDS is a game AI component for camera logic, with minimal requirements regarding the encoding of the narrative. We chose Unity 3D, a widely used cross-platform game engine, to improve reusability by non-experts. An implementation of classic **principles of cinematography** acts as reasonable baseline for directing game dialogue scenes. Based on reviewing a host of literature on asserted idioms, formulas, grammar conventions, and rules of film, e.g. [1, 2, 4], we have selected a range of basic idioms that are applicable to triadic conversations and reasonably independent of directorial style, noting the important tension between the idea of universal rules and individual styles as well as the potential effect of breaking unwritten rules.

- The *rule of thirds* provides an aesthetic baseline.
- Shot types are based on the *framing ratio* of characters, from wide shot to big close up shot, which determines the distance between camera and characters.
- *Camera angles* can be used to reflect hierarchies or emphasize moods.
- The *line of action rule*, a.k.a. line of interest or 180° rule, helps spatial continuity.
- Dialogue is edited in *action-reaction shot* sequences: speakers then reactions.

By **analyzing conversation scenes** directed by different accomplished directors that involve three characters, we work towards a catalog of how rules are applied in successful films, providing insights into how this can be encoded into dynamic conversation in games using general rules while allowing for capturing the variability of styles. Several triadic conversation scenes were studied, twenty of them analyzed in detail. We present an overview of recreating three with our system in a later section. One scene is taken from the film "The Lady Vanishes", directed by Alfred Hitchcock. The director divides three characters into two groups, and shows the story using a range of framing from a medium long shot (apex shot of three characters) to close-ups showing the facial expression on characters. This scene exemplifies several rules present in most of the analyzed scenes that establish a baseline for camera setups building on the theory-driven starting point.

- Basic rules for framing, camera positioning and orientation are observed, including standard shot types, the rule of thirds, and the over-the-shoulder shot idiom.
- An apex camera showing all characters is used most frequently for establishing and ending a conversation scene.
- The line-of-action is observed and adapted when characters change positions.
- Further, this scene shows the influence of a scene's mood on camera parameters. In this case, higher emotional tension is reflected in an increased use of close-ups.

The aim of the iterative approach of analyzing scenes from successful film is to eventually abstract the practical knowledge embedded in those creations, rather than postulating it from theoretical considerations alone. The current iteration of the VDS works partly as a director that determines what cinematic conventions fit the specific real-time conditions in conversation scenes, and partly as a controllable camera

system for which game designers will input basic instructions to get suitable shot sequences. The following is a high-level summary of the **abstracted principles** of cinematography that employ real-time character information to generate suitable shot sequences. In triadic conversations, the system firstly sets up an apex camera so that most faces can be revealed. Subsequently, cameras to capture each character are positioned on the same side as the apex camera relative to the line-of-action. During the conversation, three kinds of changes automatically affect shot selection:

- Horizontal movements of characters or turning heads change the line-of-action.
- Character changes, e.g. sitting down, affect framing ratios automatically.
- The mood of the scene and individual characters is represented as an "emotion" parameter per character that affects framing factors and angles in real time.
- Cuts between cameras are driven by dialog acts and reactions to player actions.

By design, the system enables the game designer to pre-specify shot sequences based on events such as character actions and utterances or changes in mood and character emotions. This approach allows the combination of system intelligence with authorial control and directorial stylistic choices. This design decision is also instrumental for our empirical approach of iteratively recreating analyzed scenes, based on the layered automatic techniques described above.

We used our system for three **scene recreations** from well-known films. While taken from linear narratives, they serve as approximations of interactive story settings in so far as one character is freely directed by the player, triggering interactions with other characters. These settings thus validate the functionality of our baseline system. At the same time, they serve as a platform for the iterative abstraction of camera automation principles and for the analysis of directorial style and other parameters that are not yet accounted for in the system. One example is the scene from "The Lady Vanishes" mentioned above. The other two are taken from "Chinatown" and "Strangers on a Train", respectively, see Fig. 1.

Fig. 1. Generated Shot Compare To Original Shot

As shown in Fig. 2, the system automatically adapts to variations in the scene resulting from player actions. The commonalities that were pointed out above were integrated into the baseline system for camera setups. The unique aspects of analyzed scenes, such as tendencies for selecting specific angles to reflect mood changes are just as valuable results towards enabling support for directorial styles.

Fig. 2. Automatic Adjustment on Shot Variations

3 Summary

We presented our combined theoretical and empirical approach towards an automatic Visual Director System focused on dynamic conversation scenes involving three characters. The implemented system provides for automatic real-time camera setups partly specified by authorial input and is realized as an AI module for a popular game engine. The empirical study of movie scenes is used to iteratively refine the techniques used for automating cameras without losing the focus on authorial control and the potential for directorial style when using the system in interactive games. The restriction to triadic conversation scenes limits the generality of the system but, at the same time, enables our approach that revisits essential problems of camera automation from the perspective of the desired end result.

References

1. Arijon, D.: Grammar of the Film Language. Hastings House, New York (1976)
2. Edgar-Hunt, R., Marland, J., Rawle, S.: Basics Film-Making: The Language of Film. Fairchild Books, New York (2010)
3. Hawkins, B.: Real-Time Cinematography for Games. Charles River Media, Newton Center (2005)
4. Mascelli, J.V.: The Five C's of Cinematography, vol. 1181. Silman-James Press, Los Angeles (1976)
5. Newman, R.: Cinematic game secrets for creative directors and producers, ch.7, pp. 91–106. Focal Press, Burlington (2008)
6. Pinelle, D., Wong, N., Stach, T.: Heuristic evaluation for games: usability principles for video game design. In: Czerwinski, M. (ed.) Proceedings of the SIGCHI Conference on Human Factors in Computing Systems, pp. 1453–1462 (2008)
7. Wand, E.: Interactive storytelling: The renaissance of narration. In: Rieser, M., Zapp, A. (eds.) New Screen Media-Cinema/Art/Narrative, ch.4, pp. 163–178. British Film Institute, London (2002)
8. Xue, B., Rank, S.: Capturing Triadic Conversations - A Visual Director System for Dynamic Interactive Narratives. In: Proceedings of the 7th Workshop on Intelligent Narrative Technologies, INT-7, Milwaukee WI. AAAI Press (2014)

AR as Digital Ekphrasis: The Example of Borsuk and Bouse's Between Page and Screen

Robert P. Fletcher

West Chester University
West Chester, PA, USA
rfletcher@wcupa.edu

Abstract. With the development of ubiquitous computing, the Web 3.0, and the so-called "internet of things," the implications of augmented reality (AR) for our understanding of digital storytelling and posthuman subjectivity have begun to preoccupy a number of cultural theorists and artists. AR routinely elicits ambivalent responses of fascination and fear. This uneasiness recalls one that has been attached to the rhetorical trope of ekphrasis, the verbal representation of a visual representation. Augmented reality offers a platform for developing and understanding the complexities of what Cecilia Lindhé has termed digital ekphrasis, and the AR text Between Page and Screen, by Amaranth Borsuk and Brad Bouse, exploits this digital ekphrasis to examine the metamorphosis of posthuman subjectivity in an age of pervasive data.

Keywords: augmented reality, digital storytelling, ekphrasis, electronic literature.

1 Introduction

With the development of ubiquitous computing, the Web 3.0, and the so-called "internet of things," the implications of augmented reality (AR) for our understanding of both digital storytelling and posthuman subjectivity have begun to preoccupy a number of cultural theorists and artists. Citing Adam Greenfield's *Everyware*, Virginia Kuhn claims that "the new Foucauldian gaze is no longer visual but biometric, computational, algorithmic and, as individual systems are linked, spreading their data exponentially, the gaze becomes environmental." [1] Lev Manovich notes that "the previous icon of the computer era—the VR user traveling in virtual space—has been replaced by . . . a person checking his or her email or making a phone call . . . while at the airport, on the street, . . . or any other actually existing space." [2] He argues that the "old binary logic" of visible/invisible (or present/absent) has been replaced by Claude Shannon's logic of pure signal and complete noise and that in a typical situation, we are "usually somewhere in between," for example, deep in the midst of a cellphone conversation punctuated by a spotty connection, or struggling to make out the figures in the blurry image on our friend's Facebook page. One ideal for enthusiasts of AR remains the same as it was for VR visionaries: immersion in a more complete, computer-mediated reality. If augmented space is saturated with data and

A. Mitchell et al. (Eds.): ICIDS 2014, LNCS 8832, pp. 220–223, 2014.

therefore ripe for narrative, we will have access to a reality both synesthetic and syn-chronic—the visual will merge with the aural, the material with the virtual, stories present with stories past.

However, Manovich, Kuhn, and others also note the key difference between 90s VR and emerging AR: "augmented space is monitored space" because it is also net-worked space. [3] The neologism "Glasshole" (for the wearer of Google Glass, which promises, among other things, the ability to record one's surroundings unob-served and share them on the network) expresses the anxiety of living in such a sur-veilled environment in which everyone and every thing is tagged, the stories to be told not always within the control of the marked individual. AR routinely elicits these oscillating responses of fascination and fear, bemusement vying with a sense of the uncanny. This uneasiness recalls one that has been attached to the long history of attempts to unite two different representational realities—visible and conceptual—through the rhetorical trope of ekphrasis, the verbal representation of a visual repre-sentation. Augmented reality, I would argue, offers a platform for developing and understanding the complexities of what Cecilia Lindhé has termed digital ekphrasis, and the AR text *Between Page and Screen*, by Amaranth Borsuk and Brad Bouse, exploits this digital ekphrasis by telling a story of the metamorphosis of posthuman subjectivity in an age of pervasive data.

2 Rhetorical and Digital Ekphrasis

W. J. T. Mitchell has analyzed the transhistorical ambivalence with ekphrasis into three typical responses, which are relevant to understanding AR's potential for digital storytelling as well: ekphrastic *indifference, hope,* and *fear.* While the indifferent see no possibility of the verbal and visual coming together into something greater, the hopeful see the promise of transcendence in such an augmented reality (and therefore more immersive story), wherein semiotic differences are overcome; on the other hand, the fearful are threatened by the "counterdesire that occurs when we sense that the difference between the verbal and the visual representation might collapse and the figurative, imaginary desire of ekphrasis might be realized literally and actually"—in other words, devolution from coherent narrative into a realm of absolute noise where differences in the signal are indiscernible. [4] However, for Lindhé, these contesta-tions in modern aesthetics over the relationship between visual object and its verbal representation leave out the rhetorical dimensions of an older understanding of ekph-rasis—the ancient rhetor's attempt to affect the listener's bodily perception of the object, an experience that could appeal not only to the visual but to the aural and tac-tile senses as well, and which forecast the bodily engagement of the AR user. [5] Artists and technology companies have indeed begun to explore these digital aesthet-ics through AR experiences, narrative performances that also highlight "the interac-tion between visual, verbal, auditive and kinetic elements" in the digital work of art. Examples include Google's "Night Walk in Marseille," J.R. Carpenter's "Entre Ville," and Augmented Reality in Philly. [6]

3 The Augmented Book

If location-based AR presents one version of digital ekphrasis—immersing the user in an aural, kinetic, and visual virtual world superimposed upon the real world—print-based AR offers a second: a digital ekphrasis that can engage the ambivalence that has characterized the relationship between visual and textual media in digital narratives, and it can do so while facilitating the reader's exploration of embodiment and subjectivity.

In her collaboration with developer/programmer Brad Bouse, *Between Page and Screen*, Amaranth Borsuk explores how AR can complicate our sense of postmodern identity as narrated in pervasive media. This "augmented" artist's book tells the love story of "Page" and "Screen" through eight letters and supplementary animated texts that are interspersed throughout the letters. Thus, the ekphrastic relationship of print and electronic media is personified as a tense epistolary romance—Heloise to Abelard, Robert Browning to Elizabeth Barrett—and the temperamental difference between lovers also communicates the ontological difference between media. The instability of both romance and mediated reality is conveyed through the medium used for the story, as described on the accompanying, indeed essential, website:

> The pages of this artist's book contain no text—only abstract geometric patterns and a web address leading to this site, where the book may be read using any browser and a webcam. The poems that appear, a series of letters written by two lovers struggling to map the boundaries of their relationship, do not exist on either page or screen, but in the augmented space between them opened up by the reader. [8].

In other words, to read the "book," the user must hold up an open page to the webcam until the AR software in the browser decodes the fiducial and displays the poem or animation in a uncanny, "real" 3D space between the page and screen. [9] The story told in the letters presents "P" as the partner in the relationship seeking to "pin" or "join" or "stake a claim"—in other words, to stabilize or define or unify them—while "S" explains that his best subject is "division" and that he likes "partition." The letters are composed in a pun- and rhyme-filled, syncopated style that seems influenced by hip hop, and this verbal duel between the lovers is punctuated by animated screens that continue the linguistic transformations.

P and S compete for control over the fraught, unstable reality of their relationship, as the story is played out in the floating space between page and screen, and this struggle over meaning is mirrored in the linguistic transformations programmed into the text. Etymology thus becomes another metaphor for a mediated, collaborative sense of reality, like the heterosexual romantic coupling and the page/screen binary, because the transformation of words through time violates the borders between languages—threatening the collapse of meaning—but also revitalizes language(s) in that very crossing. If the nature of the Page is to "fasten," the dissolution of the relationship through the narrative seems to favor the Screen's sense of reality as ephemeral, and his penultimate letter complains of the limitations Page would impose: "Page, don't cage me. Why this mania to name what's between us? That way is carnage, carnal carnival." Of course what's between them is the relationship itself, the reality of which is only embodied through the reader's performance of the book-machine.

4 Conclusion

Recently, philosophers of the posthuman have tried to push contemporary thought beyond the endpoint of poststructuralism by engaging with the ramifications of information technologies. For example, Brian Rotman has posited a *haptic self* that exists prior to and alongside the *alphabetic self* of literate society and suggested that embodiment and virtuality have thus always coincided. [10] Brian Massumi has called for an understanding of embodiment that will take us beyond the impasse of cultural studies. However, he also insists that embodiment is more complicated than a naive realism would allow for and contains a vestige of the ghostly and indeterminate: "The charge of indeterminacy carried by a body is inseparable from it." [11] As instantiated by Borsuk and Bouse, the digital narrative of *Between Page and Screen* deploys ekphrasis as a trope that echoes these philosophers' complex formulations of subjectivity. Material <u>and</u> virtual, the augmented book embodies a sense of the posthuman subject as collaborative and transactional.

References

1. Kuhn, V.: Web Three Point Oh: The Virtual is the Real. In: High Wired Redux: The Cybertext Yearbook, p. 11. Research Centre for Contemporary Culture, University of Jyvkaisuja Press (2013)
2. Manovich, L.: The poetics of augmented space. Visual Communication 5(2), 224 (2006)
3. Manovich, p. 223
4. Mitchell, W.J.T.: Picture Theory, p. 14. University of Chicago Press, Chicago (1994)
5. Lindhé, C.: A Visual Sense is Born in the Fingertips: Towards a Digital Ekphrasis. DHQ 7(1), Par. 3 (2013)
6. Google. A Night Walk in Marseille, https://nightwalk.withgoogle.com/en/home (accessed June 19, 2014)
7. Carpenter, J.R.: Entre Ville. The Electronic Literature Collection, V. 2, http://collection.eliterature.org/2/works/carpenter_entreville.html (accessed June 19, 2014)
8. Wink, C.: Augmented reality in Philly historic photos: Azavea and Philadelphia Department of Records smartphone details, http://technical.ly/philly/2011/02/28/augmented-reality-in-philly-historic-photos-azavea-and-philadelphia-department-of-records-smartphone-details/
9. Borsuk, A., Bouse, B.: About Between Page and Screen, http://www.betweenpageandscreen.com/about
10. Borsuk, A., Bouse, B.: Between Page and Screen. Siglio Press, Los Angeles (2012)
11. Rotman, B.: Becoming Beside Ourselves: The Alphabet, Ghosts, and Distributed Human Being. Duke University Press, Durham NC (2008)
12. Massumi, B.: Parables for the Virtual: Movement, Affect, Sensation, p. 5. Duke University Press, Durham NC (2002)

Appraisal of Emotions from Resources

Yathirajan Brammadesam Manavalan and Vadim Bulitko

Department of Computing Science, University of Alberta
Edmonton, AB, T6G 2E8, Canada
{yathi.bm,bulitko}@ualberta.ca
http://www.cs.ualberta.ca/~bulitko/research/emotion

Abstract. There have been tremendous advances in video-game graphics leading to realistic looking characters in many modern AAA titles. Unfortunately, the realistic looks do not always come with believable behavior of non-playable character AI. In particular, AI-driven video-game characters do not show plausible emotional reactions to interactions with the player unless they are hand-scripted for the particular encounter. We propose a light-weight algorithm for automatic generation of NPC emotional reactions at the level of actions and at the level of appearances. To do so adapt a recent resource-driven emotion model to generate NPC actions and extend it with a simple appraisal mechanism to explicitly compute emotional descriptors.

1 Introduction

Believable non-playable characters (NPC) are critical to creating an immersive character-rich experience whether it is for AAA game titles or training simulations [11,3]. Emotionally plausible characters make the fictional world come alive. Conversely, emotionally implausible interactions break the player's immersion and remind her that she is merely playing a video game. While it is possible to manually script primary NPCs to display emotionally plausible responses, the procedure is expensive. Other, non-scripted, characters are left to utter repeated one-liners, ignore the player or warmly greet her after she walked on their dinner table during a meal. In this paper we propose a modest step towards a more realistic story-telling experience by developing a light-weight computational model that drives NPC appearance and actions.

2 Problem Formulation

The problem we are concerned with in this paper is giving non-playable characters populating an interactive digital storytelling medium believable emotion-driven behavior and appearance. We strive for a model that (i) makes the NPCs behave and look emotionally believable, (ii) has a light computational footprint, (iii) is relatively easy to implement and integrate with other systems (e.g., procedural facial animation system).

A. Mitchell et al. (Eds.): ICIDS 2014, LNCS 8832, pp. 224–227, 2014.
© Springer International Publishing Switzerland 2014

3 Related Work

Below we review three camps of work on making NPCs emotionally believable. In the first camp we have manual scripting and actor capture [12]. Both approaches are resource-demanding at the development stage. As a result, only primary video-game NPCs can be afforded such treatment. Scripting each NPC individually for a wide range of situations is possible [8,9] but the prohibitive costs limit the scope of the game.

Outside of video games, NPCs in intelligent training systems have benefited from procedurally generated emotionally and culturally affected behavior [15,4,7,1]. Some of such systems use appraisal models of emotion postulating that emotions are elicited by an appraisal of character's goals with respect to the character's chances of reaching those goals from the current state [6,13,10]. This requires specifying the goals, computing the plans and computing the probability of their success. An automated planner may need to be run to compute this information. While powerful, this approach may not be lightweight enough for an easy inclusion into an interactive storytelling environment.

The third camp embraces the idea of the player's attributing emotions to an NPC based on the observed NPC behavior (e.g., if an NPC walks away during a conversation with a player it is likely offended or frightened by the player). Without having to model the emotional state of an NPC explicitly, the approaches in this camp focus on coping mechanisms of the NPCs. A particular coping mechanism is based on conservations of *resources* [5] which postulates that NPC's actions stem from protecting and gaining resources the NPC deems valuable. The psychological theory has been computationally implemented as the *Conservations of Resources Engine* (COR-E) [2]. The model is intuitive, relatively easy to implement and computationally light weight which encourages its adoption in interactive storytelling. However, it does not compute emotional descriptors (e.g., the intensity of fear the NPC is experiencing). Consequently, COR-E is unable to drive appearance of an NPC such as facial animations and voice modulations. Thespian [14] is a similar model which holds continuous values called goal states instead of discreet resources and these goal states are ranked using goal weights. But this model also does not compute emotional descriptors.

4 Proposed Approach

We extend the COR-E model with the ability to explicitly compute emotions. We do so with a simplified version of the appraisal model of EMA to drive NPC appearance. We name the combination *Appraisal for Conservation Of Resources Engine* (A-CORE). The key concept of COR-E and, by extension, A-CORE is resources. Each NPC modelled by A-CORE has a vector of resources weighted by their importance to the NPC. The weights are NPC-specific. The weighting determines the personality of each NPC as is done in Thespian.

Notationally, given an NPC, $\bar{r}_t = (r_1, r_2, ..., r_N)$ is the vector of resource values the NPC has at time t. Here N is the total number of resources modelled. The NPC's resource weights are $\bar{w}_t = (w_1, w_2, ..., w_N) \in [0, 1]^N$.

4.1 Computing Actions

Each NPC has a set of actions available to it[1] which can affect the resources the NPC holds (e.g., getting into a fight may negatively affect the NPC's health). NPCs select actions that are expected to increase their cumulative weighted resource value as formalized below. Let the set of actions available to an NPC be denoted by A. By taking an action $a \in A$ at time t, the NPC expects its resources \bar{r}_t to be affected by the action and become \bar{r}_{t+1}. Action effects may be stochastic in which case the NPC cares about the expected value $E[\bar{r}_{t+1}|a]$. The value of the action to the NPC is the weighted sum of the expected resource gain the action yields: $V(a,t) = \bar{w}_t \cdot (E[\bar{r}_{t+1}|a] - \bar{r}_t)^T$. Having computed the value of each action, the NPC will execute the action a_t with the highest expected value, using a soft max or a hard max over the values: $a_t = \arg\max_{a \in A} V(a,t)$.

4.2 Emotion Appraised from Resources

We simplify the process of computing emotion as compared to EMA by assuming that each NPC has only a single goal: increasing the weighted resource value. The appraisal process is then limited to considering changes in the resource vector. In line with CEMA [1], we model only four emotions: hope, joy, fear and distress. The emotion of hope is elicited when an action can possibly improve a resource but it is not certain to do so. An action that is guaranteed to improve a resource elicits joy. Likewise, an action likely to worsen a resource elicits fear and when it is a certainty then the NPC will feel distress. The intensity of each emotion with respect to a resource is a product of the desirability of the change in the resource caused by the action and the certainty of the change. The total intensity of each emotion is the sum of its values for each resource.

 Notationally, suppose at time t the NPC has a resource r_t (a single component of the resource vector). Suppose an action a is expected to change the resource r_t to $E[r_{t+1}|a]$. The desirability of the change in the resource r_t is $\delta(r_t|a) = w_t \cdot (E[r_{t+1}|a] - r_t)$. The certainty of the change is the probability that the change will occur as desired: $\beta(r_t|a) = \begin{cases} Pr(r_{t+1} \geq r_t|a) & \text{if } \delta(r_t|a) \geq 0, \\ Pr(r_{t+1} < r_t|a) & \text{if } \delta(r_t|a) < 0. \end{cases}$ Thus, if an action a is expected to improve the resource r_t (i.e., $\delta(r_t|a) \geq 0$) but is not certain (i.e., $\beta(r_t|a) < 1$) then the emotion of hope is elicited with the intensity of $|\delta(r_t|a)| \cdot \beta(r_t|a)$.

5 Contributions and Future Work

A-CORE makes three extensions to the previously published COR-E. First, whereas COR-E did not explicitly compute emotional states of an NPC, we do so by adopting an appraisal-style model of emotions from EMA. Second, whereas COR-E represented the NPC's preference over resources as a ranking

[1] The actions were called behaviors in COR-E [2].

relation, we do so with weights which allows us to represent multiple resources equally important to the NPC. Third, whereas an NPC in COR-E either had a resource or did not, an NPC in A-CORE holds resource at a continuous value. The appraisal is done over resources which are already defined in the COR-E system and thus does not require explicitly computing the NPC's goals and plans to achieve them and is expected to maintain a light computational footprint.

We have implemented an early prototype and are preparing a user study to evaluate the emotional believability of A-CORE as well as measure its computational footprint. We also plan to work with commercial video game developers to evaluate the integration of A-CORE to modern video game titles.

References

1. Bulitko, V., Solomon, S., Gratch, J., van Lent, M.: Modeling culturally and emotionally affected behavior. In: The Fourth Artificial Intelligence for Interactive Digital Entertainment Conference, pp. 10–15. AAAI Press (2008)
2. Campano, S., Sabouret, N., de Sevin, E., Corruble, V.: An evaluation of the cor-e computational model for affective behaviors. In: The 2013 International Conference on Autonomous Agents and Multi-agent Systems, pp. 745–752. International Foundation for Autonomous Agents and Multiagent Systems, Richland (2013)
3. Gratch, J., Marsella, S.: Fight the way you train: the role and limits of emotions in training for combat. Brown Journal of World Affairs X(1), 63–76 (2003)
4. Gratch, J., Marsella, S.: A Domain-independent Framework for Modeling Emotion. Journal of Cognitive Systems Research 5, 269–306 (2004)
5. Hobfoll, S.E.: Conservation of resources: A new attempt at conceptualizing stress. American Psychologist 44(3), 513 (1989)
6. Lazarus, R.S.: Emotion and adaptation. Oxford University Press, New York (1991)
7. Marsella, S.C., Gratch, J.: EMA: A process model of appraisal dynamics. Journal of Cognitive Systems Research 10(1), 70–90 (2009)
8. Mateas, M., Stern, A.: Façade: An experiment in building a fully-realized interactive drama. In: Game Developers Conference (GDC 2003) (2003)
9. Mateas, M., Stern, A.: Structuring content in the façade interactive drama architecture. In: Young, R.M., Laird, J.E. (eds.) The 1st Conference on Artificial Intelligence and Interactive Digital Entertainment, pp. 93–98. AAAI Press (2005)
10. Ortony, A., Clore, G., Collins, A.: Cognitive Structure of Emotions. Cambridge University Press (1988)
11. Reilly, W.S.: Believable Social and Emotional Agents. Tech. rep., Defense Technical Information Center (DTIC) Document (1996)
12. RockstarGames: L.A.Noire (2011)
13. Scherer, K.R., Schorr, A., Johnstone, T.: Appraisal processes in emotion. In: Davidson, R.J., Ekman, P., Scherer, K.R. (eds.) Affective Science. Oxford University Press (2001)
14. Si, M., Marsella, S., Pynadath, D.V.: Thespian: using multi-agent fitting to craft interactive drama. In: Fourth International Joint Conference on Autonomous Agents and Multiagent Systems, pp. 21–28. ACM (2005)
15. Traum, D., Rickel, J., Gratch, J., Marsella, S.: Negotiation over tasks in hybrid human-agent teams for simulation-based training. In: Second International Joint Conference on Autonomous Agents and Multiagent Systems, pp. 441–448. ACM (2003)

A Little Goat Builds the World –
An Interactive Children Story for Tablets

Kamil Kamysz[1] and Marcin Wichrowski[2]

[1] Jan Matejko Academy of Fine Arts, Faculty of Industrial Design,
Department of Visual Communication, Krakow, Poland
[2] Polish-Japanese Institute of Information Technology, Warsaw, Poland
kkamysz@asp.krakow.pl, mati@pjwstk.edu.pl

Abstract. This work presents a prototype of non-chronological open structure children narrative dedicated for tablets. How will young readers find themselves in this new environment and react to new kind of storytelling experience? Is the notion of "interactivity" just a marketing trick to sell more software and mobile apps or is it a tool that will really support a child's development?

Keywords: interactivity, digital storytelling, ergonomy for children, fine motor skills development.

1 Introduction and Related Works

E-books, e-book readers, touchscreens and other types of displays do not belong to the realm of fantasy any more, but are an indelible part of our reality. Interactivity is becoming a key ingredient of electronic publications.

There are several projects dedicated for children which allow to practice important literacy skills, such as language development, story comprehension, sense of the structure, collaborating in storytelling by playing and experimenting [1,2]. These activities are crucial to a child's development [3]. During middle childhood what seems to be the most important is a process of development involving increasingly creative use of playing to develop plots and episodes, the transition from individual to group play, the growing importance of language in plot development and strengthening of links between play and social life. It is important that a child interacts with a book, not just by passively following a story but by participating in its creation upon every encounter. Graphic design should aim at facilitating linguistic and social development of a child, at the same time stimulating his or her creativity and abstract thinking, as well as supporting the development of fine motor skills, which are all necessary to self-sufficiency.

The presented solution is a new type of plot construction in a publication – an open structure which is not chronological but has some key points (like the beginning and end) predefined. It is also an attempt at using gestures, which are native to software in a way that is beneficial from the point of view of developmental psychology [4]. Therefore project's key requirements involve the following aspects: educational, emotional, ergonomic as well as more detailed objectives:

A. Mitchell et al. (Eds.): ICIDS 2014, LNCS 8832, pp. 228–231, 2014.
© Springer International Publishing Switzerland 2014

- using gestures to facilitate a child's development (the development of brain hemispheres, eye-hand coordination, developing abstract thinking),
- the opportunity of constructing a variety of stories – a child builds a story by himself or herself, deciding on the plot development,
- the use of the random algorithm – the book becomes a new story, explored by a child at every encounter, but within the preprogrammed framework (beginning-development-ending),
- simplifying the interface, "learning the use of the book" as part of the game.

2 Idea and Construction

The idea of the publication is based on two independent screen parts (upper and lower), which can be manipulated at will, changing their order. The construction concept is not new but the project tries to go one step further – attempting to link the contents of the upper and lower parts so that they always make sense and build a story with the aid of the reader. The construction of illustrations allows for the story to be modified – in the example presented below the upper part of the screen remains the same, while the lower is changed (see Fig. 1.). It gives the impression of fluid course of action, at the same time presenting different content from the previous screens.

 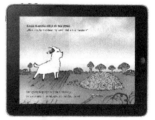

Fig. 1. Combination of upper and lower screen parts building different scenes

For example, the sun from the top screen may cause different behavior of objects on the lower screen - water will disappear, leaves will dry up, animal will fall asleep and so on. If you change the sun to the wind then elements from the lower screen behave differently - water will move, leaves will begin to fly, animal will wake up etc. The application consists of five screens that can be moved independently of each other, and the final screen which is displayed at the end of story. The screens have been combined into a single panoramic image with tonal transitions which smoothly blend the screens together (see Fig. 2., Fig. 3.).

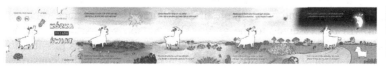

Fig. 2. All screens combined into a single panoramic image

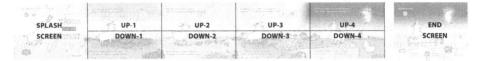

Fig. 3. The division into individual screens and the end screen

The mechanics of the application has been designed so that it corresponds with basic gestures and actions which serve to control the operating system in order to prevent a user's feeling of being lost [5] (see Fig. 4.). The story engine was developed in Adobe Flash CC which provides both the tools for creating vector graphics and animation, as well as options to produce advanced interactive applications for desktop and mobile platforms (using Adobe AIR) [6,7].

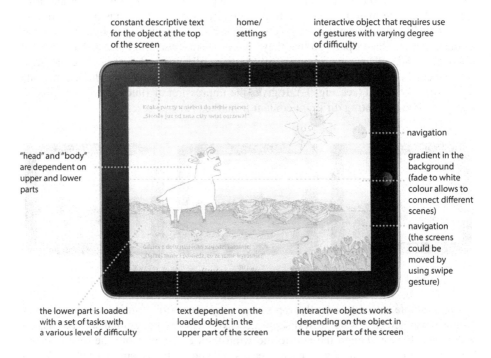

Fig. 4. Layout of application with interactive areas

3 Research Methodology for User Study

The qualitative user study will be conducted on a group of early readers (aged 6-9) in primary school in Cracow, Poland on a sample of 20 children. Two interface versions of the application will be presented to the group. One version will be using classic arrow-themed navigation, the other one aims to use as little visual hints as possible to compare the comprehension of symbols (or lack of them) used in navigation construction. The test also aims to verify the speed of learning the user interface usage while

little or no visual hints are provided. Alternatively, a test of visual affordance is to be conducted, using two versions of the same application, built with different saturations of backgrounds. Setting the proper colors would help making the user experience as useful as possible. The tests are to be recorded using video camera for later analysis.

4 Future Development and Conclusions

Proposed open structure design, based on randomly chosen interactive elements allows to update the software periodically extending the product life cycle with new objects and functionalities. Future development involves also adding new TouchEvents / TouchGestures for providing better and more natural user experience. Another idea is releasing a series of publications using presented engine. In a relatively simple way, it is possible to redesign characters with different activities and relationships with other objects to make more engaging stories based on a new content.

The presented prototype and planned user study will allow to check children reaction to non-chronological storytelling application and aim to verify the design principles along with the fine motor skills needed to manipulate the objects on touch screens.

This project is also a great opportunity to join forces of an artist and an IT specialist to use new mobile technology for creating interactive storytelling experience dedicated to children.

References

1. Figueiredo, A.C., Pinto, A.L., Branco, P., Zagalo, N., Coquet, M.E.: Bridging book: a not-so-electronic children's picturebook. In: Proceedings of the 12th International Conference on Interaction Design and Children, IDC 2013, pp. 569–572. ACM, New York (2013)
2. Sylla, C., Gonçalves, S., Brito, P., Branco, P., Coutinho, C.: A Tangible Platform for Mixing and Remixing Narratives. In: Reidsma, D., Katayose, H., Nijholt, A. (eds.) ACE 2013. LNCS, vol. 8253, pp. 630–633. Springer, Heidelberg (2013)
3. Okoń, W.: O zabawach dzieci (How children play). PZWSZ, Warszawa (1950)
4. Maas, V.F.: Uczenie się przez zmysły. Wprowadzenie do teorii integracji sensorycznej dla rodziców i specjalistów (Learning Through our Senses). WSiP, Warszawa (1998)
5. Sikorski, M.: Interakcja człowiek-komputer (Human-Computer Interaction). Wydawnictwo PJWSTK, Warszawa (2010)
6. Caleb, C.: Flash iOS Apps Cookbook. Packt Publishing, Birmingham (2011)
7. Labrecque, J.: Flash Development for Android Cookbook. Packt Publishing, Birmingham (2011)

CHESS: Personalized Storytelling Experiences in Museums

Akrivi Katifori[1], Manos Karvounis[1], Vassilis Kourtis[1], Marialena Kyriakidi[1], Maria Roussou[1], Manolis Tsangaris[1], Maria Vayanou[1], Yannis Ioannidis[1], Olivier Balet[2], Thibaut Prados[2], Jens Keil[3], Timo Engelke[3], and Laia Pujol[4]

[1] Department of Informatics and Telecommunications,
University of Athens, Athens, Greece
{vivi,manosk,vkourtis,marilou,mroussou,
mmt,vayanou,yannis}@di.uoa.gr
[2] DIGINEXT, Toulouse, France
{olivier.balet,thibaut.prados}@diginext.fr
[3] Department for Virtual and Augmented Reality,
Fraunhofer, IGD, Darmstadt, Germany
{jens.keil,timo.engelke}@igd.fraunhofer.de
[4] Department of Humanities, Pompeu Fabra University, Barcelona, Spain
pujol.laia@gmail.com

Abstract. In this work, we present the CHESS research prototype system which offers personalized, interactive digital storytelling experiences to enhance museum visits, demonstrating the authoring and visiting experiences.

Keywords: Personalized interactive storytelling, mobile experience, authoring.

1 Introduction

Museums routinely "tell stories" through the meaningful presentation of their collections with the help of visual and narrative motifs [1]. Incorporating a form of narrative in a museum visit comes as a natural extension to the museum function as a storyteller. It can contribute to making collections more accessible and engaging for different audiences and a great line of work is being carried out on that front [2, 3].

CHESS (Cultural Heritage Experiences through Socio-personal interactions and Storytelling) [5] aims to enrich museum visits through personalized interactive storytelling. Besides visitors, CHESS also considers another type of users; museum authors. It follows a hybrid, plot-based approach for story authoring and uses personalized information to create customized stories that guide visitors through a museum. It also employs mixed reality and pervasive games techniques, ranging from narrations to augmented reality (AR) on mobile devices. Two museums participated in the effort, the Acropolis Museum in Greece, and the Cité de l 'Espace in France. In this work, we focus on an example story developed at the Acropolis Museum (AM).

A. Mitchell et al. (Eds.): ICIDS 2014, LNCS 8832, pp. 232–235, 2014.
© Springer International Publishing Switzerland 2014

2 Creating CHESS Experiences

CHESS experiences are created with the CHESS Authoring Tool (CAT), which helps to visually manage and publish them. After defining a plot and gathering the basic exhibits and assets (images, texts, activities), authoring with CAT involves creating the story graph nodes and linking them to hotspots on the museum map and to multimedia assets (Figure 2b). Personalization annotations can be added to the graph through the attributes panel.

CHESS stories can be implemented through a wide range of activity types, from simple audio with still images, to animations, games, interactive images, and AR. These activities are integrated in a seamless storytelling flow. For example, AR is not only used as an individual media type but rather as an extension of the presentation form: when pointing the device towards a statue, its original bright colours, along with superimposed text and audio annotations, are presented (Figure 2a). The implementation of these activities is based on web technologies, thus easing their technical integration in the CHESS system.

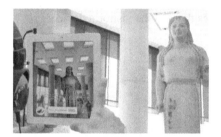

Fig. 1. (a) On the left, an AR activity, (b) on the right, the CHESS Authoring Tool

3 A Personalized Storytelling Experience

The visitor's experience starts with a quiz, which can be accessed remotely, through the Web, or at the museum, from the visitor's mobile device. The quiz gathers evidence regarding visitor preferences in order to initialize the user profile. Quiz questions are kept at a minimum (usually 3-5 questions) to minimize the time spent on the quiz. An indirect approach is followed, to avoid visitors feeling "tested" and to make the quiz more engaging. An example is presented in Figure 2a. After initializing the visitor profile, the system chooses the most suitable story and the experience begins.

Let's take for example one of the five stories created at the Acropolis Museum, which is narrated by the fictional character Melesso: "Melesso, a noble woman, talks about her life in Athens during the 6th century BC. Join her journey of memories, choose the ones you want her to share with you, and learn about the historical events that affected her life." The story covers many topics, including love and marriage, women's life, ancient temples, (Figure 2b), mythology and the Persian wars. The narrations guide the visitor in the Gallery and unfold along different paths that all lead to a 6th century bronze statue dedicated by a woman named Melesso.

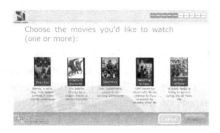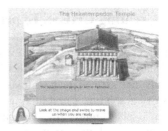

Fig. 2. (a) On the left, a typical quiz question; (b) on the right, Melesso presents a temple located on the Acropolis of Athens

The story is constructed so as to allow dynamic personalization of its contents. During the experience, the visitor is presented with menus and action buttons. The visitor selections and actions during the visit shape the visitor profile and influence subsequent choices of the system regarding which part of the story graph will be presented next. The story graph contains script nodes and branching points (BPs) and it is internally represented using an XML-based format. It is accessed at run-time by the Adaptive Storytelling Engine (ASTE), which traverses the graph, retrieves the corresponding digital resources, and then provides them to the visitor's device.

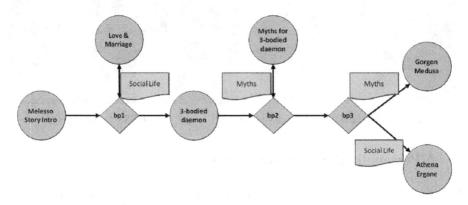

Fig. 3. Part of the Melesso story graph with annotations

Story adaptation is based on authors' annotations for the different options at the BPs. These annotations summarise the content of each branch. The ASTE uses these annotations in two ways: (a) when a BP is reached, the current visitor's profile is used to rank the possible choices (branches) in descending order of predicted interest, and thus, recommend the top choice to the visitor; (b) when the visitor selects an option, depending on his behaviour during the corresponding story part (successful completion or skip), his profile is updated with positive or negative evidence respectively [4].

In our example (Figure 3), after the introduction to the story, the visitor is presented with a menu (bp1) asking whether he wishes to move on or stay at a nearby showcase to learn about love and marriage in ancient Athens. If the visitor chooses "Love and Marriage" and then decides to skip it, then negative evidence is stored in his profile for subsequent content with the annotation "Social Life". If afterwards he

chooses to listen to the part "Myths about the three-bodied daemon" and completes it, positive evidence is created for content with annotation "Myths". As a result, when bp3 is reached, the ASTE will recommend to the visitor the branch "Gorgon Medusa", related to "Myths", and not "Athena Ergane", related to "Social Life".

It is worth noting that ASTE can handle any vocabulary of annotations, since it is based on a generic content-based approach. In this way, it enables authors to create any type of annotations appropriate for their story. However, when the vocabulary of annotations changes or expands, the CVS needs to be adjusted to effectively represent the relations between the CVS questions and the new concepts introduced.

4 Results and Conclusions

To evaluate the described approach, implemented through the story of Melesso, an in situ evaluation with 28 museum visitors and staff took place at the Acropolis Museum. Users were "shadowed" by two evaluators while experiencing a CHESS story and then interviewed. The results are still being analyzed and have not been collectively published yet; nevertheless, user feedback has been very positive overall, both from visitors and museum staff. According to museum curators, CHESS stands out as a very promising system for the creation of different approaches to exhibits, allowing adaptation to different visitor types. Regarding visitors, CHESS seems to foster interest for the exhibits, even in the case of visitors with no pre-existing interest for the museum, and may encourage re-visiting. As one user expressed, "CHESS is a fun way of visiting a museum. It can take you back to your childhood where you had your parent playing the role of discreet guide and entertainer."

Acknowledgements. This research has been conducted under the CHESS project that has received funding from the European Union's 7th Framework Programme for research, technological development and demonstration under grant agreement no 270198.

References

1. Bedford, L.: Storytelling: the real work of museums. Curator 44(1), 27–34 (2004)
2. Ioannidis, Y., Raheb, K., Toli, E., Boile, M., Katifori, A., Mazura, M.: One object many stories: Introducing ICT in museums and collections through digital storytelling. In: Digital Heritage International Congress, pp. 421–424 (2013)
3. Lombardo, V., Damiano, R.: Storytelling on mobile devices for cultural heritage. The New Review of Hypermedia and Multimedia 18(1-2), 11–35 (2012)
4. Vayanou, M., Karvounis, M., Katifori, A., Kyriakidi, M., Roussou, M., Ioannidis, Y.: The CHESS Project: Adaptive Personalized Storytelling Experiences in Museums.In: UMAP Project Synergy Workshop (to appear, 2014)
5. CHESS, http://chessexperience.eu/

Unfinished Business – A Transmedia Project

Ana Carolina Silveira von Hertwig

New Media Artist
Florianópolis, Brazil
cinejornal@gmail.com

Abstract. Unfinished Business is a transmedia project presented at the seventh International Conference on Interactive Digital Storytelling's Demonstrations. It is an interactive Web platform based on a hybrid non-linear narrative available at the following link: http://www.unfinishedbusiness.com.br

1 Interactivity and Innovation in Contemporary Storytelling

Unfinished Business is a Web-based interactive narrative hybrid fiction/non-fiction and it constitutes a preliminary investigation of how interactivity coupled with non-linearity can help effectively express intangibles and how such ordered irrationality is related to the development of non-narrative storytelling for the Internet.

This project was defended in August 2013 as a final year undergraduate film thesis at the Federal University of Santa Catarina. In April and May 2014 it was shown at the Helena Fretta Art Gallery in Brazil and its concept permits a transmedia experience presented as a small-structure installation, including a computer-based animated presentation/projection and an exhibition of still photography.

Motivating audience participation via the juxtaposition of complementary technologies to create compelling interactive storytelling experiences, this project adapts and shares personal stories with an aesthetic perspective based on the psychological, sociological and environmental parameters that define the human condition. It constitutes an examination of how interactivity coupled with non-linearity can help art effectively express immaterial sentiments, impressions and reflections distilled from observations gathered in particular from my investigative wanderings through contemporary environments, both public and personal.

Concretely, Unfinished Business is made up of films, still pictures, projections, texts and soundscapes to create an immersive and irrational mental state. This project was put together on Klynt, a content edition tool for Web platforms that permits the construction of a multilayered structure, facilitating non-linear exploration. This structure permits an investigation of the creative potential inherent in combining diverse formats and media from 16mm, super 8, s35mm, multiple still photography formats and experimental techniques to the latest digital audiovisual supports. In doing so, it exploits traditional black and white chemical procedures and non-conventional developing processes, also including experimentations on scanning, digital treatment and animation techniques.

A. Mitchell et al. (Eds.): ICIDS 2014, LNCS 8832, pp. 236–237, 2014.

My main influences are the works on perspective and spatial organization found in the Dutch graphic artist M.C. Escher's "Impossible Constructions" [1], the writings of Argentine writer Jorge Luis Borges, "The Library of Babel", in which author imagines the universe as a vast network of interconnected reading rooms including all possible books [2]; the concepts of time and movement of French philosophers Gilles Deleuze [3,4] and Henri Bergson's [5] and their thoughts on perception, multiplicity and continuity [6].

The Web platform permits online 'wanderers' to explore, relate and interact with three main virtual environments and eighteen audiovisual segments involving multilayered screens. The audience can associate and interact to embark on a journey through both known and unknown states of mind resulting in a dynamic self-analytical diary.

It unveils impressions and thoughts exploiting transmedia's potential to promote new perspectives via the multilayered combination of photography, cinema, literature and philosophy in a framework in which storytelling and art are fused to shed new light on contemporary issues provoking compelling intellectual and psychological exchanges. By stimulating reflection on the nature of flows (imagetic or connective) and the use of technology as devices for artistic creation, the project encourages the exteriorization of our innermost desires to comprehend our contemporary urban lives.

As an artist I challenge myself to transform simple everyday events and situations into stories that could motivate people to interact with this state of mind as if it were their own in order to provide a totally immersive online cinematographic experience.

I believe interactive storytelling coupled with art empowers us emotionally, intellectually and fundamentally alters the way in which we gather and share information, promoting the development of innovative partnerships between interactivity and self-expression. This approach has permitted Unfinished Business to further stimulate my ongoing interest in both the technological and creative sides of contemporary storytelling. It is my hope that perhaps this experience embodies perspectives capable of motivating people to push back their boundaries as well as those of new media forms of expression to go beyond what is known and comfortable. In the end, it is all about risk-taking and getting up again every time we fall down. It is all about life.

References

1. Escher, M.C.,
 http://www.mcescher.com/gallery/impossible-constructions/
2. Borges, J.L.: Ficções. Companhia das Letras, São Paulo (2007)
3. Deleuze, G.: Bergsonism. Zone Books, New York (1988)
4. Deleuze, G.: Cinema I: The Movement-Image. University of Minnesota Press, Minneapolis (1986)
5. Bergson, H.: Duration and Simultaneity. Clinamen Press, Manchester (1999)
6. Bergson, H.: Matter and Memor. Zone Books, New York (1994)

A Storytelling Game with Metaphor

Andreas Magnus Reckweg Kuni[1], Byung-Chull Bae[2], and Yun-Gyung Cheong[3]

[1] IT University of Copenhagen, Copenhagen 2300, Denmark
anmk@itu.dk
[2] Sungkyunkwan University, Seoul, South Korea
byuc@skku.edu
[3] Sungkyunkwan University, Suwon, South Korea
ygcheong@gmail.com

Abstract. In this paper we present a cartoon-like 2D storytelling game utilising metaphor and symbolism with a form of framing narrative. The game and the story were designed in an abstract and satirical manner, providing the player room for interpreting her gameplay in various ways.

Keywords: storytelling game, metaphor.

1 Introduction

The primary goal of this work is two-fold. The first is to design a storytelling game in which narrative and gameplay are tightly coupled. The second is to make a short game using simple game mechanics as metaphors to tell a story. Hereby we define 'game mechanics' as the rules that governs the gameplay. Examples of game mechanics being used in our game are as follows: the player can jump by pressing a button; the player can move by pressing buttons; the actors fall when they aren't standing on a platform; other actors can push the player and the other actors can mimic the player's actions.

This project was inspired by several games and literature. The gameplay for this project was inspired by The Game [1]. While being a funny game, it didn't utilise its great humour or metaphors to tell a cohesive story. The story and feel was slightly inspired by the game Loneliness [2]. It manages to make the player feel a deep sympathy for a simple cube, only through gameplay and music. This work utilizes the framing narrative device similar to the one used in 1001 Arabian Nights, where 1001 stories are embedded into one long overarching story[3, p. 28].

2 Game Design and Implementation

The game is a simple 2D game where the player controls one character through 10 levels or scenes. At the most superficial level, the game is about a grandpa who is telling his grandchild a story, or several small stories, about his life and the world. Each mini-story (that is, each level or scene) recounts a constituent event with one major topic like friendship, marriage, religion, etc. In the end, the story slightly confuses the grandchild and the two leaves to get some ice cream.

A. Mitchell et al. (Eds.): ICIDS 2014, LNCS 8832, pp. 238–241, 2014.

We designed the game mechanics simple (move, jump) to prevent the player from being distracted from interpreting the story by having to learn complex rules and controls. A level is terminated when any actor jumps or falls off the platform; most often it is the player who does this. Falling or jumping off the platform could be interpreted in different ways. Creating multiple scenarios using the same mechanics was essential to keep the player focused on the story.

The colours and shapes represent the mentality of the storytelling grandpa. Everything except him is represented in monotone (black, grey and white) because he thinks that the world is a sad place. To him, religion is only about blindly following a prophet like a sheep. All the actors are also almost literally and figuratively squares, as opposed to being rounded characters. The actor that represented grandpa in the 10 scenes was coloured blue, so that the player could remember him as re-occurring actor. The main problem is finding a way to glue together the different scenes in a cohesive way.

To combine different scenes in a natural manner, we designed a story that embedded the 10 mini-stories (or levels) where a grandpa tells stories to his grandson. Using this framing device allows the game to jump around in time without confusing the player. The most important purpose of the framing narrative, about grandpa and his grandson, is that it allowed experimentation of combining gameplay mechanics, metaphors, and storytelling. The implementation itself only had to be a simple dialogue, shown as text. Even though there is no explicit clock in the game, players could feel the passing of time though the events. This "chrono-logic of narrative" [3, p. 16] allows the discourse of the game to be conveyed in 2 minutes, while the story itself is about a life-time long.

The following is a breakdown of each scene where the most important design decisions are accounted for. The point was to use game mechanics as metaphors to tell a story.

Scene 1 – Childhood. The Childhood scene contains grandpa as a very young child and his parents. The player does not control grandpa, but rather his father. The purpose of the scene was two-fold: teaching the player how to walk and setting up the beginning of grandpa's story.

Scene 2 – School. The School scene contains player-controlled grandpa and a teacher who points to a blackboard that says: "Jump". Again, the purpose of this scene was two-fold. Teaching the player how to jump, but also give an impression of grandpa's attitude towards the public education system. The authoritative teacher tells us to jump off a cliff, and then we jump off a cliff without any idea of why we did it.

Scene 3 – Friends. The Friends scene contains player-controlled grandpa who is being pushed off the edge by other kids. The push and fall here represents the resistance, but inevitable subjection to peer pressure.

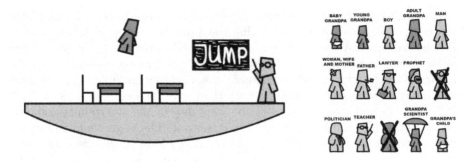

Fig. 1. Left: Screenshot of the second scene (School) in the game; Right: Design of the game characters. The two figures marked cross were not chosen in the current game.

Scene 4 – Relationships. The Relationships scene contains a grown-up, player-controlled grandpa, and two groups of female actors on both sides. When the player attempts to go near them, they simply move away until they fall off the platform. The scene was inspired by the phrase: *"I rather die than to go on a date with you!"*, or in this case, jump off a cliff.

Scene 5 – Marriage. The Marriage scene contains player-controlled grandpa and a woman who runs around on the platform, shoving grandpa aside if he stands in her way. This is essentially the same scene as Friends, although grandpa has gained a bit more control.

Scene 6 – Divorce. The Divorce scene is an extension of the marriage scene. It contains the same things with the addition of a running lawyer who will be positioned on the left side of grandpa.

Scene 7 – Religion. The Religion scene contains a prophet, whom the player controls, and a big crowd of people facing him. The group does not move until the prophet has jumped over the edge of the platform, which is the point where the group will follow suit like sheep or lemmings, even if it gets them killed by wandering off a platform.

Scene 8 – Politics. The Politics scene is built similarly to Religion. It contains a politician and a big crowd of people facing him. Unique to this scene, the player controls all the actors. They all move in perfect synchronisation. The only detail is that the politician is unable to fall over the edge of the platform. The crowd can be controlled and moved to drop over the edge like lemmings, again.

Scene 9 – Science. The Science scene only contains player-controlled grandpa. It is the first scene which was intended to say something positive, and can be interpreted in a lot of ways because of its high level of abstraction. When grandpa goes over the edge, a parachute unfolds and he gently descends.

Scene 10 – Parenthood. The Parenthood scene contains player-controlled grandpa and a slightly bluish child which reacts with love when grandpa walks near, which will also end the scene. Alternatively, grandpa can end the scene by jumping over the edge. The player has a choice to make grandpa follow in his father's steps and leave his child, or simply stay.

3 Pilot Study and Conclusion

A pilot study has been conducted with 6 (male 5; female1) students from IT University of Copenhagen, Denmark. Each participant played our game on a laptop and then had an one-on-one interview about the overall play experience.

All the players agreed that the story was about the life of someone, at least up until Scene 7 (Religion), but two of the players did not realize that it was the grandpa's life. The players were also asked about their three favourite scenes. Five of the Players chose Religion and four of those also went with Politics. The reason was that they were funny and worked well together. They liked the similarities between the two scenes. After naming their favourite scenes, they were then asked to interpret them. Two of the players did not think that there was any greater purpose to the fact that (almost) every scene ended with falling down. They simply thought it was a way to advance the story.

In conclusion, there is still information to be extracted from more user testing. To improve the sense of agency and the feeling of playing a game, more choices, or just the illusion of having more, could be incorporated. To some people, the game mechanics enhanced the story by allowing them to feel the main character's powerlessness, simply by sharing what limited control he had over his life. To others, it simply felt like an interactive story where you only had to press buttons to advance the story. However, most players recognised the overarching, framing narrative about grandpa who tells his own life story, and were able to interpret at least some of the scenes as designed.

Acknowledgments. The authors would like to thank the ITU students who voluntarily participated in the pilot study. The authors are also grateful to the Brain Korea 21 Plus Program through the National Research Foundation (NRF) funded by the Ministry of Education of Korea (10Z20130000013).

References

1. The Game by NutcaseNightmare, `http://www.newgrounds.com/portal/view/467574` (visited on August 18, 2014)
2. Loneliness by magjor, `http://www.newgrounds.com/portal/view/548694` (visited on August 18, 2014)
3. Porter Abbott, H.: The Cambridge Introduction to Narrative, 2nd edn. Cambridge University Press (2008)

K-Sketch: Digital Storytelling with Animation Sketches

Richard C. Davis and Camellia Zakaria

Singapore Management University, School of Information Systems, Singapore
{rcdavis,ncamelliaz.2014}@smu.edu.sg

Abstract. K-Sketch gives novice animators an easy way to tell stories with animation sketches. It relies on users' intuitive sense of space and time, and makes animation easy through the use of sketching and demonstration. Our studies have shown that people take naturally to telling stories with K-Sketch, and it is particularly helpful for exploring the timing of events. We also found that K-Sketch is a good collaborative medium for telling stories. In this demonstration we will show how K-Sketch works and explain how these advantages are realized in practice.

Keywords: Storytelling, animation, sketch, demonstration-based, informal user interfaces.

1 Introduction

Animations provide an attractive and engaging way to communicate ideas that are difficult to put into words, but most animation tools are difficult to learn and use. K-Sketch gives novice animators an easy way to tell stories with animation. K-Sketch provides an informal, sketch-based [4, 5] and demonstration-based [1] interface that makes animation easy by relying on users' intuitive sense of space and time. Originally built for pen-based computers, K-Sketch was recently redesigned to work for multi-touch mobile devices, specifically iPads and Android tablets. This demo will explain how the K-Sketch user interface works and how it has been used to tell stories.

2 The K-Sketch User Interface

K-Sketch is implemented using Adobe's Flex toolkit and AIR runtime. The user interface provides a single design space and is visually divided into three parts: tool palette on top, a drawing canvas in the center, and time controls on the bottom.

2.1 Positioning and Animating Objects

Tapping on an object or drawing a loop around it with the lasso tool will select it (Fig. 1-f). Dragging different regions of the manipulator executes different transformation operations: center region to translate, circle region to rotate, and any of the four cornered arrows to scale. Tapping on the manipulator (or double-tapping on an unselected object) enters a special mode where the next manipulation will be "performed"

A. Mitchell et al. (Eds.): ICIDS 2014, LNCS 8832, pp. 242–245, 2014.

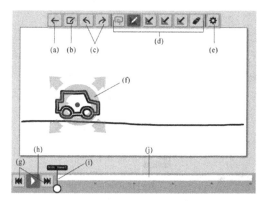

Fig. 1. K-Sketch User Interface. (a) Back to Main, (b) New Canvas, (c) Undo/Redo buttons, (d) Lasso, Pen and Eraser buttons, (e) Options button, (f) Object Manipulator, (g) Previous/Next Key Frame buttons, (h) Play button, (i) Time Slider and Magnifier, (j) Time bar.

(i.e., recorded in real time). After a motion has been recorded for an object, modifying the object's position will stretch the earlier part of a motion path, but leave the later part unchanged, as shown in Fig. 2(a).

Performing motions in this mode is users' primary means for creating animation, but we also support key-frame animation. Inserting a key frame pins an object to a location at a particular time. This can cause later parts of a motion path to stretch, as shown in Fig. 2(b).

Fig. 2. Changing an object's position in the middle of a motion stretches motion paths. In both figures, the original motion was from left to right, and the car was moved up half way through the motion. (a) The normal case. (b) When a key frame follows the current time.

2.2 Time Bar Navigation

Many animation tools include a timeline control that displays the history of every moving object. K-Sketch provides a simplified timeline that compresses all events into one list [3]. Performing a motion adds a gray tick mark at the beginning and end of the motion, changing an object's position in the middle of a motion adds a gray tick mark, and inserting a key frame adds a thick, black tick mark. When an object is selected, the timeline shows events for that object only. Users can modify the timing of a motion by selecting and dragging a tick mark along the time bar. Pressing and holding the time slider on a tick mark will select the tick mark. A magnifier appears to show that the tick mark is selected (see Fig. 3).

Fig. 3. Dragging a selected tick mark to adjust the end time of a motion path

3 Telling Stories with K-Sketch

K-Sketch encourages a wide variety of stories to be expressed quickly and clearly. In a previous field study, secondary school students used animation sketches to tell stories about science concepts (see Fig. 4). Telling stories with animation helped to motivate students, revealed misconceptions, and also helped retention of information. In another study, a UI design student used K-Sketch to tell stories about the behavior of a user interface (see Fig. 5). The ability to present her ideas efficiently and effectively facilitated team discussions and expedited the design process [6].

Fig. 4. An animated story about formation of crude oil created by a child during a field study

Fig. 5. Trapezoidal feedback animation created by a UI design student during a field study

Lastly, we conducted a study where children designed video games by telling stories about game sequences [2]. We found that children were about as good at describing game behavior with sketched animation as they were with words or static

sketches, and that animation was particularly well suited to describing action sequences. Also, the children in our study took naturally to collaborating around sketched animation: stories unfolded as one child would pick up and embellish an animation sketched by another child.

4 Conclusion

This demonstration will present K-Sketch as medium for telling stories. We will show how the K-Sketch user interface works, and we will show how it is being used to tell stories.

Acknowledgements. This work was supported in part by a grant from the Singapore-MIT GAMBIT Game Lab.

References

1. Baecker, R.: Picture-Driven Animation. In: Proc. AFIPS Spring Joint Computer Conference, vol. 34, pp. 273–288 (1969)
2. Colwell, B., Davis, R.C., Landay, J.A.: A study of early stage game design and prototyping. Technical report UW-CSE-08-10-03, Computer Science and Engineering Department, University of Washington, Seattle, WA (October 2008)
3. Davis, R.C., Colwell, B., Landay, J.A.: K-sketch: a 'kinetic' sketchpad for novice animators. In: Proceedings of the SIGCHI Conference on Human Factors in Computing Systems, pp. 413–422. ACM (2008)
4. Gross, M.D., Do, E.Y.: Ambiguous intentions: a paper-like interface for creative design. In: Proc. UIST 1996, pp. 183–192 (1996)
5. Landay, J.A., Myers, B.A.: Sketching Interfaces: Toward More Human Interface Design. IEEE Computer 34(3), 56–64 (2001)
6. Davis, R.C.: K-Sketch: A Kinetic Sketch Pad for Novice Animators (Unpublished doctoral dissertation). EECS Computer Science Division, University of California, Berkeley, CA (2008)

Telling Stories via the Gameplay Reflecting a Player Character's Inner States

Achim Wache[1], Byung-Chull Bae[2], Yun-Gyung Cheong[3], and Daniel Vella[4]

[1] Independent Game Developer, Nideggen, Germany
achimwache@gmail.com
[2] Sungkyunkwan University, Seoul, South Korea
byuc@skku.edu
[3] Sungkyunkwan University, Suwon, South Korea
ygcheong@gmail.com
[4] IT University of Copenhagen, Copenhagen 2300, Denmark
dvel@itu.dk

Abstract. In this paper we present our effort to combine an internally focalized narration with simple game mechanics using a silent narrative game in which player interaction possibilities are connected to the protagonist's state of mind and changing along with it as the story progresses. A preliminary user study indicates that our game successfully delivered a story during the activity of playing.

Keywords: Narrative-oriented gameplay, internal focalization.

1 Introduction

According to the narrative theorist Genette [2], a narrator's perspective can be focused either on objective information distribution (i.e., external focalization) or on the portrait of the subjective viewpoints of the story characters including their perception of the world and the events happening in the storyworld (i.e., internal focalization).

A few research on internal focalization has been made in games and interactive storytelling. Porteous et al. [3] presented a way to generate different narrative discourse using different viewpoints of characters in interactive storytelling. Bae et al. [1] made an analysis on multiple internal focalization, where the story events occurred during a particular period are retold by multiple characters, with a computational approach. Zhu et al. [4] presented an example of how a video game can include internal focalization, where the game world is rendered in a range of colors depending on the mood of the game's main character.

Inspired by Genette's concept of internal focalization and other previous works, particularly the work of Zhu et al.[4], our underlying research question is as follows - Can designed gameplay be the main vehicle of narrative conveyance as well as reflecting a main character's inner state of mind?

To test the idea of game mechanics and levels serving as a direct presentation of how a protagonist experiences a situation, we made a story-oriented game

A. Mitchell et al. (Eds.): ICIDS 2014, LNCS 8832, pp. 246–249, 2014.

including variations of game mechanics and settings that can reflect a main player character's inner states[1].

2 Game Design and Implementation

Stan, the protagonist in our game, is a caricatural nobody leading a life based on routines. The only fluctuant things in his life are his mood and the people around his environment. The three days of his life presented by our game start with the way to work, climax with the lunch break, and end with the way home. Cutscenes displaying dialogues including facial expressions without explicit speech between Stan and his co-worker are shown after each lunch break. These cutscenes were intentionally designed to not deliver crucial story information by themselves alone.

The First Day. As the game starts, Stan is briefly introduced and no instructions are given. The unwilling Stan is facing backwards and he is drawn towards work by x-axis gravity. The player has to get Stan to work by negating the x-axis gravity. During lunch break, Sophie, Stan's co-worker, is introduced and starts a conversation with Stan who is not listening. This is represented by the player's controlling a pong-board in order to repell Sophie's words. On every hit that Stan receives text fragments appear until displaying "She said something". Once the sentence is complete, the game progresses and the first dialogue is shown, where Stan fails on Sophie's request to take part in the conversation. He discovers that he did not want to upset her, which leads to the way home being free fall into his personal abyss. The player has to make Stan hit a randomly appearing small platform. If hit, Stan bursts into pieces - symbolizing his self-realisation. Otherwise, the fall continues until the platform is hit. The depth of the abyss was supposed to be calculated out of the displayed evaluation of player effort.

Fig. 1. The First Day (Left: Way to Work; Middle: Blah-Pong; Right: Way Home). Stan is facing in backward direction and going downhill, implying his reluctance to going to work; in Blah-Pong the player can block what Sophie says as in the traditional Pong game; on the way home Stan is free-falling and literally bursting into pieces, implying his rude awakening metaphorically.

[1] A gameplay example of our game can be seen here: `http://youtu.be/xpQsAcVyOEQ`

The Second Day. Feeling bad, Stan decides to make things right the next day. The player is in full control of Stan's movement due to removed x-axis gravity. The jumps are higher; the platforms start to tremble and disappear shortly after being touched. The second lunch break presents the same as the day before, but with switched roles this time. The player controls a gun shooting "Sorry" at Sophie, who is protected by a computer-controlled pong-board repelling the player's effort. The dialogue in the next cut-scene shows Sophie accepting his apology. The way home on this day now is a fall braked down by a parachute and the landing platform cannot be missed.

Fig. 2. The Second Day (Left: Way to Work; Middle: Sorry-Shooter; Right: Way Home) Stan is now facing in the forward direction and going uphill with more controllability, implying Stan's positive inner state; in Sorry-Shooter the player can shoot the word Sorry to Sophie who is continuously blocking the words; on his way home Stan is falling safely with a parachute, implying the environment around Stan is getting better.

The Last Day. After having taken action, Stan wakes up with a clear mind and experiences the way to work as a regular work towards a bus stop. Jumping is deactivated and the way to work is just flat. The lunch break game presents the same setting as in the first lunch break, but now Sophie's words centre around the middle of the screen. The player controls a little Stan, who is able to jump between three platforms with words below and chooses what Stan is going to reply. The goal of the game is to match the words for a perfect result and progresses after ten turns. However, the game cannot be lost since a healthy conversation does not require all the words to fit each other. Stan and Sophie enjoy their time and the last way home, rendered in colourful meadows with flowers, turns into the end screen.

Fig. 3. The Last Day (Left: Way to Work; Middle: Talk-Together; Right: Way Home) The way to work is now smooth and flat, implying Stan's peace of mind; in Talk-Together the player can select matching words to what Sophie suggests, implying the two-sided conversation finally; there is an ending scene with colorful flowers, implying Stan's inner thought on his bright future with Sophie.

3 Pilot Study and Conclusion

We conducted a pilot study with 15 participants (male 13; female 2). Each participant played the Flash game in private followed by an one-on-one interview. Goals of the study were to assess whether the players were able to recount a story matching the one intended; whether they would perceive Stan as an individual disconnected from the player and where they drew most of their information from gameplay or graphical display. Participants were divided into four groups based upon their willingness to find a story in however little information. First, story-oriented (3 participants) were considered being very likely to recognize the game's story and its impact on gameplay. Second, mechanic-oriented players (6) were the opposite to the story-oriented. Third, balance-oriented (4) formed the middle of the two. Last, the group of non-players (2) was assumed to give subjective feedback free of too specific expectations, experience, or knowledge of the game medium.

Results show that all groups recognized the story and its impact on gameplay in relatively short time with high empathy for Stan. On average, mechanic-oriented players were confused by the lack of information regarding what to do and why. A non-player stated explicitly that the dialogues were unnecessary and that the mini games would speak for themselves. Explicit need for the dialogues was never stated.

Limitations of this study are the number of participants and the uneven gender distribution. A further study with more participants equally distributed across all groups and genders would allow to approximate a more general conclusion. A more complete and polished version of the game would add to this, as well as various story states.

Acknowledgments. The authors want to thank all the participants of our study as well as everyone who shows interest in our topic and the field of narratives in games. The authors are also grateful to the Brain Korea 21 Plus Program through the National Research Foundation (NRF) funded by the Ministry of Education of Korea (10Z20130000013).

References

1. Bae, B.C., Cheong, Y.G., Young, R.M.: Automated story generation with multiple internal focalization. In: Proceedings of the IEEE Conference on Computational Intelligence in Games, pp. 211–218 (2011)
2. Genette, G.: Narrative Discourse: An Essay in Method. Cornell Univ. Press (1980)
3. Porteous, J., Cavazza, M., Charles, F.: Narrative generation through characters' point of view. In: Proceedings of the 9th International Conference on Autonomous Agents and Multiagent Systems, AAMAS 2010, Richland, SC, vol. 1, pp. 1297–1304 (2010), http://dl.acm.org/citation.cfm?id=1838206.1838375
4. Zhu, J., Ontañón, S., Lewter, B.: Representing game characters' inner worlds through narrative perspectives. In: Proceedings of the 6th International Conference on Foundations of Digital Games, FDG 2011, pp. 204–210. ACM, New York (2011), http://doi.acm.org/10.1145/2159365.2159393

An Introduction to Game-Mastering: Telling Stories with Tabletop Role-Playing Games

Shao Han Tan

Independent
Singapore
shao.han.tan@gmail.com

Abstract. This full-day workshop introduced participants to some perspectives and techniques of storytelling commonly used by "game-masters", a subset of players of tabletop role-playing games. A talk and presentation was held on the uses of these games as tools for collaborative storytelling. Some practical exercises involving role-playing and world-building were also held at this workshop. There was also some discussion on how game-masters' approaches to storytelling could be applied in the field of computer games.

Keywords: Tabletop role-playing games, Dungeons and Dragons, Storytelling, Collaborative storytelling, Game-masters.

1 Introduction

In recent years, there has been a revival in interest from the general public toward the field of tabletop role-playing games (TRPGs) such as Dungeons and Dragons (D&D). There exists a strong level of mystique and misunderstanding about these games, which are encouraged by the barriers to entry that exist for new players. The rules can be difficult to learn, it may be hard to find groups to play with, and playing these games requires large quantities of time and social interaction, which are both scarce commodities in the frenetic world which we live in today.

2 Description

This full-day workshop sought to dispel some of these misconceptions and break past these barriers by introducing participants to the basics of TRPGs. It also shared some methods which TRPG players use to create stories together, and also discussed how stories are told and remembered by groups of players together over long periods of play. Different types of motivations, perspectives and practices of TRPG players were also discussed, and storytelling exercises were conducted.

These questions were explored—what are some storytelling (and story-remembering) methods used by TRPG players? What can we learn, in terms of both knowledge and practice, about story creation from observing and understanding some of the practices of TRPG players?

A. Mitchell et al. (Eds.): ICIDS 2014, LNCS 8832, pp. 250–251, 2014.

In particular, this workshop focused on the role of a subset of TRPG players known as "game-masters" (GMs), and discussed the roles which GMs assumed within their respective gaming groups as the leaders, organizers, and sustainers of creative collaborations. The workshop organizer shared his opinions and insights on how to draw upon one's emotions, feelings, and thoughts in fostering a safe atmosphere for one's friends and fellow players to engage in creative collaboration and storytelling.

3 Workshop Organizer, Shao Han Tan

Shao Han Tan is an avid and experienced TRPG player and GM. He currently works as a teacher in the National University of Singapore, and was previously a game designer at the Learning Sciences Laboratory in the National Institute of Education of Singapore. Shao Han sees several applications for learning which can be drawn from the practices and perspectives of TRPG players. He is currently planning to increase the public awareness of storytelling games, and is working to develop more storytelling games for a general audience. It is his hope that more people will become interested in becoming "game-masters" of sorts, and create and share narratives with each other.

Managing Informational Interactive Digital Storytelling (IDS) Projects

Deborah Elizabeth Cohen

Gyeongju University
Gyeongju, South Korea
DrDElizabethcohen@cognition-ignition.com

Abstract. The aim of this half-day interactive tutorial workshop was to intro-
duce the informational interactive digital storytelling lifecycle and affiliated
processes and deliverables. The session provided an overview of project man-
agement and design management processes necessary to achieve a high quality
product and smoothly functioning development process that involves stake-
holders and fosters the collaboration of interdisciplinary collaborators.

Keywords: interactive digital storytelling, project management.

1 Introduction

The design of an informational interactive digital storytelling project is a highly
complex enterprise. When fully realized, informational interactive digital stories are
intricate products integrating design features from numerous disparate domains.
Sophisticated design processes are necessary to facilitate communication enabling the
integration of interdisciplinary design features.

Such products have the capacity to not only be engaging but highly effective in
conveying information and, when appropriate, to fulfill learning outcomes. The man-
ager of such projects must be aware of how to lead such a design project with exper-
tise not only in working with designers from different disciplines but the ability to
facilitate the design process to enhance quality and quantity of original ideas. The
manager must coordinate the initial gathering of product requirements and determine
at product completion not only product usability but also how well the requirements
have been fulfilled. Processes must be utilized to maximize the contributions of
contributors and stakeholders to make the best choices of content to include and strat-
egies with which to implement them, and to create the optimal story world, narrative,
and interactive affordances to result in excellent user interactions and user experience.

2 Description

In this half-day participatory tutorial workshop, Elizabeth Cohen provided a roadmap
for people interested in best practices for managing the design and development of
informational interactive digital storytelling projects. She provided an overview of

A. Mitchell et al. (Eds.): ICIDS 2014, LNCS 8832, pp. 252–253, 2014.
© Springer International Publishing Switzerland 2014

project management and discussion of why the complexity of interactive digital story-telling projects is well supported by project management processes. She also discussed issues related to interdisciplinary collaboration and stakeholder involvement.

Cohen discussed phases of the IDS design and development process, introducing deliverables associated with them, including requirements gathering, designing from requirements, communicating visual and interactive information through storyboards, managing the review process, bridging the design and development phases through walkthroughs, and testing for usability and quality control. Students were provided with deliverable samples and given the opportunity to practice various design processes.

3 Workshop Organizer, D. Elizabeth Cohen

Elizabeth Cohen is an experienced interactive digital storytelling producer, a currently certified Project Manager (PMP), and the recipient of numerous awards for media design and development. With early experience as a musician and theater and film director and scriptwriter, she evolved into an instructional designer. After specializing primarily in technology-based educational communications projects, she began a 15 + year career managing educational multimedia products for a variety of high-profile clients. Her PhD is in Computing Technology in Education, and she is currently an Associate Professor in the Global Education Center at Gyeongju University in South Korea. Her research interests encompass global digital media for education and social change.

Narrative Analysis of Interactive Digital Storytelling

Colette Daiute

The Graduate Center, City University of New York
365 Fifth Avenue
New York, NY 10016, USA
cdaiute@gc.cuny.edu

Abstract. The "Narrative Analysis of Interactive Digital Storytelling" half-day workshop presented theory and methods for research, practice, and design of IDS as a sense-making process. Workshop presentations, activities, and discussions built on the idea that interactive digital storytelling is dynamic, complex, and unpredictable, yet, as a symbolic communication system, IDS invites analysis as well as surprise, enjoyment, and human development. The focus of the workshop was the application of strategies for analyzing meanings and interactions in different kinds of IDS environments. Colette Daiute, Professor of Psychology at the Graduate Center, City University of New York, highlighted narrative inquiry strategies including hyper-plot analysis, multi-dimensional character mapping, and poly-cultural values analysis, based on her published and ongoing research. Dr. Daiute welcomed elaborative discussion with workshop participants, who included researchers, program designers, and others interested in studying and extending IDS.

Keywords: Narrative analysis, Interactive digital storytelling research, Interactive digital storytelling design.

1 A Narrative Lens on Interactive Digital Storytelling

Digital storytelling is multi-modal, multi-interactive, playful, and sometimes profound. While complex, dynamic, and unpredictable, interactive digital storytelling is symbolic communication and, as such, invites analysis as well as surprise and enjoyment. The "Narrative Analysis of Interactive Digital Storytelling" workshop presented interdisciplinary theory and methods for IDS in research, practice, and design. The foundational premise of the workshop was that narrating is an interactive process of meaning making [1].

Definitions of narrative as an interactive process have become increasingly common. Cognitive theories have explained that narrative is "something used by humans for the purpose of aiding, enhancing or improving cognition" [2, 3]. Socio-cultural developmental theory highlights narrating as an activity to "figure out what is going on in the world, how one fits, and sometimes how it should be changed," [4], and critical discourse theory posits tensions between master narratives and personal stories. [5] Together these and other approaches are consistent with literary theory explaining that even extended monologic narratives, like novels, interact with authors' prior, present, and intended interactions with relevant others [6]. Contemporary

A. Mitchell et al. (Eds.): ICIDS 2014, LNCS 8832, pp. 254–257, 2014.

theories of narrative include that culture is integrated in the narrative process via se-miotic elements that also contribute meaning. [7] On this view, narrative authors (speakers, performers, artists) use narratives to mediate interactions with actual and imagined audiences. The primary narrative goal is, thus, to *do* something serving one's knowledge development, pleasure, and/or participation in ways that connect with actual and imaged expectations in the environment. A narrative approach to IDS puts this organizing function of narrating into action (and to the test) by paying atten-tion to the creative and interpretive narrative qualities like plot, character, values, and so on.

Consistent with definitions shared among ICIDS conference participants, this workshop focused on analysis of stories created completely or partially with digital tools in digital environments, expressed in multiple symbolic modes, with contribu-tions by multiple participants who add to or alter a story intended as a whole in some way. Interactive digital stories may be defined by digital space, context of origin (such as website, classroom, user group), project goal, or another relevant category. IDS may occur among self-defined on-line communities, guided contexts such as education and community activism, or experimental projects. The analysis strategies were relevant across such contexts.

2 Toward the Analysis of Interactive Digital Storytelling

Extending other models of narrative relevant to IDS, the approach in this workshop was to employ qualities inherent in narrative – such as plot and character – as analytic tools. Presentations, activities, and discussions applied this idea that the major orga-nizing frames of narrative meaning include purpose (values), structure (plot), and character and demonstrated how these literary concepts can provide parsimonious analytic means for insights about IDS.

3 IDS Narrative Analysis Concepts and Strategies

The workshop began with a brief overview of narrative theory and rationales for narr-ative analysis, with an illustration of each in IDS contexts. The following principles provided a foundation for subsequent workshop activities: 1) narrating is a dynamic process—interactive across persons, time, space, semiotic media; 2) narrating is a meaning making process, implicitly purposeful for connecting, disconnecting, figur-ing out what is going on, how one fits, and sometimes changing things to create innovations; 3) interactive digital storytelling weaves multiple expressive strands of meaning; 4) IDS is amenable to narrative analysis. Consistent with these principles, Colette Daiute presented three strategies for analyzing interactive digital stories and storytelling processes: "Hyper-plot Analysis," "Multi-dimensional Character Map-ping," and "Poly-cultural Values Analysis". For each, she offered an example, a template and guidelines for participants to apply, and invited discussion about the kinds of questions the analyses could address.

Hyper-Plot Analysis: Plot is the structural organization of stories, guiding perception and interpretation of meaning. From the reader's and the author's perspectives, story

meaning – and a reason for interacting – comes in large part from his/her sense of the evolving plot as integrated with sub-plots, parallel plots, and so on as these relate to some personal or collective purpose. To create and make one's way through complex narratives, a participant uses a plot structure (often intuitively). Because IDS is interactive across even more dimensions than non-digital narrating, interactive digital story participants engage with what we refer to as "hyper-plots"—multiple plots within and around digital stories.

Daiute illustrated hyper-plot analysis with an example of multi-modal interactive storytelling from an activity coordinated with community centers across separated countries following the 1990s wars that shattered the former Yugoslavia. Story authors included youth and young adults growing up during and after the wars, and one of their digital activities was to continue from a story seed [8].

Daiute explained that this story launch inspired 137 participants across the post-war contexts in different ways, and then she illustrated hyper-plot analysis with examples. The following excerpts offered a mere hint to the richness of the interactive storytelling in that context and the effectiveness of the hyper-plot analysis for identifying patterns of uptake, development, and transformations across the completion alternatives. The story "Rockers and Posers," for example, by Thor in Serbia, emerged as relatively rich in how it picked up and elaborated the story seed setting. Thor established an initiating action with the metaphor of fire and its vengeance, developed the story with complicating actions, and concluded by resolving with a stated lack of resolution. Daiute explained that a story by JS in Croatia picked up in a different way on the story seed, introducing the initiating actions of financial obstacles and, in contrast to the previous story, a series of activist resolutions.

The group considered relevant questions that could be addressed, such as "Which plot elements from the story seed do diverse story participants take up? How do they develop and alter these plot elements, with what similarities, differences, transformations across story, mode, time, participant, or group?"

Multi-dimensional Character Mapping: While plots function as structural scaffolds, characters serve as anchors of interactive digital storytelling. Dynamic in their own way, characters enact and/or develop different meanings with their orientations, qualities, goals, or relationships over time and spaces in a story world. For that reason, character mapping offers insights about another dimension of how story authors create meaning individually and collectively, to interact with one another, to elaborate or shift plots, and to change or maintain their own involvement over time in the story world. The workshop leader illustrated the character mapping process with excerpts from a different story world than in the example above and provided a template to guide a character mapping workshop activity with prepared materials and/or for participants to apply to their projects. Analytic categories included: character, character person (first person ["I"...], second ["you"]), third ["he, she, it"]), character number (singular, plural), character enactment (actions, psychological states).

Poly-cultural Values Analysis: As cultures, interactive digital storytelling environments establish values, which may be temporary, enduring, consistent, conflicting, or transforming as participation by different authors augments the story in different expressive modes/spaces and over time. Guiding story values are worth identifying as

the basis for author/interpreter selection of what to express, what not to express, and how to do that, as well as the contribution of implicit and explicit values with plot and other elements to meaning. Daiute presented an example of values analysis of a multi-modal story world to address questions about community development related to immigration rights in the United States. Daiute illustrated, for example, how the importance of separating the past and future emerged in a values analysis of multi-modal stories. She explained that once researchers identify values from the database of interactive digital stories, they apply the broader set of values to the entire database, revealing the nature and frequency of values across modes. As presented in the workshop, visual expressions tended to highlight graphically the value that immigrants who participate positively deserve and expect possibilities for the future, while textual examples critiqued obstacles. In addition to indicating interplay of values across expressive modes, the analysis example addressed interplay among story participants, time, and digital genres.

4 Conclusion

The workshop concluded with a discussion about the narrative approach to interactive digital storytelling, the specific analysis strategies employed and integrating among them, questions about attendees' projects, and ideas for a follow-up workshop.

References

1. Daiute, C.: Narrative inquiry: A dynamic approach. Sage, Thousand Oaks (2014)
2. Alonso, A., Molina, S., Dolores Porto, M.D.: Multimodal digital storytelling: Integrating information, emotion and social cognition. Review of Cognitive Linguistics 11(2), 369–387 (2013)
3. Herman, D.: Cognitive approaches to narrative analysis. In: Brône, G., Vandaele, J. (eds.) Cognitive Poetics: Goals, Gains and Gaps, pp. 79–118. Mouton de Gruyter, Berlin (2009)
4. Daiute, C., Nelson, K.A.: Making sense of the sense-making function of narrative evaluation. Journal of Narrative and Life History 7(1-4), 207–215 (1997)
5. Fairclough, N.: Critical discourse analysis: The critical study of language, 2nd edn. Pearson, New York (2010)
6. Bakhtin, M.M.: The problem of speech genres. In: Emerson, C., Holquist, M. (eds.) Speech Genres and Other Late Essays, pp. 60–102. University of Texas Press, Austin (1986)
7. Zittoun, T.: Transitions: Development through symbolic resources. InfoAge, Greenwich (CT) (2006a)
8. Daiute, C.: Human development and political violence. Cambridge, New York (2010)

Future Perspectives for Interactive Digital Narrative

Hartmut Koenitz[1], Mads Haahr[2], Gabriele Ferri[3], Tonguc Ibrahim Sezen[4],
and Digdem Sezen[5]

[1] University of Georgia, Department of Telecommunications,
120 Hooper Street, Athens, GA 30602-3018, USA
[2] School of Computer Science and Statistics, Trinity College, Dublin 2, Ireland
[3] Indiana University, School of Informatics and Computing
919 E Tenth St, Bloomington, IN, USA
[4] Istanbul Bilgi University, Faculty of Communications
santralIstanbul, Kazim Karabekir Cad. No: 2/13, 34060 Eyup, Istanbul, Turkey
[5] Istanbul University, Faculty of Communications
Kaptani Derya Ibrahim Pasa Sk. 34452 Beyazit, Istanbul, Turkey
hkoenitz@uga.edu, Mads.Haahr@cs.tcd.ie, gabferri@indiana.edu,
tonguc.sezen@bilgi.edu.tr, dsezen@istanbul.edu.tr

Abstract. In a maturing field of Interactive Digital Narrative (IDN) it is vital to identify trends and areas that require continued attention to understand opportunities for future research. This ICIDS workshop will be an exercise in futuring, starting with a discussion of broad trends described by the organizers. Given the speculative nature of the exercise, broad visions for the field are also invited, from the Holodeck to a meta-narrative textual universe to ubiquitous narrative computing and brain-wave interfaces.

1 Introduction

Interactive Digital Narrative (IDN) is an ever growing field that encompass a wide range of practices, from avant-garde art to electronic literature, and applications in video game design. While the pace of development in the field shows no sign of slowing down, after more than 25 years, we can identify broad trends and major achievements as a foundation for an exercise in futuring. By hypothesizing about possible developments, researchers in the field can identify opportunities for future research and create a foundation for collaborations and grant development.

To start the discussion in this half-day workshop, we suggested a range of directions. More exactly, we discussed narrative game experiences, place-specific digital experiences and finally, the application of IDN technologies in news reporting and documentary practices.

2 Perspectives on Future IDN Development

Current video games are adopting a wide range of narrative strategies: from the overarching narratives in single-player games such as the Assassins' Creed [1] series, to

A. Mitchell et al. (Eds.): ICIDS 2014, LNCS 8832, pp. 258–261, 2014.

the chains of quests in massively multiplayer online roleplaying games such as World of Warcraft [2] to the more emerging structures that can appear in sandbox games like the Grand Theft Auto [3] series. Games like The Wolf Among Us [4] or The Walking Dead [5] have appropriated forms of episodic storytelling typical of graphic novels or television series. Independent video game auteurs have experimented with tropes like the unreliable narrator or role reversal in pieces such as Dear Esther [6], Gone Home [7] or The Stanley Parable [8]. Finally, hybrid forms exist, for example CAVE! CAVE! DEUS VIDET [9], an art piece blending elements from interactive visual novels with graphic adventure games. A plausible future trend for this specific IDN practice would be an even tighter integration between narrative components and game design elements, leading to a more central role of computer-controlled characters in video game narratives and, at the same time, to a more conscious and varied use of dramatic compression.

Micro-narrations that react to their user's physical location are another recent trend. Currently, the Foursquare app [10] is one of the best-known examples in this category as a "recording device (in the fashion of a travelogue, to share written notes on places, routes, episodes)." [11] Several other apps are specifically designed for storytelling – amongst them Broadcastr [12] and MapSkip [13]. The combination of interactive digital narratives with location-based technology and pervasive gaming has resulted in playful travel guides, interactive museum experiences and even geolocalized fitness apps. For example, Whaiwhai [14], currently available for the cities of New York, Florence, Rome, Milan, Venice and Verona, blends the style of traditional travel guides with game elements. Fitness apps like Zombies, Run! [15] and The Walk [16] feature complex narrative structures. These titles are the first to rely on interactive storytelling to entice users to start training. Future developments in this specific area of IDN practice would rely on more advanced techniques for geolocalization, especially following recent developments in in-door location tracking for an even tighter integration between narrative and physical places. The combination of interactive narrative and ubiquitous computing could open a new field for IDNs to develop.

Adopting IDN elements and technologies to present news and other journalistic contributions is a relatively new tendency in this field. Partially overlapping with the fields of newsgaming, serious gaming and interactive documentaries, some recent digital narrative projects aim to inform their audience or present political messages. While interactive documentaries have existed since the 1980s as exemplified by Glorianna Davenport's piece *A City in Transition: New Orleans 1983-86* [17], only recently, with the widespread diffusion of fast broadband connections, interactive documentaries are becoming a more established genre of IDN. *Inside the Haiti Earthquake* [18] is a recent example that casts the user variously in the role of journalists, aid workers or survivors of the January 2010 Haiti earthquake. The piece is designed to challenge assumptions about relief work in disaster situations, allowing interactors to try various strategies and experience their consequences. *Fort McMoney* [19] discusses the Canadian oil industry and lets players explore the small town of Fort McMurray and the consequences caused by the get-rich-quick mentality of its inhabitants. This piece is more explicit than many others in blending some typical video game structures and design tropes with a documentary objective. *Fort McMoney* creates a quest-like system: participants need to search for information by exploring

interviews; their progress is tracked using points and credits on a dashboard. Finally, *1000 Days of Syria* [20] presents three narratives set in the Syrian civil war that began in 2011: users can follow a foreign photojournalist, a mother of two living in Daraa or a rebel youth living in Aleppo. *1000 Days of Syria* is presented as a text-only hypertextual structure in an attempt to force users to empathise more with the characters' internal struggles without being distracted by visual elements. Future developments for this specific IDN practice might follow different paths. One could be tied to more realistic virtual environments for players to explore, interacting with relevant computer-controlled virtual characters. This way, users could experience far away or dangerous places and interact with specific characters within these environments. Another possibility would be related to new developments in three-dimensional presentation: for example *Condition One* [21] presents video footage in which users can rotate their point of view by physically turning the device. One of the demonstrations for this system was a short interactive documentary in which the participant was situated in a trench during a battle in Libya. An improved version of the same system is currently under development for the Oculus Rift virtual reality goggles, promising a true immersive experience in documentary footage. Finally, documentary IDNs might become more closely associated with the newsgame genre, adopting more ludic characteristics such as providing players with objectives to achieve and leaving them to explore the diverse consequences and effectiveness of various tactics.

3 Workshop Format

These three perspectives were meant only as a start for the discussion, in which participants debated possible future trends in IDN. As a next step the workshop considered resulting issues and identified opportunities for research that resulted from the findings. More exactly, we discussed the following questions with the participants:

- What research questions arise from the trends in IDN practice?
- How do these questions connect with existing research?
- Which discipline/field has the best expertise to cover these questions? Is an interdisciplinary approach needed
- What opportunities for collaborations and grant development exist?

The organizers asked participants to send a list of cutting-edge examples and potential grant opportunities before the conference as a basis for discussion. The results of the discussion are shared on *the Games & Narrative* research blog [22].

References

1. Assassins' Creed [video game series]. Ubisoft (2007-2013)
2. World of Warcraft [video game]. Blizzard Entertainment(2005-2013)
3. Grand Theft Auto [video game series]. Rockstar Games (1997-2013)
4. The Wolf Among Us [video game series]. Telltale Games (2013)
5. The Walking Dead [video game series]. Telltale Games (2012-2013)

6. Dear Esther [video game]. The Chinese Room (2012)
7. Gone Home [video game]. The Fullbright Company (2013)
8. The Stanley Parable [video game]. Galactic Café (2013)
9. CAVE! CAVE! DEUS VIDET [video game]. We Are Muesli (2013)
10. Foursquare [app]. Foursquare Inc. (2009-2014)
11. Caruso, G., Fassone, R., Salvador, M., Ferri, G.: Check-in Everywhere. Places, People, Narrations, Games. Comunicazioni Sociali Online (2011)
12. Broadcastr [app]. Broadcastr (2011)
13. Mapskip [website] (2007-2013), http://Mapskip.com
14. Whaiwhai [game series]. Log607 (2009-2011)
15. Zombies, Run! [video game]. Six to Start (2012)
16. The Walk [video game]. Six to Start (2014)
17. Davenport, G.: New Orleans in transition, 1983-1986: The interactive delivery of a cinematic case study. In: The International Congress for Design Planning and Theory, Education Group Conference Proceedings, Boston, MA, pp. 1–7 (1987)
18. Inside the Haiti Earthquake [interactive documentary]. PTV Productions, Inc. (2010)
19. Dufresne, D.: Fort McMoney [interactive documentary] (2013)
20. Swenson, M.: 1000 Days of Syria [interactive documentary] (2014)
21. Condition One [interactive documentary]. Condition One Inc. (2011-2014)
22. http://gamesandnarrative.net

Story Modeling and Authoring

Ulrike Spierling[1] and Alex Mitchell[2]

[1] Hochschule RheinMain, Wiesbaden, Germany
[2] National University of Singapore
ulrike.spierling@hs-rm.de, alexm@nus.edu.sg

Abstract. The complexity of interactive storytelling technologies often requires the use of authoring tools, which may embody specific models for thinking about storytelling. These models can both empower and constrain authors. This workshop addressed the issue of story modeling and authoring within the interactive story conceptualization and creation process. Contributions were sought in the form of informal position papers and presentations. These contributions formed the basis for discussions about the impact of story models on the authoring process, the relationship between story models and authoring tools, and the ways in which these models can be made visible and accessible to non-technical authors.

Keywords: story modeling, authoring tools, authorial constraints and affordances.

1 Motivation

Interactive Digital Storytelling (IDS) is an interdisciplinary field of research, technology development and artistic expression. Intelligent technologies have often been presented in the form of concept papers and working prototypes at previous conferences. These papers and prototypes have encompassed a wide range of perspectives on interactive storytelling, including various approaches to automatic drama management in reaction to user actions within storyworlds; various ways to structure AI-based behavioural models of agents for digital characters; methods for language understanding and generation as a foundation for dialogue design; and frameworks for smart graphical rendering and animation. Complete end-user experiences that make use of the above-mentioned intelligent components have not been presented as frequently. This lack of "real" examples of interactive stories has often been attributed to the obvious difficulty for story creators and authors to apply their full artistic expression in the context of technically challenging tools and programming concepts.

On the one hand, difficulties for content creation take the form of direct practical obstacles to perform technical authoring with complex programming languages. Authoring tools can help to ease the technical creation, but often bring with them certain models for thinking about storytelling. On the other hand, when the implementation of dynamic content is distributed across different authoring roles and performed by technically savvy teams, the conceptual and creative aspects of storyworld creation

A. Mitchell et al. (Eds.): ICIDS 2014, LNCS 8832, pp. 262–263, 2014.
© Springer International Publishing Switzerland 2014

may be predetermined by the method of drama management provided by the underlying technical system. Different tools and engines contain, to a greater or lesser extent, predefined story modeling approaches, thus presenting affordances for the creation of specific types or genres of stories and interactive experiences.

There have been several discussions at ICIDS conference workshops in previous years (2008 to 2010) that have encouraged interdisciplinary conversations about authoring problems on the one hand, and the comparability of tools and drama engines on the other hand[1]. This year we returned to this topic, revisiting the actual state of the art and focusing on the influence that tools and preset models have on our creations. We also addressed the notion of story modeling as an authoring task, and how to provide authors with the ability to see, and potentially modify, the underlying models embodied in the tools they are using to create interactive stories.

2 Workshops Aims

Researchers, engineers and creators in the area of Interactive Storytelling were invited to contribute to the workshop in the form of informal position papers and presentations, and to participate in a joint discussion about drama management models, authoring tools, generative story engines, narrative structure, as well as various approaches to story conception and creation in interactive storytelling. We called for contributions in (but not limited to) the following general areas:

- Presentation of story engine approaches operating on narrative structures
- Presentations and/or comparisons of narrative structures in interactive storytelling
- Types of models of interest for interactive storytelling (e.g. character models, relationship models, psychological models, plot models, dialogue models, interactive fiction and hypertext models etc.)
- Practical reports of authoring challenges in interactive storytelling with specific story models and authoring tools
- Abstraction and story modeling performed during authoring and interactive story conception

The discussion was guided by (but not limited to) the following questions:

- Does the inherent presence of narrative structures in a tool lead to the creation of ever-similar interactive story experiences?
- What types of narrative models within tools are more or less constraining for authors?
- Do constraints support and/or hinder creativity, and in which way?
- Can representation layers (choice of graphics, camera, audio, text) be thought of separately from story structures during authoring?
- How can authors craft their own models?

[1] For example, see http://redcap.interactive-storytelling.de

Author Index